Child of the Fire

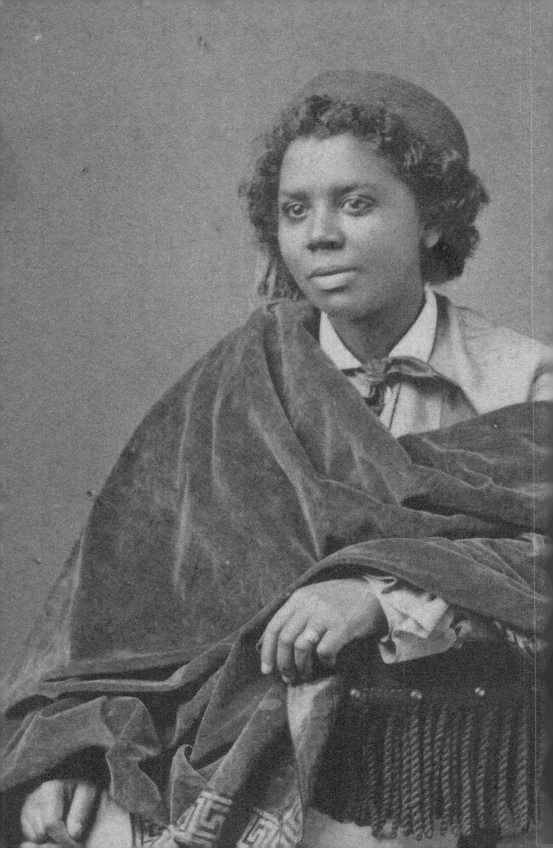

Child of the Fire ⁓

Mary Edmonia Lewis and the Problem of
Art History's Black and Indian Subject

Kirsten Pai Buick

DUKE UNIVERSITY PRESS
Durham & London 2010

© 2010 Duke University Press
Designed by Jennifer Hill
Typeset in Garamond Premier Pro by Tseng Information Systems,
Inc.

Library of Congress Cataloging-in-Publication Data appear on the
last printed page of this book.

Duke University Press gratefully acknowledges the support of the
Mary Duke Biddle Foundation, which provided funds toward the
production of this book.

For Ruth

For we are not pans and barrows, nor even porters of the fire
and torch-bearers, but children of the fire, made of it, and only
the same divinity transmuted and at two or three removes,
when we know least about it.

Ralph Waldo Emerson (1844)

Men talk of the Negro problem. There is no Negro problem.
The problem is whether the American people have loyalty
enough, honour enough, patriotism enough, to live up to their
own Constitution.

Frederick Douglass (1893)

As a disabling virus within literary discourse, Africanism has
become, in the Eurocentric tradition that American education
favors, both a way of talking about and a way of policing
matters of class, sexual license, and repression, formations
and exercises of power, and meditations on ethics and
accountability.

Toni Morrison (1992)

CONTENTS

FIGURES

PLATES (*after page 102*)

➤ Framing the Problem

American Africanisms, American Indianisms, and
the Processes of Art History

To echo one of the most famous opening lines in the
history of cinema, I believe in art history.[1] I believe
that it can make a difference; I believe in its tools and
methods, and I believe in the men and women who have
gone before me and who are my contemporaries—that
their commitment to the visual record of human endeavor
is profound and sincere. What has puzzled me, however,
has been the lack of dialogue in certain cases. This lack of
communication between scholars was never as apparent
as when, on the advice of Rick Powell, I took up the topic
of Mary Edmonia Lewis, first as a dissertation and then
as a book (plate 1). At a certain point in the process of
transforming the dissertation into a book, I realized that I
was frequently asking myself what this scholar would have
said to that one about Lewis had this area of the disci-
pline reflected the passionate engagement of other areas,
areas related to U.S. landscape, nineteenth-century French
painting, or to the Italian Renaissance, for example. What
put this kind of scholarship, I asked, scholarship about a
self-proclaimed African American and Native American
woman, off-limits?

I decided to work it out on paper with the result that I
was actually writing two books—two books that are mutu-
ally supporting and interdependent. One book comprises

an examination of Lewis's career, the systems in place to support that career, and a thematic discussion of her sculpture, which I have divided into "slavery works," "Indian works," and *The Death of Cleopatra*. The other book is a verbalization of the ongoing dialogue I had with art history while studying Lewis and more generally while studying "American" and African American art historiography.[2] In chapters 2, 3, and 4, the "books" are reflected in the two halves, or sections, of the chapters. The first section of each chapter functions to lay the theoretical grounds for its corresponding thematic section, which treats a specific category of Lewis's ideal sculpture — that is, sculpture of an idealized subject based on the Bible, mythology, literature, or history. For example, the first section of chapter 2 is titled "Reading Duncanson (and Reading Lewis)" and explores how art history constructs the black or Indian subject and what is at stake in upholding that subject. Concomitantly, the following section in the chapter, titled "Slavery Works: Embodying the Black Subject," represents what art history could do if its methods and procedures were adhered to so that race and gender are historicized and "put in their place" among the myriad of discourses that determine an artist's career.

I have attempted in the process of this exercise to be ever mindful of the words of the three great intellects quoted in the epigraph: Ralph Waldo Emerson, Frederick Douglass, and Toni Morrison. They have been my touchstone in this endeavor. In his essay "The Poet," published in 1844, Emerson writes, "For we are not pans and barrows, nor even porters of the fire and torchbearers, but children of the fire, made of it, and only the same divinity transmuted and at two or three removes, when we know least about it."[3] Emerson kept me alert and kept me open to the possibilities of Lewis's agency in areas where art history would normally assign her the role of passive vessel or victim (as "pan" or "barrow") of race and gender, creating works that are merely reactionary to her status as either "exotic" or "subversive," either as black or Indian. Emerson proclaimed in his essay that America had "listened too long to the courtly muses of Europe" and that Americans "worshipped the past." Emerson's lament was that America did not have someone of sufficient genius to interpret the present. "I look in vain for the poet whom I describe. We do not with sufficient plainness or sufficient profoundness address ourselves to life, nor dare we chaunt our own times and social circumstance . . . Time and nature yield us many gifts, but not yet the timely man, the new religion, the reconciler, whom

all things await." In Emerson's view, true art sprang from the present, the regional, and the national. Rather than attend to America, the unsung "poem," misguided artists and writers chose to ignore the richness of the indigenous culture. Emerson characterized indigenous American culture as "our logrolling, our stumps, and their politics, our fisheries, *our Negroes and Indians*, our boats, and our repudiations, the wrath of rogues and the pusillanimity of honest men, the northern trade, the southern planting, the western clearing, Oregon and Texas," and ended with the lament that they "are yet unsung." [4] As his list of inspirational material is structured, the only two groups that are characterized by race are "Negroes" and "Indians." He very deliberately intersperses raced bodies in the mix of regions, character types such as rogues and honest men, and cultural institutions, albeit they are bodies that represent economic matters — blacks who were associated with slave labor, and Indians whose land placed them in immediate and desperate conflict with Europeans. Here, Emerson iterates the central dichotomy of otherness that I will examine throughout this book: that of the white knowing subject and the black and Indian known object.

The function of Emerson's poet, then, was to reconcile, to make sense or meaning of, the various ideologies. Although unsanctioned by Emerson, I propose that Lewis functioned as one of his "poets," and in attempting to locate Lewis's agency, the historian Barbara J. Fields's discussion of ideology has proven beneficial. In an essay titled "Slavery, Race and Ideology in the United States of America," Fields proposes, "Ideology is best understood as the descriptive vocabulary of day-to-day existence, through which people make rough sense of the social reality that they live and create from day to day." [5] As a distillate of experience, Fields rejects the notion that ideology is "internalized" and passed down "like a germ." "It will not do," she argues, "to suppose that a powerful group captures the hearts and minds of the less powerful, inducing them to 'internalize' the ruling ideology (to borrow the spurious adjective-verb in which this artless evasion has so often been couched). To suppose that is to imagine ideology handed down like an old garment, passed on like a germ, spread like a rumour, or imposed like a dress code. Any of these would presuppose that an experience of social relations can be transmitted by the same means, which is impossible." [6] Rather than the handing down of appropriate attitudes, ideology is perpetuated by the ritual repetition of appropriate social behavior. Ideology, therefore,

involves the mutual consent and reenactment by those who benefit and by those who do not. Ideologies also coexist as demonstrated by the three prevailing ideologies that form an integral part of my study of Lewis: sentimentalism, true womanhood, and the vanishing American.

The problem with scholarship about Lewis, of course, is that it makes static artistic process and rests on the infinitive "to be" rather than "to do." Lewis "is" exotic or subversive, black or Indian, and scholars tend to judge her work based on those narrow subject positions. But process is active; therefore, artistic intent is never fixed. If we work from the premise that process is a space through which the artist moves freely, a context, which changes just as much for the artist as it does for the audiences of objects created by artists, then perhaps we can begin to conceptualize artistic intent as the infinitive "to do." Moreover, race, like gender, is something that we *do*; each is a performance and each is contingent, each is a sign that points to something else. Thus, if we keep in mind that race and gender are also "processes," we can avoid the traps of identity politics that would provide pat answers about why those who have race (nonwhite artists) and why those who have gender (nonmale artists) create an art that reflects their "pathologies of lack." And as Michael Baxandall asserts in *Patterns of Intention*, to understand intention is not to reconstitute a historical state of mind, rather it is about understanding the relation between an object and its circumstances.[7] What, then, does the object *do* in its various contexts?

In the "process" of writing this book, one of the most difficult things for me to let go of was the overwhelming drive to reconcile Lewis's art as one consistent note on a theme. However, she was most of all a participant in culture and helped to actively construct the major ideologies of her time. This will make her, for some, not a very attractive heroine. Nevertheless, Emerson helped me to stay focused and it is from his declaration—that we are "children of the fire," creatures of context—that I borrowed and adapted the title of this book, "Child of the Fire," not realizing until speaking with Sharon Patton that the title is also a pun on Lewis's Indian name "Wildfire."

In his biography of Frederick Douglass, William S. McFeely gives a powerful recounting of the context for the second epigraph and the subtitle of this book. The setting was Chicago, 1893, at the World's Columbian Exhibition. Douglass was invited to attend, not as an African American but as ambassador to Haiti. Specifically, he was invited to speak at

"Darkies' Day at the Fair," the day set aside for African American atten-
dees. The vendors were to sell slices of watermelon as a joke — in fact, the
entire day was a joke with the press in attendance to record all the amusing
happenings. Douglass began reading from his speech "The Race Problem
in America" when he was interrupted by jeers and catcalls from a group
of white men at the very rear of the crowd, which was made up mostly of
solemn black spectators. One of the witnesses was the African American
poet Paul Laurence Dunbar. McFeely, through the eyes of Dunbar, records
the event in this way:

In the August heat, the old man [Douglass] tried to go on, but the mocking per-
sisted; his hand shook. Painfully, Dunbar witnessed his idol's persecution; the great
orator's voice "faltered." Then, to the young poet's surprise and delight, the old
abolitionist threw his papers down, parked his glasses on them, and eyes flashing,
pushed his hand through his great mane of white hair. Then he spoke: "Full, rich
and deep came the sonorous tones, compelling attention, drowning out the cat-
calls as an organ would a penny whistle." "Men talk of the Negro problem," Doug-
lass roared. "There is no Negro problem. The problem is whether the American
people have loyalty enough, honor enough, patriotism enough, to live up to their
own Constitution." On he went for an hour: "We Negroes love our country. We
fought for it. We ask only that we be treated as well as those who fought against it."
The applause when he stopped was the welcome thunder of old times.[8]

The framing of race and gender as "problems" or "questions" acts as a
rhetorical index of the condition of racial and patriarchal subordination
within which white male subjectivity takes shape.[9] This framing is what
Douglass sought to challenge and expose with his speech, significantly
titled "The *Race* Problem in America" rather than the "Negro" problem,
and he pushed the challenge further in his indictment of the nation's em-
brace of former traitors of the United States, that is, Confederates. Ten
years earlier, in 1883, John Greenleaf Whittier read a speech titled "The
Indian Question" before an audience in Boston in which he blamed "out-
breaks of Indian ferocity and revenge" on the "wrong and robbery on the
part of whites." Furthermore, he argued, the acts of such whites "will in-
creasingly be made the pretext of indiscriminate massacres [by Indians]."
Whittier predicted, "The entire question will soon resolve itself into the
single alternative of education or extermination." Either the Indian would
be civilized and answerable to the laws of the republic or as a people they

must cease to exist.[10] As I will argue during the course of the book, America still has a Negro Problem and an Indian Problem and a Woman Question, and furthermore these problems are deeply embedded in the discipline of art history. Douglass's critical stance regarding the attachment of "problem" to those who lack whiteness (and maleness) inspired the second part of my title: "Mary Edmonia Lewis and the Problem of Art History's Black and Indian Subject."

Almost one hundred years separate the words of Frederick Douglass and Toni Morrison, while Morrison's words were written over a decade before the publication of this book. In 1990, Morrison gave a series of lectures at Harvard University; the result is *Playing in the Dark: Whiteness and the Literary Imagination.* Morrison developed the term and explored the concept of "American Africanism," which "is the vehicle by which the American self knows itself as not enslaved, but free; not repulsive, but desirable; not helpless, but licensed and powerful; not history-less, but historical; not damned, but innocent; not a blind accident of evolution, but a progressive fulfillment of destiny."[11] Through the structuring opposition of blackness, or "Africanism," the "Negro Problem" is constituted and reconstituted in American literature. Morrison contends, "As a disabling virus within literary discourse, Africanism has become, in the Eurocentric tradition that American education favors, both a way of talking about and a way of policing matters of class, sexual license, and repression, formations and exercises of power, and meditations on ethics and accountability."[12] And like the "Negro Problem," "Africanism" (and here I would expand the concept to include "Indianism") is the rhetorical index of the condition of racial subordination within which white subjectivity performs itself. Both "American Africanisms" and "American Indianisms" are an integral part of the writing of art history and the practice of these "American–isms" (even as they seek to persuade one of a white subjectivity) is not restricted to white art historians. They are tools wielded by those with a vested interest in their existence, and concomitantly, invested in the reification of race. The practice of these "isms" is indeed a way of policing matters of ethics and accountability, specifically an accountability that honors and acknowledges only the "authentic," which demands a replication of the artist's race and gender within the artwork — intention lodged like a stone whose only authority is a reaffirmation of noncontingent alterity.

Ultimately, I desire to complicate the notion of "problem" — to re-

FRAMING THE PROBLEM ➤ xix

deploy it as equally an issue of visual culture. To that end, I want to say more at this point about the first sections in my chapters. The first section of chapter 2 addresses directly the Negro Problem framework within which art history operates. I found that the scholarship on the landscape artist Robert S. Duncanson provided an illuminating contrast to the study of Lewis. I chose Duncanson because he elected not to portray the black subject; yet despite his decision, art history has proven dogged in its determination to find that subject. The central question is "What could the study of Duncanson teach us about the study of Lewis, who, unlike Duncanson, so conveniently provided her audiences with black and Indian subjects?" One possible answer is to not accept so readily the normalization of racialized readings of her art—rather we must begin to accept that race is a construct beginning with Lewis herself as architect. The first section of chapter 3, titled "Estranged Bedfellows," deals with Lewis's representation (the process of American Indianism) in museums by two art historians, specifically by way of her Longfellow-inspired works. Lewis's presence in the museum begins to complicate the neat separation by scholars of the respective functions of blackness and Indianness in representation. Of particular interest, therefore, are the competing claims made by scholars who would argue that Lewis is either "exotic" or "subversive," Indian or black. Each camp is invested in Lewis as the black or Indian subject, but each has a different motive and neither recognizes the complexity of Lewis's agency. Because of their failure to theorize Lewis's own cultural work, Lewis exists and is fixed at one or the other pole, either on the side of the exoticizing or the celebratory narrative, either as Indian or black. In the first section of chapter 4, titled "The Failure of Description," I seek to narrow the focus on Lewis—on one work of art—but what does it mean to narrow the focus on distortion? What is accomplished when even up close the image remains blurred and obscured, contradictory and (given the lack of dialogue among art historians) comfortably so? I hope that I can bring some measure of focus not only to Lewis but to art history as well.

THE "PROBLEM" OF EDMONIA LEWIS

The study of Mary Edmonia Lewis presents a fascinating challenge because to examine her career nuances and inflects what it meant to search for a national art in the nineteenth century. And by necessity, to analyze

Lewis's career dares us to call in order to question those voices overlooked or deliberately ignored. As this book will argue, Lewis was thoroughly engaged by the search for a national art, and her participation in the discourse raises both the contingency of difference and the contingency of American culture. Even as her agency raises those contingencies, her agency also *razes* the notion that a national art as conceived in the nineteenth century was the univocal enterprise of the white knowing subject. As an American woman of self-proclaimed African and Native descent, she was directly implicated in the call for indigenous themes. Alternately, her participation in the construction of ideal womanhood was equally fraught, as it was a construction that by necessity excluded her because of her racial heritage. By her participation, then, what pressures did she bring to bear on the idea of a national art — an art that invoked even as it rejected her? What, ultimately, were Lewis's intentions?

Even as Michael Baxandall attempts to explain why artists make pictures and why the pictures look as they do, Baxandall is very particular in what he means by "intention." In agreement with Baxandall, intention is not "a reconstituted historical state of mind . . . but a relation between the object and its circumstances . . . So 'intention' here is referred to pictures rather more than to painters."[13] Employing a definition of culture as a system of construable signs, Baxandall focuses on the object as a cultural achievement. Baxandall notes, "Cultures do not impose uniform cognitive and reflective equipment on individuals . . . Living in a culture, growing up and learning to survive in it, involves us in a special perceptual training. It endows us with habits and skills of discrimination that affect the way we deal with the new data that sensation offers the mind."[14] Culture is a context, outside of which nothing is possible. In order to recover that achievement, Baxandall argues that scholars must practice what he calls "inferential criticism," which comprises a tripartite relationship between concepts pertaining to how the object comes into being ("the objective task or problem"), concepts pertaining to resources used or not used ("a range of culturally determined possibilities"), and finally concepts descriptive of the object.[15] Within the pattern of intention, the problem can be particularized into the more general "charge" and the more specific "brief," that is, what technically must be done to fulfill the charge. Consequently, the brief is the set of circumstances that will affect the artist's perception both of the problem and the solution. It includes a set of cultural facts

such as what physical media is available, a historical context including knowledge of the existing range of types, and aesthetics. In the nineteenth century, the general belief was that art exposed the quality and character of a culture. Moreover, the line between art and life was at all times permeable. As the art historian Michael Hatt has demonstrated, "Already in the 1860s, boundaries are being forged and cultural categories formulated. Ideal sculpture had a crucial role in the emergence of high culture."[16]

I concur with Baxandall that the artist is "a social being in cultural circumstances."[17] Therefore, if we study "intention" as it relates to Lewis's work—that is, rigorously investigate the relation between the object and its circumstances—we can perhaps begin to understand the nature of her "problem" not as a reductive reading of art-as-self (more about that later) but rather as that of the objective task comprising charge and brief. My purpose is to explore how Lewis, the first documented woman of African and Native American descent to work abroad as an artist, created an "American" art. In order to accomplish that, I will investigate how Lewis's brief compares with the goal of American sculpture in general, which, in order to distinguish itself from European sculpture, strove for indigenous themes, modernity, and morality. How she understood those general requirements is revealed in her art. As a producer of sentimental commodities, Lewis's art in varying degrees exposes/complicates/destabilizes/contests/and adheres to the overarching ideology of sentiment to which the ideologies of true womanhood and the vanishing American were answerable.

Lewis negotiated constantly her status as insider/outsider, subject/object, self/other. Her complicity and her utilitarian approach to race and gender highlight her importance as a cultural object, and sculpture was the perfect vehicle to communicate that comprehension. Sculpture allowed her to blur the boundaries between subject and object, between subjectivity and subject matter, because while there is a subject of sculpture, it is also an object of critique. Sculpture best suited her personality dynamic; for sculpture is the embodied art, and as an African and Native American sculptor, she became both the subject and object of her own oeuvre, allowing for the simplistic readings of her work as "self-portraiture." She manipulated the dichotomy of otherness but did so in a semiotic slippage so elegant that art historians across the board still aren't quite sure how the known object became her own knowing subject.

So many people helped me in this undertaking. I begin by thanking the mentors and scholars, both known to me and known only through their scholarship, whose work continues to inspire. I offer sincere and eternally renewing thanks for the help, advice, and friendship of Sharon F. Patton. I would like to thank also Richard J. Powell, Elsa Barkley Brown, George Gurney, Diane Kirkpatrick, Margaret Cool Root, Ilene H. Forsyth, Carol J. Ockman (I took to heart our walks along the trails in Williamstown and your caution to shine a light between Lewis and her works), Thomas Crow, Ronnie Hartfield, Howardena Pindell, Joyce Szabo, Lois Elizabeth Bingham, Pamela Gooden (no, you have changed *my* life), Valerie Mercer, Amalia Amaki, Bill Gaskins, Lisa Farrington, Freida High W. Tesfagiorgis, Floyd Coleman, Tritobia Hayes Benjamin, Barry Gaither, Eileen Johnston, Scott Baker, Leslie King Hammond, Brenda Chandler, Jacquelyn Serwer (thank you for allowing me the luxury of thinking more intensively about Lewis's cartes-de-visite), Walter and Linda Evans (thank you for the access to your brilliant collection and the many kindnesses you both have shown me), and Adolph Reed (you have opened mental doors for me).

I also wish to gratefully acknowledge the Smithsonian American Art Museum and my experiences there as a pre-

doctoral fellow from 1994 to 1995. In particular, I would like to thank Col. Merl M. Moore Jr. of Falls Church, Virginia, who gave me unfettered access to his private archive materials stored at SAAM. I also thank the art history department at Williams College, where I spent 1995 and 1996 on a Charles Gaius Bolin fellowship, researching and writing my dissertation. I also wish to thank Lynn Evans, Mary Tsiongas, and Jocelyn Nevel for their support and encouragement.

For the generosity and brilliance of their scholarship, I would like to acknowledge Toni Morrison, Nell Irvin Painter, Philip Fisher, Lori Merish, Michael Baxandall, Patricia Hill Collins, Barbara J. Fields, Theodore Allen, Linda Bolton, Hazel Carby, Patricia Morton, Kirk Savage, Kymberly Pinder, and Tamar Garb. My friends and fellow travelers, without you this truly would not have been as much fun: Robin L. Harders (the only person I would trust to read the roughest of my rough drafts), Andrea D. Barnwell (my "second eyes"), Nadra Franklin, Miranda Hofelt, Jeffrey Nigro, Susan Aberth, George Robb, William Peniston, Amy Mooney, Raymond Hernandez-Duran, D. Aaron Fry, Ali BabuChe Johnson, Jeffrey Moline, Maureen Shanahan, Andrew Walker, Alison Edwards, Finnie D. Coleman, and Eva S. Hayward (without whom that last, hard edit would not have been possible — thank *you* for witnessing).

At the University of New Mexico, I have found a well of support for which I am eternally grateful: Christopher Mead, Martin Facey, Michele Penhall, David Craven, Basia Irland, Holly Barnet-Sanchez, Patrick Nagatani, Steve Barry, John Wenger, Kathleen Jesse, Michael Cook, Tom Barrow, Babs Baker, Shelley Cooley (I miss you!), and Agnes Harris (who kept things in perspective for me). I also thank my students, especially Lissa Dehring and Erika Adams; you helped me to work through the most difficult, last stages of this process.

I would also like to acknowledge the love and support of my family: my mother and father, Geraldine and Eugene Buick; my sister and brother-in-law, Chronda and David Spurlin; Stanley and Carolyn Barnes; Venola and Sherwood Williams; Terence and Marilyn Williams; Kenneth Johnson, Alvin E. Barnes; and so many more that space will not allow. Finally, I want to thank Duke University Press and the amazing people there: Courtney Berger, Leigh Barnwell, Lynn Walterick, Molly Balikov, Margie Towery, and, especially, my friend Ken Wissoker, who told me that he would "rather have a good book than a rushed one."

Child of the Fire ❧

❧ Inventing the Artist

Locating the Black and Catholic Subject

Against all odds, Mary Edmonia Lewis aspired to be a sculptor. Who can really say when her dreams began? That she had them at all is rather miraculous. Born a free person of color, she received an unusual amount of formal education but chose not to follow the natural direction of that education and become a teacher. Instead, she found a path virtually uncharted by African Americans, that of an artist. In her *carte-de-visite* (plate 1), one can observe the precarious nature of Lewis's choice. The image represents an element of risk — risk because Lewis's image is one that rests in tension between her status as celebrity and her status as specimen. Her status as celebrity was determined by her career as an artist living and working as part of an expatriate community of American sculptors in Italy. These artists were responsible for linking the United States to a long history of European creativity; simultaneously, as Americans they would be credited by home-grown theorists with improving upon the art of antiquity and the Renaissance because of the superior moral condition of the American Republic. Lewis's status as specimen was determined by how race and gender shaded and nuanced her career. The dissonance between being an "artist" and being "black" or "Negro" made her an anomaly, but an anomaly

easily accommodated in an age in which human beings were exhibited as curiosities.

In the pursuit of why she chose this course, most scholars focus on the personal details and minutiae of Lewis's life. They mention the art training she received at Oberlin because it contradicts later constructions (corroborated by Lewis) of her as without knowledge of art. They focus on the scandals in which she was involved at Oberlin to highlight the personal damage they must have done to her, one source going so far as to suggest that her art career was a form of revenge.[1] And in terms of Oberlin College itself, they celebrate its liberalism in admitting women and African Americans, juxtaposing the college's commitment to abolitionism in the face of the surrounding towns' racism. Or, when the subject of the scandal arises in the context of the college, the focus becomes Lewis's affront to the conservative policies such as temperance and the strict codes of behavior for men and women adopted by Oberlin. Regarding her time in Boston, again the focus is on the personal: for example, her tutelage by Edward Brackett; the studio on Tremont Street that she took and all its famous inhabitants; the support she received from individual abolitionists; and the works of art she created that facilitated her travel to Rome.

Counter to the traditional readings of Lewis's education, this chapter will focus on the institutionalized processes and the places that made Lewis's career possible. I employ the concept of "career" in order to consciously move the discussion away from biography and all the ideological baggage and confusion that it carries. While the craft of biography attempts a verisimilitude of the lived experience, a kind of fictional transparency that can be laid over a life, the writing of the career adheres to different rules. The career stands as the medium between the artist as individual and the artist as a product of culture. To study the career is to study the effects of culture and institutions on the artist that then reveal to us patterns of intention—that is, the relation between the object and its circumstances.[2] By focusing on the institutionalized processes that helped to shape Lewis, both as an individual and as an artist, my line of reasoning differs subtly but significantly from the discussions of others. Her education at Oberlin, for example, was an education in sentiment, while the scandals at Oberlin can be viewed as Lewis testing and being tested by Victorian culture.

Precedent and expediency allowed Lewis to forge a successful career as

a sculptor, and her racial identity helped as much as hindered her in the pursuit. Lewis studied, trained, and practiced in three of the most important centers for education and art culture. Oberlin College trained her for teaching, and it also educated her in the role that women were expected to play in society. In Boston, she found yet another milieu that was both a haven for African Americans and one that would cultivate her objective to train as an artist. The abolitionists of Boston fought not only for the immediate emancipation of African Americans held as slaves; they also lobbied for the rights of full citizenship for enslaved and free blacks. A significant part of their arsenal was the individual example of African American accomplishment. In Lewis, they found it expedient to use the artist as an example of the artistic achievements of which the African American was capable, if given a chance. As a result, Lewis received national and international press coverage from those sympathetic to the cause of human rights. In Rome, she encountered the white American women who had gone before her to practice as artists. There, Lewis enjoyed more social, spiritual, and artistic freedom than she had in the United States: in Italy, she escaped the racial politics of America; as a Catholic, being in Italy brought her closer to her spiritual home; and finally, expatriation to Italy represented the mainstreaming of her artistic experiences. Furthermore, in Italy she could fully participate in the market for sculpture, which by the 1860s was an international affair. Conversely, had Lewis remained in the United States, she would have had to continue to rely on abolitionist patronage almost exclusively and the sale of her work would have been largely dependent upon her as a product of race. By going to Italy, however, she made herself part of the international art world, gained a measure of distance from her abolitionist patrons, and thus set the terms upon which she would practice her art — as part of a highly visible community of *American* artists — that depended on a national rather than a racial identification. Therefore, environments did exist, if only minimally, to nurture Lewis. Her most steadfast patron, however, was her brother Samuel, who lent emotional and financial support throughout his lifetime. Through the lens of Lewis's career we begin to understand that patronage is a dialogue, a kind of cultural discourse of reciprocal manipulation though rarely involving an equal exchange between parties.

EARLY HISTORY AND OBERLIN COLLEGE

Contrary to Lewis's claims, evidence suggests that her mother, Catherine, was not a "full-blooded Indian." Catherine Lewis was born in Canada to an African American father named John Mike, an escaped slave, and to a mother of mixed African American and Ojibwa parentage. Catherine lived with her parents on the Credit River Reserve, now known as the city of Mississauga, on Lake Ontario. The Indians living on the reservation were entitled to annual government payments. However, because membership derived from the father and Mike was black, the council of elders voted to exclude him and the children from a share in the government grants. Although the council had no authority to enforce its ban, it did bring pressure on the family to leave. The Mike family went to Albany, New York. Records show that there Catherine Mike married a black man named Lewis. A date for the wedding was not provided nor was his first name given. Lewis was from the West Indies and worked as a gentleman's servant.[3] In 1832, Edmonia Lewis's brother, Samuel, was born. Shortly thereafter, the family relocated to Newark, New Jersey. Early in 1844, they moved again — to the village of Greenbush, across the Hudson River from Albany, New York.[4] Edmonia Lewis, according to her passport application, was born on or about the fourth day of July in the year 1844.[5] According to Lewis, she and Samuel bore Indian names as well; Samuel was known as Sunshine, and Lewis as Wildfire.

By the time that Lewis was about nine years old both parents were dead. Catherine's two sisters adopted the children, who remained with them near Niagara Falls for approximately four years. They made and sold baskets, moccasins, blouses, and souvenirs for tourists at the falls, in Buffalo, New York, and in Toronto. In 1852, Lewis's brother placed her in the care of a Captain S. R. Mills and left for California. Though he conscientiously sent money back for her board and education, his life diverges from his sister's at this point. In 1856 Lewis was enrolled at New York Central College in McGrawville, a Baptist abolitionist school. According to Lewis's biographer, Marilyn Richardson, the college "was founded in 1848 as a daring and progressive academic enterprise. All of those connected with the school — faculty, students, trustees, and administrators — pledged their commitment to abolitionism, to 'the doctrine of the unity, common origin, equality and brotherhood of the human race,' and to the right of

women to access to all levels of education." Later, Lewis was in residence at New York Central College for the second half of the 1856–57 academic year, and for the summer and fall terms in 1858. During the summer term, she took classes in the Primary Department, which would have prepared her for regular courses in the academic and collegiate programs.[6] According to Lewis in a later interview, she remained for three years but left when she was "declared to be wild."[7]

With Samuel's aid and with the help of abolitionists, Lewis was sent to Oberlin College in 1859; she was probably fifteen years old. At Oberlin, she boarded with the Reverend John Keep and his wife from 1859 until she left the college in 1863. Reverend Keep, who was white, was a member of the board of trustees and was an ardent abolitionist and spokesman for the benefits of coeducation.[8] Although integration was a matter of choice for white and black students, African American students were welcomed in both white and black households. Those who did not board with white families found accommodation among the town's stable and prosperous black community. Ellen Lawson and Marlene Merrill have demonstrated in their research on antebellum black coeds at Oberlin that "by the mid-1850's, a growing and substantial black community existed in the town, with many families headed by skilled craftsmen, such as carpenters, masons, and harness makers. The Oberlin census statistics for 1850 and 1860 indicate that these families provided homes not only for kin but for other black students attending the preparatory school and the college."[9] The college required that host families be pious and morally upstanding within the community. In 1862, for example, the Ladies' Board decreed "no young lady shall board in any but a regularly organized family, where one at least of the heads of the family presides at table and family worship."[10]

The significance of education for African Americans during the nineteenth century cannot be overstated. In an interview in 1864 with the abolitionist Lydia Maria Child, Lewis responded to the question of education in this manner: "'But, surely,' said [Child], 'you have had some education other than that you received among your mother's people, for your language indicates it.' 'I have a brother,' [Lewis] replied, 'who went to California, and dug gold. When I had been three years with our mother's people, he came to me and said, 'Edmonia, I don't want you to stay here always. I want you to have some education.' He placed me at school in Oberlin."[11] Lewis, in a few phrases, managed to convey Samuel's concern

for her future, that he wanted something for her beyond the life she had with her Indian relatives. That "something" was only attainable through education. In the nineteenth century, there were few opportunities for women, and for African American women in the North there were three basic alternatives: domestic servant, operator of small businesses, or educator. Those who hired out in domestic-related service worked as cooks, seamstresses, laundresses, and caretakers, often in white households. The small businesses that African American women operated were enterprises such as hairdressing, catering, and owners of boardinghouses, or working as merchants in partnership with their husbands.[12] Whether white or black, parity in wages did not exist for men and women. Women always earned less than men earned. Furthermore, teaching did not even ensure a viable living. It proved especially unrewarding for those African American women who established private schools. Frequently, they turned to religious organizations and antislavery societies for financial help.[13]

Despite Oberlin College's advanced attitude toward parity in education, those attitudes still fell under the aegis of nineteenth-century mores, which meant adjustments in the curriculum according to the perceived differences in the mental and emotional capacities of men and women. Oberlin had separate departments for the sexes, and although some women did receive bachelor's degrees from the College Department, most studied in the Young Ladies' Department, which conferred literary degrees. Also, when men and women did take classes together, as one professor assured the student body in 1849, "in those exercises which have for their direct object a preparation for public speaking and for public life, the ladies take no part."[14] Like the College Department, the Young Ladies' Department was a four-year program. It differed from the College Department in that it did not require either in-depth study of ancient languages or higher mathematics. After 1850, the college substituted a number of courses to make up for not teaching women Hebrew, Greek, and advanced Latin language and literature. French, linear drawing, poetry, and modern literature were added to the curriculum in order to make Oberlin College comparable to the leading female seminaries.[15]

Between 1835 and 1865, at least one hundred and forty black women attended Oberlin College, 80 percent of whom matriculated into the Young Ladies' Course proper after first attending the preparatory courses

within the Young Ladies' Department. By 1865, three black women had received the bachelor of arts degree.[16] The Young Ladies' Department oversaw both the prep school for young ladies and the Young Ladies' Course.[17] The Preparatory Departments were designed to supplement gaps in students' education so that they could take classes within the normal college departments.[18] The prep school covered arithmetic, English grammar, elocution, spelling, linear drawing, modern geography, and beginning Latin and algebra.[19] The curriculum for young women in the prep school was much lighter and more elementary, with no classes in history or Greek but with a strong emphasis on religious instruction.[20] Lewis was enrolled in the Young Ladies' Preparatory Department for the 1859–60 school year.[21] Oberlin does have a partial list of Lewis's classes: during the winter term of her first year, we know that she took three periods of algebra. After successfully completing her preparatory studies, she entered the Young Ladies' Department, where she spent the next three years. During her second year, Lewis was excused from her conic sections class, which was a branch of geometry dealing with circles, ellipses, parabolas, and hyperbolas. She did very well, however, in composition.[22] The Young Ladies' Department was designed "to give Young Ladies facilities for thorough mental discipline, and the special training which will qualify them for teaching and the other duties of their sphere."[23]

By probing the significance of Oberlin's mission, we begin to view Lewis's education in a radically different way; rather than focus on the "liberalism" of the school in admitting white women and students of color, we begin to uncover the institutional ideology that incurs on the student. In what Richard Brodhead suggested was the complicated interfiliation of sentimental values and educational policy at midcentury, Lewis was being trained for the duties of her "sphere" — as mother and teacher of the young.[24] Education was viewed as advantageous for women, who controlled the domestic environment and child development. And within the family dynamic, teaching was the most active role that a woman should play. Lewis and the other black women who studied at Oberlin College were also part of a larger project, the subjects and objects of "domestic imperialism" in which the values and superiority of white middle-class culture were instilled by the school. In her study of nineteenth-century interracial boarding schools, Laura Wexler has demonstrated how "the

ideology of domesticity infiltrated precisely those public institutions that
are gatekeepers of social existence." Sentimentalism, she continued, "sup-
plied the rationale for raw intolerance to be packaged as education. With-
out the background of the several decades of domestic 'sentiment' that
established the private home as the apotheosis of nurture, the nineteenth-
century interracial boarding school could probably not have existed, since
it took as its mission the inculcation of domesticity in former 'savages' and
slaves."[25]

Not everyone in the community supported coeducation. Those who
were opposed viewed it as a threat to the morality of its students. There-
fore, Oberlin College had a number of safeguards in place to counteract
any possible ill effects of coeducation. In 1836, the trustees ruled on rec-
ommendation of the faculty that students be prohibited from becoming
engaged to one another while enrolled at the college.[26] Also, to ensure that
the candidate be of "unimpeachable morals," letters of recommendation
were mandatory for admission. The handbook proclaims that "conditions
of admission to the Institute shall be trustworthy testimonials of good
intellectual and moral character, ability to labor four hours daily, freedom
from debts, total abstinence from ardent spirits as an article of drink or
refreshment and Tobacco except as a medicine."[27]

However, that protective environment was on occasion not enough to
prevent all incidents that could shake the faith in the virtues of biracial and
coeducation.[28] On February 11, 1862, the *Cleveland Plain Dealer* carried
the following headline: "Mysterious Affair at Oberlin — Suspicion of Foul
Play — Two Young Ladies Poisoned — The Suspect under Arrest." The "sus-
pect" was none other than Edmonia Lewis.[29] The seriousness of the charge
was intensified because the two housemates were white women, Lewis and
the two women had been friends, there were men and alcohol involved,
and the "poison" Lewis allegedly used was an aphrodisiac well known to
the nineteenth century — cantharides, or "Spanish Fly."[30] For Lewis, the
repercussions were immediate: friendship was betrayed and lost; vigilantes
attacked her; she was arrested; and several local newspapers covered her
trial.[31] Most damning of all, she had betrayed everything that her education
at both McGrawville and Oberlin represented.

The *Cleveland Plain Dealer*, published in Cuyahoga County in the city
of Cleveland, had Democratic and consequently anti-abolitionist sympa-

thies, and it kept the people of Ohio abreast of the scandal.[32] The newspaper had informers at Oberlin and was able to report that the incident had occurred during the winter term on January 27, 1862.[33] The newspaper implied that at least two serious infractions had been committed, causing one to question the license allowed students and the moral fiber of the college. First, in light of Oberlin's strict temperance policy and in light of the reputation of the Keeps, the possession of wine by a student was a clear transgression.[34] Furthermore, the victims in the affair had set out on a journey, unchaperoned, with two young men.

For as long as the administration could, they refused to turn Lewis over to the authorities. Lewis was fortunate to secure as her attorney a fellow alumnus of the college. John Mercer Langston (1829–97) graduated from Oberlin College in 1849, becoming Oberlin's fifth black graduate and, eventually, the first African American to hold elective office.[35] Langston tells of her trial in his autobiography of 1894, *From the Virginia Plantation to the National Capitol*. To maintain the anonymity of his client, however, he did not mention Lewis by name.[36]

When Lewis was finally arraigned, her trial was delayed. The *Cleveland Plain Dealer* revealed the reason for the delay and that the defendant was African American, stating, "The supposed poisoning case that occurred in Oberlin a short time since . . . did not come on for trial at the appointed time, from the fact that the supposed guilty one was ill from the effects of a severe hurt, received, it was thought, at the hands of some persons who threw her upon the ice while skating—breaking a collar bone. The girl is colored."[37] The persons responsible for the beating were never found. There was no attempt to do so. Thirty years later, Langston remembered the attack differently. According to him, Lewis was leaving the boarding house "one evening, just after dark" when she was kidnapped, taken to an empty field nearby, and severely beaten. Her clothes and jewelry were torn from her and she was left for dead. The town bells were rung in alarm once Lewis was discovered missing, and a community-wide search began. They found her, after a long search, in the deserted field. Langston reported her injuries as "very serious" and "so crippling her that she was confined to her room for several days and then was not able to move about except as she did so on crutches. Her arrest took place within a few days after this occurrence."[38] He asked for a delay in the trial due to her injuries, and once the

case was called, Lewis was carried into the courtroom in the arms of her friends.

Lewis's trial lasted six days, from February 26 to March 3, 1862. Langston chose not to call Lewis to the stand; instead, after a six-hour closing argument, he won the case on the argument of corpus delicti, the prosecutor not having saved the stomach or stool samples of the alleged victims. Langston recalled that Lewis was carried out of the courtroom, victorious, "in the arms of her excited associates and fellow-students . . . fully vindicated in her character and name."[39]

In 1864, the spring term of the school year began on February 25.[40] Lewis was one term shy of graduation from the college. However, as powerful as her allies were among the administration, she also must have made quite a few enemies by her refusal to fade quietly away after what was tantamount to a sex scandal. Almost one year to the day after her trial for poisoning, Lewis was accused of theft. The alleged crime was dutifully reported in the *Lorain County News*: "Mary Lewis had another audience with Esq. Bushnell on Saturday. The provocation was alleged theft of artists' materials from Prof. Couch; but the evidence was not considered sufficient for conviction and Mary was dismissed."[41] In the face of a new scandal, the Keeps appear to have remained steadfast in their belief in Lewis's innocence. Nevertheless, no one fought for her this time. Although Lewis was acquitted for lack of evidence, the principal of the Young Ladies' Course, Marianne Dascomb, refused to allow her to register for the term, which meant she was unable to graduate.

Oberlin College had been in many ways a haven and a prison for Edmonia Lewis. Oberlin's commitment to equality (within limits), abolition, and education provided Lewis with everything that she would need to secure a future. Most importantly, Oberlin provided her with contacts that allowed her to pursue an artistic career. Even before the poisoning incident, Reverend Keep and the faculty had protected her and provided her with comfort and friendship. In exchange, all that they asked was that she fulfill the contract she signed with them upon admission — that she be of good character. For someone of Lewis's conflicted character, however, Oberlin must have seemed especially restricting. Proclaiming herself "wild" in an interview, given her extreme youth while at the college, and considering her free-roaming childhood, the strictures imposed upon her

to follow the cult of true womanhood must have been confining to say the least. Yet she did absorb those tenets, and her life and art after Oberlin was a complex dance between the spectrum of concession and conflict.

NETWORKING AND ABOLITIONIST SUPPORT IN BOSTON

Blocked from graduating, Lewis left for Boston in early 1864. Once there, she began to pursue a career as a sculptor. With the help of abolitionist supporters, she was able to reestablish herself in the public eye and to re-define her role within the various communities in which she participated. The majority of what we know about Lewis is from newspapers, journals, and letters written by others about her. Despite the often-conflicting bio-graphical information supplied in the nineteenth century, such sources enable us to piece together a picture of her career. In nineteenth-century America, whether it was a presentation in person or in writing, the "intro-duction" was the mainstay of networking. Fortunately, Lewis retained the support of the Keeps, who were able to write a letter of introduction on her behalf to William Lloyd Garrison in Boston. Garrison, in turn, opened two doors of opportunity for Lewis: an introduction to sculptors already established in the field; and an introduction to writers who were able to publicize Lewis in the abolitionist press. In Boston, she found continuity in the abolitionist network that had so strongly supported her while at Oberlin.

The sources that I rely upon in this section are letters and articles and interviews taken from the press. Letters, in particular, play a valuable role in understanding the construction of Lewis's career: Anne Whitney's letters, both while they were together in Boston and in Rome; three of Lewis's four extant letters—three to Maria Weston Chapman and one (not discussed here) to Dr. William Henry Johnson;[42] and Lydia Maria Child's letters to others about Lewis. Child's letters are particularly revealing when used to test the abolitionist's public writings about the artist against her private writings to third parties about Lewis. The difference in Child's language, the more casual and less careful musings in her private writings, illuminates a very difficult relationship between the two women. Broadly speaking, the letters open a door to the age in which Lewis worked and reveal the com-plexities of patronage. In addition to the letters, articles from the extensive

press coverage of Lewis are equally important in reconstructing the artist's career. They chart her movement from Boston to San Francisco, and from the United States to Europe; they also chart her successes, often providing the prices for which some of her pieces sold. Ultimately, we must glean her triumphs, sorrows, and humiliations through the eyes of others.

The first door that the Garrisonian network opened for Lewis was an introduction to Edward A. Brackett (1818–1908). Himself a moderately successful sculptor, Brackett became Lewis's instructor. He specialized in marble portrait busts and lived in a studio on Tremont Street in Boston.[43] His clients numbered among the most famous men of the day: William Cullen Bryant, Henry Wadsworth Longfellow, Washington Allston, Charles Sumner, William Lloyd Garrison, Wendell Phillips, and John Brown.[44] Brackett's abolitionist leanings made him the logical choice to mentor the young African American woman who professed a vocation to sculpture. Lewis claimed that she had wanted to meet the sculptor because she had heard of his sympathy for her people and because of the bust of John Brown that he had completed.[45] Although their relationship did not end amicably, Lewis continued to mention the sculptor kindly or not at all in future interviews. By August 9, 1864, they had a definite parting of the ways. We know that something did disrupt the relationship between Lewis and Brackett because a fellow sculptor and friend of Lewis's, Anne Whitney, reported the split in a letter to her sister in 1864, claiming that Brackett "has given her up."[46] The reason for the dispute, however, was never revealed.

In controlling what was written about Lewis, the abolitionists were able to recast her public persona so that nothing remained of the Ohio debacle. Mary Lewis was buried under a barrage of publicity for the "girl of about twenty years old, of brown complexion and a short, slight figure" (plate 1). Other notices mentioned the "colored lady, whose sex, extreme youth, and color invite (the) warmest sympathies," who was "born of an Indian mother, and a Negro father."[47] Between the years 1864 and 1871, Lewis was written about or interviewed by four very important women in the Boston and New York abolitionist circles: Lydia Maria Child, Elizabeth Peabody, and Anna Quincy Waterston, all of Boston, and Laura Curtis Bullard of New York.[48] These four women had the power of access to the printed word. Because of them, articles about Edmonia Lewis appeared in at least

eight nationally circulating abolitionist journals: *National Anti-Slavery Standard*, *Liberator*, *The Freedmen's Record*, *Broken Fetter*, the *Revolution*, *New National Era*, the *Christian Register*, and the *Independent*. Among those women, Lydia Maria Child was perhaps the most effective writer and advocate for the abolitionist cause after William Lloyd Garrison. Although she never gained power through wealth, she was one of the most influential people active in the movement. Lewis's image was (re)shaped largely by the white women who wrote her into existence. In this endeavor, Lewis was complicit. As Benjamin Quarles has remarked, "The abolitionist press had a marked effect in making Negroes more active in social and civic affairs. Negro organizations felt no hesitancy in asking these newspapers to carry notices of their coming meetings and lists of their officers . . . Brief notices of Negro weddings dotted the back pages of abolitionist weeklies. How warming to the self-esteem to see one's name in print! But more important was the sense of civic participation it engendered."[49] That sense of access and entitlement stretched to individuals such as Edmonia Lewis as well. In an interview in 1864 with Lydia Maria Child, Lewis confirmed, "Some praise me because I am a colored girl, and I don't want that kind of praise. I had rather you point out my defects, for that will teach me something."[50] Lewis was not objecting to the coverage she received in the abolitionist press, nor did she ever turn down monetary aid. Rather, what she found insupportable was the condescension regarding her skill as an artist. Here, one must make the very important distinction between support and false praise.

Lewis did wrest some control through the subject matter of her art, whether it was the people she chose to make portraits of, or the ideal subjects that she chose to depict. Early in Brackett's career, he was praised in the columns of the *New-York Mirror* for understanding that the formula for fame rested on the subject that the artist chose to depict, a subject whose deeds and whose face were instantly recognizable. "When an artist is aspiring after fame, there is no other way of making himself known in this country than to take the likeness of some man well known in the community, for the dullest perception can trace resemblances."[51] Lewis's subjects in 1863 and 1864 can be counted among the most famous men of her day, and for the African American community, perhaps the most revered men of the day: John Brown and Colonel Robert Gould Shaw (figure 1). Lewis

1 Edmonia Lewis, *Bust of Robert Gould Shaw*, 1864. Marble, height 24 inches. Museum of African American History, Boston and Nantucket.

enterprisingly moved to capitalize on the sentiments of a Boston public for their fallen hero, Shaw, by making plaster casts of her bust. She sold one hundred of these reproductions at fifteen dollars apiece. The sum of money must have encouraged her as a solid professional economic beginning, because soon thereafter she applied for a passport and booked a passage to Italy.[52]

These good professional omens were offset by difficulties that arose between Lewis and Child over the abolitionist writer's response, both private and public, to the bust of Shaw. Publicly, Child was a proponent of the idea that Lewis was a "representative Negro." Privately, however, Child's patronage was more conflicted. As part of her "duty" as Lewis's patron, Child felt bound to provide both aesthetic advice and advice on how the artist should conduct her career. As an independent creative spirit, Lewis naturally had her own ideas about both. The misunderstandings that arose between them concerning the bust of Robert Gould Shaw illustrate well the difficulties in reconciling their two positions. The story is laid out mostly in a letter Child wrote to Sarah Blake Sturgis Shaw, Robert Gould Shaw's mother. In the letter, Child speaks on a very personal level about her estimation of Lewis's talent, within the context of Lewis's bust of Shaw. According to Child, Lewis was "younger than young," that is, in too much of

a hurry to set up a studio in order to make art that would pay for her board, and "young" in the sense that from a cultural standpoint, she sprang from "young" people — "Chippewas and negroes." Admitting that Lewis's bust of Voltaire had turned out well, Child remarked that she was surprised, "given her antecedents." Child then goes on to the real purpose of the letter — her response to Lewis's bust of Robert Gould Shaw. "When she told me she was going to make a bust of [Colonel] Shaw, I remonstrated against it. I had a feeling about him that made me reluctant to have any prentice [*sic*] hands tried upon his likeness."[53] Child's objection is to the reversal of the formula — in this instance a black knowing *subject* and a white known *object*.

The increasingly uneasy relations between artist and patron may have been further strained by the fact that Lewis did not choose to follow all of Child's ideas about how Lewis should manage her career. Harriet Winslow Sewall and her husband, Samuel Sewall, a prominent Boston attorney and one of the founders of the New England Anti-Slavery Society, were dear friends of Child's and very active in abolitionist circles. Writing to Harriet Winslow Sewall, Child reported, "I suggested to her to work in stucco-molding for architects, which I have been told employed a good many hands in Europe . . . She might, meanwhile, keep trying her hand at statuary during [after] hours, and if, in the course of years produced something really good, people would be ready enough to *propose* to put it in marble for her. I have also thought of *wood* carving as a means of subsistence for her."[54] Child emphasized the word *propose* because Lewis often would not wait for a commission but execute it, send the piece back to the United States, and leave it to the person to whom she "dedicated" the work to find a buyer if he or she chose not to purchase it. About Lewis's strong will, Child wrote, "What she *undertakes* to do . . . she *will* do, though she has to cut through the heart of a mountain with a pen knife."[55]

Impatient with Lewis's ambition, Child felt (and rightly so) that it was outstripping her talent. As a result, she refused to publicly endorse *Forever Free* even after Lewis had brought it to the States and formally presented it to the Reverend Leonard A. Grimes (plate 2). Child's refusal to promote the work would have proved disastrous if not for Elizabeth Peabody. Fluent in ten languages, a practicing Transcendentalist, a writer and an educator, Peabody opened the first English-speaking kindergarten in this country. She was a tireless advocate of good causes.[56] Edmonia Lewis was one of

many. In a letter to Sarah Blake Sturgis Shaw, Child tells why she refused to review *Forever Free* and why Peabody did review the work:

[Lewis] wanted me to *write it up*; but I could not do it conscientiously, for it seemed to me a poor thing. Good Elizabeth Peabody wrote a flaming description of it for the Christian Register, in which she said, "Every muscle is swelling with emotion." Now, the fact is the figures *had* no muscle *to* swell. The limbs were like sausages. Miss P[eabody] rebuked me for what she called my "critical mood." She said, "it is the work of a colored girl, it ought to be praised." I replied, "I should praise a really good work all the more gladly because it was done by a colored artist; but to my mind, *Art* is sacred, as well as *Philanthropy*; and I do not think it either wise or kind to encourage a girl, merely because she is colored, to spoil good marble by making it into poor statues." The sale of that work, and the puffs written to accomplish it, have encouraged Edmonia to make another large statue; the Hagar. I think it is better than the Freedman & his Wife, but I do not think it is worth putting into marble. It looks more like a stout German woman, or English woman, than like a slim Egyptian, emaciated by wandering in the desert.[57]

Child's private letters reveal the pressure that many abolitionists felt to promote African Americans primarily because of their race. In particular, they reveal Child's private and personal sense of integrity—private and personal because in her public writings on African Americans, she is much less critical and her rhetoric is more careful. Publicly, the only way that Child could maintain that integrity was by silence—literally and "literarily" by withholding the pen.[58] As for Lewis, either she played a very coy game with the press or it is a true irony that she proclaimed to want serious criticism based on the merits of her talent, and then, when it was offered by Child, rejected it in favor of an appeal, described below, that was highly personal and indeed based on her race.

Lewis's personal and racialized appeal emerges in one of the few extant letters we have written by her. In order to check an unready Lewis, Child had created monetary obstacles for the artist by interfering in her business dealings with Samuel Sewall. He acted as Lewis's agent in the sale of *Forever Free*, and when Lewis wrote to inquire why she had not received the eight hundred dollars it was to be sold for, he failed to reply. Critically short of money, she wrote to Maria Weston Chapman to ask if she had heard anything. "I am in great need of the money. What little money I had I put all in that work with my heart. And I truly hope that the work of

two long years has not been lost. Dear Mrs. Chapman I been thinking that it may be that you have met with some who think that it will ruin me to help me—but you may tell them that in giving a little something towards that group—that will not only aid me but will show their good feeling for one who has given all for poor humanity."[59] The "some" to whom Lewis obliquely referred could only have been Lydia Maria Child, for Lewis had already mentioned Sewall by name in the letter. Two months later, Child's letter to Harriet Winslow Sewall confirmed her part in Lewis's monetary difficulties. "My mind has been troubled somewhat about the letter I wrote to Edmonia, because you thought it must have been 'very hard' for me to write it. The fact is, I should rather have given $50, than have done it. But I have observed that she had no calculation about money; what is *received* with facility is *expended* with facility. She is not to blame for this deficiency. How could it be otherwise, when her childhood was spent with poor negroes, and her youth with wild Indians?"[60] Although the details have not surfaced, we must assume that Lewis was eventually paid. What the excerpts from these letters reveal, however, is the critical fissure in the relationship between Lewis and Child. They could not engage even on the same level, with Lewis writing of aesthetic matters and her need for money and Child writing of fiscal responsibility and aesthetic matters to which Lewis refused to even listen. Lewis wanted her hard work acknowledged, and she also viewed the piece as a worthy tribute to Garrison. Child, on the other hand, viewed Lewis as importunate, ahead of herself artistically, and careless with money but blameless because of her racial heritage.

Child's public support seems to have ended when Lewis continued to defy her by creating "statuary." The last time that Child wrote about Lewis publicly was April 5, 1866, in an article for Theodore Tilton's *Independent*.[61] Child's private correspondence to third parties about Lewis, however, continued until 1870, when, in the letter to Mrs. Shaw, Child mentioned Lewis for the last time. Included in the long diatribe against her, she conveyed that "there is at present a *little* coolness between us." Because Lewis did not or could not adhere to Child's value system nor follow Child's advice with regard to what and how she should sculpt, she remained subject to Child's punitive style of patronage. After 1870, all ties between Lewis and Child appear to have been severed.

Although Lewis may not have been privy to the letters written about her, for us, their availability may shed some light on patronage relations.

The largest known body of letters from one source is the correspondence of Lydia Maria Child to third parties about Lewis; by necessity I rely heavily on them. As revealed in this correspondence, Child and Lewis enacted a complex, nuanced pas de deux. When compared to Child's public writing about Lewis, the letters illuminate the tension that often occurred between white abolitionists and blacks in general. We begin to understand the private machinations behind the public façade of patronage and abolitionism. Each side had something to gain. There were also more concrete types of patronage at work in the formation and maintenance of Lewis's career: they involved the active participation of the patron in the creative process; publicity for Lewis and her work; the purchase of works; the donation of money and/or materials; and on Lewis's part, travels to the United States where exhibition opportunities were made available.

ROME AND THE MAINSTREAMING OF LEWIS'S CAREER

Away from America, Lewis found that the categories "black" and "white" manifested themselves differently. In a *New York Times* interview of 1878 titled "Seeking Equality Abroad," Lewis states, "I was practically driven to Rome in order to obtain the opportunities for art culture, and to find a social atmosphere where I was not constantly reminded of my color. The land of liberty had no room for a colored sculptor." The writer ends the interview with a rather ambiguous statement by Lewis about race and her experience in Rome: "Miss Lewis makes no secret of the reason of her return to Rome, which she has adopted as her home. 'They treat me very kindly here,' she said, 'but it is with a kind of reservation. I like to see the opera, and I don't like to be pointed out as a negress.'"[62] By 1878, the year of the interview, Lewis had disappeared from the personal correspondence of her contacts in the United States and of her fellow expatriates. Therefore, not reminded of her color by whom? Who treated her with reserve? Behind the gesture — pointing her out — rested an entire system of assumptions to label and know her and reinforce her alterity.

The "they" of her statement was almost certainly the Italians of her acquaintance. The reserve that Lewis encountered was perhaps because no convenient categories existed to circumscribe her position within Italian society. A more pertinent question is: how did Lewis fit into the iconography of visual types already in place? Italians adopted their own

ideas about blackness in general from a standard iconography of types, developed by Europeans over a long period of contact with Africans. According to the historian Karen Pinkus, "To suggest that blackness springs fully grown into the consciousness of the Italian public is to ignore a long and complex iconography that dates back at least to romantic notions of savagery; to nineteenth century sexology; and to a whole range of allied discourses. During the various military and economic maneuvers linking Italy with East Africa in the late nineteenth century, a number of organizations such as the Italian Geographic Society published descriptions of the natives. At times, written descriptions were supplanted by sketches based on a standard iconography of types (the tribal warrior, the sensuous black whore, and so on)."[63] Additionally, cultural notions of blackness and of race in Italy sprang from the long iconographic tradition of Orientalism; to paraphrase the art historian Rossana Bossaglia, Christianity continued to stimulate the search for illustrative models in the world of Africa and the Orient.[64] Also, contact with Americans (primarily through the literature) gave Italians a sense of the concept of race as it existed in the United States until the late nineteenth century. Finally, in 1880 Italy began to colonize North Africa.[65]

For the most part, Italians perceived the Americans and the English interchangeably as *inglesi* or *anglosassoni*.[66] However, they were very conscious of the American political system as well as the concept of "race" in its American context. Those Italians who were concerned with American race relations received their information primarily from American abolitionists. Italy was among many European countries in the 1830s and 1840s that donated crafts to sell at antislavery fairs.[67] Also, translations into French and Italian of the major abolitionist texts were in circulation; in 1869, Henry Wadsworth Longfellow's *Poesie sulla schiavitù* (*Poems on Slavery*, 1842) was translated into Italian and published in Italy.[68] Harriet Beecher Stowe's *Uncle Tom's Cabin* was translated soon after its 1852 publication date.[69] When Stowe arrived in Rome in March 1857, she was fêted by the Romans as the famous author of *Uncle Tom's Cabin*. According to the historian William Vance, "While an artisan saw her admiring the head of an Egyptian slave carved in black onyx, he gave it to her, saying, 'Madam, we know what you have been to the poor slave. We are ourselves but poor slaves still in Italy; you feel for us; will you keep this gem as a slight recognition of what you have done?' An awareness that Italians, especially

Romans, were in several senses 'enslaved' — was widely shared by Americans, and perhaps the one thing that almost all writers agreed upon . . . But the ideal of *unity* for Italy was one that was less certainly held, even as in America that ideal was also being cast into doubt."[70] Stowe's antislavery novel became a favorite of those interested in unification. An Italian choreographer, Giuseppe Rota, wrote two ballets based on *Uncle Tom's Cabin*.[71] The first was performed during the carnival of 1858 and 1859 at the Teatro di Apollo in Rome and was titled *Giorgio il Negro*. The second was more lavish and was performed in Italy and then in England before Queen Victoria. Titled *I Bianchi ed i Negri* (Whites and Blacks), it was typical of nineteenth-century musical theater.[72] When, in 1863, the *National Anti-Slavery Standard* carried the review, the critic stated that the enthusiastic British audience called Rota back three times. The reviewer also expressed puzzlement over the ending, when well-dressed black men danced with formally dressed white women.[73] The critic's bafflement must have been disingenuous because the threat of miscegenation was the favorite argument of the proslavery cause.

Within this environment, Italians possessed an awareness of racial typing but had little actual direct experience on which to hang those types. Moreover, slavery was the metaphor by which they understood their own impediments to unification. Finally, those Americans who had expatriated to Italy may have done so in part for reasons very similar to Lewis's — to escape American racial politics embodied by "the Negro Problem." This may explain Lewis's rocky start abroad. She began her Italian sojourn in Florence, where, with a letter of introduction from an abolitionist supporter, she was to be received by an American family living in the small art center. Faced with the Negro Problem on their doorstep, they denied Lewis entry to the home, which sparked an unpleasant exchange in the press between Lydia Maria Child and the American branch of the offending family.[74] In 1873, while visiting San Francisco to sell works and to visit her brother, Edmonia Lewis spoke in an interview about her experiences in Florence and in Rome: "I did not know a single person there. The uniform kindness, which I have met with wherever I have gone seems strange to me now that I look back upon the past. When I reached Florence I happened to stumble at once on the American minister, Mr. Marsh. I stopped at the same hotel with him two weeks, and when I started for Rome, I found my bills were all paid. He treated me very kindly and the artists of

Florence flocked around me and received me into their circle at once."[75] Lewis elided the initial unpleasantness she faced in Florence, preferring to reconstruct her experiences for the public as untroubled by racial intolerance. She hints at difficulties in Rome, however. According to Lewis, certain "gentlemen artists" did not visit her, thereby leaving the reason for the snub ambiguous — was it the general bias against women artists or did it have to do with Lewis's race? Lewis's decision to expunge the difficulties that stemmed from racial bias was a smartly political one. By purging such incidents, Lewis refused to allow the perception of her time in Italy to be limited by those experiences concerned primarily with race. She wanted her experiences to be consistent with those of an internationally renowned artist. Therefore, from the vantage point of Italy, Lewis could become a *producer* of race, as evidenced by the theme of her sculptures, rather than a *product* of race.

When Lewis left Florence for Italy's cosmopolitan center, she found "two Romes" in place and at play in the minds of the foreign artists who lived and worked there and in the minds of the tourists who visited and patronized them: there was "classical Rome" and there was "contemporary Rome." Together with ancient Greece, classical Rome was the birthplace of Western civilization, and therefore it represented the cultural and spiritual heritage and inheritance of both England and America. Ideologically and culturally, English and American artists desired to assume nineteenth-century Rome's place on the continuum between past and future. In George S. Hillard's *Six Months in Italy*, there is a chapter titled "English in Italy" in which Hillard presumptuously states that "the legitimate descendants of the old Romans, the true inheritors of their spirits" are the English. The English, he declares, are "the true Romans" because "they force the mood of peace upon nations that cannot afford to waste their strength in unprofitable war. They are the law-makers, road-makers, and bridge-makers." And, he continued, the English had inherited the practice of bathing, which he stated had been abandoned by contemporary Italians.[76] As Chloe Chard demonstrates, tourism with its attendant ideologies, guidebooks, and travelogues was primarily responsible for this dichotomy. "One strategy that serves to invest classical statues with the safeness that allows them to become major tourist sights is the device of emphasizing their familiarity — and so separating them from the topography of the foreign and unfamiliar in which they are set."[77]

In addition to the dichotomy of ancient and modern Rome, another dichotomy existed for those living in the Eternal City during the nineteenth century. There was the Rome at war and the Rome for tourists. The sociopolitical topography of nineteenth-century Italy was one of the most tumultuous in the country's history. It was a country divided, as it had been for centuries, first into city-states and then into small kingdoms.[78] The ultimate paradox lay in the fact that while Italy was struggling to unite, with attempts made to capture Rome in 1862, 1866, and 1870, tourism remained Rome's main source of revenue.[79] The primary impediment to unification was the Pope, and American artists such as Hiram Powers, William Wetmore Story, and Thomas Ball supported the overthrow of papal authority. These men were Protestant and so did not suffer the same conflict that a Catholic supporter of the Risorgimento might have suffered.[80] Meanwhile, some Americans looked upon Italy's struggle for unification with flippancy and as an excuse to attack the Catholic Church.[81]

We can reasonably speculate, however, that Lewis supported Italian unification based on two pieces of evidence: a statue of Abraham Lincoln presented to the Central Park Museum in 1872 and a letter that Anne Whitney wrote to her family in 1867 (plate 3). Measuring thirty-nine and one-half inches, the bust of Lincoln is supported by four figures that act as animated caryatids: in the front, two allegorical female figures look up at Lincoln and one holds the Emancipation Proclamation; while in the back, two male figures look out from their position under Lincoln. One is a male slave standing on a ball and chain and holding a broken manacle. He is obviously modeled on the slave from Lewis's earlier work, *Forever Free*, while the other figure wears the uniform of a Zouave soldier with rifle in hand (plate 3, detail 1). Lewis's choice of a Zouave uniform, rather than the more identifiable, stereotypical representation of a Union soldier, is what makes the sculpture particularly rich in signification. The Zouave regiment was first raised in Algeria in 1831 to aid the French in their colonization of the region. They were recruited from a North African tribe of Berbers called the Zouaoua who lived in the mountains of the Jurjura range. They distinguished themselves in multiple ways: their colorful, North African dress of fez, short jacket, fancy vest, baggy trousers, and sash; their drills and discipline; and their fierceness in battle. Racially, in European anthropology, they were the "noble savages" of the Muslim world. According to French colonial discourse, the Zouaoua belonged to the caste of Muslims

called "Kabyles," and as such, represented the "good Berbers" as opposed to the "bad Arabs."[82] By 1838, with the formation of the "Tirailleurs algeriens," a corps strictly for Muslim troops, the Zouave battalions had become a purely French organization. These French fighting units had thus appropriated the reputation, dress, and tactics of the Berber tribe.[83] Relative to Lewis's sculpture, Zouaves fought on both sides of the struggle over Italian unification. The Papal Zouaves were formed in 1860 to defend the Papal States against the Risorgimento; while one year earlier, the Zouaves fighting under Giuseppe Garibaldi had acquitted themselves with honor at the Battle of Palestro against Austrian forces in the Alps.

There were also very real ties between Garibaldi, Lincoln, Zouave regiments, and the U.S. Civil War. The struggle for a Republican Italy was observed with great sympathy by the antislavery press, while Garibaldi was a wildly popular figure in America. Garibaldi arrived in the United States in 1850 as a refugee from the European upheavals of 1848. He lived in the village of Clifton, Staten Island, where he opened a candle factory, joined the local Masonic Lodge (Tomkinsville Lodge, No. 401) where he took degrees, and was active in the Italian community of New York. By 1851, Garibaldi had begun business ventures in Central and Latin America, where for two years he was involved in commercial shipping. He was allowed to return to Italy in 1854. At the outbreak of the Civil War, Secretary William Henry Seward invited Garibaldi to join the Northern cause. Garibaldi had two stipulations for his return to the United States as a commissioned officer: that he be granted the title of commander-in-chief and have the power to abolish slavery. Secretary Seward respectfully declined. Garibaldi, however, remained a welcome guest of Lincoln, and the two nations, both struggling for unity, watched the unfolding events in each country carefully.[84]

In the United States, Zouave regiments were raised during the Civil War and were made up of American men who fought both for the North and the South. The first recorded casualty for the North was a Zouave soldier and dear friend of Lincoln. Elmer Ellsworth (1837–61), while working as a lawyer in Chicago, raised the U.S. Zouave Cadets, and in 1860 they won national drill championships due to Ellsworth's incorporation of new maneuvers that relied heavily on acrobatic skills. To celebrate, advertise, and glamorize Ellsworth's Zouaves, Edward Mendel in 1860 created a lithograph detailing their dress uniforms (plate 4). When the Civil War began, Ellsworth raised a new Zouave unit in New York City

made up of firefighters. Known as the New York Fire Zouaves, they successfully took and occupied Alexandria, Virginia, but Ellsworth was killed capturing a Confederate flag soon thereafter. His death on May 24, 1861, inspired many men to join the Union Army, and "Remember Ellsworth" was a popular slogan. Cartes-de-visite with his image were hugely popular. A grieving Lincoln ordered his body moved to the White House, where it lay in state on May 25. The body was then moved to City Hall in New York City, where thousands paid their respects. Ellsworth was buried in Mechanicville, New York.[85] In honor of Ellsworth's sacrifice, six-year-old Tad Lincoln was photographed wearing a Zouave uniform.

I believe that Garibaldi was a hero in Lewis's eyes, as was Lincoln. While of the two only Garibaldi held a strong and vocal antislavery position, Lincoln was responsible for the partial and symbolic freedoms granted under the Emancipation Proclamation. In Lewis's sculpture, the Zouave soldier is what links the two men. Also, the original location of the sculpture was particularly evocative of the New York Fire Zouaves. The sculpture was purchased and donated anonymously and with deliberation as the inscription across the front part of the base proclaims: "A Gift to Central Park from a Woman." The sculpture was housed in the art gallery at Mount Saint Vincent's Central Park Museum, located at East 103rd Street. The chapel, in which the museum was located, was used by the Central Park Museum to house a collection of sculpture valued at $15,000. Among the works were eighty-seven plaster sketches by Thomas Crawford, donated in 1860 by his widow, Louisa, upon her husband's death.[86] In effect, Lewis has referenced Garibaldi and the Italian Risorgimento, and Lincoln and the American Civil War, particularly the Zouave regiments raised in the North and New York City. And most interestingly, in the pairing of the Zouave soldier and the freed slave, Lewis has suggested the origins of the Zouave regiments in North Africa and the transformation of Africans into slaves and again into soldiers (plate 3, detail 2).

The second piece of evidence to suggest Lewis's support of the Risorgimento emerges like so much of what we know of Lewis — that is, through letters written by others about her. According to Anne Whitney, after Garibaldi's Risorgimento troops were vanquished in 1867, she and Lewis witnessed the victorious French troops entering the city. Whitney records the following incident in a letter to her family: "Edmonia is a [green?] little creature but very kind and obliging. She saw the foreign troops making

their entrance and felt a good deal excited about it. A lady standing near said to her, 'Where are they going?' 'To the devil,' answered Edmonia with a great swing of her arm which caused her to lose her balance and tumble into a hole as deep as herself . . . out of which she had to be helped by the passer by."[87] Such hopes on the part of Lewis would not necessarily have been in conflict with her spiritual beliefs. For while American Catholics believed that the Church offered the one true faith, they also believed that there was no essential conflict between papal principles and the ideal of social justice. As William Vance has noted, "They looked to the day when all of America would be redeemed by Rome; and a few of them occasionally imagined a time when Rome itself would become more American."[88]

As a Catholic, Lewis would have been in a minority among the English and American expatriates, the majority of whom were Protestant.[89] Typical of most accounts of Lewis's life, however, there is conflicting information about when exactly she became Catholic. Her name, "Mary," suggests that Lewis was born and raised as a Catholic. Her friend and fellow artist Anne Whitney, however, has a more cynical interpretation for what she (Whitney) believed to be a rather recent and convenient conversion on the part of Lewis. In 1868, Whitney wrote to her family, "Edmonia Lewis has turned Catholic and her reasons for it are better than her Catholicism, I fancy. The American clergyman took no notice of her and her Catholic acquaintances were very friendly." In 1879, the *New York Times* included biographical information in their report about Lewis's exhibiting a work titled *Bride of Spring* at a Catholic fair in Cincinnati: "She lived with the Indians, and according to their habits, until she was 14, when, with the aid of her brother, she was sent to Oberlin, Ohio, to school. Before this, she had joined the Roman Church, and her creed and blood did not harmonize with the precision and method of Oberlin." Interesting on several levels, the article expunged the time she spent in McGrawville. It also tells us that she became a Catholic before she was fourteen years of age, while the erasure of the poisoning incident is of equal note — the implication being, of course, that it was her religion that made Lewis incompatible with the college.[90] The *Detroit Informer* in 1909 reiterates the theory that Lewis's religion made her incompatible for life at Oberlin: "As she was a fervent Catholic she found the atmosphere of Oberlin somewhat uncongenial, but she studied there for two or three years, and there her Indian name of Wildfire was changed to that of Edmonia Lewis."[91]

Contrary to Whitney's intimation, that Lewis became a Catholic in a Catholic country to serve her commercial interests, evidence suggests that Lewis was a lifelong believer and quite devoted. After 1876, her patronage and production were almost exclusively influenced by her Catholicism. In an interview of 1871, she expressed her devotion to the Virgin, stating, "I have a strong sympathy for all women who have struggled and suffered. For this reason the Virgin Mary is very dear to me."[92] The number of Virgins that she made during her lifetime amply supported her stated devotion, especially since Virgin and Child imagery was an uncommon subject for American neoclassical sculpture. Lewis received at least two commissions for tomb monuments, at least one of which may be connected to her Catholic faith. The story of this commission, which ended in disaster, provides a clue about Lewis's life outside the American expatriate community as well as her connection to a larger Catholic community. When a successful middle-class African American and Catholic couple, Mary and James Thomas of St. Louis, Missouri, visited Rome, they came to Lewis's studio, seeking an appropriate monument to adorn the grave of Mary Thomas's mother, who had been interred in Calvary Cemetery, a graveyard for Catholics in St. Louis. Lewis showed them a clay sketch for a sculpture to be titled *Virgin at the Cross* and they agreed on a price of £4000 sterling (approximately $2,000). After they had paid three of four installments, the completed sculpture arrived in St. Louis. The Thomases hated it and refused to pay the balance. Lewis hired an attorney and between January 1879 and November 1881 a very public court battle was waged. Newspaper accounts described the now-lost work as five feet two inches high. The debate centered on whether the piece was artistically rendered. Among those arguing for Lewis's side was an Italian sculptor whose deposition was mailed from Rome. Finally, Lewis won the case. However, the Boston *Daily Evening Transcript* called it a barren victory because the judge reduced the settlement to $407 from the $635 for which Lewis initially sued.[93]

Furthermore, during her time in Rome, Lewis created several works with religious themes and then exhibited at Catholic fairs or sold the pieces to Catholic churches or to members of the Catholic Church both in England and the United States. Directly related to her ties to the Catholic Church, three commissions are mentioned in the literature although none have been located. The earliest, commissioned in 1879, was the *Virgin*

at the Cross. In 1870 the *Art-Journal* reported that Lewis was "executing a Madonna for the church of S. Frances in Baltimore, by order of the archbishop." In 1883, the Marquis of Bute purchased a *Madonna and Child* for $3,000 and reportedly placed it on the Isle of Bute. Finally, in 1883, the *Woman's Journal* reported that a church in Baltimore commissioned an *Adoration of the Magi* and wrongly identified the town as Lewis's native city. They also noted that Lewis gave more prominence to the African king than either the "Caucasian or the Asiatic."[94]

Another piece of evidence concerning Lewis's Catholicism — a very important visit to her studio by Pope Pius IX — appears in two sources. The visit had to occur before 1878, the year of Pius's death, and was reported first in the *New York Times* in 1880 and then recycled in 1909 in a column for *Rosary Magazine* called "The Catholic Who's Who." According to the *Times*, "She became a Catholic, and is said to have received a visit from Pius IX at her studio in Rome." *Rosary Magazine* was slightly more enthusiastic about the event: "One of the proudest remembrances of Edmonia Lewis was the day, many years ago now, when the kindly Pope Pius IX blessed a work upon which she was engaged."[95]

Despite the specters of racialism and its attendant racism that continued to shadow Lewis, Rome represented an escape from the constraints of race and sex, an escape from American prejudice, and an opportunity that few women (especially women of color) could enjoy. Within a European context, she was neither culturally African nor was she visibly European; she was truly, *visibly*, an outsider. However, within the representational systems functioning in Italy at the time, her difference was largely unarticulated and thus inchoate. Among the Italians, her uniqueness, the lack of language to define her, allowed her a greater individuality, and ironically, invisibility. Unlike Italy, the United States had a rigid system in place to identify and deal with her. Given her difficulties and the obstacles imposed on her by Americans in Rome, Lewis seems to have carved out her own community apart from the Americans and the English. We trace her years after the Risorgimento and the Centennial Exhibition in Philadelphia through visitor's registers and ship manifestoes, through newspapers and the diary of Frederick Douglass. In 1887, Douglass and his new wife, Helen, were on their honeymoon and met Lewis. They toured Rome and Naples with her and reported that she had a studio at no. 4, via Vente Settembre. According to Douglass, they "found her in a large building near the very top in a very

pleasant room with a commanding view . . . Here she lives, and here she plies [*sic*] her figures in her art as a [sculptor]. She . . . seems very cheerful and happy and successful. She makes us obliged to her for kindly offering to help us in any way she could and she certainly seems able to serve us in many ways. She has resided in Rome twenty years and constantly speaking Italian has somewhat impaired her English."[96] To commemorate their meeting, Lewis made a bust of the elder statesman.

She also appears to have moved easily throughout Europe. At some point after 1889, Lewis signed the visitor's register at the Rome consulate. She gave as her birth the year 1854, either carelessly inverting the last two digits or deliberately lowering her age by ten years. She gave as her place of birth New York State and Boston as her past residence in the United States. She gave no. 46, via Ludovisi as her current address.[97] Three years later, in 1896, her brother Samuel died in Montana.[98] By 1898, Lewis was living in France. On August 3 she signed a visitor's register at the Rome consulate and listed her present address as the Hotel Allemagne in Paris.[99] In September, the *New York Age* reported that Lewis had arrived in America on the steamer *Umbria* of the Cunard line, direct from London, where she had been spending a few weeks. In 1909 she signed a reception book at the American embassy in Rome. The last in-depth work on Lewis appeared in *Rosary Magazine*'s "The Catholic Who's Who." Noting that Lewis had lived abroad for so long that many Americans might have forgotten her, Scannell O'Neill, the author, wrote, "Although now advanced in years she is still with us."[100]

The steadfastness of family, the opportunities available in specific places, and, most importantly, effective timing all play a significant role in Lewis's career. Her brother Samuel provided lifelong support. He ensured that Lewis received as much education and the best education then available to an African American woman. When the situation, first in McGrawville and then at Oberlin College, became insupportable, he funded a studio for Lewis in Boston, an abolitionist stronghold the equal of Oberlin, and also a center for art. The timing was perfect. The debate over the character and quality of African Americans, emancipation and its consequences, pushed Lewis's achievements to the forefront. She desired, however, to move beyond the culture that simultaneously nurtured and stifled her. In Rome, Lewis fully realized her ambition to be a sculptor, because she followed the model of so many women who had taken up the chisel before her. If not

always fully supportive emotionally, nevertheless their very presence had prepared a place for her. In Lewis's art, we decipher a kaleidoscope of responses, from questioning to conflicted to concession toward an education that emphasized the sanctity of family and domesticity. In her ideal works created in Rome, we can begin to understand how culture shaped her, the inescapability of it, and how it educated her in the interpolated cultures of true womanhood and of sentiment.

～ The "Problem" of Art History's Black Subject

There is a double-bind of past and present that keeps Edmonia Lewis in the shadows of historical understanding: during her lifetime, she provided conflicting information about the date and place of her birth; to further complicate matters, we know virtually nothing of her private life; moreover, statements that she made about her parentage are also questionable. Claiming that her mother was a full-blooded Chippewa and that her father was African American, she may have tailored her ethnic heritage to suit the expectations of her audience. In hindsight, it seems as if Edmonia Lewis handed art history the tools with which to misrepresent her. Indeed, the manner in which art history is practiced represents the second layer that obscures any clear understanding of who Lewis was and what her work signified in a nineteenth-century context. Yet her situation within art history is not unique, as evidenced by the predominant discussions about the African American landscape painter Robert S. Duncanson. Like other artists of color, Lewis and Duncanson are "problems" within art historical discourse — but the "problem" is purely racial and *liberal* in connotation. The discourse functions in a context of late-twentieth-century liberal racialism, which advocates tolerance of difference but difference defined by beliefs in racial fixity and hierarchies.

In one form or another, African Americans have been a "question" or "problem" throughout U.S. history, usually at the fluid intersections of two key factors: concern and discussion about what to do with a large, free black population, and the moment when domestic caste relations are perceived to be radically opposite the founding principles of the nation.

As the political scientist Adolph Reed contends, "The initial formulation that 'America' has a 'Negro Problem' not only reproduces the principle of black marginalization in the national experience; it also implies that the black experience exists insofar as it intersects white American concerns or responds to white initiatives . . . an instance of a general tendency to view blacks [in the words of Ralph Ellison] 'simply as the creation of white men.'" As Reed points out, those who study what he calls "Afro-American thought" and employ the "Negro Problem framework" actively construct African American intellectual history as purely reactive. Reed explains, "A general effect of the 'Negro Problem' focus on the study of Afro-American thought . . . has been to lend privilege to an approach that conceptualizes black political discourse only in its tactical dimension, as a debate over alternative styles of response to white agendas."[1] I would argue, to extend and expand Reed's discussion, that the submerged rhetoric of a "Negro Problem" retains currency in art history because art history is written in a context that is both liberal and concomitantly racialized.

READING DUNCANSON (AND READING LEWIS)

In this section, I engage a "problem" quite different from that of Michael Baxandall's meaning, which signifies concepts pertaining to how objects come into being, in favor of exploring how certain art histories come into being. It is my contention that as a discipline, art history has a Negro Problem (and in any given situation an Indian Problem and a Woman Problem and a Queer Problem, and so on). As a result, when African American artists are the subject, art history actively employs the Negro Problem framework so that the African American artist must react to in order to reinforce an ideological "whiteness," which the discipline exists to reinvent.[2] At the core of ideological whiteness as articulated by art history is the maintenance of an uninflected, normalized notion of "whiteness," which, in an American context, requires African American artists to affirm and replicate their absolute difference-as-"blackness" in their artwork. Therefore,

art history's method within the Negro Problem framework is tautological — the artwork is a recapitulation of the artist's racialized identity.

As I stated at the outset, Lewis practically handed art history the tools with which to misinterpret her, but it is both enlightening and disheartening to find a similar kind of art history deployed against an African American artist who denied art history its black subject. Consequently, the landscape painter Robert S. Duncanson provides a necessary point of comparison to Lewis because, while she willingly provides the black and Indian subject, the "nonpresence" of blacks in all but two of Duncanson's landscapes is translated by canonical art history as "absence." The distinction is subtle but significant; it is the difference between "never there" and "missing."

Tautology as Method

Since the nineteenth century, a disturbing trend in the scholarship about Lewis has persevered — the notion that her art represents a full and uncomplicated expression of her identity. Hugh Honour, writing in 1989 about the female figure in *Forever Free*, surmised that "the woman's features and flowing hair could . . . be those of an American Indian, and one may wonder whether this figure did not have an element of self-portraiture, or a reminiscence of Lewis's mother" (plate 2).[3] From the inclination to interpret her work as self-portraiture or as a representation of her "identity," two distinct lines of exposition have emerged. One line dictates that her art reflected her suffering and resistance to white and black patriarchy. Lewis is recast as a (re)activist whose politics are more palatable to a twentieth- and twenty-first-century consciousness. David C. Driskell, writing in 1976, claimed that "the zeal with which Miss Lewis portrayed racial themes indicates her strong desire to show the race hatred endured by members of her father's race, who were black, and the plight of her mother's people, the Chippewa Indians, who had also been robbed of their cultural heritage by the European quest to 'civilize' the new world."[4] It is as if racism were the only experience that shaped her identity and thus the only force that inspired her art. The second interpretation posits her work as equally self-reflecting but dictates her perspective as that of the perpetual outsider relative to white culture. The only African American in the large expatriate community of American artists in Rome, she was marginalized by William Gerdts in 1973, for example, as "the most exotic" artist among the American expatriate community.[5] Both tendencies depend on a tauto-

logical reading of the relationship between Lewis and her art, and in each case she is positioned strictly relative to a fictive, normative whiteness.

Tautology means needless repetition of the same sense in different words; it signifies a redundancy that, in this instance, reproduces identity within the work of art. Before collapsing the artist's identity into her work, however, the authors of such narratives have already decided who Lewis is a priori any investigation into the complexities of her choice of subject matter, manner of execution, or the artistic and social contexts in which those choices were performed. Clifford Geertz argues, "The unity of form and content is, where it occurs and to the degree it occurs, a cultural achievement, not a philosophical tautology."[6] Geertz defines culture as "interworked systems of construable signs" or "symbols." "Culture," he claims, "is not a power, something to which social events, behaviors, institutions, or processes can be causally attributed; it is a context, something within which they can be intelligibly — that is, thickly — described."[7] While biology may explain Lewis's interest in slaves and in Cleopatra because they were descended from or lived in Africa, or in the fictional Hiawatha because he was Chippewa, I contend that her works formed part of an intricate web of relations — that they were a "cultural achievement" — and that they do not adhere to any concerted agenda on Lewis's part. Her ideal works were materializations, not illustrations, of a sensibility that was shaped by the ideals of womanhood just as much as by her "identity," and the accumulation of her experiences was determined by her status at various times as a woman, as Native, African, Roman, American, Catholic, and artist. Furthermore, her art was a response to images both verbal and visual that preceded it. Sometimes innovative, sometimes awkward, her art was also in some ways limited by what could not be imagined beyond it.

An overview of Lewis's career is impossible because so many of her works are lost and so much of her biography at this point is missing. The distorted interpretation of Lewis is also made possible by the paucity of archival records, which allows for imaginative readings of Lewis's life. I choose, instead, to focus on the extant body of her ideal sculpture, the bulk of which she created between 1866 and 1876. Ideal sculpture was analogous in subject matter and intent to history painting, with themes inspired by history, the Bible, mythology, and literature. Its purpose was to engage the higher sentiments of intellect and morality. My purpose is to pose cultural contextualization rather than racial tautology as the means for exploring

Lewis's work. Lewis's acts of agency—her art—can provide a perspective from which to view the various communities in which she took part. As a result, the works yield the most information about Lewis, about her patrons and her detractors, and about the role of sculpture in the United States and in Europe during the third quarter of the nineteenth century. By taking apart the tautology found in traditional art historical analysis, I demonstrate that Lewis's art is more than a representation of a fixed identity, more than self-portraiture. I contend that Lewis's work sprang from a negotiated identity, as fluid as the notion of "race," "femininity," and the very concept of "America" itself. She is central to the compelling issues of ethnicity, gender, and nation.

Reading Duncanson and the Dilemma of "Absence"

The philosophical tautology, which unites form and content, which melds artistic identity to the thing created, is not exclusive to writing about Lewis. Examining two scholarly texts written in the 1990s about the landscape artist Robert S. Duncanson (1821–72) will show how pervasive is the tautological interpretation of African American art: Joseph D. Ketner's *Robert S. Duncanson: The Emergence of the African-American Artist* and David M. Lubin's chapter "Reconstructing Duncanson" in his *Picturing a Nation: Art and Social Change in Nineteenth-Century America*. Like Lewis, Duncanson has remained a presence in studies of African American art. Unlike Lewis, whom scholars from various fields within art history continue to mention, Duncanson has been marginalized in or entirely excluded from recent discussions about American landscape as it relates to national identity formation.[8] The disturbing failure to theorize Duncanson's position with respect to "Americanness" has resulted in his treatment as a subcategory within the larger dialogue always and only answerable to an essentialized notion of race. "Essentialism" is defined as absolute being, which stands outside the sphere of cultural influence and historical change. Essentialism is also the basis for the tautological interpretation of both Duncanson's and Lewis's work. Diana Fuss claims, "'Man' and 'woman' are not stable or universal categories, nor do they have the explanatory power they are routinely invested with. Essentialist arguments are not necessarily ahistorical, but they frequently theorize history as an unbroken continuum that transports, across cultures and through time, categories such as 'man' and 'woman' without in any way (re)defining or indeed

(re)constituting them. History itself is theorized as essential, and thus un-
changing; its essence is to generate change but not itself to *be* changed."[9]
Such trends in essentialist readings have a long history and are at the heart
of the writing about race and identity as well as gender. Almost without
fail when the discussion is "race" the subject is usually "black," with "black"
meaning "race" while "white" continues unchallenged. The syntactical con-
struction of "women and people of color" — the so-called language of in-
clusiveness — reaffirms the idea of "white" as an essential, ontological cate-
gory.[10] The tenuous fiction of race demanded and demands clarity even
as its "reality" (racism) continues to be produced at the level of culture.[11]
There is no better example of that tenuous fiction than the belief that a
white woman can bear a black child but that a black woman cannot bear a
white child.[12]

Duncanson's biographer, Joseph D. Ketner, notes that the artist was
"the first African-American artist to appropriate the landscape as part of
his cultural identity."[13] Landscape, by implication, was a mode to be seized
or confiscated from an implied "white culture" by the African American
artist and artificially grafted onto "his cultural identity" or race. Ketner
(and as I will demonstrate below, Lubin) suggests that Duncanson appro-
priated landscape in order to use it as a kind of talking drum, commu-
nicating codes to other African Americans, even as Ketner (and Lubin)
admit that Duncanson pursued white patronage almost exclusively. "He
achieved this by investing the mainstream aesthetics of American land-
scape painting with a veiled significance that was understood by the Afri-
can American community."[14] Ketner interprets water, trees, rocks, sky, and
earth in Duncanson's work as metaphors for emancipation and an essential
blackness. Even Duncanson's European landscapes from the antebellum
period are discussed in this manner. Duncanson's Italian landscape *Time's
Temple* (1854) is a case in point (plate 5). Ketner writes that the paint-
ing "conveys a particularly African-American perspective toward Italian
ruins subjects. For Duncanson the ancient Romans were immoral not only
because of their pagan religious beliefs, but also because they possessed
slaves." Furthermore, he argued, "In 'Time's Temple' the African-American
painter equated the fall of the Roman Empire with the practice of slavery
in the United States and offered a warning to Americans."[15]

Ketner has no other evidence that Duncanson felt this way other than
the landscapes themselves. Inevitably, the weakness of Ketner's narrative is

proven when it thins out, unable to sustain itself after the end of the Civil War, when the abolitionist, racialized landscape no longer had cultural currency. Ketner's discussion of Duncanson's final days during the postbellum period comprises a litany of formal analysis, along with a discussion of Duncanson's madness and tragic death in a mental institution in Detroit in 1872. Ketner provides crucial new information regarding Duncanson's parentage and the possible source of his mental illness (the lead white he used while working as a house painter). Counter to what has commonly been assumed, Ketner discovered that Duncanson was not "mulatto," that his father was a free black man and not Scottish.[16]

Because he willfully chooses to ignore Ketner's findings, David Lubin's study is the more problematic of the two works on Duncanson that I am examining. Lubin acknowledges in a footnote Ketner's revelations but nonetheless decides to leave the chapter as he had written it, finding the facts and their implications for his own work inconvenient and inconsequential.[17] Lubin then proceeds from the idea that Duncanson was half-white and passing for white — despite the fact that passing relies on secrecy. The idea that Duncanson was passing is especially puzzling because Duncanson, as an openly black artist, depended on abolitionist patronage. The reason for Lubin's tenacity on this issue is revealed in the introduction to his book, where Lubin talks about his own investigative method as a form of passing. Lubin's stated goal in his study of six American artists is to employ empathy as method.[18] He will "pass" for a white woman, that is, he will assume temporarily the guise of a white woman in order to discuss Lily Martin Spencer and to interpret her painting. For his examination of William Harnett, Lubin will assume a more (in his words) "objective" tone, less concerned with "storytelling" as in the case for Spencer (who represents gender) and Duncanson (who signifies race).[19] Ultimately, Lubin collapses Duncanson's identity into his own, blatantly ignoring scholarship that fundamentally changes his interpretation.

According to Lubin, his purpose is to "examine Duncanson's work in terms of American landscape painting of the mid-nineteenth century but also in terms of American race relations during that same period." He states: "The procedure . . . will be as much biographical as artifactual." He notes two pitfalls in this endeavor. "The first is that when a white art historian writes at length about a black artist, not only is that artist being reduced to an object of knowledge for the art historian, who reflexively assumes

the superior position of knowing subject—which is a problem endemic to all art history—but further objectification arises inasmuch as a black person is being reduced to an object of knowledge for the white knowing subject." It is Emerson's dichotomy all over again! But in the liberal terms of twentieth- and twenty-first-century art history, the dichotomy is posed as a *dilemma* of the white knowing subject/black known object. (He also seems to be operating under the assumption that all art historians are white; or, that somehow a contemporary black art historian will via genetic racial memory level the playing field of time to write a history that does not invoke the superior, knowing subject. What would he posit for a "mulatto" art historian?) Lubin's solution to his perceived dichotomy (or liberal dilemma) of white/subject and black/object is to attempt a nonauthoritative reading of Duncanson. Lubin warns, "I have tried to write about Duncanson, as about all the other artists in this book, not as someone who can be known fully and whose art can be fully understood, but as a site of inquiry at which various relevant questions (including those involving the social production of race) come together and play off one another."[20]

It is the "social production of race" produced by Lubin's reading that leads to his second pitfall—"that of transforming Duncanson's paintings of the land into a discourse on race."[21] This second pitfall that Lubin raises only to "handle" finds an echo in the representation of African Americans in Western art-survey textbooks. In her seminal essay on the subject, the art historian Kymberly Pinder notes "how general art historical surveys, through selection and omission, construct different identities for African American art that often employ negative stereotypes." (In Lubin's text, for example, Duncanson is constructed as passing and, as we will see later, the "tragic mulatto.") Pinder continues, "Inadvertently this treatment frames this art within the confines of racialized attitudes and makes the discussion of African American art in these books a discourse about African Americans [or as in Lubin's words, 'a discourse on race']."[22]

Despite the fact that Duncanson's landscapes are virtually indistinguishable from those of his Hudson River school counterparts, Lubin judges them different because Duncanson was different. Lubin writes, "Thus, even though the typical components of Duncanson's style derived from his Hudson River School predecessors and look almost exactly the same as theirs, his use of them is in the end different because of the ways in which *he* was different from them, his root culture different from theirs."[23] Like

Ketner, Lubin argues that Duncanson appropriated a style of painting foreign to him and to his "root" culture, or as Ketner distinguished it, Duncanson's "cultural identity." Lubin claims, "Duncanson may have appropriated 'white' landscape language and recoded it accordingly. He may even have done this with a parodic intent, one that was altogether undiscernible to his white patrons."[24]

The "problem" for Lubin, however, is the visible *lack* of discernible black subjects in Duncanson's paintings. The failure on Duncanson's part to permit a tautological reading, that is, the conflation of artist and object, frustrates Lubin. In fact, based on the nonpresence-qua-absence of the black subject in Duncanson's work, Lubin creates his own tautological reading with surprising results: "Looking at the images Duncanson produced during the first decade, the portraits, still lifes, genre scenes, and landscapes, we detect nothing to indicate that the painter was an African American, partial or whole. There seems to be a curious sort of denial, a striking *absence* of blackness or, should we say, brownness . . . a more satisfactory — as well as more troubling — answer as to why, with a couple of exceptions, Duncanson steered clear of black subject matter is that at some level and in some manner he wished to pass for white."[25] For Lubin, absence signifies denial. Therefore, Duncanson's visible "denial" of race in his art indicts the artist in Lubin's eyes as the worst sort of race traitor — as someone who wishes not only to pass for white, but also to *be* white. Like survey authors, Lubin grounds his reading of Duncanson entirely on the desire to replicate the black known object in black subject matter, the significance of which Pinder explains as the notion of "authenticity" in her article. From this point on in my examination, I will use "black subject" interchangeably with "the black known object."

"Authenticity," Pinder contends, "has been a preoccupation for African American art, as it has been for much of African American society in the first half of the century." Thus, "for the survey author, the authenticity of African American art is inextricably bound to its racial content, either overt or implied." For such authors, African American artists can only achieve validation through (black, racialized) subject matter.[26] The need to constantly prove one's racial authenticity is art history's litmus test for the racialized artist and simply verifies Adolph Reed's claim that "the idea of the authentic is always hortatory rather than descriptive." Reed astutely notes, "Beneath this view typically lie presumptions of definitive

group essences, evocations of the old belief in racial natures or tempera-
ments, as in identification of groups—all too frequent in contemporary
discourse—by their alleged possession of traits such as family structure,
orientations toward work, spirituality, thrift, and so on."[27] For Lubin, then,
Duncanson's "denial" is ultimately a denial of self. About Duncanson's "au-
thenticity," Lubin has this to say: "To view Duncanson's work exclusively
in terms of Hudson River school painting is perforce to regard it as deriva-
tive, secondary, imitative (a term commonly used to describe Sambo, the
black monkey). But this is not the case if we trace the African-American
coordinates of the work. The purpose is not to elevate Duncanson's art
from the debased category *imitative* to the esteemed one *original*—which
is a chimera in any case—but rather to understand how a body of work
that was produced in the interstices of black and white society in ante-
bellum America could give plastic form to immaterial hopes, dreams, and
fears."[28] In order for Duncanson to be "authentic," Lubin must find the
"African-American coordinates" of Duncanson's work, because it is Dun-
canson's blackness that makes him authentic but only if it is reproduced in
his art. Lubin's determination to avert having to charge Duncanson with
inauthenticity (derivative or imitative), his determination to locate a black
subject "in the interstices of black and white society," reveals that art his-
tory's investment in the tautological relationship between black artist/
black object is its need to maintain the false division between and hence
racial purity of two separate societies based on (the social construction of)
race.

 Despite the black subject's nonpresence, Lubin does manage to find it
in a leap of logic that is breathtaking. Early in the essay, Lubin identifies
Duncanson's *Blue Hole, Flood Waters, Little Miami River* (1851) as a pro-
foundly significant work (plate 6). Lubin begins by noting its similarities
to other Hudson River school landscapes, but with a difference. "To be
sure, many other Hudson River School landscapes, for example, those of
Thomas Doughty, Henry Inman, and Duncanson's colleague William
Louis Sonntag, featured boys fishing on the banks of rivers or lakes, but few
such works were as suggestive as 'Blue Hole' in evoking a sense of a lived
relationship between the figures who otherwise functioned as staffage."[29]
Duncanson has achieved, according to Lubin, the marriage, or in his clever
use of language, the "integration," of two "seemingly disparate styles of
antebellum painting, one that generally bespoke lofty ideals and leisurely

refinement, the other associated with vernacular anecdote and popular egalitarianism."[30] Lubin's fantastical assessment that Duncanson merged ideal landscape with genre (that is, the depiction of everyday life) literally re-embodies Duncanson's landscape with the subject — even though that subject is the wrong race. Despite Lubin's deliberately benign, rather apolitical definition of genre as "associated with vernacular anecdote and popular egalitarianism," scholars have demonstrated that genre is in reality a style of painting based on the racialized, classed, and gendered bodies of others and reinforces the notion that "egalitarianism" is a contingent state and depends on the enslavement of someone else.[31] In Lubin's search for the black subject, his reversion to genre, with its reliance on the human figure, is the only way that he could begin to construct for Duncanson a black subject. After all, it is through the body that the ideology of race is articulated.

Thus, Lubin's solution to Duncanson's "denial" of black figural groups in his landscapes is to propose that the white subjects in Duncanson's paintings are actually surrogates for Duncanson. They are blacks in whiteface, or to use his language, "blacks in disguise, camouflaged."[32] As the authors of Western survey texts identified by Pinder seem to believe, "The African American artist must therefore enter the canon as this subject . . . the African American artist signifies every aspect of the monolith of 'Black Culture.'"[33] Consequently, the conflation of subject and object — the subject *as* subject matter — is complete but with far-reaching consequences. Lubin's text has indeed become what he feared, a discourse on race, in which all African Americans embody the "tragic mulatto" stereotype. "Rather than concentrating on Duncanson's paintings as expressions of one particular African American's sense of lack," he writes, "His desire to pass to the other side, we have regarded them in terms of what we know of the hunger of antebellum African Americans in general, dark-skinned or light, slave or free, to cross over from racial oppression to genuine, meaningful liberation."[34] In terms of Lubin's simple formula, the desire to be free is indistinguishable from the desire to be white. I would argue that Lubin's desire at any cost to invest Duncanson's landscapes with the black subject (featuring the artist himself) is expressive of the need for race to be visible, coherent, and legible at all levels of culture but especially in works of art. Race, like gender, must communicate itself on the level of art if we are to believe that it articulates itself cleanly on the level of culture (the idea of

two distinguishable "societies," that is, races) as an extension/expression of biology.

I want to return briefly to statements made by Ketner and Lubin regarding Duncanson's cultural identity. Both scholars make implicit in their assessment of Duncanson that *his* culture was different from white culture (this is particularly ironic given Lubin's stubborn insistence on Duncanson's mulatto identity). While Ketner argues that Duncanson was "the first African-American artist to appropriate the landscape as part of his cultural identity," Lubin employs the term "root culture" to distinguish between the culture of Duncanson and that of the other artists of the Hudson River school.[35] The idea that the United States is made up of two separate nations is flawed for many reasons, but in particular, Ketner's and Lubin's claim is an essentialist reading of race that replaces biology with culture. Adolph Reed asserts, "With respect to Victorian ideology, racial essentialism does not necessarily depend on biological arguments. After World War II discovery of the Nazi death camps made biologically based justifications of racial hierarchy unfashionable in liberal American intellectual life. Therefore, 'culture' gradually replaced biology as the metaphor characterizing the source of essential traits that supposedly define and separate human populations ... As it has become hegemonic, moreover, this strain has made clear the extent to which prevailing notions of race, ethnicity, and culture function interchangeably as templates for essentializing claims about social groups."[36] Moreover, the assumption is that the actions and lives of people do not inflect the lives of those who are perceptually different from them. Laboring under such assumptions, they get to the heart of what difference does *not do*. Difference does not march side by side with difference; difference is relational. We live our differences at the expense of one another.[37] It is difficult to understand how Lubin could write seriously about different root cultures when cross-cultural claims were made all the time by white men like Emerson, Longfellow, and the painter Thomas Cole. Their invocation of Native Americans does not inspire Lubin to claim that they wanted to be Indian, for example.

The "dilemma of absence," then, is Lubin's. I would reiterate here the difference between an assumed "nonpresence" of the black subject as opposed to a presumed "absence." Lubin transfers his dilemma of absence to Duncanson, and the now racialized dilemma emerges as W. E. B. Du Bois's famous (and here anachronistic) rhetorical strategy of "double conscious-

ness" artificially transliterated as pathology. Prefatory to his discussion of double consciousness, Lubin lays the groundwork with a romanticized re-telling of the cause of Duncanson's madness—not from the lead paints he used but from the irreconcilable divisions of blackness and whiteness, the so-called self-contradictions that inhabited his psyche. "The following summer [1872], while hanging another exhibition in Detroit, Duncanson suddenly broke into 'weeping and wild laughter at his imagined medi-ocrity.' Committed to the Michigan State Retreat, he died insane before the end of the year. According to an obituary, 'He had acquired the idea that in all his artistic efforts he was aided by one of the spirits of the great masters, and this so worked on his mind as to affect him not only physically but mentally.'" Choosing the psychological over the physiological expla-nation for Duncanson's illness, Lubin discards the evidence uncovered by Ketner, which suggests that Duncanson was affected by his exposure to massive quantities of lead paint while apprenticed to a housepainter. As noted previously, we know for a fact that Lubin was familiar with Ketner's scholarship because Ketner's book is footnoted in Lubin's essay.[38] Tellingly, however, Lubin chooses to use an explanation for Duncanson's illness from the nineteenth century, a source contemporary to Duncanson and plagued by the sentimental racialism of that era. Lubin elaborates on Duncanson's supposed delusions: "On the one hand Duncanson conceived of him-self as an artistic mediocrity, on the other as the heir to a great master—although we do not know which one. The self-contradiction, the fluctua-tion between poles, is perhaps characteristic of many artists but certainly of Duncanson in particular. Neither all black nor all white, directed simulta-neously toward Africanism and Eurocentrism, his life was predicated upon an irreconcilable division. This was the greatest gulf of all, too deep and too wide for him to pass."[39]

Lubin explains his anachronistic use of Du Bois's formulation of double consciousness by claiming that Duncanson was "ahead of his time, suf-fering early what many more African-Americans were to suffer later. Al-though the great majority of the blacks of Duncanson's era had virtually no occasion to know what it was like to pass to the other side of the color gulf, Duncanson made the trip many times, thanks to the lightness of his skin and the prodigiousness of his talent." (Ironically, the formulation of being "ahead of one's time" usually weights toward the positive!) Nevertheless, according to Lubin, Duncanson's "appearance" of equality with whites was

responsible for his psychological anguish. "As a result," Lubin contends, "he was tormented by a double-consciousness not typical for blacks of his period." But, as Lubin declares, double consciousness does become the archetypal state for African Americans: "A generation or so later, black double-consciousness did become typical, according to *The Souls of Black Folk*. In Du Bois's view, African-Americans had become heir to 'a peculiar sensation, this double-consciousness, this sense of always looking at one's self through the eyes of others, of measuring one's soul by the tape of a world that looks on in amused contempt and pity.' As a result, the African-American 'ever feels his twoness, —an American, a Negro; two souls, two thoughts, two unreconciled strivings; two warring ideals in one dark body, whose dogged strength alone keeps it from being torn asunder.' In the end Duncanson was torn asunder, despite his dogged strength." [40] Lubin's study is indeed a discourse on race, grounded in the belief of African American pathology of absolute difference (as black), as if that pathology is merely reconfirmed rather than reinvented. Adolph Reed explains, "As a proposition alleging a generic racial condition—that millions of individuals experience a peculiar form of bifurcated identity, simply by virtue of common racial status—the notion seems preposterous on its face. Yet, the image has become especially popular and evocative among post-segregation era black intellectuals." [41]

With the sentence "A generation or so later, black double-consciousness did become typical, according to *The Souls of Black Folk*," Lubin validates his own, all-encompassing diagnosis of black pathology. As Adolph Reed argues, "Annexation of Du Bois's exalted reputation gives an aura of non-contingent truth to a proposition that might be controversial—that black Americans universally (or even typically) experience bifurcated identity. Noting that Du Bois declaimed on double consciousness at the turn of the century, furthermore, enhances the claim's apparent strength by positing its enduring reality. Thus the references function to circumvent the need for argument and evidence." [42] Or in the case of Lubin, the evidence rests on a few statements made by Duncanson and on nineteenth-century racialist writings. The popularity and hence longevity of what is actually a rhetorical trope relies on an essentialist reading of race, sexuality, and gender with the simultaneous reification of dominant/white/American/male/heterosexual identity as separate and pure. For scholars who use double consciousness as an analytical tool in the study of visual culture

and who find it a viable explanation of artistic intention, the assumption is that within a work of art resides not only artistic identity but also evidence of "two-ness," a two-ness that encompasses as it reflects both margin and center within the body of the artist—race made visible and coherent in the art work. As Reed avows, "They presume an unchanging black essence and do not consider the possibility that Du Bois's construction bears the marks of historically specific discursive patterns, debates, and objectives. That blindness, moreover, underlies the tendency to treat Du Bois's text as clear fact and conceals from its appropriators their own historical and discursive contingency."[43] Unfortunately, art history continues to find double consciousness an appealing explanation because it continues to rely on the visuality, "coherence," legibility, and fiction of race.[44]

Lubin's Sentimental Form

The model for Lubin's discussion of Duncanson can be found in the nineteenth-century sentimental narrative as outlined by Philip Fisher in *Hard Facts: Setting and Form in the American Novel.* The cult of sentiment provided the rationale and rhetoric for the abolitionist movement, and Lubin, in his exploration of Duncanson, both elucidates and unintentionally recreates the abolitionist context in which Duncanson worked. Abolitionism, using sentiment as a tool of cultural colonization, sought to inculcate white middle-class values as the norm by extending its domestic agenda into social institutions such as the interracial boarding school and the church. As a result of his liberalism and his racialism, Lubin reproduces in his text the two overarching conditions for the interlarded tropes of sentiment and abolitionism. First, Lubin establishes an emotional connection between white knowing subject and black known object. Second, Lubin uses what I would characterize as "sentimental art history" to make central an uninflected, noncontingent "whiteness" as the cultural norm of "America."

Lubin's method is much like other works of nineteenth-century sentimentality in that he uses himself as a conduit to establish an emotional connection between the reader (assumed to be white) and the object of sentiment (who is other—sometimes a child, prisoner, woman, madman, animal, or black/slave). Lubin comments in his introduction, "I have tried to empathize with the artist I write about, tried to understand what made them live and paint as they did. I have tried also to empathize with their

contemporaries, even when their politics or aesthetics run counter to my own. And I have tried to empathize, if that is the right word, with my reader."[45] In Lubin's attempt to create Duncanson as a new hero for art history, his program matches closely the sentimental novel. Fisher notes, "The presence of sentimentality is most obvious at precisely those places where an essential extension of the subject matter of the novel itself is taking place. Just where new materials, new components of the self, new types of heroes and heroines, new subjects of mood and feeling occur: at exactly those places will the presence of sentimentality be most marked."[46]

Lubin, perhaps unintentionally, reiterates the racialism of the nineteenth century when he identifies in Duncanson's landscapes more "feeling" than in those of his white counterparts. He reproduces the dichotomy of racial traits specific to whites and those specific to blacks: whites inhabited the realm of the abstract, objective and objectifying, rational, cold, and without feeling; while blacks, women, and children inhabited the opposite sphere, subjective, instinctual, without reason, all feeling and emotion. This dichotomy extends to Lubin's larger narrative, as stated above, in his treatment of Harnett (a white male artist) and Spencer (a woman). Lubin explains his shifts as predicated on the works of the individual artists, as if those works register and read the same to all observers. With such assumed transparency of style, Lubin defends his "cool" tone as a mirror of Harnett's "cool" art. (On a side note, how one can describe the representation of animals killed by the absent hunters in Harnett's paintings as "passionless" eludes me.)[47]

Nevertheless, such extensions of the (white) self are not without risk, as Fisher illustrates. "Like the Romance of Consciousness which I have identified as the modern historical form, the Sentimental Novel depends upon experimental, even dangerous, extensions of the self of the reader. It is, therefore, not realistic." In the realm of the unrealistic, recall Lubin's invention of a white father for Duncanson. Fisher continues,

Unlike the modern form it draws on novel *objects* of feeling rather than novel feelings. As its center is the experimental extension of normality, that is, of normal states of primary feeling to people from whom they have been previously withheld. It involves the experimental lending out of normality [Duncanson's alleged desire to be white] rather than the experimental borrowing of abnormality as in the modern form. This experimental loaning out of normality assumes that nor-

mality—full human normality—is itself a prized possession and not yet an object of boredom and contempt, as normality is in the modern Romance of Consciousness. Sentimentality is, therefore, a romance of the object rather than a romance of the subject.[48]

Even as Lubin extends to Duncanson the right to feel and to feelings, those emotions are restricted to Duncanson's need to feel, to perform, to be white through his paintings. There is really, then, no risk to the reader. For Lubin, Duncanson is indeed an *object* of feeling, the prop used to convey the correctness of white middle-class values.

Finally, like the focus of sentimental narratives, Lubin is inordinately concerned with the family. But it is a family of Lubin's invention, which excludes (the real) father, mother, siblings, and uncles, all of the extended family and friends in favor of a mythical white father with whom Duncanson longs to reunite. Fisher observes,

By means of the family, the sentimental novel argues first of all for the reality, strength, and priority of an emotional life not based on sexual passion. It is not the relations between men and women that are its central reality . . . but the relation of a parent to a child. Such relations were asymmetrical, tender rather than passionate, helpful rather than experiential. They are the fundamental social example of compassion: that is, of the correct moral relation of the strong to the weak. The political importance of the family for the sentimental novel's version of history lies in the fact that throughout human history the family is the only social model for the relations between non-equal members of a society.[49]

In setting Duncanson up as the perpetual child to the white father, and by extending to all of African American society Duncanson's desire to reunite with the white father, Lubin constructs black culture as the child of white culture.[50] Lubin makes the relationship paternal rather than one of force or coercion, using the terms *father* and *master* interchangeably. Lubin re-represents the "Negro Problem," though ostensibly from the perspective of its object, but only to strip Duncanson of his agency, or redirect his passion, toward the (re)union with the white father. Duncanson's art, therefore, is an impotent testimony to the impossibility of the union, or merging, of the two separate cultures. Fisher relates, "In sentimental narrative the work of art itself is the solemn memorial to the ruin, and the ruin is itself an inverse monument: a witness to human failure rather than to human glory or ac-

complishment." Lubin's role is as a witness to Duncanson's failure—failure as an artist, as a man, as a human being. "The melancholy of ruins, whether human or inanimate, depends upon the presence of the witness for whom the stories of suffering and of the failure to survive, stories that because they are deep in the past invite no compensation and provide no hope of redress, offer, instead, training in pure feeling and response."[51] Tragically, Duncanson's achievements are only important insofar as they are the training ground for Lubin's empathy.

Reading Lewis and the "Autobiological"

Unlike Duncanson, Lewis did provide the black (and Indian) subject for her critics, allowing for tautological readings of her work-as-identity. The rhetoric of authenticity is thoroughly normalized in discussions about Lewis. Such readings of her as authentic, of Lewis as her own object (the real thing), are seamless and for that reason have occluded more reliable interpretations of her art. Intrinsic to any discussion of Lewis and Duncanson is biography, especially the kind of psychobiography indulged in by Lubin and Ketner. In Lewis's case, biography serves to reiterate the subject matter of her art, whereas in Duncanson's case, biography fills the vacuum left by the "absence" of black subject matter. Etymologically, the root *bio* signifies life, of living things, biological. I contend that there is a double thread woven through narratives such as Lubin's and Ketner's, that of biography (the writing of a life) and biology (racial essentialism and biological determinism). Mired in biography, the scholarship on African American artists has lagged behind the advances made in the field of gender studies, which critically focuses on the work of European and European American women.[52] Tamar Garb has written persuasively on the artist Berthe Morisot (1841–95) and the "feminizing of Impressionism." In the language employed during the nineteenth century, Garb uncovered a tautology that served to merge Morisot to impressionist technique. In the 1890s, male critics interpreted impressionism's concern with surfaces and its nervous excitability as extensions of female nature and thus "natural" for women to practice. In their critical reevaluation of the old style of painting, "the language of form and the language of sexual difference mutually inflect one another, creating a naturalized metaphoric discourse that operates on the level of common sense in late nineteenth-century parlance."[53] It was generally believed that gender difference was essentially constituted, and

because women were biologically different they naturally *saw* differently from men. Morisot's "true femininity," Garb continued, "was seen to lie in her manner of perceiving and recording the world . . . To function ideologically, Morisot's adherence to a particular set of pictorial practices had to be viewed as an unconscious and happy expression of self and sex."[54]

Leila Kinney, writing on Morisot, and Deborah Cherry writing about feminine spectatorship, propose an alternative — an escape from tautology and essentialism — that is germane to my study of Lewis. Kinney argues that "the feminine is neither a floating abstraction nor a congenital endowment; rather it is shaped and formulated in dialogue with social mores and through the institution of the family."[55] Kinney investigated Morisot's letters and statements about herself in order to probe the artist's awareness of context within "a psychic and social constellation of acceptance and resistance to contemporary expectations."[56] Cherry expanded the possibilities for thinking about the multiple positions from which even one woman can look, positing "vision [as] a social and cultural activity framed by and taking place within the broader field of power relations which were not polarised but a tense and unstable web of interrelated and productive forces."[57] Finally, Kinney's statement about Morisot's art perhaps best expresses what I wish to say about Lewis: "There is in these various pictures no one position that Morisot as some unified self might occupy; rather they represent a set of alternatives and contradictions that mark the limits of expectation and possibility."[58] Therefore, what does it mean to propose "culture as the solution rather than tautology as the method" of investigating Lewis's art production? What *were* those webs of significance in which Lewis was suspended? What was *her* "problem"?

As it relates to U.S. culture, the word *problem* is loaded, and in conjunction with my study, multivalent, in the sense that the art historian Michael Baxandall provides an alternative way of thinking about it — as an integral part of artistic intention and broken down into two stages, "Charge" and "Brief." Baxandall proposes, "Historical objects may be explained by treating them as *solutions* to *problems* in *situations*, and by reconstructing a rational relationship between these three."[59] In order to understand why her objects appear the way that they do, one must begin by contextualizing Lewis's work within the technical and ideological parameters of neoclassical sculpture and the culture of sentiment in mid-nineteenth-century Europe and the United States. Lewis, who so readily supplied the racialized

subject that enables a tautological reading, compounds the ways in which art history consistently misrepresents women (of all colors) and artists of color (across gender). The mistake has been to use her racialized subjects as evidence of autobiography and the "autobiological." In such interpretations, race-as-power supplants culture-as-context. The question, then, is how does Lewis take on the problems that she set for herself . . . while being a "problem"? As I have shown in this section and as I will demonstrate in subsequent sections dealing with the art historical discourse on black and Indian subjects, one can also speak of the intentionality of art historians, Lewis's interpreters.

SLAVERY WORKS: EMBODYING THE BLACK SUBJECT

Edmonia Lewis created her ideal sculpture in the context of nineteenth-century American neoclassicism. The subjects for her ideal work were taken from history, the Bible, and American literature, and the finished pieces were wrought in gleaming white marble. Lewis chose for her ideal sculpture women who conformed, across the barriers of race, to the gender ideals of her time, which were largely informed by the culture of sentiment. As Karen Halttunen argues, "'Sentimentalism' defined nineteenth-century middle-class culture in the broadest sense of the term: not simply as a body of literature or as a lofty ideal of personal conduct, but as a set of assumptions that determined, for example, what kind of bonnet a woman should wear, when a man should remove his glove to shake hands, and how men and women should shed tears over their dead."[60] If, as in the case of Hagar, Lewis's subjects could not conform, it was because racialism, racism, and sexual victimization frustrated their attempts to do so. In the nineteenth century, from the 1830s, when women entered the struggle over Native American and African American rights, to the early twentieth century, the culture of sentiment was pervasive in literature.[61] Sentiment was not, however, as long-lived in the visual arts, beginning in the 1840s and reaching its peak in 1876, before tapering off as the generation of sculptors living and working in Italy passed into obscurity.

In literature, women dominated the discourse of sentimentality. As the literary critic Jane Tompkins asserts, the sentimental novel was written primarily "by, for, and about women." Tompkins interprets it as a "political enterprise, halfway between sermon and social theory, that both codifies

and attempts to mold the values of its time."[62] The sentimental novel was a bid for power by women, who posited "the kingdom of heaven on earth as a world over which women exercise ultimate control."[63] If women dominated the literature of sentiment, then men dictated its visualization in sculpture. In the nineteenth century, art, allegory, and genius were male provinces, but the cultural saturation in sentiment spawned many more statues of women as allegorical figures than of men. This saturation also eased the way for an unheralded community of women artists, living and working abroad, who attempted to accomplish in stone what their sisters had in literature.

Despite the influence of her education, in many ways Lewis did not conform well to the gender ideals that Victorian culture supported. Personally, she was opposite everything that Victorian culture defined as the "true woman," who was heralded as pious, submissive, domestic, and obedient. Her clothes, her lack of marriage, her decision to sculpt, all appear to have gone against such conventions as I have enumerated here. One newspaper described her in this way: "Miss Lewis, the colored American sculptress in Rome, is short, stout and rather fine looking. Her hair, which is slightly curly, is parted on the side and cut short. She dresses in a short black skirt and roundabout jacket, and wide rolling collar. Her appearance is masculine and her voice hard and gruff."[64] However, her decision to dress oddly, not to marry, and to sculpt, were all choices that did not really distinguish Lewis from the other women sculptors who had preceded her to Rome, women such as Harriet Hosmer, Anne Whitney, and Louisa Lander.

Additionally, Lewis refused to represent her subjects with the degree of "ideal realism" later scholars might have wished. Twentieth- and twenty-first-century scholars have long been puzzled by the paradox in Lewis's art, by the fact that the women of her ideal works do not "look African" or "look Indian." Their long, straight hair, their keen, European features, the white marble of their "skins" all belie the subject matter, from the representation of Minnehaha to Hagar to the woman in *Forever Free* and, one assumes, to the woman in Lewis's first ideal work (now lost), *The Freedwoman on First Hearing of Her Liberty*. By providing contextualized readings of *Forever Free*, Hagar, Hiawatha, and Cleopatra and by probing earlier scholarship on Lewis, I open up meanings contemporaneous to both Lewis and the objects themselves.

The Freedman and the Freedwoman

Completed in Rome in 1867, *Forever Free* was the third documented ideal work that Lewis made in Europe (plate 2). Fashioned four years after the Emancipation Proclamation of January 1, 1863, it was also Lewis's second contribution to the celebration of liberty. Lewis originally titled the sculpture *The Morning of Liberty*, but inscribed on the front of its base are the words "Forever Free" from the text of the Emancipation Proclamation.[65] Evidence suggests, however, that she began modeling the figure in 1866, soon after the ratification in 1865 of the thirteenth amendment to the Constitution, which abolished slavery. Initially, she intended for the sculpture to be purchased by subscription and then to present it herself to William Lloyd Garrison. For reasons unknown, Lewis was never able to dedicate the sculpture to Garrison, but she did find another great man to honor: Reverend Leonard A. Grimes, the person to whom the sculpture was ultimately dedicated. *Forever Free* was a gesture of thanks, an acknowledgment of great work done on behalf of her people.[66] The statue also acknowledges the continuing importance of the new holiday. From 1864 to almost a century later, African Americans honored January 1 as Emancipation Day, as Independence Day, or as Natal Day (the day that they were reborn as true citizens of the United States).[67]

Standing at a little over three feet, the statue represents a two-figure group of a man and a woman at the very moment of liberty. The woman is dressed in a simple, belted shift. She kneels on one knee and her clasped hands are lifted; and with head tilted and chin raised, she gazes upward. Her long hair is without curl, flowing from a center part, and viewed in profile, her nose is straight. Around her left ankle is a manacle and chain that seems to bind her to the base of the statue. At her side stands a man dressed only in soft-looking cloth shorts. His chest and feet are bare. He stands in a classic contrapposto, while under his left heel is an abandoned ball and chain. His left arm is raised and a manacle encircles the left wrist. In his left hand is the broken manacle and chain from his right wrist, while his freed right hand rests on the right shoulder of the woman, who leans against his right leg. He, too, gazes upward. His hair is a tight cap of curls.

Formal analysis of *Forever Free* supports the figures being read as a unit, rather than in opposition. Together, they form a compact silhouette made up of a series of discrete triangles, beginning with the horizontal triangle

formed by his upraised arm and his right shoulder. The motif is continued with the vertical triangle created by his head at the apex and widening to encompass his bent left leg and his female companion. The overall triangulation of the figures is reinforced and echoed by the pyramidal shape of the female. Within the composition itself, their bodies are in perfect harmony in spite of the fact that she kneels and he stands, that she is chained and he is not. There is parity in their gazes, while the tilt of their heads, his to the right and hers to the left, creates a sense of intimacy that is heightened by his touch on her shoulder. Despite the separate chains that bind them, the pair exhibits, through the rhythms of the individual bodies, the indivisible "bonds" of their commitment to one another. Tellingly, the man's freedom comes first, because until he is free to establish a black patriarchy, the woman remains vulnerable to the specter of sexual exploitation by white men.

For twentieth- and twenty-first-century scholars, the first, most consistently noticed element in Edmonia Lewis's *Forever Free* is the gesture of the raised arm. Second, the relative positions of male to female are usually remarked as reinforcing gendered stereotypes of male "aggression" and female "passivity." Third, the relative ethnicity of the figures remains problematic for contemporary viewers. Most often the relative ethnicity is either a stated paradox that is left unexplained or sometimes it is used to indict Lewis herself.[68] In 1980, Jacqueline Fonvielle-Bontemps wrote that Lewis "never sculpted a black figure, though many of her statues dealt with racial or sexual repression as a theme. She glorified abolition as a movement and individual abolitionists, but not black people . . . her friends were all white."[69] In 1989, Jean Fagan Yellin included the sculpture in her admirable study of antislavery feminists. In *Women and Sisters: The Antislavery Feminists in American Culture*, Yellin begins her description of the statue by noting the antithetical positions of male and female. She interprets the male's hand as resting "protectively" on the woman's shoulder, while his other hand is raised triumphantly.[70]

Depending on the scholar, the black male's hand that rests on the shoulder of his female companion tends to be interpreted as either safeguarding or as autocratic. Albert Boime, in *The Art of Exclusion*, reads the gesture as dictatorial. Like Yellin, he interprets the relative positions of the male and female as occupying dominant and subordinate sites respectively on the power scale. Therefore, the black woman is interpreted as submissive

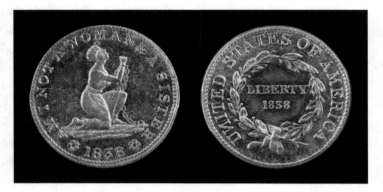

2 "Am I Not a Woman and a Sister?," Antislavery token, America, 1838. Copper,
1⅛ inch. The Colonial Williamsburg Foundation, Williamsburg, Virginia.
Accession #1999-213, image #R2004-4853.

and dependent. However, Boime is untroubled by any ethnic difference
between female and male, while, contrary to Yellin's reading, he interprets
the male as placing his hand "condescendingly" on the woman's shoulder.[71]
Despite differing interpretations of the touch, for both scholars the issue
is male agency in the face of female passivity. The interpretation of male/
active and female/passive is reiterated in a later essay by Francis K. Pohl,
who explains the group in the following manner: "The subservient posi-
tion of the woman in 'Forever Free' may have been a subtle commentary on
the struggles that lay ahead for African-American women within their own
community."[72] Finally, Marilyn Richardson, Lewis's biographer, interprets
the sculpture in a similar vein. Richardson contends, "The kneeling woman
in *Forever Free*, a work executed some years after emancipation, deftly sug-
gests the continuing subjugation of black women in various spheres of do-
mestic and public life. Her supplicating posture, which recapitulates the
anti-slavery feminist emblem inscribed 'Am I Not a Woman and a Sister?,'
posits a possibly ironic intention in the title of the piece" (figure 2).[73]

 As described by these four scholars, *Forever Free* is a visual testament
to the war of the sexes that condemns the black woman to fourth place
behind the white man and white woman and behind the black man. The
temptation to look at *Forever Free* from the point of view of recent devel-
opments in the areas of race and gender studies is wholly understandable,
but we must not let such thinking blind us to the aspirations of nineteenth-

century African Americans. Claudia Tate, in her article "Allegories of Black Female Desire; or, Rereading Nineteenth-Century Sentimental Narratives of Black Female Authority," notes,

The two modernist allegories of desire, one black male-centered [Richard Wright's *Black Boy*] and the other black female-centered [Zora Neale Hurston's *Their Eyes Were Watching God*], characterize marriage and freedom as antithetical. Marriage, in these two texts, mediates desire with promises of matrimonial bliss and respectability, as well as disavows individual subjectivity and, indeed, compromises individual freedom. These are the beliefs that we largely share and are likely to bring to Afro-American texts that depict marriage because, given our postmodernist conditioning, the subject of marriage signals its opposite — (unmarried) freedom — and because the genesis and general preoccupation for black literature places those texts automatically in a discourse on freedom. Thus, when we read texts that not only focus on marriage but privilege that institution as well, as in the case of nineteenth-century black women's sentimental fiction, we are likely to find ourselves conforming to patterns of value formation dictated by our historical moment rather than historicizing the texts and couching our readings in the black cultural ethos for the nineteenth century.[74]

I contend that we have similar patterns for reading as well as for viewing, and so when we look at Lewis's sculpture we interpret it according to our own understandings of the meaning of gender roles and their attendant ideologies. Thus description, the third element of Baxandall's "triangle of reenactment," fails. Contrary to the most current interpretations of the sculpture, I propose that the statue is not a feminist statement by Lewis about the dual burdens of sexism and racism that the black woman in America was forced to bear.

In fact, nineteenth-century interpretations of *Forever Free* differ greatly from those generated during the late twentieth century and early twenty-first. For the audience of the nineteenth century, Lewis had composed a work that speaks strongly to the solidarity between African American men and women, and that solidarity was at the expense of expanded rights for women. In order to participate fully in the culture of the United States, African American men and women had to adhere to the dominant gender conventions, and thus submission by black women was a necessity. As Tate demonstrates, "Nineteenth-century people, white and black, were well aware of the social ethos for their period. They staunchly sanctioned civil

marriage as the vehicle for promoting family stability, social progress, and respectability; indeed, marriage was the sign of civilization. Black people, in particular, regarded marriage as an important index of their propensity for civilization and as uncontestable evidence for their moral commitment to social progress. In fact, many advocates for racial justice referred to the high marriage statistics for ex-slaves to counter popular argument about the decline in morality among the newly freed blacks."[75] All women were destined to lose any bid for equality under the cult of sentiment. I concur with Shirley Yee's argument that the irony in "constructing a life that truly reflected 'freedom' meant adopting many of the values of white society, in part symbolized by male dominance and female subordination. This model, however racist, sexist, and classist, prevailed in American society and became an important symbol of freedom to many black men and women."[76] Marriage was a way for African Americans to prove that they too could form stable and healthy families and communities. Indeed, not only does *Forever Free* conform to certain gender expectations of the nineteenth century but also it presents a reconstructed image of the African American family after slavery and becomes a subtle commentary on the hopes for the newly liberated population.

To the extent that gender conventions for free blacks in Victorian America tended to reflect the dominant culture's expectations of male and female pattern behavior, there is a connection between Lewis's freedwoman and women who were not of African descent. Furthermore, throughout the literature of the nineteenth century, the cult of true womanhood also existed as a set of prescriptives for the African American female. Barbara Welter clarified the four qualities that define the true woman in a groundbreaking essay published in 1966. The African American female, like her white counterpart, was expected to be domestic, submissive, pious, and virtuous.[77] As the historian Judith Sealander has shown, before the Civil War the African American press employed such images of what a woman should be to protest the constant violation of woman's "true" nature under slavery. The enslaved African American woman lived in the midst of a paradox, for as an ideal woman, she was "a soothing helpmate to her husband. She might also be ... wily and physically courageous ... able to murder her master, hide out in swamps, and ford rivers."[78]

African Americans were forced to deploy the ideology of the dominant culture to protest their treatment under the system; their use of senti-

mentality formed an effective social critique. Ironically, therefore, African Americans reified and validated white, middle-class life as the norm even as they critically assessed it. In a sensitive analysis of gender conventions, James Oliver Horton states, "During the nineteenth century, as now, Black liberation was often defined in terms of the ability of Black women and men to become full participants in American life. Ironically, this not only meant the acquisition of citizenship rights, almost all of which were applied only to men, but also entailed an obligation to live out the gender ideals of American patriarchal society . . . All women were expected to defer to men, but for Black women deference was a racial imperative."[79] Thus, *Forever Free* represents conformity to gender ideals of the time. With emancipation, former slaves could marry and recreate their realities to reflect the norm. If we reexamine Lewis's statue as a representation of the birth of a "family" after slavery, the woman that Lewis depicts reflects every quality ascribed to the "True Woman." The freedwoman's posture is the embodiment of "submission" and "piety" that by implication make her a virtuous woman.

In 1867, there was no established iconography for freedwomen — nor would there ever really be one.[80] The model Lewis relied on was the modified Wedgwood medallion (1789). Josiah Wedgwood's representation of a kneeling male figure, around whom the inscription reads, "Am I Not a Man and a Brother?" was replaced with a woman for the first time in 1826. Published in the Ladies Negro's Friend Society of Birmingham, England, it bore the adjusted legend "Am I Not a Woman and a Sister?"[81] By the 1830s, the image had become the abolitionists' weapon of choice, resulting in pincushions, tokens, and other ephemera bearing the image of the kneeling slave and the all-important caption. The emblem was a direct appeal to white women for empathy across racial lines; it was the visual sermon of sentiment that sought to influence, to change, the political landscape. For example, Elizabeth Margaret Chandler urged her (white) readers to "let the fetter be with its wearing weight upon their wrists, as they are driven off like cattle to the market, and the successive strokes of the keen thong fall upon their shoulders till the flesh rises to long welts beneath it, and the spouting blood follows every blow."[82]

Lewis clearly drew inspiration from the emblem for her rendering of her freedwomen. From nineteenth-century descriptions, we can reasonably suppose that the freedwoman in *Forever Free* was perhaps based on the

earlier, lost work *The Freedwoman on First Hearing of Her Liberty* and that
both were adaptations of the abolitionist emblem. Moreover, Lewis's first
Freedwoman seems to support the family-oriented reading of *Forever Free*.
We can guess what the first sculpture looked like from descriptions that
have come down to us. In 1866, Henry Wreford, columnist for the Boston
journal *Athenæum*, described Lewis's first ideal work thus: "She has thrown
herself to her knees, and, with clasped hands and uplifted eyes, she blesses
God for her redemption. Her boy, ignorant of the cause of her agitation,
hangs over her knees and clings to her waist. She wears the turban which
was used when at work. Around her wrists are the half-broken manacles,
and the chain lies on the ground still attached to a large ball. 'Yes,' [Lewis]
observed, 'so was my race treated in the market and elsewhere.'"[83] In her
first, recorded ideal group, Lewis chose to depict what is perhaps the oldest
personification of family in all of Western art: mother and child. Within
the cult of true womanhood, motherhood was the most valued role that
woman could play within prescribed gender norms. Ann Douglas suggests,
"The cult of motherhood was nearly as sacred in mid-nineteenth-century
America as the belief in some version of democracy. Books on mothers of
famous men ... poured from the presses in the 1840s and 1850s; their mes-
sage was that men achieved greatness because of the instruction and inspi-
ration they received from their mothers."[84] With the end of slavery, true
motherhood was now a possibility for black women. Black mothers would
no longer be torn from their children by the separate sale of parent and
offspring as property to different owners. Both of Lewis's "freedwomen"
are posed in submissive, pious attitudes, grateful, perhaps, for the freedom
to act out normalized gender roles. Both are part of a family.

Within this new family that liberty created, Lewis's sculpture seems to
suggest that the male had a role to fill as well. Like his white counterpart,
he was entrusted with the protection of his family. His stance, and his
raised left arm, which can be interpreted as either triumphant or aggres-
sive, signifies potential. The ability to protect is inherent in his figure and it
is a marker for his new status as the head of a family. For African American
men, Horton observes, "the ability to support and protect their women
became synonymous with manhood and manhood became synonymous
with freedom. Often slaves demanding their freedom used the term 'man-
hood rights.' Manhood and freedom were tied to personal power."[85] The
historian Elsa Barkley Brown further refines the relationship of African

Americans to the cult of true womanhood by emphasizing the sense of col-
lective freedom gained by black male suffrage and by showing that until the
black woman could truly attain equality, the black male was entrusted to
work in her best interests as well. Furthermore, Brown writes, for African
American women "the question was not an abstract notion of individual
gender equality but rather one of community. That such a vision might
become over time a lead into a patriarchal conception of gender roles is
not a reason to dismiss the equity of its inception."[86] If we read Lewis's
work as a unit instead of as a reflection of opposing forces—domination
vs. subordination or man vs. woman—we see that, as Yellin intimated, the
black male's hand rests protectively on the woman's shoulder. No longer is
she the white man's property. In terms of gender ideals of the nineteenth
century, woman belongs to the man who has the capacity to protect her.
Significantly, it is with the freed right hand that the newly liberated slave
grasps his mate, while with his left heel he rests his weight on the ball and
chain that once restrained him.[87]

There is no evidence in the work itself that Lewis was critical of their
relationship or commenting on female oppression. Nor did the viewing
public perceive it in this way. At the time of its dedication, *Forever Free*
was removed from its temporary exhibition site at the gallery of Childs and
Company to Tremont Temple. During the nineteenth century it was quite
common to have exhibitions devoted to single works of art. By October
18, 1869, Lewis had returned to Boston to attend the dedication of the
sculpture. That evening at seven thirty, for an admission fee of twenty-five
cents, the public was invited to the ceremony in which the statue was for-
mally presented to the Reverend Leonard A. Grimes, a prominent aboli-
tionist minister. William Wells Brown, a speaker present at the dedication
ceremony, included a biographical sketch of Grimes in his book *The Black
Man, His Antecedents, His Genius, and His Achievements*. According to
Brown, Reverend L. A. Grimes was born a free person of African descent
in Leesburg, Virginia, in the year 1815. He was an entrepreneur and a Bap-
tist minister. Furthermore, he dedicated his life to helping in the Under-
ground Railroad and providing sanctuary for runaway slaves. As the sketch
reveals, Reverend Grimes was particularly known for his work in reuniting
families torn apart by enslavement.[88] Therefore, Lewis's sculpture is a fit-
ting tribute to a man who actively sought to establish an African American
patriarchy among those who were not born free.

The dedication was a carefully staged event that included singing and, according to one newspaper account, a "colored performer" who played the organ.[89] Prominent male abolitionists, both white and black, were featured speakers — the reverends J. D. Fulton and R. C. Waterston, William Lloyd Garrison, William Craft, and William Wells Brown.[90] A description of the event survives in the work of Phebe Hanaford (1829–1921), the first woman ordained in New England in the Universalist Church and the first woman to serve as chaplain in a state legislature. In addition to her activity in the temperance movement and the suffrage movement, Hanaford was also a writer of inspirational fiction, biographies, and light verse. In 1882, Hanaford published the expanded edition of her book *Women of the Century* under the title of *Daughters of America*.[91] Originally written for the centennial celebration, the work was a series of short biographies of American women lawyers, reformers, actresses, and artists. Hanaford excerpted the description of *Forever Free* from an earlier article about Lewis written by Elizabeth Palmer Peabody for the *Christian Register* around 1869.[92] Peabody reported, "All who were present at Tremont Temple on the Monday evening of the presentation to Rev. Mr. Grimes of the marble group 'Forever Free,' executed by Miss Edmonia Lewis, must have been deeply interested. No one, not born subject to the 'Cotton King,' could look upon this piece of sculpture without profound emotion. The noble figure of the man, his very muscles seeming to swell with gratitude; the expression of the right now to protect, with which he throws his arm around his kneeling wife; the 'Praise de Lord' hovering on their lips; the broken chain, — all so instinct with life, telling in the very poetry of stone the story of the last ten years."[93] For all present at Tremont Temple that evening, *Forever Free* represented a fine and appropriate testament to what abolitionists had been arguing for across so many years — the integrity of the black family. Albeit they argued for a black family based on gendered norms found in the dominant community, norms which some white abolitionists rejected for themselves, especially those women who spoke publicly and their husbands who overlooked such shocking behavior.[94] Nevertheless, both white and black abolitionists viewed slavery as an assault on patriarchy, as perverting biologically determined male and female functions within society. They believed that slavery "degendered" slaves.[95]

Even though it postdates emancipation by almost four years, Lewis's work is revolutionary primarily because it memorialized in three di-

mensions what Harriet Beecher Stowe accomplished in print. Meant to build a bridge of empathy between white and black women, Stowe published *Uncle Tom's Cabin* in 1852, the first international bestseller. It asked middle-class white women to put themselves in the place of black women who were forced to watch their children stolen from them by the brutal masters who enslaved them.[96] As the historian Arthur Riss has shown, pro-slavery advocates posited slavery as the ideal social system because it was in essence a family, based on a system of white male patriarchy. It was a "domestic" issue, inseparable from devotion to the family, so that those who attacked slavery attacked the family. In her novel, Stowe argued that the only real families were biological families. "Thus, slavery (was) dangerous precisely because it (substituted) imaginary families for real families and (attempted) to replace actual, substantive kinship with metaphorical and inauthentic forms of kinship."[97] Like Stowe, Lewis made emancipation an issue of a "true, biological family unit."[98]

As Reverend Grimes and the other abolitionists believed, the abolition of slavery would set male and female roles to rights. For white abolitionists, however, there were limits. The clue to those limits is how Elizabeth Peabody chose to interpret the gesture in the *Christian Register*. The potential expressed in the male figure's upraised arm was neutralized within one paradoxical phrase: that of "muscles" seeming to "swell" with "gratitude." I propose that whites' fear of black male physicality, which represented violence, emerges as an uncomfortable subtext in the description of the sculpture; the black male's "muscles" will swell, or fill with adrenaline, not for revenge but for thankfulness.[99] This is further alluded to by the reviewer's ventriloquism in which the figures are made to say in the vernacular "Praise de Lord." By implication, the black male's piety, in particular, will constrain any violent tendencies. The quality of "piety" for an African American male was a code word of some complexity in the nineteenth century. It could refer to the trope of the infantile (as opposed to the savage) black man, innocent and demasculinized; it could also refer to the race as a whole. In Harriet Beecher Stowe's view, blacks were "natural" Christians as proved by their grace under slavery. As a race, females and males were "feminine" because they were characterized by the fluid virtues ascribed to the true woman, namely, piety and submission. Thus, the "piety" ascribed to Lewis's male figure poses some interesting problems with regard to masculinity.[100]

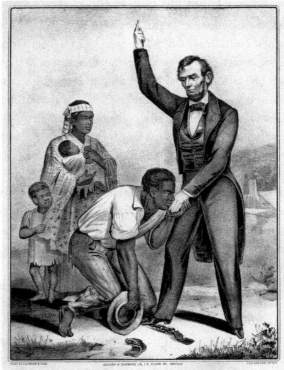

FREEDOM TO THE SLAVES
Proclaimed January 1st 1863, by ABRAHAM LINCOLN, President of the United States.
"Proclaim liberty throughout All the land unto All the inhabitants thereof." ___ LEV XXV. 10

3 Currier and Ives, *Freedom to the Slaves*, 1863. Lithograph, 16 × 11⅝
inches. Indiana Historical Society, Indianapolis, Indiana. Jack Smith
Lincoln Graphics Collection, P 0406.

Among Americans and Europeans, black emancipation was popularly
represented as male-gendered. Yet the physicality of the black male, and
the notoriety in the press about uprisings led by men, fostered the paranoia
about black male aggression, despite repeated attempts (including Stowe's
book) to make that male passive and feminine. Indeed, when emancipation
was represented as an issue of family, in, for example, the Currier and Ives
lithograph *Freedom to the Slaves*, the black male is still depicted as a passive
and grateful recipient of freedom — situated below even the black woman
and child — as he kneels in obeisance to kiss Lincoln's hand (figure 3).
Lewis's depiction of freedom is distinct from both the lithograph and
Thomas Ball's *Freedmen's Memorial to Lincoln* modeled in 1866, placed in

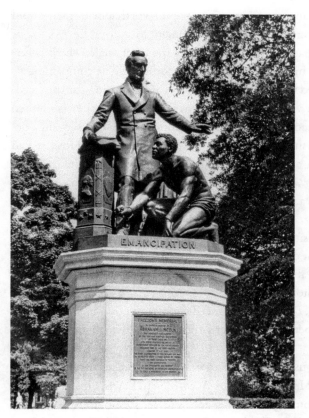

4 Thomas Ball, *Freedmen's Memorial to Lincoln*, 1876. Sculpture: bronze, height 12 feet; base:
 granite, height 12 feet. Lincoln Park, Washington, D.C. Prints and Photographs Division,
 Courtesy of the Library of Congress, Washington, D.C. Digital File cph 3a 46164.

1875 (figure 4). Ball's monument, located in Lincoln Park in Washington,
D.C., depicts a standing Lincoln, who, with a sweeping gesture of his left
hand, frees the kneeling and chained black man at his feet. Unlike Ball,
who has portrayed black male freedom as a function of white power, Lewis
has given us a figure in which freedom is translated into an active gesture
on the part of the black man. Relative to Lewis's freedman, Ball has con-
structed a truly passive black male. Nevertheless, Lewis's construction of
black masculinity has its drawbacks: while she divests black male freedom
of its association with white power, her representation plays into stereo-
types of black male violence, as seen in the description of the work in the
Christian Register. After all, abolitionists were well aware that proslavery

advocates' main argument against emancipation was that black men would begin to rape or intermarry with white women. Moreover, Lewis's use of partial nudity emphasizes the physicality of the black male, which is further highlighted by his juxtaposition to his clothed female companion.[101]

Just as Lewis used the abolitionist emblem as inspiration for the freedwoman in *Forever Free*, I have found evidence to suggest that Lewis adopted and adapted her freedman in *Forever Free* from a model of a slave in a design by Harriet Hosmer (plates 2, 7). Like many sculptors, Hosmer had been inspired by the assassination of Abraham Lincoln to begin designing a *Freedmen's Memorial to Lincoln*. The artists knew that Lincoln's assassination would spark a flurry of memorials. Unfortunately, Hosmer's sculpture was never realized, but Lewis could have seen the model in Hosmer's studio during her visit.[102] Frances Pohl astutely noted that Harriet Hosmer "provided Lewis not only with a supportive environment within which to work in Rome, but also with examples of images that addressed the issues of slavery and rebellion."[103] Pohl cites Hosmer's two most famous works of imprisoned women, *Beatrice Cenci* and *Zenobia*, but never makes the more direct connection between Hosmer's and Lewis's emancipation imagery that I suggest here.

History has left us little information about the relationship between Edmonia Lewis and Harriet Hosmer. According to Lewis, Hosmer warmly welcomed her to Rome, granting her access to her studio on April 5, 1866. In an article, Lydia Maria Child quoted from a letter she had received from Lewis: "A Boston lady took me to Miss Hosmer's studio. It would have done your heart good to see what a welcome I received. She took my hand cordially, and said, 'Oh, Miss Lewis, I am glad to see you here!' and then, while she still held my hand, there flowed such a neat little speech from her true lips!"[104] The friendship between Lewis and Hosmer never seemed to develop beyond that first early acquaintance.[105]

Hosmer's plan was for a three-tiered arrangement, with the figure of Lincoln occupying the topmost position and housed within a round "Temple of Fame." In the plaster model of 1866, Lincoln reclined on a tomb, but when the *Art Journal* published an engraving of the revised monument in 1868, he was standing and holding the Emancipation Proclamation. Hosmer felt that Lincoln had two great moments in his administration, the first, emancipation, and the second, the preservation of the Union. Four female figures occupied the next tier and represented the winds of freedom.

Finally, at the four corners of the lowest tier, four statues, all male, were to display the progressive stages of liberation: on the right front, a slave is in the process of being sold; on the right rear, a slave tills the fields; on the left rear, a fugitive slave (or contraband) is in the service of the Union Army guiding and assisting the troops; on the left front, finally having attained "manhood rights," the slave is able to serve as a soldier in the army and fight for his own liberation. Each figure was to be eleven and a half to twelve feet high. The figure that seems to have inspired Lewis is the first slave on the right front of the model. The curly hair, the torso, the cloth shorts, the contrapposto pose: all reappear in Lewis's *Forever Free* and reappear *again* in Lewis's *Central Park Lincoln*. In the Lincoln statue, Lewis has even repeated Hosmer's trope of slave to soldier (plate 3, detail 2).

The attitude of the male embodied in *Forever Free* is what distinguishes him from Hosmer's slave, as Lewis's male figure raises his arm and head in victory. Thus, Lewis appropriated two icons of slavery; she took the female figure from the antislavery token and the humbled slave from Hosmer's design. Combining those elements made available to her by opportunity and access, Lewis transformed the grammar of slavery in order to create a new language that proclaimed freedom. Four months after Lewis's visit to Hosmer's studio in April 1866, Hosmer was exhibiting the first model for her Lincoln monument. Close on her heels, as early as February 1867, Lewis had already completed one sketch of *Forever Free*.[106] For a brief time, and for very different venues, Hosmer and Lewis may have been rivals in a race to complete their respective works.[107] Perhaps this partially explains their abortive relationship.

There is another element of *Forever Free* that further reveals the complexity of Lewis's choices. Her freedwoman wears only the *trappings* of a specific ethnicity, while her earliest portrayal of Minnehaha is consistent with a Europeanized physiognomy clothed as a Native American. And aside from Hagar, whose bonds are allegorical, her African American women wear chains, manacles, and iron balls, while her Native American women wear animal skins, beads, and feathers.

Conversely, in Lewis's works, men consistently signify ethnicity and race. When race is the subject, Lewis uses men as carriers of specific, racial identities. They are the "bearers of meaning." The man in *Forever Free* has the curly hair associated with an African heritage and his features are slightly broader than those of the woman. In her first ideal sculpture, *The*

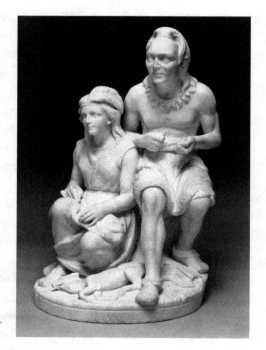

5 Edmonia Lewis, *Old Indian Arrow-maker and His Daughter*, 1872. Marble, 21½ × 13⅝ × 13⅜ inches. Smithsonian American Art Museum, Washington, D.C. Gift of Mr. and Mrs. Norman Robbins.

Freedwoman on First Hearing of Her Liberty, Lewis included the figure of a son clinging to his mother's waist, uncertain of what was happening and what freedom meant. I propose that the son in her first ideal work also bore the symbolic responsibility of a racialized identification with Africa. Moreover, the profile of the old man in the *Old Indian Arrowmaker and His Daughter* of 1872 and Lewis's bust *Hiawatha* of 1868 display the high cheekbones and hooked noses commonly associated with Native American physiognomy (figures 5, 8).

Why did Lewis "whitewash" her black and red female figures? Her decision to obliterate "color," like her positioning of the female figure in relation to the male, was again influenced by the cult of true womanhood, which, as I have argued, crossed all racial boundaries. However, Lewis's decision to "neutralize" (some of) her women (see chapter 3) while racializing the men was a more complex matter than making her heroines acceptable, sympathetic figures to the dominant culture. Her decision, I believe, was a direct result of how Lewis wanted to be perceived as an artist and as a person. Under slavery, as Hazel B. Carby points out, African American

women "gave birth to property and, directly, to capital itself in the form of slaves, and all slaves inherited their status from their mothers."[108] But because she has shed all markers that would identify her as chattel, Lewis's freedwoman in *Forever Free* can no longer be a carrier of property or even of racialist stereotypes. She is indeed "free." The "purging" of blackness was a well-worked theme in antislavery fiction, as Karen Sánchez-Eppler argues: "The very effort to depict goodness in Black involves the obliteration of Blackness."[109] In fact, the tragic mulatta, invented by the white abolitionist Lydia Maria Child, was, according to Carolyn J. Karcher, just white enough to bridge the gap between black and white women.[110] Her very whiteness, moreover, symbolized the "penetration" of her body by the white master. A sympathetic figure, she existed between two worlds but belonged to neither.

Examining the intersection of slavery with the rhetoric surrounding the meaning of "blackness" is one way to interpret Lewis's sculpture, and it provides a likely explanation for Lewis's decision to purge color. By eliminating ethnic identity, Lewis eliminated the stereotype as well. But the question remains as to why she eschewed ethnological models only for her women. If one looks at the nature of the journal articles and interviews with Lewis during the course of her career, it may help to rephrase the question this way: What would Lewis have risked if she had sculpted obviously black or obviously Indian women?

Hagar

Unlike the fulfillment of family in *Forever Free*, Lewis's *Hagar in the Wilderness* (1875) represents the frustration of normalized gender roles within the body of one female figure (plate 8). *Hagar in the Wilderness* also is consistent with two types of subject matter that were very popular with neoclassical artists: biblical heroines and tragic heroines — and the two types were certainly not mutually exclusive. Lewis's Hagar was one in a long list of biblical heroines created by American expatriate sculptors working in Rome.[111] And because Egypt was coded as black Africa among abolitionists in the nineteenth century, Hagar represented a particularly pertinent allegory of chattel slavery and the indignities that black women suffered.[112]

Since the seventeenth century, artists generally have selected one of two dramatic moments in Hagar's story: her banishment by Abraham, or

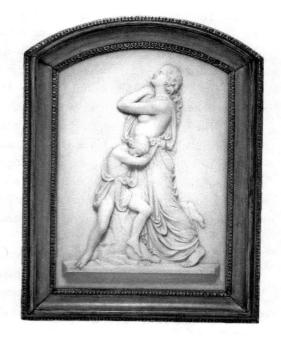

6 Edward Sheffield Bartholomew,
 Hagar and Ishmael, 1856. Marble,
 28 × 19⅝ inches. The Art Insti-
 tute of Chicago, Chicago, Illinois.
 The Roger McCormick and J. Peter
 McCormick Endowments, 1995.38.
 Photography © The Art Institute
 of Chicago.

Hagar and Ishmael in the wilderness. The latter subject was definitely the
most popular with American artists. In the eighteenth and nineteenth cen-
turies, Benjamin West, John Singleton Copley, John Gadsby Chapman,
and Asher B. Durand painted Hagar and Ishmael in the wilderness. Only
one artist working in America, Peter Frederick Rothermel, chose to repre-
sent the banishment of Hagar.[113] However, Hagar was an unusual subject
for American sculptors: their rare sculptural representations of her depict,
as do the paintings, her time in the wilderness.

In 1832, Washington Allston gave the Boston Athenaeum a plaster group
Hagar and Ishmael (now lost) by the sculptor John S. Cogdell. The second
known *Hagar and Ishmael* belongs to the Art Institute of Chicago and is
the work of Edward Sheffield Bartholomew (figure 6). Executed in 1856,
the white marble bas-relief shows a distraught Hagar with Ishmael cling-
ing to her waist. An overturned jug symbolizes her futile search for water.
Lewis's figure of Hagar is remarkably similar to Bartholomew's: both look
up; both are clasping their hands in obvious pleading; both have long, rip-
pling hair and even-featured faces. The obvious difference is that Lewis

realized her work in the round, but when viewed from the profile, it, like Bartholomew's, resembles a standing version of the abolitionist emblem that bears the caption "Am I Not a Woman and a Sister?" Bartholomew established his studio in Rome in 1850 but on the recommendation of his doctors relocated to Naples in 1858, where he died soon thereafter. Bartholomew's career lasted only a decade, and after his death most of the works in his studio were shipped to Hartford, where they became possessions of the Wadsworth Athenæum.[114] It is quite possible that Lewis saw the plaster bas-relief in Connecticut before she left for Europe.

Lewis's figure is unique, however, because of the absence of Ishmael. *Hagar in the Wilderness* displays the rounded, cylindrical modeling so characteristic of Lewis's style. There is a plumpness of limb that is consistent with most of her figural groups. Of her ideal works before *The Death of Cleopatra*, however, *Hagar in the Wilderness* is one of the few given over to a single figure. By leaving out the figure of Ishmael, Lewis's treatment of the subject skillfully manages to allude to each appearance of Hagar in the Bible. The first time that Hagar appears, she becomes pregnant and is perceived by her mistress, Sarah, as making a mockery of Sarah's barrenness. Abraham gives Sarah full authority over Hagar and Sarah deals "harshly with her" (Gen.16:6). As a result, the pregnant Hagar flees into the wilderness where she is comforted by the angel of the Lord near a fountain of water. In this scenario, Lewis has located Hagar's son, Ishmael, in the womb of Hagar while the jug at her feet metaphorically stands for the water near which she is discovered. The angel tells Hagar to return and submit to Sarah. Then, God makes the ninety-year-old Sarah fertile, and she also bears a son, Isaac. When Sarah finds the two boys playing together, she insists that the bondwoman and her son be sent away. Once in the wilderness, they exhaust their water supply and to insure their survival, Hagar is forced to search for water. Because she could not bear to watch her child die of thirst, Hagar placed Ishmael under a shrub (Gen.21:15). Once again, in the midst of her despair, an angel of the Lord met her. In this scenario, Ishmael is "absent" or "hidden" within the wilderness, and Lewis has used the jug to symbolize Hagar's search for water.

Given Lewis's penchant for the two-figure group, one would expect her to have included Ishmael. By absenting him, Lewis made the work less anecdotal, less stagelike, as the characters cannot interact with one another—or, to extend the theatrical metaphor, they cannot play off one

another. Because Ishmael's presence is implied rather than made manifest, the work must depend for its impact on Hagar's expressive emotionalism alone. Also, the casual stance of the contrapposto was unequal to the task of conveying Hagar's emotional trauma. Slender, and beautifully proportioned, Hagar appears to be in motion. Her left leg is planted, while her right leg is bent as if she were indeed wandering through the wilderness. It is in the face, however, that Lewis portrays the drama and pathos of Hagar's situation. During the neoclassical era, the faces of marble, ideal works were as smooth and as blank as masks. Only for portraits, in fact, were pupils drilled into the eyes. Any line marring the brow, then, signified an extreme of emotion. Lewis has creased Hagar's forehead with two vertical lines at her brow and one horizontal line above them. By manipulating the marble in this way, Lewis successfully communicated Hagar's stress and tears, reinforced by the clasped hands. Unlike the clasped hands in *Forever Free*, which symbolize thankfulness, Hagar's clasped hands represent abject pleading as she worries over the life of her son and herself, a true prisoner of the flesh and the world.

The final appearance of Hagar is in the New Testament, where she is invoked as allegory to differentiate between those who are free within the spirit and those who are enslaved by the flesh (Galatians 4:24). Paul writes, "Cast out the bondwoman and her son: for the son of the bondwoman shall not be heir with the son of the freedwoman" (4:30). In Lewis's allegory, Hagar, with the presence of her son implied, represents the despair and dismantling of the African American family under slavery, and it is not a coincidence that a son accompanied Lewis's first freedwoman. Here, Hagar and Ishmael are an allegory of the pathology of the African American family, "pathological" in the sense that under slavery, the African American family signifies the functional manifestations of a disease. That disease is slavery, which is indeed a departure or deviation from a normal condition, that of patriarchy. Where there is no male to protect their interests, the mother and child are disinherited. This was not Lewis's first depiction of Hagar. Another sculpture of the bondwoman, completed in 1870, was exhibited in Chicago that year.[115] It is now lost, but we do have Lewis's comment on it: "I have a strong sympathy for all women who have struggled and suffered. For this reason the Virgin Mary is [also] very dear to me."[116]

Lewis's neoclassical sculpture is an allegorical statement about the abuses

suffered by black women when a black male patriarchy is not in place to protect them. Hagar, like the second *Freedwoman* (and presumably like the first), clasps her hands, but unlike her sisters, Hagar is troubled. Her brow is furrowed. She stands and she is alone, trapped by invisible bonds in slavery. *Hagar in the Wilderness, Forever Free,* and *The Freedwoman on First Hearing of Her Liberty* express themes specific to the plight of African Americans. In terms of *race*, however, Hagar shares with Lewis's freedwoman the straight hair and classically straight and narrow nose that nevertheless dissociates her and the "freedwomen" from a racialized identification with those of African descent. Instead, Lewis masks them as white ethnics. For as her education in ideal womanhood taught her, when measured against the yardstick of the true woman, neither African American nor Native American women could be considered wholly "female."

This brings us back to the absent figure of Ishmael. His very existence, in a nineteenth-century context, would have signified the living embodiment of not only Abraham's transgression but also Hagar's. In an era when women were blamed for inciting the passions of men, Hagar would not have been considered blameless. This raises an interesting question with regard to Lewis's choices in treating the subject. In fact, the sculpture risks narrative illegibility, for without the inscription on the base, one would not know automatically that the figure is Hagar. Ishmael's absence in the composition, his erasure, recasts Hagar as without stain — a Hester Prynne without Pearl. The very real consequence of the adulterous affair in which she was a participant is not there as a visual testimony to her sin. Yet Lewis's Hagar is not without guilt, for aside from the figure's similarity to Bartholomew's Hagar, there is another prototype: Donatello's horrific *St. Mary Magdalene* (1445–55) (plate 9). Carved in wood and gilded, the emaciated figure stands with clasped hands and open mouth, her features strained with grief. The hair shirt that she wears signifies her time in the wilderness, where she went to do penance for her sexual promiscuity. The similarity of Lewis's sculpture to that of Donatello is striking. By depicting a "Penitent Hagar," Lewis has expanded the range of meaning possible in the subject. Here, Hagar has moved beyond victimization and, in the very act of asking for forgiveness, has taken responsibility for her own actions and has claimed for herself a measure of subjectivity not allowed by slavery.

Finally, Hagar's story in the hands of Edmonia Lewis challenges and de-

stabilizes the meaning of Victorian womanhood. By placing Lewis's work in its historical context, we begin to register another dimension of the sentimental, which, as Claudia Tate suggests, was "not merely a code word for describing domestic narratives that moralize about proper male and female spiritual, familial, and social conduct in the conventions of hyperbolic emotionality, but a term that is somewhat misleading for women's texts because they generally appropriate the conventions of sentimentality to mask the heroine's growing self-consciousness, rationality, and ultimately her desire to redefine feminine propriety."[117]

Lewis's Sentimental Form

One can characterize Edmonia Lewis's slavery works by their "distances": the time when they were created relative to the end of slavery; the place where they were created relative to where slavery occurred; even Lewis's own removed experience in that she was never a slave. Nevertheless, those works are interpreted as representing "her people" and even her "self." These indiscernible distances between Lewis and her art have at their core Lewis's position as, what Laura Wexler has called, the "unintended reader" of sentimental texts. Wexler's crucial addition to the Ann Douglas/Jane Tompkins debate about sentiment is a critique of their approach to cultural history as centered in literary history. As Wexler argues, this privileges "white, middle-class, Christian, native-born readers and their texts as the chief source of information about culture."[118] As a result of their narrow focus, Douglas and Tompkins are unable to trace and record the responses of those who were the objects of sentimental feeling—the madmen, the slaves, the children, the lower classes—who became more than the victims of sentimentalism's externalized aggression. The "literary eavesdropping" of these "unintended readers," such as Frederick Douglass and Margaret Fuller, "could lead to stunningly vibrant political insights into the nature of class distinctions, when the unintended reader compared his or her life and even habits of reading to the situation of the reader who was deliberately being addressed." According to Wexler, "By this term I mean to identify readers who were *not* the ones that sentimental authors, publishers, critical spokesmen, or the nascent advertising industry had in mind. They were readers who read material not intended for their eyes and were affected by the print culture in ways that could not be anticipated,

and were ungovernable by the socioemotional codes being set forth within the community-making forces that literature set in motion."[119]

Lewis registered her response to sentimentalism in her sculptures, but as I argue, she kept herself on the periphery — at a distance — from what she chose as her subject matter. She took for herself the position usually assigned to the white knowing subject, and the discomfort and dissonance that this causes, I believe, accounts for the misinterpretation of her work. On the one hand, she rejected the signs of sentimental femininity in her daily life — in her performances as artist — in favor of a childish or boyish persona that would explain her commitment to her career. The legibility of such a persona was predicated on the women artists whom Lewis joined in Italy, among them Harriet Hosmer and Anne Whitney. On the other hand, she embraced for her black and Indian known objects all the tenets of sentimental womanhood. Her willing concession to sentimentality also revealed its hypocrisies. In this way, just as Wexler acts as a corrective for Douglas and Tompkins, Lewis acts as a critique and a corrective to Wexler's "reading" of black and Indian subjects of sentimental imperialism because Wexler posits black and Indian experiences as strictly separate, a separation challenged by Lewis's claims about her identity and by her choice of subject matter.[120]

Yet, in many ways, Lewis's sculpture was limited by what could not be imagined beyond it. One could argue that, given the standard for representing women in marble and in adherence to the neoclassical style, Lewis's figures follow the idealization of the female form so endemic to sculpture at this time. Lewis's work, in fact, was a series of quotations and modified quotations (recall the striking resemblance of Hagar to Donatello's Magdalene), limited to a certain degree by the range of culturally determined possibilities. Within the range of these possibilities, I would argue, there was no standard iconography for freedom. From the description of her first ideal work *The Freedwoman on First Hearing of Her Liberty*, and from the appearance of the freedwoman in *Forever Free*, Lewis seems to have borrowed the female figures from the abolitionist emblem of the kneeling woman in chains. It, along with the image of the kneeling man, had become by the 1860s *the* emblem for abolitionism throughout England and the United States. Lewis took an image developed during the periods of enslavement in the United States and of England's colonialism to represent

freedom, perhaps highlighting that liminal moment of emancipation, between being enslaved and free.

The risk for Lewis was that the public would view the works as self-portraiture. Therefore, "distance" was a necessity for Lewis—a distance that twentieth-century scholarship failed to register. Clearly Lewis did not want viewers to make a one-to-one correlation between her women and "self." In a sense, she suppressed "autobiography" so that she could not be read into her sculptures.[121] As a result, Lewis identified with the freedwoman, Hagar, and with Minnehaha on the level of discourse only— through interviews and reviews of her work. She refused to be victimized by her own hand. This perspective becomes clearer by examining the strategies adopted by African American women autobiographers. Beth M. Doriani, who has studied two autobiographical accounts by black women— Harriet Jacobs's *Incidents in the Life of a Slave Girl: Written by Herself* (1861) and Harriet Wilson's *Our Nig: or, Sketches from the Life of a Free Black* (1859), published as a novel—points out that female slave narratives are entirely different from male slave narratives. Male narratives masculinized the meaning of freedom and recounted the journey from "bondage to independence" as one from slavery to freedom and manhood. The journey was marked by the achievement of literacy and the physical mastery over the slaveholder; it was a gradual emergence into personhood and self-reliance.[122] The emergence of the black woman into personhood was an altogether different matter. Unlike the black male narrator who could "buil[d] his story around a presentation of himself that emphasized . . . the qualities valued and respected by white men," for the black woman, a presentation of self based on the qualities valued by white women was not possible for two reasons. First, the sexual abuse black women suffered had to be addressed, but in as detached a manner as possible to avoid alienating the audience. Above all, narratives by female slaves had to be rooted in "facts." "The most reliable slave narrative therefore would be," writes James Olney, "the one that seemed purely mimetic, one in which the self is at the periphery instead of the center of attention . . . transcribing rather than interpreting a set of objective facts."[123]

Second, because the history of sexual abuse was a matter of public record, black women had to wrest for themselves a sense of morality that (while not equal to) was as legitimate as that prescribed for white women. As a result, they engaged and subverted the "sexual morality found in the

white women's genres, daring their readers to confront the complexity of morality and virtue. In doing so, they bent the conventions to their other purpose, the creation of selves consistent with their own experience as black women. They show that the world of the black woman — as a person inextricably bound up with others yet responsible for her own survival, emotionally, economically, and politically — demands a revised definition of true womanhood, a revision of the nineteenth-century white woman's social and literary stereotype as well as that of the black woman, the 'tragic mulatta.'"[124]

Like Jacobs and Wilson, Lewis, though a freewoman of color, had to rely on white abolitionist patronage for support and success. To maintain authority over her voice, Lewis had to authenticate her position as an objective observer. She had to safeguard her position of power as an artist. By "whitening" the features of her African American and Native American women, Lewis obtained a distance from them and a measure of objectivity — and therefore credibility, not only with her patrons but as an artist who worked in the neoclassical style. Thus, instead of taking her Indian subjects directly from her mother's people and naming them as such, she opted to interpret Native American culture through the mediating figure of a white male author, Henry Wadsworth Longfellow. In selecting a female figure from Longfellow's *The Song of Hiawatha*, Lewis chose to represent what was perhaps the most sympathetic treatment of the indigenous population to be sanctioned by dominant culture.[125] Although her iconography was highly personal and directly relevant to her life, she maintained a distance from it by choosing to portray Minnehaha in the first place, while concomitantly refusing to portray her as identifiably "Indian" in the majority of her sculptures based on Longfellow. Quite literally, Lewis placed herself "on the periphery of the action."[126]

Through a complex process of invocation and inversion, Edmonia Lewis achieved — if we follow Doriani's logic — a "creation of self through subversive interplay" with her viewers' expectations.[127] She came into "personhood" by drawing on and reshaping the prevailing aesthetic — the neoclassical style conveyed in white marble — to illustrate sentimental literature and her heritage as an Indian, as well as those themes pertinent to the black experience in America. Her art transformed as it reconstructed the imagery of emancipation and sentimental fiction. Yet Lewis remains a presence that is paradoxically absent in her work: she is present as an "artist,"

as the creator of art, but she is absent as the "subject matter" (Emerson's and Lubin's black known object) of her art. She invoked autobiographical readings of her works while inverting those expectations by following mainstream modes of representation in her idealized (read "white") depictions of women. Lewis was not unlike the author of the slave narrative, for whom, as Charles T. Davis and Henry Louis Gates note, "the narrated, descriptive 'eye' . . . was put into service as a literary form to posit both the individual 'I' of the Black author, as well as the collective 'I' of the race. Text created author, and Black authors hoped they would create, or re-create, the image of the race in European discourse."[128]

Interestingly, Lewis never sculpted a happy family that consisted of a black father and a Native American mother, which indeed would have been "autobiographical" to her audience. Thus, because of the strict racial segregation imposed by Lewis on her figures, her construction of "correct" biological families, she allowed for opportunistic or selective readings of her work. Because of Lewis's acts of segregation, critics past and present tend to interpret her sculpture along strict racial lines rather than look at the body of her work as a whole. If one *were* to look at the body of her extant work, one would notice that there is a similar emphasis on patriarchy as a positive/norm in her Indian works as in her slavery works. Yet her Indian works tend not to be interpreted by twentieth- and twenty-first-century scholars as a feminist commentary by Lewis on the double subjugation (racial and sexual) of Native American women. In fact, recent accounts of Lewis's Indian works tend to be rather one-dimensional; they are interpreted as affirming her Native American identity and as inflexibly autobiological.[129]

CHAPTER THREE

~ Longfellow, Lewis, and the Cultural Work of *Hiawatha*

P hilip Fisher, in his book *Hard Facts: Setting and Form in the American Novel*, distinguishes the more famil-
iar work done by culture — as giving shape to and sorting
out some part of the past that can then be of use to the
present — from "another meaning to the work of culture
when we consider what the present does in the face of
itself, for itself, and not for any possible future." Fisher
continues, "Culture, in this sense, does work that, once
done, becomes obvious and unrecoverable because it has
become part of the habit structure of everyday perception.
Within the present, culture stabilizes and incorporates
nearly ungraspable or widely various states of moral or
representational or perceptual experience."[1] In the nine-
teenth century, cultural work was accomplished in part by
what Shirley Samuels has characterized as "the aesthetics
of sentiment" or the "sentimental complex": advice books,
statues, photographs, pamphlets, lyric poems, fashion ad-
vertisements, and novels.[2] Among those who shaped the
aesthetics of sentiment, according to Fisher, were some
who managed to insert "into the already filled moral and
cultural realm one new reality." In the case of Harriet
Beecher Stowe's *Uncle Tom's Cabin*, for example, the au-
thor did the cultural work that reinforced the legal act of
the Emancipation Proclamation and the military victory

of the Union over the South. Stowe made obvious the fact that blacks were not things or property but human beings. As Fisher writes, "Where culture installs new habits of moral perception, such as the recognition that a child is a person, a black is a person, it accomplishes, as the last step, the forgetting of its own strenuous work so that what are newly learned habits are only remembered as facts."[3]

ESTRANGED BEDFELLOWS

Beyond noting its popularity among nineteenth-century American artists, however, few art historians seem to remember the cultural work done by Henry Wadsworth Longfellow's epic poem *The Song of Hiawatha* (1855); how, as part of the "sentimental complex" it helped to actively transform its present. Even less satisfactory is the examination of the relationship between Edmonia Lewis, her art, and Longfellow's poem. The seeds are there: Lewis is charged with exploiting her authenticity as "Indian" and thus becoming a legitimate interpreter of the poem, but aside from a listing of the scenes that Lewis adopted and adapted to take advantage of her audience's expectations, the implications of those choices are not adequately explored. Before I consider those implications, I want to accomplish two goals: first, to demonstrate how art history has fallen prey to the cultural work done by Longfellow's poem and its consequences: *The Song of Hiawatha* did indeed "become part of the habit structure of everyday perception"; second, through a close reading of two scholarly essays that focus on Lewis and Longfellow, to lay bare what is at stake in keeping such strange bedfellows estranged.

Resituating "the American Epic" in Art Historical Discourse

The idea that Longfellow's poem *The Song of Hiawatha* was *the* American epic persevered throughout the nineteenth century. It tells the story of the Chippewa brave Hiawatha, who won the love of Minnehaha, a beautiful maiden of the rival nation of the Dacotahs. Ending as it did, with the death of Minnehaha, Hiawatha's vision of the arrival of the Europeans, and his subsequent departure, the poem became part of the American mythology, a kind of genesis for the European American in the New World. Hiawatha's absence metaphorically signaled the European's right to own and inhabit the land.

At the time of its publication in 1855, Longfellow (1807–82) was among the most celebrated poets of the United States. He was born into a patrician family in Portland, Maine (then part of Massachusetts), and like his father before him, he attended Bowdoin College in Brunswick, Maine. Graduating in 1825, Longfellow traveled to Europe in preparation for a career teaching modern European languages and literature. From 1829 to 1835, he taught at Bowdoin but resigned in 1835 to take another trip to Europe. In 1836 he returned to the United States, whereupon George Ticknor handpicked him as his successor as Smith Professor of Modern Languages at Harvard. As Matthew Gartner notes, "[Longfellow's] biographer Lawrence Thompson shows how assiduously the young Longfellow worked as a Bowdoin professor to master his discipline and, through an impressive variety of academic projects, to escape what he called in a letter 'this land of Barbarians — this miserable Down East.' In exchanging Brunswick for Cambridge, Longfellow was finally moving out and up."[4] Longfellow's ambition was not restricted to academic advancement; in fact, that achievement was intertwined with his literary aspirations to become the bard of the American people.

Attendant to his desire to be first among American poets was his deliberate crafting of the character of "the poet." Longfellow's literary achievements followed his arrival at Harvard; in 1839 he published *Voices of the Night* and *Hyperion, A Romance* and in 1841 *Ballads*. While *Voices of the Night* established Longfellow as a national poet, *Hyperion, A Romance* and *Ballads* established poetry as manly labor.[5] As Gartner observes, *Hyperion, A Romance* combined travelogue, autobiography, sketchbook, sentimental romance, and literary essay; it is "a portrait of the artist donning the trappings of the master of culture."[6] "*Hyperion* begins by asking what a poet is and pursues this question through its hero's various experiences and encounters; it conducts a parallel investigation into the question of what it means to be a man. The two questions may be synthesized into what may be the paramount question in Longfellow's romance: Is poetry suitable work for a man? The question goes to the heart of conflicts in American society during the years of the early republic, conflicts that evidently lingered for Longfellow even after he had attained the Smith Professorship at Harvard and had proved that literature could make him a man of importance and reputation."[7] Longfellow had a delicate balancing act to perform: to justify poetry as manly labor in the midst of ideologies of Jacksonian manhood; to

counter the stereotypes of Jacksonian manhood with an alternative form of masculinity — the sentimental man; and to play to the idea of the United States as an egalitarian society while maintaining his inherited sense of himself as a New England patrician.[8]

Very early in his career, while still a professor at Bowdoin, Longfellow expressed his position with regard to both poetry and sentimental manhood in an essay written in 1832 for the *North American Review*. About the "Defence of Poetry," Eric L. Haralson contends,

> Longfellow's "Defence" of 1832 warns against those "barbarians" — read go-ahead Jacksonian men — who asked only that literature "display a rough and natural energy" . . . To put this another way, the "Defence" announced the poet's plan to foster a process (dating from before the Revolution) in which the arena of civic virtue slowly shifted from male preserves of power such as the military and the government to female spheres of influence such as the church, school, and home . . . Longfellow's poetry of the 1840s and 1850s both enacted and encouraged this transition, taking its metaphors for exemplary conduct from the discourse of masculine exertion . . . but pressing them into the service of what was, by prevailing norms, a more feminine mode of self-carriage: chaste, patient, endlessly laboring and waiting.[9]

In effect, Longfellow sought to shift the "male preserves of power" directly into what was ideologically the terrain of feminine domestic concerns, that were, in the words of Laura Wexler, "those public institutions that are the gatekeepers of social existence."[10] Not only Longfellow's message made poetry legitimate as an occupation fit for men; his commercial success also helped to gender poetry-as-profession "masculine." His literary earnings made him the most successful poet of his generation, especially when in 1845 and 1846 he purchased the stereotype plates of all his books, both verse and prose. Thereafter, whenever publishers wished to print from them, they had to pay Longfellow a fee in addition to royalties.[11]

As a national poet in the Emersonian sense, Longfellow would sing the unsung poem that was America by focusing on historical, indigenous themes but in a distinctly sentimental vein. In the creation of a national mythos, *The Song of Hiawatha* belongs to a trilogy of narrative poems with America as their focus: *Evangeline: A Tale of Acadie* (1847); *The Song of Hiawatha* (1855); and *The Courtship of Miles Standish* (1858). Each narrative poem, while directly relevant to its present, takes place "elsewhere":

Evangeline occurs in the prerevolutionary era when the fate of the British and French empires in North America was still unresolved. Set during the French and Indian War (1754–63), it tells the story of the expulsion from present-day Nova Scotia by the British of over six-thousand French Acadians.[12] *The Song of Hiawatha* is set during Native American precontact with Europeans; and *Miles Standish* is set in seventeenth-century Puritan New England. *Evangeline* and *The Courtship of Miles Standish* are linked in that they strictly enact Fisher's first, more familiar work done by culture; that is, giving shape to and sorting out some part of the past that can be of use to the present. Furthermore, each has some continuation *into* that present, the Cajuns in Louisiana and the Puritan stock from which Longfellow himself descends.

Unlike *Evangeline* and *The Courtship of Miles Standish*, *The Song of Hiawatha* has no continuation into the present and yet is directly relevant *to* its present in part because of the governmental policy of Indian removal. Fisher holds that, like James Fenimore Cooper's novel *The Deerslayer* and Francis Parkman's history *The Conspiracy of Pontiac*, Longfellow's *Hiawatha* represents a collapse of prehistory. They are "poetic, historical, and novelistic versions of the same moral and historical configuration. Each is a pre-history of America and each designs the nation's beginnings as at least partially, a stained and guilty supersession." Each reinforces the trope of the "vanishing Indian" and takes place at the moment before "the formal beginning of national identity" and U.S. history. As Fisher notes, "The renaming or reimagining of beginnings as endings" is "fundamental to the techniques by means of which the American nation came to moral terms with the fact of the American Indian" and the Indian's eventual "extinction." As end-structured narratives, Fisher contends, "*The Song of Hiawatha*, and Cooper's *The Deerslayer*, both usually seen as escapist and candied 'popular' myths that leave out all of the hard facts, are in reality based on a single dark premise — that American culture is a successor culture that founds itself by extinguishing the culture already in place."[13]

Regarding his sources, Longfellow made a number of borrowings and distortions in crafting *Hiawatha*. In 1854 he left Harvard to work on the narrative poem, borrowing the form and trochaic tetrameter from the Finnish national epic *Kalevala* published in 1835 by Elias Lonrott. Additionally, he borrowed some narrative content from the research of the ethnologist and Indian agent Henry Rowe Schoolcraft. As Haralson observes,

Much of the preliminary work in accommodating these materials to sentimental middle-class life had already been done by Longfellow's sources, chiefly by Henry Rowe Schoolcraft. In fact, "authenticating" Native-American culture *as* Eurameri-can culture proceeded by means of a mutual admiration society: first Longfellow legitimized Schoolcraft's (and others') ethnographic research by quoting it at length in the scholarly endnotes to *Hiawatha*; then Schoolcraft, riding the crest of the poem's popularity in 1856, extracted and reissued *The Myth of Hiawatha*, in effect *re*validating what his dedication called "the pleasing . . . pictures of Indian life [and] sentiment" in Longfellow's poem.[14]

Joe Lockard writes in "The Universal Hiawatha," "Although Schoolcraft preferred not to acknowledge his intellectual debt, his mixed-blood wife, Jane Johnston, and her storytelling family provided both the original Chip-pewa stories and oral translations into English. When born on America's northeastern seaboard in the mid-nineteenth century, Hiawatha was the mixed-blood Chippewa-Finnish progeny of an intellectual marriage be-tween reports from a conquered tribal nation to the west and national revisionism to the east." Lockard continues:

That Schoolcraft's text substantially distorted Chippewa beliefs and stories is un-questionable, although he professed a desire to record and publish these to ex-emplify the Red Man's nobility. Longfellow, misplacing his faith in Schoolcraft's credibility as an anthropologist observer, viewed Hiawatha as a faithful rendering of tribal stories, and the reading public shared a similar regard. Yet Longfellow continued this chain of distortions. One sign of his "raw clay" approach to lit-erary transformation of Chippewa culture lies in the poem's title. Longfellow disregarded the Chippewa name Manabozho and substituted Hiawatha, an Iro-quoian name, because it was more manageable in an English-language poem. This complete renaming was hardly the standard of literalism buttressed by "slight and judicious embellishments" that, in a European context, Longfellow set himself for his translation from the Spanish of Coplas de Don Jorge Manrique. As ethno-graphic pretense, Longfellow's storytelling contributed substantially to the body of fakelore that has sought to reenunciate historic and lost glories, a body that includes Macpherson's Ossian forgeries, Lonrott's *Kalevala*, and other national pseudoepics.

What is at issue is that to a certain extent the reading public still views Hiawatha as a faithful rendering; or, when comparing Hiawatha to Long-

fellow's representations of Native Americans in *The Courtship of Miles Standish*, Hiawatha is viewed as more "sympathetic" and therefore more "modern" in the sense that Longfellow anticipates twenty-first-century political correctness. Furthermore, Lockard contends, the translation of *The Song of Hiawatha* into various languages (including and especially Chippewa) actually endorses Hiawatha as an "authentic cultural object, or at least one whose representational deficiencies can be rationalized broadly as those common to narrative processes. As a body, Hiawatha translators have near uniformly accepted this conceit of fidelity between 'Indianness' and Longfellow's representations of Native subjects; indeed, their acceptance of the proposition empowers and enables their translations."[15]

For example, John Derbyshire, writing for the *New Criterion* in 2000, finds Longfellow an "authentic" voice of Indianness and *Hiawatha* a more "modern" conceptualization of Indians: "Longfellow's epics are much more authentic than Mel Gibson's—though it is interesting that the portrait of American Indians as seen through white men's eyes in 'Miles Standish' is so different from the one in the earlier Indian-viewpoint 'Hiawatha.' There the Indians are noble savages with a rich oral culture; in the later 'Miles Standish' they are treacherous, boastful, and cruel. This later portrayal accords much better with the accounts we have from people who actually lived among New World aborigines: W. H. Hudson in *Green Mansions*, for example, or the memoirs of Kit Carson. The other is much closer to modern sensibilities."[16] Derbyshire's comparison of "viewpoints" in *Hiawatha* and *Miles Standish* is inherently flawed because, as represented in each narrative poem, the voice of the Indian and the voice of the white man *is* Longfellow's voice. Also, Derbyshire's comparison of the two poems is dubious because they should be read, as they were written, in tandem. If *The Song of Hiawatha* represents, as Fisher argues convincingly, the collapse of prehistory, then the "noblest" savages had the grace to disappear with the coming of the white man, and what was left was a degenerate and degraded race of Indians who bore no resemblance to the civility of Hiawatha. Like nineteenth-century paintings and photographs of Native Americans, Longfellow's prose functioned to differentiate the noble from the ignoble savages but all toward one purpose. As Anne Maxwell writes in relation to colonial photography and exhibitions, "Photographs of Native Americans at exhibitions tended to fall into two categories: stereotyped images showing re-enactments of famous battles such as Little Bighorn,

and documentary recordings of Indians and their cultures before they faded from existence. Both types had the effect of excluding Native Americans from the nation, either by projecting savage traits on them, or by representing them as timeless emblems of a pre-colonial past that was rapidly disappearing."[17]

Common among Longfellow enthusiasts is the notion that Longfellow has fallen into literary obscurity. According to John Derbyshire, even though the representation of Indians in *Hiawatha* is closer to the one held by modern sensibilities, "This . . . will not help 'Hiawatha' become known again. One knows without trying that any attempt to revive interest in narrative verse would be futile. We do not read as our grandfathers read, we do not hear as they heard." Those scholars who lament the passing of Longfellow into literary anonymity seem to feel that it was because Longfellow was so genial. Both Derbyshire and Charles C. Calhoun, writing for the *Chronicle of Higher Education* in 2004, find this an adequate explanation for why Longfellow is supposedly "overlooked." Calhoun explains, "The problem of course is that he was so very nice a man. He did not sleep with his sister, grow addicted to opium, have to flee college because of his gambling debts, cruise the waterfronts, sire an illegitimate child abroad, or drink himself into dementia. He did not, in other words, behave the way the public has come to hope great poets will behave."[18]

Nonetheless, the "problem" is not as Derbyshire and Calhoun would have us believe — that Longfellow has been forgotten because he was such a nice guy. The "nice guy" explanation is inadequate and is belied by the sales and number of editions as well as the ongoing translation of *The Song of Hiawatha*. Cynthia D. Nickerson records that by April 1857, fifty thousand copies had been sold in the United States alone, and Longfellow wrote in his journal in 1860 that his publisher was selling two thousand copies per year.[19] *Hiawatha* was translated into Flemish (1856); German (1856–59); French, Danish, and Polish (1860); Dutch and Latin (1862); and even Chippewa (1900). In the twentieth century, it was translated into Yiddish (1910), Hebrew (1913), Russian (1918), and Italian (1920), and from 1976 to 1985 twelve translations were published, including Korean and Moldavian (1976); Swedish (1978); Georgian (1979); Euskadi and Lithuanian (1981); Ukranian (1983); German (tenth German translation 1984); and Chinese, Finnish, and Kazakhstani (1985).[20]

In fact, Longfellow "vanishes" in much the same way as Native Ameri-

cans: he is "gone" even as he resides in plain sight, something that scholars who lament his disappearance must acknowledge. Derbyshire charges that the "literary critics in present-day academia, obsessed as they are with the 'transgressive,' do not find much of interest in Longfellow's life." But even as he admits that discussion of Longfellow is not welcomed in academic circles, "Longfellow has been a continuous presence in our language since *Voices of the Night* was published . . . and his lines are still familiar today, though many who know them could not tell you who wrote them."[21] By implication, the audience that matters is the literary elite, while the notion that Longfellow, though disappeared in some circles, is simultaneously a "continuous presence in our language" connotes a literature that is not literary or that bypasses the literary to work directly upon language.

Virginia Jackson, in "Longfellow's Tradition; or, Picture-Writing a Nation," tenders an alternative explanation as to why Longfellow "vanished," which can perhaps explain the position of scholars who, like Derbyshire and Calhoun, insist on having it both ways. For even as Longfellow disappeared into his sentimental heroes, Jackson suggests, he perfected a style of writing that seemed to be not like writing at all; it was instead a form of *feeling*.[22] In fashioning himself as the nation's poet, as the conduit of the nation's sentiment, Longfellow wrote the nineteenth century's best-selling poems, and he fashioned them, Jackson contends, in such a way that they were "made to be read as if they were pictures, as if reading were self-evident, as if their elaborate classical meters were really a transparent language. What Longfellow imprinted was perhaps not a national literary tradition but the much more historically persistent fantasy that a nation might *become* a literature . . . From the early moment of Longfellow's reception, the poems have been cast as the spontaneous overflow of popular feeling rather than its representation."[23] Longfellow's writings are examples, as Fisher remarks, "of culture that invites and then achieves incorporation. Because so much of its reality has leaked out and merged into the common language of perception and moral action, its very success, as mimesis, in altering the categories of reality, hides the extra-ordinary energy that now seems already ours."[24]

Unfortunately, art history actively helps to construct the more problematic views of Longfellow as a "nice guy" who only created "sympathetic" Indians, and it gives Longfellow's believers hope for a "resurrected" national bard. An additional concern is that in art history's reanimation

of Longfellow, the poet's sources are usually cited as "proof" of the "authenticity" of his Indians with no closer look taken at those sources or at how they are deployed. Furthermore, *The Song of Hiawatha* is perceived as a *reflection* of government policy and social attitudes toward the "vanishing Indian" rather than as an *agent* that actively reinforced and shaped those policies and attitudes. Jackson references Longfellow's liberal use of transliterated Ojibwa terms that gave the American public the sense that they were reading the poem in the "original" language of America, the Ojibwa language, long dead like Latin. She insists, "In this way the persistent elegiac strain in Longfellow's poem surely participates in what Lora Romero has identified as 'the historical sleight of hand crucial to the topos of the doomed aboriginal: it represents the disappearance of the native not just as natural but as having already having happened.' But *Hiawatha* not only actively joins the American campaign to 'disappear' native cultures by appearing to chronicle genocide passively as a fait accompli: it makes the passage of one American language into another — of the na*tive* into the na*tion* — the vehicle of that disappearance."[25] *The Song of Hiawatha* allowed for the absorption of the native into the successor nation; and art history's persistent evocation of Longfellow's "sympathetic" Indians reinforces the nostalgia for something permanently gone. Finally, separating Longfellow's treatment of Native Americans in *The Song of Hiawatha* from that in *The Courtship of Miles Standish*, rather than considering them in tandem, hampers a more nuanced examination of Longfellow's "vanished" Indians and their (re)appearance in art.

Without doubt, Cynthia D. Nickerson's "Artistic Interpretations of Henry Wadsworth Longfellow's *The Song of Hiawatha*, 1855–1900" is invaluable. Published by *American Art Journal* in 1984, the essay is a substantial resource and lays the foundation for further study. Furthermore, Nickerson synthesizes materials that are commonly overlooked by art historians, materials that demonstrate the importance of Longfellow in the nineteenth century, how his poem inflected painting, sculpture, illustration, theater, and even the naming of ships. Her central argument is that *Hiawatha* answered the nationalist call for indigenous themes in poetry as well as an inspiration to the other arts. However, Nickerson's essay also displays the weaknesses of an insular art history as she notes, "After poring over the writings of Henry Rowe Schoolcraft, George Catlin, John Hecke-

welder, and others who gave first-hand accounts of Indian life, Longfellow incorporated customs and legends into an epic poem recounting the adventures of an Ojibwa—or Chippewa—chief named Hiawatha."²⁶ Not only does she list Longfellow's sources as if they were not subject to question, but her own sources are strictly nineteenth-century reviews of the poem and of the artists sutured to twentieth-century references in art history. Evidently not consulted are two invaluable books published prior to her own essay that, even though not produced within the discipline of art history, still are concerned with representation: Robert F. Berkhofer Jr.'s *The White Man's Indian: Images of the American Indian from Columbus to the Present* (1978) and Brian W. Dippie's *The Vanishing American: White Attitudes and U.S. Indian Policy* (1982). Both authors expose how the "Indian" (as a European/white construct) has functioned to justify the various policies of removal, dispossession, assimilation, and genocide that have been a mainstay of contact. Both Berkhofer and Dippie move beyond the identification of stereotype to deconstruct the actual functions of the various constructs that are found not only in art but also in religion and anthropology, and in the legal systems of Europe, the British colonies, and eventually the United States. These books would have been useful to Nickerson's essay because they provided a context, not only for Longfellow's poem, but also for why artists mined the poem for imagery during those times.

In her concluding remarks, Nickerson states, "Artists such as [Thomas] Moran, [Edmonia] Lewis, [Augustus] Saint-Gaudens, and [Thomas] Eakins wanted to rely less on European sources, but they were still ingrained with academic ideas acquired during their European training. By turning to *Hiawatha*, they could satisfy the requirements of academic art while demonstrating pride in the legends of their native country."²⁷ The final sentence negates all the research and reasoning contained in her essay as Nickerson's sensitivity to the individual issues surrounding each artist's interest in Longfellow is collapsed into a nativist explanation along the lines of Emerson's lament about America as an "unsung poem." The tendency of most writing is to "go out on a high note," but the cost is that the collapse of individual motivation for mining *Hiawatha* forces the reader to assume that the artists were all "American" in the same sense, eliding differences of class, race, and gender. And it hides, through this high note of nationalism and pride in the Indian-as-symbol, the hard fact that Fisher

7 Edmonia Lewis, *Bust of Henry Wads-worth Longfellow*, 1871. Marble, 28¾ × 15 × 12 inches. Harvard University Art Museums, Fogg Art Museum, Harvard University Portrait Collection, 1872.552, Cambridge, Massachusetts. Photo: Imaging Department © President and Fellows of Harvard College.

raises — that America is a successor nation — and that the Indian is required as a symbol of that vanished culture to confer legitimacy upon the interlopers.

Lewis and Longfellow at the Fogg Art Museum

From February 18 to May 3, 1995, the Fogg Art Museum on Harvard University's campus held the exhibition "Edmonia Lewis and Henry Wadsworth Longfellow: Images and Identities," curated by Timothy Anglin Burgard. The exhibition was a timely affair to honor the poet's influence on the visual arts, in tandem with the establishment one year earlier of the Longfellow Institute, founded to celebrate his pioneering role in teaching comparative literature in the United States.[28] The occasion for the exhibition and the accompanying publication was Edmonia Lewis's bust of Longfellow, who sat for the sculptor when he visited Rome between December 1868 and February 1869 (figure 7). From the shared title of the exhibition and catalogue, one would expect some parity in focus, not only

between the two artists but also between exhibition and catalogue. Yet there seems to be a disjuncture between the expansive nature of the exhibition and the narrow focus of the publication. The exhibition comprised sixty-eight items ranging from authenticating objects, such as moccasins and birch bark boxes from Ojibwa culture, culled from Harvard's Peabody Museum of Archaeology and Ethnology; to the daguerreotypes of slaves commissioned by the anthropologist Louis Agassiz and taken by J. T. Zealy in 1850, also part of the Peabody's collection; to first editions of Phillis Wheatley's poems, Stowe's *Uncle Tom's Cabin*, and Sojourner Truth's and Frederick Douglass's slave narratives; to various portraits of Longfellow, by Hiram Powers, Edmonia Lewis, Thomas Badger, and Sir Thomas Brock; to an array of Limoges china, paintings, prints, and sculpture inspired by *The Song of Hiawatha*. Harriet Hosmer was also well represented in the exhibition even though she contributed nothing to the body of art work inspired by Longfellow: there were several photographs of her, her sculpture tools, and her statue *Zenobia*.[29] Nevertheless, the exhibition essay makes no effort to narrativize its own checklist. With the focus strictly on Lewis and Longfellow, the essay follows its own path and is a separate text while the gathering of objects must fend and speak for themselves.

The central theme of the catalogue is a barometer of Lewis's and Longfellow's fame relative to one another, which I believe charts Burgard's anxiety over Longfellow's "plunge" into literary obscurity and the concomitant rise of "marginal studies" (my term, not his — but such a sensibility is present) that places Lewis in the forefront of contemporary scholarly attention. As he states at the conclusion of his essay, "In recent years, Edmonia Lewis has become an historical paradigm of the experiences of Native Americans, African Americans, and women as they struggle to define their images and identities in American culture. Popular and scholarly interest in Henry Wadsworth Longfellow, who is widely perceived as epitomizing privileged Euro-American culture, has diminished. Yet, the ongoing reappropriation and redefinition of both Lewis and Longfellow by successive generations of Americans may reveal as much about the values of the searchers as it does about their subjects."[30] This is a reversal, Burgard is careful to note, of the situation in the nineteenth century when Longfellow was preeminent and Lewis an unknown. "Longfellow, described in 1881 as a 'poet only less known than Shakespeare,' long occupied a central position in American

culture, while Lewis remained on the periphery, her biography and her work obscured by critical neglect, historical circumstance, and her own selective recall."[31]

As Burgard painstakingly points out, Lewis and Longfellow had little in common except for "circles of acquaintance, patronage, and influence, especially among Boston's political, social, and cultural elite, which accounts for the acquisition of her portrait bust [of Longfellow] by Harvard." In terms of upbringing, religion, ethnicity, and fame, however, they could not have been more different. Regarding relative fame quotients, while the place and date of Lewis's death and burial are unknown, Burgard relates, Longfellow was the only American honored with a bust in the Poet's Corner of Westminster Abbey in London. Burgard's final comparison is of their work: "While Lewis's works incorporated Native American and African American themes, Longfellow's poetry played an important role in the construction of a shared Euro-American identity."[32] In Burgard's estimation, what makes Lewis's representations of Native Americans different from Longfellow's? Why do her works merely incorporate, while Longfellow's construct? More significantly, why *won't* he make the connection between Longfellow's "construction of a shared Euro-American identity" and his representation of Indians, a connection that reveals the contingent nature of that "shared Euro-American identity," which was formed in part by its conceptual opposition to Indianness?

The difference between incorporation (to embody) and construction (to build) is vast yet — in the most paternalistic sense — symbiotic. It is the intense, mutual interdependence of the apprentice who internalizes only to embody the work of the master and the master whose work is made manifest in the apprentice. (This was Lubin's sense also in constructing Duncanson's failure to manifest his "master.") According to Burgard, "Lewis is known to have read Longfellow's poems, particularly *The Song of Hiawatha* ... which greatly influenced her work. Lewis and Longfellow provide case studies in the production and reception of images and identities over time, through self-definition and external definition. Their careers demonstrate that both privileged and peripheral artists are subject to the mediating forces of history and revisionist interpretation."[33] And although the catalogue is ostensibly about Lewis and Longfellow, most of the catalogue's one essay is concerned with Lewis's heritage and the phases of her career, from Oberlin to Boston and Rome. Burgard's reconstruction of

Lewis's career has a very particular tone: it is about how she "exploit[s] the preconceptions of her white patrons regarding Native Americans" and how she "capitalized on her unique status as an African American artist, and produced portraits of the abolitionists John Brown, William Lloyd Garrison, and Wendell Phillips for her patrons." And once she was in Rome, the essay reports, her role models were Charlotte Cushman and Harriet Hosmer, and she "emulated not only outward attributes such as their unconventional (and often male) attire, but also their independent artistic personae." In Burgard's rendering, in addition to a career made up of exploiting and capitalizing upon her heritage and emulating the dress and personae of powerful white women, Lewis also took advantage of the historical moment in which she worked: "Following the Civil War and the abolition of slavery, Lewis focused increasingly on her Native American heritage." [34]

Burgard portrays Lewis as (re)acting wholly on the premise of base self-interest, as opportunistic, and a mimic. Her "identity" is hollow, while Longfellow is the deposed king whose fame has been diminished because of Lewis's concomitant rise. Burgard spends page after page mapping Lewis's opportunism, culminating with what amounts to a false chronology of her work, despite the fact that, within the category of ideal sculpture, Lewis's slavery works and her works inspired by Longfellow were conceived and executed almost simultaneously in the period from 1866 to 1875. For example, her sculptures *The Wooing of Hiawatha* and *Hiawatha's Wedding* of 1866 appeared one year earlier than *Forever Free*. As Burgard constructs her career, the tone of his false chronology yields more about his opinion of Lewis than it does the trajectory of her career — a career that does not begin until *after* the Civil War. Burgard's construction also brings into sharp relief a bias that favors the character (or what he might call the "identity") of Longfellow over Lewis. The impression one receives from the essay is a sharp dichotomy between Lewis and Longfellow: Longfellow, unlike Lewis, acts in the noble interests of the nation (the shared Euro-American identity) and of the Native American (for whom the nation is to have *feelings*). Burgard asks that the reader remember that "Longfellow's work and popularity must be viewed in the context of a struggle by nineteenth-century American artists and writers to create a national cultural identity independent from that of Europe." [35] Burgard neither qualifies what he means by "a national cultural identity" nor does he question why the

representation of Native Americans is vital to the construction of such an identity. Furthermore, he replicates the authenticating maneuver of art historians who cite Longfellow's sources as if they were gospel: "Based on the research of ethnologist Henry Rowe Schoolcraft," Burgard informs us, "and set on the shores of Lake Superior, this epic poem synthesizes Native American mythology with the fictional narrative romance of the Ojibwa Hiawatha and the Dacotah Minnehaha."[36]

What is perhaps most telling about Burgard's position is his summary of the cultural work done by Longfellow's *The Song of Hiawatha*. According to him, the poem "inspired innumerable interpretations in all forms of material culture, and played a defining role both in *fostering sympathy for* Native American culture and *reinforcing* romanticized public perceptions of Indians."[37] With the contention that *Hiawatha* "foster[ed] sympathy for Native American culture," Burgard uncritically instantiates the rhetoric of nineteenth-century sentimentalism. Why does Lewis exploit while Longfellow fosters sympathy? Why is the reverse — that Longfellow exploits while Lewis fosters — unthinkable? Why are fostering and exploitation mutually exclusive? Why is the dichotomy of difference and estrangement from Lewis vital to the sentimental reconstruction of Longfellow? Burgard reinscribes Longfellow as the man of sentiment who has successfully shifted male preserves of power into female preserves of affect and influence. As Lori Merish argues, "According to the popular antebellum doctrine, influence was a form of authority, exercised on the passions rather than reason, which operated through persuasion instead of force: by appealing to an individual's love of virtue, influence engaged and subtly directed his or her affections."[38] In his statement that *Hiawatha* "reinforc[es] romanticized public perceptions of Indians," Burgard strips Longfellow's poem of any cultural agency. And as I have said earlier, the main illusion surrounding sentiment is that it is neither aggressive nor imperial. Longfellow, in Burgard's reading, possesses all the ideal qualities of sentimental manhood, with all the powers of influence and moral suasion, while Lewis represents "the dark side" of sentiment, abusing her privileges as a sentimental object and using manipulation and exploitation to steal for herself the fame that rightfully belongs to Longfellow.

Burgard mentions one final reason for Lewis's attraction to Longfellow's narrative poem: that the marriage of Hiawatha and Minnehaha, a marriage that unites the two warring nations of Chippewa and Dacotah,

represents for Lewis the metaphoric reconciliation of North and South during Reconstruction. The art historian William H. Gerdts first proposed the idea in an essay from 1974 titled "The Marble Savage" and it has remained a popular theory as to why Lewis was drawn to Longfellow's *Hiawatha*. Nickerson reiterated the theory in 1984 as did Norman L. Kleeblatt in 1998, who wrote an essay titled "Master Narratives/Minority Artists." Like Gerdts, both Nickerson and Kleeblatt note that Lewis's exclusive concentration on the romance between Hiawatha and Minnehaha provides compelling evidence of a broader intent on her part that goes beyond the poem's relevance and straight to the heart of her racial heritage as "black." Interestingly, Burgard slightly alters Gerdts's original point. According to Gerdts: "While they certainly referred to the sculptor's Indian heritage, these figures may have further reference to the Civil War, for Hiawatha's marriage represented the union of two previously warring tribes, the Ojibways and the Dakotahs; for Lewis, perhaps the theme reflected the hope for unity in the aftermath of America's own civil conflict. This interpretation is not far-fetched, for around the same time, in 1867, Lewis created a more direct reflection of that strife in 'Forever Free,' with its black man and woman with broken chain." [39] Listing Gerdts as the only source for this theory, Burgard writes: "The reconciliation of the Ojibwas and Dacotahs through the marriage of Hiawatha and Minnehaha has been interpreted as symbolic of hopes for the reconciliation of the North and South *in the pre-Civil War period*, and this theme may have had added resonance for Lewis *during the Reconstruction period*." [40]

Of what possible significance is Burgard's distortion? First of all, had Burgard faithfully transcribed Gerdts's point, Burgard would have had to abandon the false chronology that he constructs for Lewis. Clearly, Gerdts has the right of it. But to follow Gerdts's point too closely would have weakened the charge of "event-driven" opportunism on Lewis's part. Second, in Burgard's rewording of how and when such an interpretation happens — by some unnamed something *before* the Civil War — he strips Lewis of any creative initiative in her response to the poem. Finally, I want to address this second means of nationalizing the significance of *The Song of Hiawatha*, beyond the Indian, and acknowledge that Lewis facilitates such a construal of healing on behalf of the poem. While the aftermath of the Civil War may indeed have been an inspiration for the particular focus of her Indian pieces, the lack of any critical analysis of the poem's

cultural work prior to the war inhibits a more sophisticated reading of Lewis's choices. Because the poem has been so divorced from its context, the only way to reinvest it with meaning, and a meaning that must not harm Longfellow's reputation, is to nationalize its significance as a "black/white" issue rather than a "red/white" one even as Hiawatha sets sail in his longboat and vanishes into the sunset. In effect, reversion to the North/South or black/white dichotomy, before the retrieval of Longfellow's cultural work has been accomplished, simply enables the perpetually vanishing Indian and keeps in the shadows the dark premise "that American culture is a successor culture that founds itself by extinguishing the culture already in place."

Lewis and Longfellow at the Detroit Institute of Arts

In the same year that Harvard exhibited "Lewis and Longfellow: Images and Identities" (1995), the Detroit Institute of Arts commissioned the art historian Juanita M. Holland to write an essay in honor of its recent acquisition of two busts by Edmonia Lewis, the pendant sculptures of Hiawatha and Minnehaha (figures 8 and 9). Titled "Mary Edmonia Lewis's *Minnehaha*: Gender, Race and the 'Indian Maid,'" Holland's essay is very different in tone from Burgard's and replete with positive adjectives describing Lewis as "proud, intelligent, and aggressive," with qualities of "will, ambition, pride, and stubborn intelligence" — and these descriptions are taken from only one page.[41] Holland's essay does share with Burgard's the interest in identity politics as it relates to Lewis. Holland writes that Lewis's choice of subject matter was determined by how her public, patrons, and acquaintances responded to her heritage. Unlike Burgard, Holland provides a reason for Lewis's maneuvers, writing, "She shrewdly utilized both aspects of her heritage to skillfully navigate the maze of sexism and racism that defined her reception as a woman sculptor of mixed ancestry."[42] Holland also suggests a reason why Lewis's public seemed to prefer "the Native American aspect of her background" to the African American: "Lewis did not easily fit some of the deeply embedded stereotypical perceptions of African American women popular in white American society, such as the tragic mulatta or hardy slave woman." She concludes, "Such threatening aspects of Lewis's identity [free, talented, and successful] could be more easily defused by placing her within the stereotypes of Native American women."[43] Holland also does not shy away from discussing the difficulties

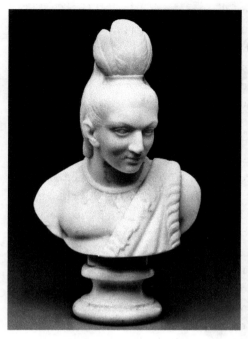

8 Edmonia Lewis, *Bust of Hiawatha*, 1868. Marble, 11 × 6 × 3½ inches. Detroit Institute of Arts, Detroit, Michigan. On loan from the Manoogian Collection. DIA.T1989.403.

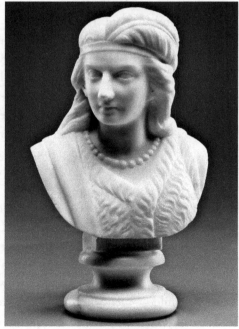

9 Edmonia Lewis, *Bust of Minnehaha*, 1868. Marble, 11 × 6 × 3½ inches. Detroit Institute of Arts, Detroit, Michigan. Gift of the Centennial Planning Committee for Sharing Traditions and Romare Bearden Exhibitions with a major contribution from Founders Junior Council (1986.33). Photograph © 2006 The Detroit Institute of Arts.

that Lewis faced with her powerful patrons such as Lydia Maria Child and Anne Whitney, carefully testing the private correspondence about Lewis against their public support of her.[44]

Nevertheless, her analysis of Lewis's art is both celebratory and tentative, as it seems to conflate "identity" with "stereotype." Holland paints Lewis as strictly reactive, the artist's choices determined, even dictated, by how those most distant from her—an amorphous audience made up of "public, patron, and acquaintance"—responded to her heritage. This type of discussion is an unfortunate result of viewing Lewis as intransigent and answerable only to cultural stereotypes. For reasons of the supposed inadequacy of black stereotypes to contain Lewis, Holland then maps the artist through a succession of Indian stereotypes. Taking anecdotes from Lewis's biography and using examples of the work inspired by Longfellow, she posits in rapid succession Lewis as the Indian Maid, Lewis as Pocahontas, and Lewis as Minnehaha in order to reveal how Lewis profitably reproduces herself for her various "publics" as identified by Holland.

Holland's envisioning of Lewis as Indian Maid and as Pocahontas relies on the artist's interviews with the abolitionist press in the nineteenth century. Holland uses the stories of Lewis's early childhood, traveling with her mother's people and selling souvenirs, to locate Lewis within the stereotype of the Indian Maid. These stories, she argues, which identified Lewis as a "naive savage," helped to defuse the implications of power that would accrue had Lewis been considered "wholly black." "As a black woman," Holland proposes, "she was able to use the abolitionist fervor of midcentury Boston as a springboard for her career and as a continuing source of sculptural subject matter and patronage. But it was as the Indian lass that her public most easily accepted and approved of her, and this *gave her the exotic edge* so necessary for public recognition. Lewis's aggressive and remarkable shaping of her Native American identity into a public persona was as carefully crafted and presented as any of her marble pieces."[45] Unlike Burgard, who interprets Lewis as a simple mimic of fame, Holland teases out the strategies adopted by Hosmer and Lewis to deflect attention from their professions, which were normally the province of men. "Both Hosmer and Lewis were described as 'mannish' and unconventional dressers, but any questions of gender identification were resolved by their depiction as playful child-women with a chaste dedication to their art." She aligns Lewis with the Pocahontas stereotype, or, in her words "the mythic con-

structs of Indian womanhood,"[46] by retelling Lewis's so-called discovery
of sculpture and concession to Euro-American methods and style of sculp-
ture as parallel and comparable to the story of Pocahontas, whose rescue of
John Smith, conversion to Christianity, and marriage to John Rolfe sym-
bolized her embrace of civilized life and recognition of the superiority of
Euro-American ways.

In Holland's estimation, Lewis's art, like her life, was dominated by
"mythic constructs of Indian womanhood." She writes, "Lewis's Native
American subjects certainly reflected her canny understanding of the
power and importance of the mythic Indian in white American culture."
One might assume, Holland acknowledges, that her Indian subjects by
right of heritage could have been inspired by Lewis's own childhood ex-
periences, but this is not the case. She also notes at the end of the essay
that none of Lewis's anecdotal accounts about her Indian heritage can be
substantiated.[47] Her interpretation of Lewis as Longfellow's Minnehaha
is couched between these two points, while the cultural work done by
Longfellow's epic poem is entirely consistent with art historical discourse.
With no mention of Longfellow's sources at all, Holland writes, "Long-
fellow's work, widely read and admired, not only became a familiar aspect
of American culture, but also inspired a number of painters, sculptors and
illustrators" and that "in *The Song of Hiawatha*, Longfellow echoed popu-
lar sentiments about the potential to civilize the Indian savage."[48]

Holland contends that *Hiawatha* embodies two concepts of the Native
American vital to U.S. culture: the Indian as the noble savage and the
Indian as a vanishing race. She traces the two concepts through the poem
and through Lewis's sculptures. In the poem, she writes, Hiawatha "served
his people by bringing them skills for agriculture and hunting, vanquishing
supernatural enemies, and promising peace."[49] In Lewis's sculptures, she
argues, the nobility of the Indians is conveyed through their physiognomic
connection to classical sculpture, while the concept of the Indian as a van-
ishing race is conveyed in the poem by the death of Minnehaha and the
departure of Hiawatha. Lewis also neutralizes her Indians, Holland sug-
gests, through the narrative moments she chose from *Hiawatha*: "peaceful
artisanship, courtship, and marriage — [these] would have been reassuring
images, especially in the context of often violent displacement of Native
Americans from their lands that was integral to America's western expan-
sion." It is at this point in Holland's discussion that a disconnect occurs,

because she does not think to ask *why* Lewis did not portray the death of Minnehaha or Hiawatha's departure, which, one can argue, were equally reassuring to an American public. She concludes instead with an authenticating statement about the nineteenth-century audience's acceptance of Lewis's right to interpret the poem: "While other sculptors' renditions of Native Americans also expressed the popular stereotypes comfortable to white viewers, it was Lewis's self-proclaimed identity as a Native American that made her renditions so powerfully appealing."[50]

To interpret Lewis's choices strictly in terms of adherence to stereotype or controlling images is inadequate, and when paired with Holland's discussion of those works inspired by Longfellow, the picture remains both two-dimensional and tautological. The historian Patricia Hill Collins has written persuasively on the function of controlling images in nineteenth-century American culture:

The dominant ideology of the slave era fostered the creation of four interrelated, socially constructed controlling images of Black womanhood [mammy, matriarch, welfare mother, and Jezebel], each reflecting the dominant group's interest in maintaining Black women's subordination. Given that both Black and white women were important to slavery's continuation, the prevailing ideology functioned to mask contradictions in social relations affecting all women. According to the cult of true womanhood, "true" women possessed four cardinal virtues: piety, purity, submissiveness, and domesticity. Elite white women and those of the emerging middle class were encouraged to aspire to these virtues. African-American women encountered a different set of controlling images. The sexual ideology of the period as is the case today "confirmed the differing material circumstances of these two groups of women . . . by balancing opposing definitions of womanhood and motherhood, each dependent on the other for its existence."[51]

Therefore, the decision to view Lewis and her art in terms of controlling images of Native American womanhood rather than to look carefully at what images Lewis did or did not select from Longfellow reduces her to an embodiment of the master's imagination, strips Lewis of her agency, and makes Holland's essay eerily similar in impact to Burgard's. Like Burgard, Holland credits Lewis with exploiting her heritage, noting, if you recall, that "playing the Indian lass" gave Lewis "the exotic edge so necessary for public recognition."[52] I contend that a metaphorical estrangement between Longfellow and Lewis happens because both Burgard and Hol-

land conceive of Lewis as the embodiment of the master's work, thereby deploying Lewis as the quintessential sentimental object. It is an estrangement endemic to Burgard's and Holland's argument because they cannot envision Lewis as an interpreter/translator of Longfellow—they do not ask why she made certain decisions; instead they credit her with manipulation or self-glorification or a "natural" inclination to either identify with Longfellow's characters or trade on Longfellow's fame.

If controlling images reflect the dominant group's interest in maintaining one group's subordination over another's, we must ask who has the authority to wield such images and in what instances. Here is an example: Burgard puts into play a controlling image that until now I have left unexamined—that of the "privileged Euro-American male author(ity)"—the "bad guy" of the academy, posited by Burgard as the newly oppressed. Burgard's lament—that with the rise of interest in Lewis, "popular and scholarly interest in Henry Wadsworth Longfellow, who is widely perceived as epitomizing privileged Euro-American culture, has diminished"—is the subtext of the "nice guy" explanation for Longfellow's loss of status. As any study of representation will show, controlling images are only invoked at the expense of someone else, and Burgard invokes that particular controlling image to restore a balance, to invest Longfellow with power and to subordinate Lewis *in defiance of* contemporary interest in "marginal studies." The above example helps to expose a deep flaw in Holland's argument. Because, by its definition, a controlling image cannot be wielded against itself, this raises the question of the nature of Lewis's agency—not as an embodiment of Longfellow but as an interpreter/translator with her own agenda.

I would argue that Holland's essay is highly problematic because it tries to rationalize a false agency on Lewis's behalf. Holland's tentative reading of Lewis's sculpture culminates in the statement that the narrative moments Lewis chose would have been "reassuring," but she does not qualify for whom.[53] The note attached to that statement resurrects Gerdts's speculation on the meaning of Lewis's Longfellow-inspired works as "representing the union of two previously warring tribes, [which] might have expressed her hopes for national unity after the Civil War."[54] This explanation serves three purposes: it allows the cultural work of Longfellow's poem—the eradication of the Indian—to be displaced onto the more laudable issue of abolition. Also, it represents the further eradication of Native American

subjectivity, as once more the Indian is put into service as a symbol for something else, subsequently highlighting Gerdts's, Nickerson's, Burgard's, Kleeblatt's, and Holland's investment in Lewis *as the black subject*. Finally, it gives credence to a grim possibility about the source of Lewis's agency. To recur to Patricia Hill Collins's argument, controlling images mask contradictions in social relations affecting all women, and unless Holland and other scholars who study Lewis are willing to consider Lewis's agency as a matter of the artist *as a black woman* wielding controlling images *against* Indian women, the premise of Lewis as the "Indian Maid" will continue to ring false. Lewis capitulates even as she recapitulates the dichotomy of otherness along the sliding scale of race, in this instance, that of the black knowing subject and the Indian known object.

INDIAN WORKS: IMAGES OF DISAPPEARANCE, ABSENCE, AND BETRAYAL

The period in which Henry Wadsworth Longfellow wrote *The Song of Hiawatha* and the period in which Edmonia Lewis sculpted works inspired by the poem were very different in terms of U.S. policy toward Native Americans. Longfellow conceived his trilogy of American epic poems (*Evangeline*, *Miles Standish*, and *Hiawatha*) during the Jacksonian era, which spans from General Andrew Jackson's war against the Creek nation (1813–14) through the presidencies of James Monroe (1817–25), John Quincy Adams (1825–29), and Jackson himself (1829–37) and culminates in the Compromise of 1850. As Michael Paul Rogin argues, "The primitive accumulation of Indian land by force and fraud . . . initiated the market revolution that created capitalist America, the political revolution called Jacksonian democracy, and the cultural revolution that established American national identity in the myth of the West."[55] The rapid expansion of the United States under Jacksonian-era politics and the Monroe Doctrine also spawned the expansion of African American enslavement, because for every free state admitted into the Union a corresponding slave state was admitted in order to maintain the delicate balance in the Senate. Recalling Ralph Waldo Emerson's insertion of "Negroes" and "Indians" into his litany of "American attributes," we are reminded of the interconnectedness of the fates of African Americans and Native Americans. As Rogin notes,

The Compromise of 1850, a last effort to preserve the Jacksonian political system, admitted California to the Union as a free state. "Expanding the area of freedom," in Jackson's term for taking Mexican territory, failed to benefit not only the slaves in Texas and the fugitive slaves in the North, but western Indians as well. California Governor Peter H. Burnett predicted, in his 1851 annual message, "That a war of extermination will continue to be waged between the two races until the Indian race becomes extinct" . . . Like the transportation and hyperexploitation of slave labor in the new world, which killed millions upon millions of Indians and blacks, the seizure of Indian land belongs to the history of slave and capitalist production.[56]

In the pursuit of westward expansion and the acquisition of private property, the South was therefore able to assert what it held in common with the rest of the country and thereby to divert attention from slavery. "Inevitability" was the word employed to explain the "disappearance" of the Indian, and as an explanation it allowed those responsible for the dispossession of the Indian to evade the appearance of human agency as they assumed the mantle of destiny or fate. And at least in this regard, North and South were united.

Alexander Saxton has characterized the Jacksonian revolt in American politics as originating from "outside and down." The participants were laborers—both skilled and unskilled, small farmers, Irish and German Catholic immigrants, and self-made men. The core member of this Democratic Party was as different from the patrician Longfellow as possible. However, Longfellow did share with this new Jacksonian man a belief in the inevitability of Indian racial extinction.[57] The ideology of the vanishing American transcended the regional differences between Jackson and Longfellow. Different groups and individuals responded to the ideology in different ways; some wanted to preserve Native American culture (in the visual arts, in folklore, in music, and so on) before it disappeared, while others welcomed the disappearance of the Indian without lament. Brian W. Dippie writes frankly about what, exactly, the ideology of the vanishing American was: "a cultural tradition, based on emotion, self-interest, and error, not logic or moral necessity, and serving ends that were deplorable and wicked."[58]

By the time that Lewis made her pieces inspired by Longfellow, the vanishing American was still a viable ideology as were the principles of

Jacksonian democracy. But with the end of the Civil War and the election of Ulysses S. Grant in 1869, the suppressed conflict regarding the fate of Native Americans—referred to commonly as the "Indian Problem"—re-emerged. And at least the eastern part of the nation was ready for peace with its Indian neighbors, which placed them at odds with western settlers. And here, despite the different perceptions of African Americans and Native Americans, one could exchange "African American" for "Native American" in Adolph Reed's discussion of the "Negro Problem." My adjustments are enclosed in brackets: "The initial formulation that 'America' has [an] '[Indian] Problem' not only reproduces the principle of [Indian] marginalization in the national experience; it also implies that the [Indian] experience exists insofar as it intersects white American concerns or responds to white initiatives . . . an instance of a general tendency to view [Indians] . . . 'simply as the creation of white men.'"[59]

One could argue that Lewis performed her Indianness (verbally and visually) in the context of yet another civil war—this time between East and West. As I intimated at the end of the previous section, she played a complicated game, a game that cannot be reconciled simply as a one-to-one correlation between her statements about her Indian past and her work in marble—such claims merely replicate the tautology but replace her "identity" with her "statements" as synonymous with her art. I contend that Lewis's rhetorical Indianness signified more than an authenticating maneuver on her part, and that the extent of her claims has yet to be properly understood or contextualized; I believe that her rhetorical Indianness diverged radically from her art and exposed a tension between past and future, extinction and the promise of renewal.

Images of Disappearance

At the time that Longfellow wrote *The Song of Hiawatha*, the visual as well as the literary arts reinforced the ideology of the vanishing American. In the visual arts, the vanishing American first appeared in the portraits of Charles Bird King and George Catlin during the early decades of the nineteenth century, and as a narrative subject in painting and sculpture toward the middle of the century. Like Longfellow's elegiac poem, those paintings and sculptures from midcentury posited the nation's beginnings as the end of the Indian. Tompkins H. Matteson's *The Last of the Race* (1847), for example, shows a small group of Native Americans literally at the edge of

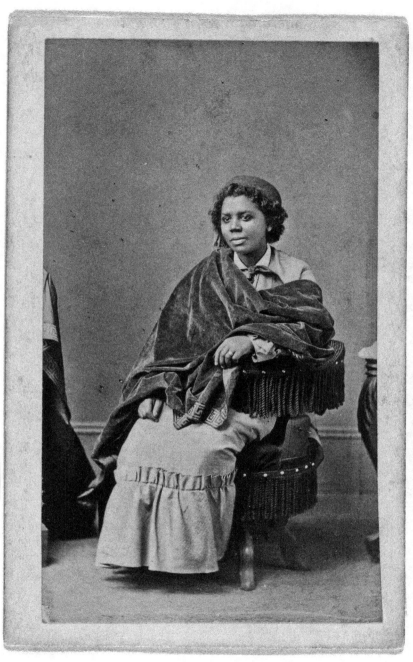

1　Henry Rocher, Carte-de-visite of Edmonia Lewis, ca. 1870. Albumen silver print,
3⅝ × 2¹⁄₁₆ inches. National Portrait Gallery, Smithsonian Institution. NPG.94.95.

2 Edmonia Lewis, *Forever Free (The Morning of Liberty)*, 1867. Marble, 41¼ × 22 × 17 inches. Howard University Gallery of Art, Washington, D.C.

3 Edmonia Lewis, *Central Park Lincoln*, 1872.
 Marble, 39 × 12½ × 11½ inches. Anonymous
 Collection. Photograph from the author's collection.

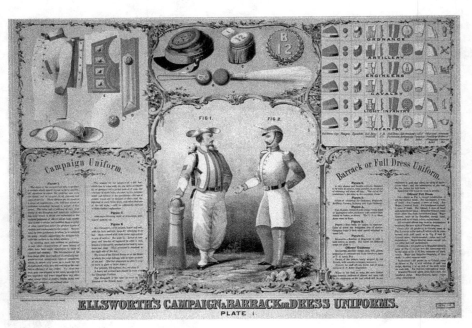

4 Edward Mendel, *Ellsworth's Campaign in Barrack or Dress Uniforms*, plate 1, 1860. Lithograph. Prints and Photographs Division, Courtesy of the Library of Congress. 42C.3; Digital ID# pga-02164.

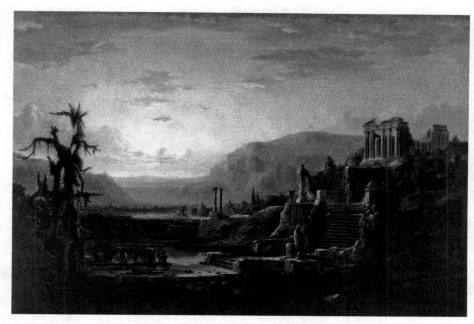

5 Robert S. Duncanson, *Classical Landscape with Ruins (Times Temple)*, 1854. Oil on canvas, 34 × 59 inches. Howard University Gallery of Art, Howard University, Washington, D.C.

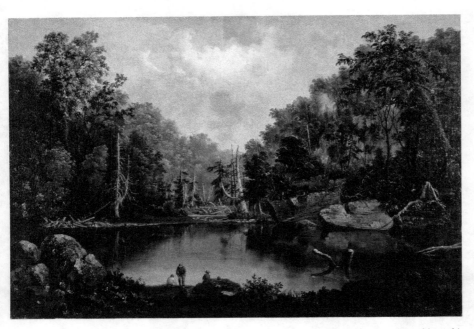

6 Robert S. Duncanson, *Blue Hole, Flood Waters, Little Miami River*, 1851. Oil on canvas, 29¼ × 42¼
 inches. Cincinnati Art Museum, Cincinnati, Ohio. Gift of Norbert Heerman and Arthur Helbig.
 Accession # 1926.18.

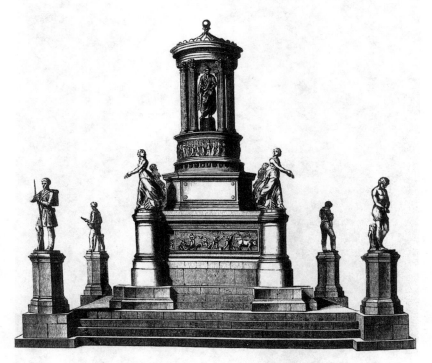

7 Harriet Hosmer, *Freedman's Memorial to Lincoln*, 1867. Plaster, height 74 inches. Ryerson and
Burnham Libraries, Chicago, Illinois. Photo courtesy of Ryerson and Burnham Libraries.

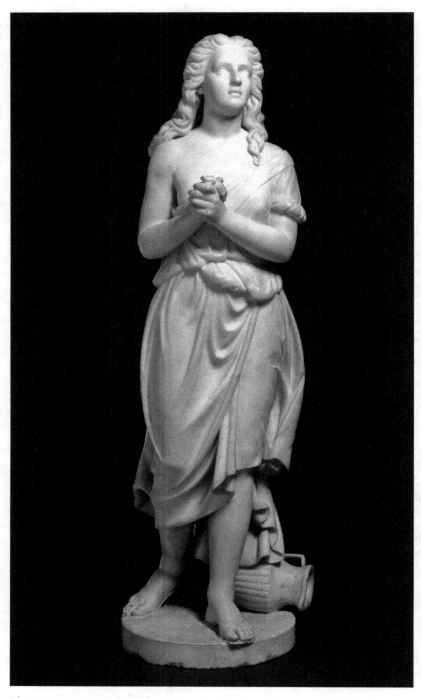

8 Edmonia Lewis, *Hagar in the Wilderness*, 1875. Marble, 52⅝ × 15¼ × 17 inches. Smithsonian American Art Museum, Washington, D.C. Gift of Delta Sigma Theta Sorority, Inc.

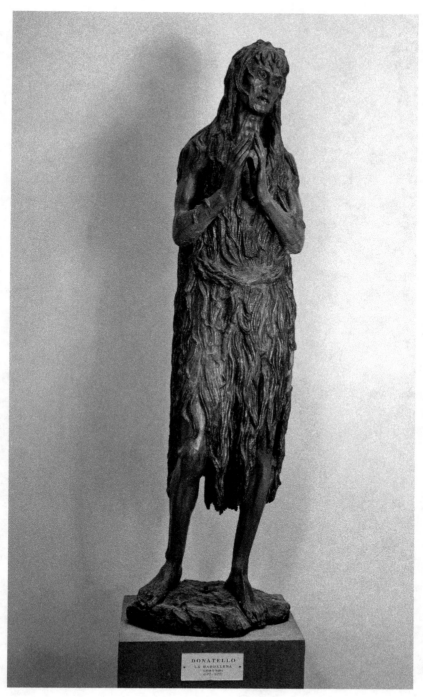

9 Donatello, *St. Mary Magdalene*, 1445–55. White poplar wood, polychrome, height 74 inches.
Museo dell'Opera del Duomo, Florence, Italy. Photo courtesy of Mary Ann Sullivan,
Bluffton University.

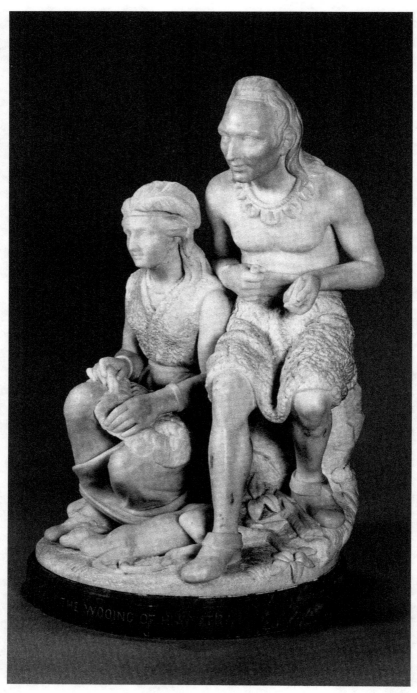

10 Edmonia Lewis, *The Wooing of Hiawatha*, 1866. Marble, 24 × 15 × 15 inches.
Walter O. Evans Collection.

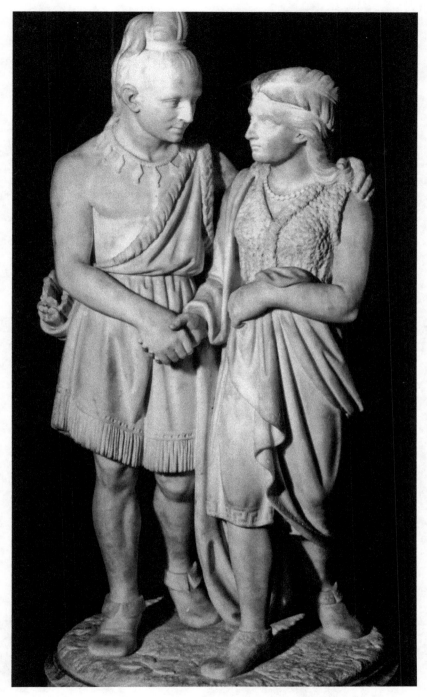

11 Edmonia Lewis, *Marriage of Hiawatha*, 1866. Marble, height 27 inches. Camille O. and William H. Cosby Jr. Collection. Photograph Courtesy of Sotheby's, Inc. © 1992.

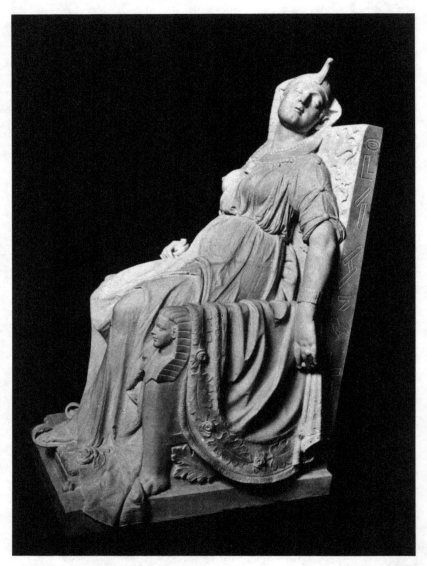

12 Edmonia Lewis, *The Death of Cleopatra*, 1875. Marble, 60 × 43 × 33 inches. Smithsonian American Art Museum, Washington, D.C. Gift of the Historical Society of Forest Park, Illinois. 1893 photograph Courtesy of the Chicago Historical Society, Chicago, Illinois.

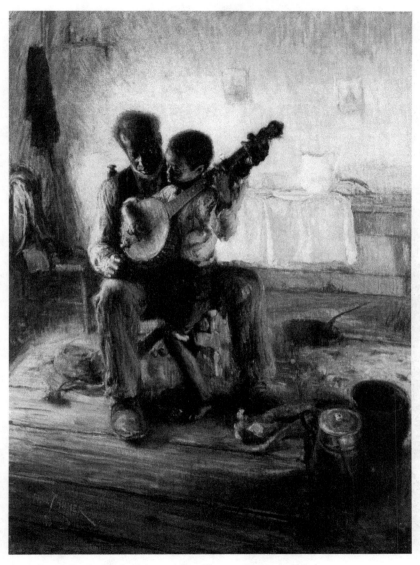

13 Henry Ossawa Tanner, *The Banjo Lesson*, 1893. Oil on canvas, 49 × 35½ inches.
Hampton University Museum, Hampton, Virginia.

14 Henry Ossawa Tanner, *The Good Shepherd*, ca. 1902–3. Oil on canvas, 28 × 36 inches. Jane
Voorhees Zimmerli Art Museum, Rutgers, the State University of New Jersey. In memory of the
deceased members of the Class of 1954. Photo by Jack Abraham. 1988.0063.

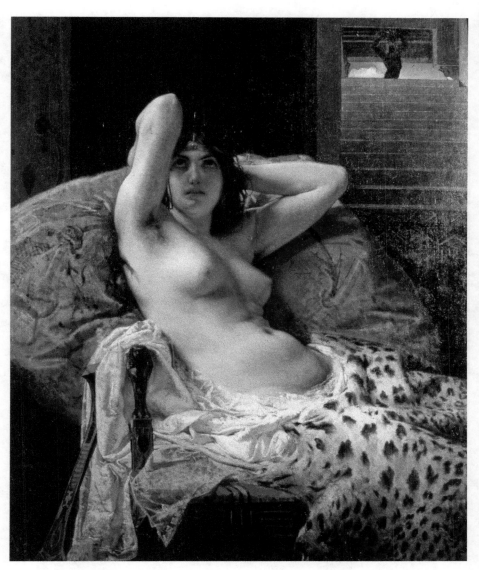

15 Mosè Bianchi, *Cleopatra*, 1865. Oil on canvas, 54 × 44 inches. Galleria d'Arte Moderna, Milan, Italy. Copyright Comune di Milano, all rights reserved.

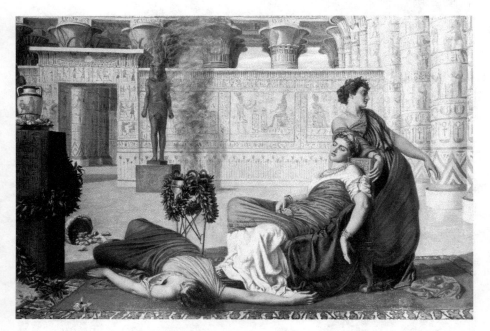

16 Valentine Prinsep, *The Death of Cleopatra*, 1870. Oil on canvas. Sotheby's, London, England.

their world, where land meets water, with no options except resignation to their fate (figure 10). In sculpture, Ferdinand Pettrich's *The Dying Tecumseh* (1856) and Erastus Dow Palmer's *Indian Girl, or The Dawn of Christianity* (1856) also reinforce the cultural ideology and tradition of the vanishing American, one disappearing through death and the other through conversion to Christianity (figures 11, 12). Alternatively, when not resigned to their fate, Native Americans were portrayed as impediments to civilization. In works such as John Mix Stanley's *Osage Scalp Dance* (1845), Indians are depicted as murderous barbarians, terrorizing a pioneer mother dressed in white and her half-naked child (figure 13). Such images of Indians share much in common with Longfellow's portrayal of them in *Miles Standish*.[60]

It wasn't until after the Civil War that the golden age for *Hiawatha* interpretations began; it lasted from 1865 to 1875 and was the age in which Edmonia Lewis worked. Lewis, together with other artists, resurrected Longfellow at a time of increased activism for some kind of cultural and political resolution to the "Indian Problem." In postbellum America, those activists such as Lydia Maria Child, William Lloyd Garrison, Charles Sumner, and Wendell Phillips (all supporters and patrons of Lewis), who had temporarily suspended their efforts on behalf of Native Americans during the war, turned their attention once more to the issue.[61] Formerly the mouthpiece for abolitionism, the *National Anti-Slavery Standard* was now geared toward the struggle for Native American rights, specifically the mistreatment of the Western Plains Indians under ruthless white settlers, territorial governors, Indian agents, and the military. Robert Winston Mardock, in his book *The Reformers and the American Indian*, explains, "In 1868, [Wendell] Phillips' concepts were still strongly influenced by the issues of the Civil War. His first postwar statement on Indian policy indicated that he perceived the troubles with the Indians as the diabolical plot of former Confederates." Phillips published his opinions in the *National Anti-Slavery Standard*, writing that if the federal army were forced to keep peace on the northwestern Plains, "the Ku-Klux, Forrest [rumored to be the head of the Klan], Hampton and the rest . . . [could] dip their hands in loyal blood with little chance of meeting their desserts." In the article, Phillips noted three impediments to real reform: popular indifference, the "selfish greed and bloodthirstiness" of white men on the frontier, and political intrigue. He warned, "We shall never be able to be just to other

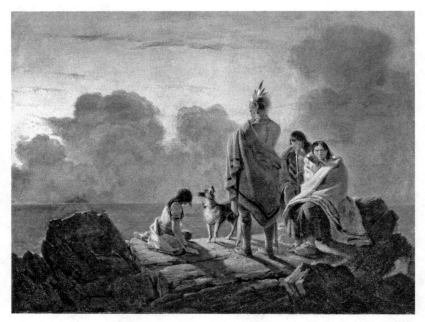

10 Tompkins H. Matteson, *The Last of the Race*, 1847. Oil on canvas, 39¼ × 50¹⁄₁₆ inches. Collection of The New-York Historical Society, New York City. Gift of Edwin W. Orvis on behalf of his family, 1931; negative #6311c; accession #1931.1.

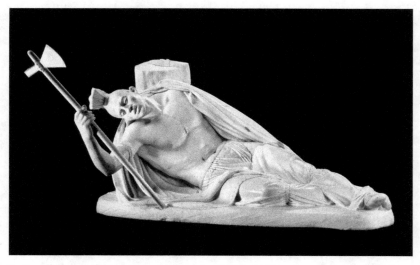

11 Ferdinand Pettrich, *The Dying Tecumseh*, 1856. Marble, length 77¼ inches. Smithsonian American Art Museum, Washington, D.C. Transfer from the U.S. Capitol.

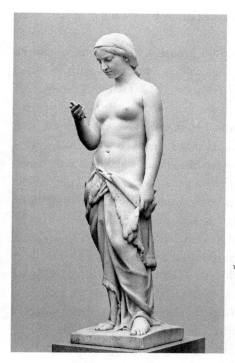

12 Erastus Dow Palmer, *Indian Girl, or
The Dawn of Christianity*, 1853–56. This
version, 1855–56. Marble, 60 × 19¾ ×
22¼ inches. The Metropolitan Museum
of Art, New York City. Bequest of Hamil-
ton Fish, 1894 (94.9.2). Image © The
Metropolitan Museum of Art.

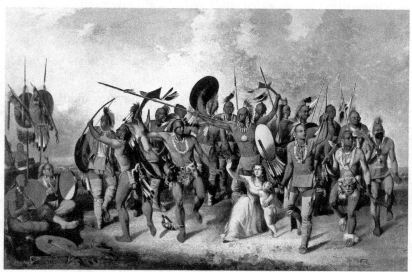

13 John Mix Stanley, *Osage Scalp Dance*, 1845. Oil on canvas, 40¾ × 60½ inches. Smithsonian
American Art Museum, Washington, D.C. Gift of the Misses Henry.

races, or reap the full benefit of their neighborhood till we 'unlearn contempt.'"[62]

Within the U.S. government itself, a group of congressmen organized the Peace Commission in the summer of 1867 to confer with so-called hostile tribes. As Mardock records, "Nathaniel G. Taylor, Commissioner of Indian affairs, was chairman of the Peace Commission, and Senator Henderson, John B. Sanborn, Samuel F. Tappan, General Sherman, and Major Generals William S. Harney, Alfred H. Terry, and C.C. Augur were its members. They were directed to establish peace with the hostile tribes, to remove, 'if possible,' the causes of war, and to secure the safety of the frontier settlements and the men who were building the transcontinental railroads. Also, they were to inaugurate a plan for civilizing the Indians."[63] The Peace Commission and the Quakers, who had a firm commitment to civil rights, certainly had the ear of President Grant. As a young officer stationed at Fort Vancouver, Washington Territory, Grant noted the horrors of Indian/white relations, with the Native Americans the recipients of "civilization" in the form of smallpox and whisky. When he was elected in 1869, he took care to state during his inaugural address, "The proper treatment of . . . the Indians — is one deserving of careful study. I will favor any course toward them which tends to their civilization and ultimate citizenship."[64] Thus, Grant was more than ready to listen to alternatives to military action against the Plains tribes, and his administration became known for its support of the Peace Policy, sometimes called the Quaker Policy.

Most of those in the East, especially among the humanitarians, envisioned cultural extinction for Native Americans; such was necessary as the first step to full assimilation. The ideology of the vanishing American would be realized through education and the weakening of the communal tribal system by redefining the Indian's relationship to property ownership in order to better reflect that of the dominant culture. The first step in the process of cultural assimilation was the reservation (and later boarding schools for the very young). "By the spring of 1869," Mardock comments, "the humanitarians generally agreed on the basic objectives that they wanted to see incorporated in the Peace Policy. The most important objectives were the reservation system, education, Christianization, the assimilation of the Indians into the social and economic system of the nation, and, finally, citizenship. These goals had to be accomplished without

bloodshed." The Grant Administration's plans for the reservation were quite specific; the intent was to concentrate all the western tribes upon a few large reservations, ideally in two large areas on public lands north of Nebraska and south of Kansas.[65] Also, conveniently, "surplus" land left vacant by the establishment of reservations would then be available for white settlement.

The transition from abolitionism to the struggle for the rights of Native Americans was symbolically complete when, on April 9, 1870, the Reform League was organized to replace the dissolved American Anti-Slavery Society. Their purpose was ambitious and sweeping in its goals: to promote the eradication of the caste spirit and to advance the cause of Native American civilization, the enfranchisement of women, temperance, labor, and prison reform. Frederick Douglass made an address at the first meeting, challenging the ideology of the vanishing American and stating that the Reform League was to continue in the spirit of the American Anti-Slavery Society, "to continue its activity through new instrumentalities, first for the Indian, whose condition today is the saddest chapter of our history. The most terrible reproach that can be hurled at this moment at the head of American Christianity and civilization is the fact that there is a general consent all over this country that the aboriginal inhabitants . . . should die out in the presence of that Christianity and civilization."[66]

Unlike their eastern counterparts, westerners did not have the long history of highly organized activism, intellectualism, or reformism. What they did possess, however, was firsthand experience of the Plains Indian, and the western response to the Indian Question was very much predicated on close contact with them. The spokesmen for the frontier region employed the Mississippi River as the traditional and convenient demarcation for the Great Divide between eastern and western attitudes toward the Indian. Western interests were also represented in Congress. As Mardock comments, "The formation of sectional and congressional Indian-policy battle lines, during the years 1865 through 1868, set the pattern for the disagreement and conflict that would emerge during the next ten years. The resulting lack of national unity, complicated by the Interior and War departments' disagreement about which could best manage Indian affairs, often seriously weakened the effectiveness of reform."[67] The most reliable source for western attitudes can be found in frontier editorials. For example, the editor of the *Kearney* (Nebraska) *Herald* wrote in July 1866,

"To the Indian, destruction is gain; it is a generative instinct and one which goes from infancy to the grave. Educated to look upon the white man with inveterate enmity, he ignores peace and civil associations. Now and then you will hear a chicken-hearted historian, who knows nothing of the red savage, extolling his noble characteristics and praising his knightly endowments. The earnest defenders of this barbarian monster would turn away in disgust could they see him in all of his original desperation. The best and only way to reconcile the blood-washed animal will be to impose upon him a worse schooling than has ever befallen the inferior races."[68] By "worse schooling," the editor meant total extermination by the U.S. Army. Those in the Western Territories wanted a strong military presence and actively sought the transference of the Indian Bureau out of the Department of the Interior and into the War Department. "Frontier people," Mardock points out, "did not necessarily consider military control of the Indians tantamount to extermination. They strongly supported the transfer measure because the Army, they believed, would be less expensive and more effective in handling the problem."[69]

Westerners accused their eastern counterparts of gross sentimentalism in their attitude toward the Indian. As Brian Dippie reveals, James Fenimore Cooper and "Cooper's Indians" became "code words for the easterner and his sentimental view of the noble red man." Literary conventions played such a significant role in the perception of the Indian that, to a large extent, those conventions established the specific form that the dichotomy of noble and ignoble savage took. Dippie explains, "In the nineteenth century, white thought on the Indian rarely transcended the literary conventions of noble savage and bloody savage. Western realism was no exception. Eastern sentimentalism would always distinguish between the savage and savagery; western realism simply assumed they were the same. Consequently, the Vanishing American found a home in the West."[70]

In this context, of a nation divided between East and West and striving to reach some solution to the "Indian Problem," Lewis performed her rhetorical and artistic Indianness. As Cynthia Nickerson observes, there were five artists in the postbellum era who were inspired by *The Song of Hiawatha*, enough to create works of art based on the poem: Albert Bierstadt (1830–1920), Thomas Moran (1837–1926), Thomas Eakins (1844–1916), Augustus Saint-Gaudens (1848–1907), and Edmonia Lewis. She

also notes, "The poem seems to have had its strongest appeal to artists who read the work in their youth. Three of the five were children when the poem was first published, Thomas Eakins was only eleven-years-old in 1855, Edmonia Lewis was ten, and Augustus Saint-Gaudens was eight. Even Thomas Moran at eighteen was still young enough to be impressionable. No doubt the Indian tale read repeatedly to or by a child would have given the poem an aura of magic and adventure that it *could not have had for an adult.* And admiration of a childhood hero could explain why all four artists did their Hiawatha works early in their careers."[71] While I believe that Nickerson's point is an excellent one, we cannot overlook the implications of associating *Hiawatha* with childhood and children's literature. Since its publication, the poem has carried those associations. In "The Universal Hiawatha," Joe Lockard reveals the link as directly related to social Darwinism. "As advanced technological societies that perceived themselves as having achieved 'maturity' searched out descriptions of civilizational hierarchy," he argues, "the metaphors of juvenilia were consistently employed to describe 'pre-civilizations' and to justify colonial behaviors. This civilizational presumption translated into a literary taxonomy that assigned a status of juvenile literature to *The Song of Hiawatha* and its Native actors. If the colonial subject was a child needing guidance, then the colonial subject as narrative was suitable for children. Thus *The Song of Hiawatha*, a work *demanding an adult reading capacity*, was deemed most appropriate for children."[72]

Of the five artists who interpreted Longfellow's poem, "adulthood" remained a question for only one—Edmonia Lewis. Her fellow sculptor Anne Whitney, in 1864, lamented Lewis's immaturity, deemed racial rather than chronological, in a letter to her family: "Edmonia is very much of an aboriginal—spiteful, vengeful, a little cunning and not altogether scrupulous about the truth when dealing with those she doesn't love; open, kind and liberal as day with those she does—I like her in spite of her faults and will help her all I can—I wish she were a little less of an aborigine about the ordering of her wigwam."[73] As Gustav Jahoda states in his book *Images of Savages: Ancient Roots of Modern Prejudice in Western Culture*, "The child image [of the savage] in general comprised a whole range of . . . character traits viewed as signs of immaturity. These included impulsiveness, emotionalism, lack of forethought, inability to concentrate and so

on."[74] Two years after Whitney, Lydia Maria Child made the association of the aboriginal with "youth" explicit in a letter to Sarah Sturgis Shaw about Lewis:

With regard to Edmonia Lewis, I partly agree with you and partly I do not. I do not think she has any genius, but I think she has a good deal of imitative talent, which, combined with her indomitable perseverance, I have hoped might make her something above mediocrity, if she took *time* enough. But she does *not* take time; she is in too much of a hurry to get up to a conspicuous place, without taking the necessary intermediate steps . . . Then you must remember that *youth*, in its fresh strength and inexperience, naturally thinks itself capable of doing *anything* . . . And it should not be forgotten that Edmonia is younger than young—brought up, as she was among Chippewas and negroes, without any education.

Child closes the letter with the following rumination: "I doubt whether we *can* treat our colored brethren *exactly* as we would if they were white, though it is desirable to do so. But we have kept their minds in a state of infancy, and children *must* be treated with more patience and forbearance than grown people. How can they learn to swim, if they don't dive into the water? They will sprawl about, at first, doubtless, but they will find the use of their limbs by dint of trying."[75] As Jahoda points out, no one really thought that savages were stupid, only ignorant and in need of proper socialization. "It was not so much that savages as individuals were looked upon as children," he contends, "but that their society was regarded as embodying an earlier stage—the childhood—of *humanity*." More importantly, Jahoda reminds us, "the practice of describing savages as children is to be understood symbolically, reflecting the preconception of the users concerning certain characteristics of both children and savages; and the particular features singled out are likely to relate to particular contexts."[76] I maintain that Lewis understood very well the construction of her as a "child/savage" and that she registered her understanding in every invocation of her Indianness as *belonging to the past*.

The significance of the past tense is what twenty-first-century scholars fail to comprehend. Over and over again, Lewis countered the construction of her as a perpetual *child* by relegating her Indianness to childhood. The function of naming is also significant in this instance, and Lewis had two: "Wildfire" was the name that embodied her past as an Indian, while "Mary Edmonia" was the name that embodied her entry into "civiliza-

tion" — school, art, and Catholicism. "My mother," she told the English art critic Henry Wreford in what was to become the standard story of her past,

was a wild Indian, and was born in Albany, of copper color, and with straight black hair. There she made and sold moccasins. My father, who was a negro, and a gentleman's servant, saw her and married her. I was born at Greenhigh, in Ohio. Mother often left her home, and wandered with her people, whose habits she could not forget, and thus we her children were brought up in the same wild manner. Until I was twelve years old I led this wandering life, fishing and swimming . . . and making moccasins. I was then sent to school for three years in [McGrawville], but was declared to be wild, — they could do nothing with me . . . From this school I was sent to another, at Ob[er]lin, in Ohio, where I remained four years.

After recounting the number of years she spent at Oberlin, Lewis then talked about a difficult choice, a choice that distinguishes her from her Indian mother and the habits her mother could not forget but that Lewis would deliberately put aside: "I thought of returning to wild life again; but my love of sculpture forbade it."[77] We must bear in mind two important things. First of all, when Lewis granted this interview in 1866, she was speaking to an audience of Europeans and abolitionist supporters in the East. Second, narratives of maturation are narratives of disappearance — the child into the (wo)man — and in this case Lewis performed her version of the vanishing American by placing that part of her life firmly in the past: before formal education, during her own "prehistory." In fact, by 1870, and appearing in at least three sources in 1876, it was reported that Edmonia Lewis "was born in a wigwam," a beginning that makes her subsequent education, travels, and life abroad seem all the more exceptional.[78]

In August 1873, seven years after her interview with Wreford, Lewis granted an interview to the *San Francisco Chronicle*. She was visiting to sell work at the Santa Clara Valley Fair in San Jose. Moreover, she was in the West during the height of tensions between eastern activists and western settlers, speaking to a western audience during one of the most volatile periods in the Plains Wars. Only one month had passed since Captain Jack, chief of the Modoc Nation of Northern California, was sentenced to death at Fort Klamath in July 1873. He was charged with the murder of three commissioners appointed by President Grant and sent to negotiate an end to the war between the U.S. government and the Modocs,

who had been pushed from their land.[79] Public outrage against the Modocs was strident. "The frontier population took full advantage of the tragedy," Mardock writes, "to express intense opposition to Indians, humanitarians, and the Peace Policy. In Jacksonville, Oregon, the populace claimed that Secretary Delano was responsible for the massacre and hanged him in effigy. At Yreka, California, citizens demanded prompt extermination of the Modocs, and at San Francisco, the press strongly denounced the policy of dallying with treacherous savages."[80]

It is interesting to note that between the time of her first major interview of 1865 with Lydia Maria Child for *Broken Fetter* and her trip to San Francisco in 1873, Edmonia Lewis had nothing to say publicly about the dispossession of Native Americans. As far as we know, she was never an advocate for Native American rights. What does surface, on the other hand, is Lewis's sensitivity to her different audiences and to the particular historical context in which she made her statements. She understood what audiences in the East were prepared to hear and she knew very well what audiences in the West wanted to hear. When Child asked Lewis about her childhood, Lewis admitted that she had lived with her mother's people. And when Child noted that she did not speak like "an untutored Indian," Lewis related that she had "been to school."[81] And thus begins the history — after the telling of the prehistory — of Lewis's ambition and career as a sculptor on an international level. Lewis's rhetorical Indianness took a decidedly different tone when she was in the West almost ten years later. Like most articles about Lewis, the one in the *San Francisco Chronicle* began with a description of her clothes, her appearance, her manner, and her heritage. Later in the article, the interviewer asked, "How is it you come to the Far West instead of remaining in New York, as most artists do?" Lewis answered, "Well, one reason is that I love to travel. I have Indian blood in me, you know, and I love the grand scenery of the mountains. Why, do you know I almost envied the freedom of the Indians which I saw on the plains? But then they were so dirty. I didn't like that in them. Then, another reason for coming here is, that in New York, the artists never thoroughly welcome a brother or sister. They seem to be anxious to get you out of the way, fearing that you will take something from their pockets. Here they are more liberal, and as I want to dispose of some of my works, I thought it best to come West."[82]

While Lewis praised the art world in the West as "more liberal," the same could not be said of westerners' attitude toward Native Americans compared to that of easterners. Obviously, something very different and disturbing emerged from her interview in San Francisco, something that reveals, I believe, the nature of Lewis's investment in her rhetorical Indianness. And unless one is able to isolate what opportunities Lewis identified and targeted, the claim that she was an "opportunist" (no matter how deserved) is inadequate. In order to make clear what her investment in rhetorical Indianness signified, four issues must be addressed at this point: the significance of "playing Indian"; Lewis's invocation of dirt; the issue of "authenticity" as a strategy within play; and the construction of the Indian as freedom. Although Philip J. Deloria's book *Playing Indian* is concerned primarily with the study of white males who, throughout colonial and U.S. history, have "played Indian" to claim an aboriginal American identity, consolidate national power, or return to nature and the authentic, I believe that what he has found is germane to Edmonia Lewis, because Lewis "played Indian" not as a latter-day Pocahontas or mythical Minnehaha, not as "the Indian Maid"; rather she "played Indian" on a level *consistent with* white males.[83] After all, why *would* she negotiate a lateral position for herself, careening improbably between controlling images associated with black womanhood and those associated with Indian womanhood?

As has been noted earlier, we can verify little concerning Lewis's parentage and childhood. At best, we know that her mother was not "full-blooded Indian" as Lewis claimed; rather, she was perhaps only one-third Chippewa who married a man of African descent, further diluting Lewis's claims to biological, racial "Indianness." Nevertheless, Lewis did "play Indian" in the fashion understood by Deloria: she did dress up in Indian costume; and rather than join an organization that espoused "Indian" principles such as the New Confederacy of the Iroquois (1842–46), she belonged to a "real" tribe and had the "real" experience of making moccasins and selling to tourists. Lewis constructed her "play," however, as having existed in the past. And now, Lewis's "costume" is a costume made of marble and of words, words that function in both the past and the present—words that link to memories and words that connect blood to behavior and behavior to "appearance" (that is, an appearance defined syllogistically by what her audience expected to see based on their belief in "blood"). Moreover,

Deloria suggests that playing Indian offered Americans a national fantasy that made them citizens of the land itself. And, I believe, Lewis participated in this national fantasy.

Like her slavery work, Lewis's rhetorical Indianness and her Indian work was made up of distances. Lewis employed nostalgia to distance herself from her Indian past. In the West, Lewis invoked dirt to distance herself from the Indians of the present and those she may have considered culturally different from herself—Plains as opposed to Chippewa. Lewis also appears to align herself with western realists over eastern sentimentalists in a manner reminiscent of Mark Twain's conversion. Twain, who had once considered himself firmly in the camp of "romanticizing" the Indian, published *Roughing It* in 1872, one year prior to Lewis's trip. It was an account of his trip to the far West in which he describes the Gosiute (Shoshone) Indians of Utah:

Such of the Goshoots as we saw, along the road and hanging about the stations, were small, lean, scrawny creatures; in complexion a dull black like the ordinary American negro; their faces and hands bearing dirt which they had been hoarding and accumulating for months, years, and even generations, according to the age of the proprietor; a silent, sneaking, treacherous-looking race . . . a thin scattering race of almost naked black children, these Goshoots are, who produce nothing at all, and have no villages, and no gatherings together into strictly defined tribal communities—a people whose only shelter is a rag cast on a bush to keep off a portion of the snow, and yet who inhabit one of the most rocky, wintry, repulsive wastes that our country or any other exhibit.[84]

Thus, one year after Twain's blistering assault on the Gosiute and his comparison of them to blacks, Lewis's invocation of dirt reinforces negative stereotypes of Indianness (and blackness) while simultaneously distancing her from those stereotypes. As the cultural anthropologist Mary Douglas has shown, dirt is part of a complex symbolic system, and to call someone "dirty" involves the imaginative construction of oneself as clean. "If we can abstract pathogenicity and hygiene from our notion of dirt, we are left with the old definition of dirt as matter out of place. This is a very suggestive approach. It implies two conditions: a set of ordered relations and a contravention of that order. Dirt then, is never a unique, isolated event. Where there is dirt there is system. Dirt is the by-product of a systematic ordering and classification of matter, in so far as ordering involves rejecting

inappropriate elements. This idea of dirt takes us straight into the field of symbolism and promises to link-up with more obviously symbolic systems of purity."[85] By referring to the Plains Indians as "dirty," Lewis seems to imply that they were both matter out of place and matter out of time, but most importantly they were not like her.

Conversely, the "not her" was also "her"; even as she denied any association with Plains Indians, she reserved for herself the right to "be" Indian. And thus, one could reasonably argue that within the "game," Lewis employed authenticity as strategy. In countless interviews, either the interviewer or Lewis establishes the characteristics that she shared with "Indianness." For instance, Lewis attributes her love of travel to her "Indian blood." The *San Francisco Chronicle* reported during the Santa Clara Valley Fair and Races of 1873 that as well as having been born in a wigwam, "Miss Edmonia Lewis occupies a wigwam (so she prefers to call it) at the foot of the main aisle, in which she has on exhibition three unsold pieces of sculpture from her studio in Rome."[86] In other words, Lewis was wholly complicit in the construction of herself as "authentic," and by extension "other." Deloria observes, "The authentic, as numerous scholars have pointed out, is a culturally constructed category created in opposition to a perceived state of inauthenticity. The authentic serves as a way to imagine and idealize the real, the traditional, and the organic in opposition to the less satisfying qualities of everyday life . . . Because those seeking authenticity have already defined their own state as inauthentic, they easily locate authenticity in the figure of an Other. This Other can be coded in terms of time (nostalgia or archaism), place (the small town), or culture (Indianness)."[87] Lewis's otherness in the West embraced all three codes named by Deloria: temporally, Lewis mentions her envy of the freedom of the Plains Indians, but it was an envy based on nostalgia rather than fantasy. In terms of place, Lewis as an easterner (and expatriate) visiting the West was also other. Culturally, she was doubly other—Chippewa as opposed to Plains and Indian as opposed to white. I contend that Lewis willingly embraced the construction of her as authentic and therefore other, but for a greater goal.

It was Lewis's freedom-as-memory that reconciled her as both other and authentically American. The construction of the Indian as symbolic of "freedom" had a long history on the American continent. According to Deloria, "Whereas Euro-Americans had imprisoned themselves in the logical mind and the social order, Indians represented instinct and free-

dom. They spoke for the 'spirit of the continent.' Whites desperately desired that spirit, yet they invariably failed to become aboriginal and thus 'finished.' Savage Indians served Americans as oppositional figures against whom one might imagine a civilized national Self. Coded as freedom, however, wild Indianness proved equally attractive, setting up a 'have-the-cake-and-eat-it-too' dialectic of simultaneous desire and repulsion."[88] Whites who "played Indian," could only temporarily reconcile what it meant to be "American," allowing them to hold in abeyance the contradictions of a society founded on principles of freedom that were belied by its everyday practices — from gender inequity, to slavery, and to the dispossession and genocide of Native Americans. As Deloria demonstrates, Americanness is a process, "not so much the product of a collision of European and Indian as it is a particular working out of a desire to preserve stability and truth while enjoying absolute, anarchic freedom."[89] Lewis, on the other hand, having access to both experiences — the wildness of the Indian and the concomitant freedom that it brought, and the experiences of Euro-American civilization — was "finished," a complete and completed American. Her personal narrative of disappearance (which embraces both the nation's prehistory and its history) reflects, reinforces, and displaces onto her the imperial language of the United States. I offer again in this context more of John Greenleaf Whittier's remarks in "The Indian Question" as presented in 1883: "The school experiments of Hampton, Carlisle, and Forest Grove in Oregon have proved if such proof were ever needed, that the roving Indian can be enlightened and civilized, taught to work and take interest and delight in the product of his industry, and settle down on his farm or in his workshop as an American citizen, protected by and subject to the laws of the republic."[90] By essentializing the process of Americanization, by performing her personal version of "American Indianism," Lewis renders invalid the process as it happens for whites and elevates herself as the "true" author(ity) of Americanness. She embodies not the work of the master (Longfellow) or the narrative of Pocahontas, as Juanita Holland argues, but the narrative of the nation.

The Absence of Hiawatha

Lewis's gentle and sentimental pieces based on *The Song of Hiawatha* were among her most popular. For her ideal works, Lewis focused on two scenes: the courtship and the marriage of Hiawatha and Minnehaha. She

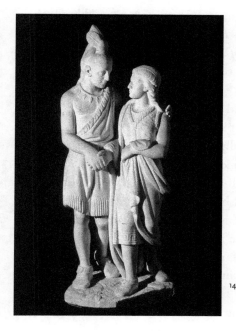

14 Edmonia Lewis, *Marriage of Hiawatha*,
1868. Marble, 29 × 11½ × 12 inches.
Walter O. Evans Collection.

created her first sculpture of the courtship in 1866, and by 1875 she had pro-
duced at least three additional versions of it in marble, renaming successive
copies *Old Indian Arrowmaker and His Daughter* (plate 10; figure 5).[91] In
1866 she also created her first sculpture of the marriage of Hiawatha and
Minnehaha, and by 1875 she had sculpted at least three more versions of
Hiawatha's Marriage[92] (plate 11; figure 14). Concurrently, Lewis began to
mass-produce single busts of Hiawatha and Minnehaha, to be sold as sets
(figures 8, 9).

Lewis entered a crowded field of Longfellow interpreters. Representa-
tions based on *The Song of Hiawatha* were rendered in painting and sculp-
ture and in the increasingly popular print media as well as on stage. The
printmakers were the earliest interpreters of the poem and the swiftest
to capitalize on the poem's popularity; they are the exception in the hia-
tus of ten years between the publication of the poem and its visualiza-
tion. As early as 1857, J. E. Tilton was advertising his engraving *Hiawatha's
Wooing* in the *Home Journal*.[93] In the meantime, between 1858 and 1868,
Currier and Ives published seven lithographs by Louis Maurer based on
The Song of Hiawatha.[94] In 1858 (and later reissued) they printed Louis

Maurer's *Hiawatha's Wedding* (figure 15). Then in 1860 (and likewise later reissued) they illustrated Maurer's *Hiawatha's Wooing* (figure 16). In 1867 and 1868 they printed *The Death of Minnehaha* and *Hiawatha's Departure*. Finally, they produced a vignette titled *Minnehaha, Laughing Water* (no date).[95]

When in 1872 Lewis sculpted the scene from Hiawatha's wooing of Minnehaha she renamed the piece *Old Indian Arrowmaker and His Daughter* although it was essentially the same image as before.[96] As in the 1866 version, Lewis arranged Minnehaha by the side of her father, the Old Arrow-maker. Industrious and self-sufficient, he makes arrowheads while she "[plaits] mats of flags and rushes," and while he dreams of the past, she dreams of the future. Those familiar with the poem would have realized that the viewer stands in the place of Hiawatha, whose presence is implied by the small deer that rests on the ground in front of Minnehaha, or Laughing Water as she is sometimes known, and the Old Arrow-maker. "At the feet of Laughing Water / Hiawatha laid his burden, / Threw the red deer from his shoulders; / and the maiden looked up at him, / Said with gentle look and accent, / 'You are welcome, Hiawatha!'" Lewis has composed the group so that they look up and out, beyond the realm of their sculpted space to the viewer, who, as Hiawatha, has just placed the deer before the father. Minnehaha is on the threshold of womanhood, at the point where she will exchange one patriarchy for another as she is transferred willingly from father to husband. She also exchanges one nation for another, she moves from the Dacotah, her father's people, to the Chippewa. As a woman, her identity is fluid, for although she was born of the Dacotah, her children will be of the Chippewa.

Like *Forever Free*, *The Wooing of Hiawatha* is a celebration of patriarchy and patriarchal continuity; moreover, both sculptures adhere to patriarchy under the assumption of white, Protestant, Victorian, and sentimental norms. The placement of the two figures relative to one another reinforces that patriarchy, for Minnehaha sits lower than her father, while both look up to the absent or implied figure of Hiawatha. In her sculptures, Lewis evokes a patriarchy that comprises black and Indian men and a patriarchy that is founded on and undergirded by feminine consent. Lori Merish has identified feminine consent as a new category of feminine agency within late-eighteenth- and nineteenth-century discourse. She explains that it is "derived from pietistic Protestantism, defined as voluntary emotional ori-

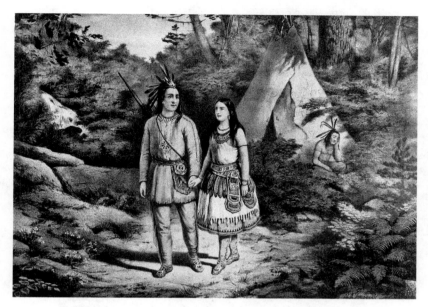

15 Louis Maurer, *Hiawatha's Wedding*, 1858. Lithograph, 19⅞ × 23⁹⁄₁₃ inches. Currier and Ives. Collection Muscatine Art Center, Muscatine, Iowa. Accession # 1988.26.

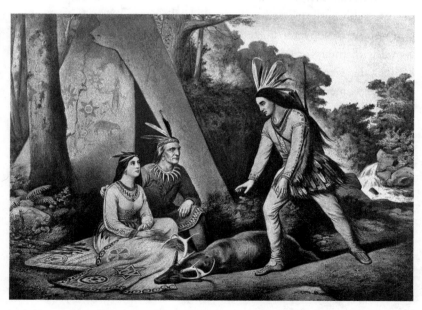

16 Louis Maurer, *Hiawatha's Wooing*, 1860. Lithograph, 19⅞ × 23⁹⁄₁₃ inches. Currier and Ives. Museum of the City of New York.

entation or affiliation." Such voluntary emotional orientation or affiliation was characterized as feminine "taste," which elevated and recognized feminine choice and preference as a positive reflection on the superiority of American men and American social forms.[97]

Although it does bear a striking resemblance to the Currier and Ives print, Lewis's image of Hiawatha's courtship cannot be explained entirely on that resemblance. Whereas the Currier and Ives print contains all three principles in the courtship drama, Lewis deliberately excludes Hiawatha from the composition. And although far from common, there is precedent for three-figure groups in nineteenth-century U.S. sculpture. But just as the absence of Ishmael in Lewis's statue of Hagar nuances the work in unexpected and surprising ways, the absence of Hiawatha functions to similarly shade the meaning of the sculpture so that it resonates in an unforeseen manner. In the Currier and Ives print, Minnehaha's father sits with his arm around the shoulders of his daughter, who sits modestly with hands folded and gazing attentively up at Hiawatha. Conversely, in Lewis's sculpture, both Minnehaha and her father are occupied making gender-appropriate objects.

With the absence of Hiawatha, Lewis has transformed a sculpture dealing ostensibly with those rites of passage leading to marriage into an image reminiscent of souvenir makers, rendering these Indians as present and coeval with their viewers/customers. Mats, like the one being woven by Minnehaha, were common touristic commodities produced by Chippewa men and women and sold at popular places like Niagara Falls. (Although Longfellow has Minnehaha belonging to the Dakotah, I do not believe that Lewis was too concerned about cultural accuracy.) Mats were made of cloth and beadwork, moose hair and birch bark, sweet grass, cloth, and quills (figure 17). And when in 1821 Henry Rowe Schoolcraft published *Travels through the Northwestern Regions of the United States*, he not only recorded "Indian Manufactures" such as a canoe, moccasins, a pipe, birch bark box, arrowhead, and a rolled mat but also provided a "shopping list" for "authentic" Native American wares (figure 18). Thus, Minnehaha's father participates in an authentically "Indian" endeavor, even as he references the prehistory of Longfellow's Indians prior to the arrival of white men. Compare, for example, Lewis's sculpture with a stereoscopic view of Tuscarora women selling items to interested white tourists at Niagara Falls (figure 19).[98] The caption on the card reads, "Tuscarora Squaws—Luna

17 Ojibwa, mat, 1869. Birch bark, sweet grass, and quills, diameter 12½ inches. Royal Pavilion Gallery and Museums, Brighton, England. 1920/04.

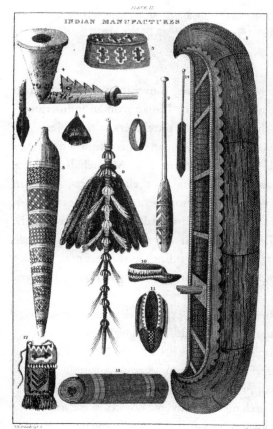

18 Henry Rowe Schoolcraft, Indian Manufactures, reproduced in *Travels through the Northwestern Regions of the United States*. (Albany: E. and E. Hosford, 1821), plate 2, p. 68. Facsimile courtesy of the Library of Congress, Washington, D.C.

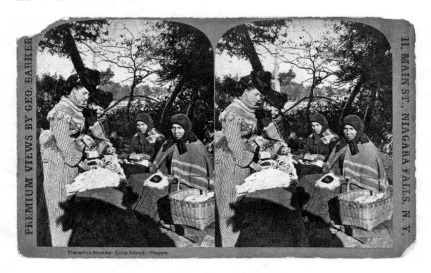

19 George Barker, *Tuscarora Women at Luna Island, Niagara*, 1865. Stereoscopic card, 3½ × 7 inches. Notman Photographic Archives, McCord Museum of Canadian History, Montreal. 7383-View. Courtesy of George Eastman House.

Island — Niagara." It is a souvenir card about souvenirs. The white women pick carefully through the wares while one Indian woman industriously makes the objects for sale, thus assuring the purchasers of the objects' authenticity. Meanwhile, the other Indian woman holds a finished sampler on her lap, obviously "selling" to the camera. Like Minnehaha and her father, the Native American women pose with their products; and as in the photograph, in Lewis's work the commodities are still in the process of being made. By its very familiarity to tourists and souvenir hunters of the nineteenth century, then, Lewis's image directly contravenes Longfellow's account of Hiawatha as "prehistory" and reminds us that her own account of her Indian childhood is part of the past, reconstructed now in refined white marble for a higher caste of tourists.

In *Trading Identities*, Ruth B. Phillips explores the desire of souvenir shoppers to have an authentic experience. Thus, given the overwhelming demand that they assimilate, souvenirs became for Native Americans a means for cultural survival and for discourse cross-culturally. Phillips writes, "The various forms of production for the tourist market, and especially the production and exchange of souvenir objects, were important means by which Aboriginal people engaged in a continuing negotiation of

the texts of Indianness current in Euro-North American society."[99] Souvenirs allowed the maker-sellers to continue to make the meaningful objects and forms that made up part of their ritual lives. Souvenirs also allowed for change, as in the crafting of objects nonnative to the maker-sellers, for example, Victorian card trays made of birch bark. Of equal importance to the product was the mode of selling, something which Lewis seemed to have understood when she told the *San Francisco Chronicle* that she was "occupying a wigwam" in order to attract visitors to the fair to purchase her "souvenirs." Like souvenir sellers, Lewis was constructed as a picturesque figure. As Phillips observes, "Written accounts are consistent in constructing souvenir sellers as picturesque figures. These texts [like the articles that featured Lewis, I would add] articulate unambiguously the way in which buyers transferred sentimental, archaizing significations from the figure of the maker-seller to the objects themselves."[100]

Through its references to tourism and souvenirs, *The Wooing of Hiawatha* instantiates the ideology of the vanishing American by way of a present and presence soon to be absent. Lewis's image places us on the cusp between prehistory and history, as Minnehaha and her father are captured forever in the process of pleasing their customers and as Hiawatha is "traded" for the tourist. Concomitantly, tourism functions in a manner similar to "playing Indian." Like playing Indian, tourism allows for a sense of wholeness or completeness. Phillips asserts, "Tourism is an important response to a widely felt need to recover experiences of cultural wholeness and integration understood to have been ruptured by industrialization and urbanization . . . the souvenir, whether picture postcard or decorative object, [is] an essential element in the structure of the touristic experience, necessary as a 'marker,' or concrete evidence, of the ephemeral experience that has been consumed."[101] The selling of souvenirs is an integral part of tourism, while the exchange of souvenirs for cash gives its buyers that sense of wholeness and completeness by conferring on them new identities, that of Natives of North America, "appropriating the place formerly occupied by the Indian. The Aboriginal seller who has, meanwhile, been transformed by the consumer economy into a producer of his own ethnicity can safely be dismissed. He is now a supplier to the *arrivées*, justifying their belief in his approaching oblivion. When the last souvenir has been bought, the selling out of the Indians will be seen to be completed."[102]

I contend that, in her Indian and slavery works, Lewis both referenced

and exploited the market in aboriginality and ethnicity. In referencing aboriginality, Minnehaha and her father make souvenirs even as they will be sold as souvenirs, and given the small size of the sculptures (each averaging about twenty-four inches high) this idea is not wholly improbable. They also serve as a visual cue or reminder of Lewis's own childhood, when she dressed up and played Indian, wandering with her mother's people and making and selling objects for tourist consumption. In terms of exploitation, the distinction should be made between its negative connotations — to take selfish or unfair advantage of a person or situation, usually for personal gain — and its more constructive significations. An "exploit" is an interesting or daring action or achievement, and the more positive shading of "exploitation" — to use or develop something in order to gain a benefit — is more appropriate to Lewis's endeavor. In a climate of such heightened racialism, she dared to respond not selfishly or unfairly but *in kind*. Those who would charge her with an unfair or selfish advantage seem to interpret that advantage as her "race," a fixed and real thing in their estimation that allows her the dual status of "victim" and "authentic," either of which confers on her some type of "power." Lewis was neither a victim nor was she authentic in the essentializing ways that she has been interpreted previously; rather she seemed to understand that "race" is one discursive field among many that could be put into play at opportune times. Even as her verbal reminiscences placed her Indianness firmly in the past, she (re)produced her ethnicity in marble. She employed "the past" and "dirt" as strategy to establish the necessary distances from that ethnicity in order to maintain her authority as artist and herself as the author of her own experiences.

The Betrayal of Sentimentalism

Significantly, Lewis continued her ideal works inspired by Longfellow with at least four versions of *The Marriage of Hiawatha*, and the three extant versions of the sculpture bear subtle differences in appearance. In the earliest documented version, currently in the Bill Cosby collection and engraved 1866, the base is beveled at the top and matches its pendant *The Wooing of Hiawatha*, which is also engraved with the date 1866 and is in the collection of Dr. Walter O. Evans (plates 10, 11). The *Marriage* that is in the Evans collection, dated to about 1868, shares with its Cosby *Marriage* counterpart a number of similarities — Minnehaha's left arm crosses

in front of her body and supports a drape of fabric from her cloak; a geo-metric design boarders the material of her skirt; her skirt discreetly covers her knees in both versions; and the top of Hiawatha's togalike garment is bunched over his belt (figure 14). Furthermore, Minnehaha's face in the earliest *Marriage* is not distinguishable as Native American and thus matches the faces of Minnehaha in the extant examples of the *Wooing* and the ethnographically indeterminate faces of Native American women as represented by artists such as Erastus Dow Palmer in *Indian Girl, or The Dawn of Christianity* and Hiram Powers in *The Last of the Tribes* (fig-ures 12, 20). Between the Cosby (1866) and Evans (ca.1868) versions of *The Marriage of Hiawatha*, however, Lewis appears to have manipulated the profile of Minnehaha so that her nose is quite prominent and in fact matches the profile of Hiawatha (plate 11; figure 14). For the extant version with the latest date, 1871, Lewis continues the prominent profiles of Hia-watha and Minnehaha along with other variations that make it different from the earlier two (figure 21). Hiawatha's arm remains around Minne-haha and they still clasp right hands, but Minnehaha has raised her hand to her chest, her skirt now rises a little above knee level, and Lewis has aban-doned the geometric design that borders the end of her skirt for a vague biomorphic design, seemingly embroidered with one continuous thread. Also, Hiawatha's garment is more fitted and does not blouse over his belt and the fringe around the bottom of the garment is more stylized.

Nevertheless, each rendering of *The Marriage of Hiawatha* provides a perfect visual accompaniment to the verses from the narrative poem: "From the wigwam he departed, / Leading with him Laughing Water; / Hand in hand they went together, / Through the woodland and the meadow, / Left the old man standing lonely / At the doorway of his wigwam."[103] In Lewis's sculpture, as the married couple walks away from the home of the Arrow-maker, their path is strewn with flowers, which invokes their jour-ney through woodland and meadow. In each version, the couple steps out with their right legs and their left legs are bent at the knee, all the while gazing raptly at one another. Hiawatha drapes his left arm around Minne-haha, and his hand rests protectively and with affection on her shoulder in much the same spirit as the black male touching the female in *Forever Free*. The right hands of Hiawatha and Minnehaha are clasped, signifying their bond of marriage.

The couple seems to enact both the metaphorical ideal that figures mar-

20 Hiram Powers, *The Last of the Tribes*,
 modeled 1867–72; carved 1876–77. Marble,
 66⅛ × 22¾ × 32 inches. Smithsonian
 American Art Museum, Washington, D.C.
 Museum purchase in memory of Ralph
 Cross Johnson.

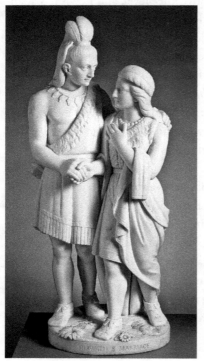

21 Edmonia Lewis, *Hiawatha's Marriage*, 1871.
 Marble, 31½ × 5½ × 12 inches. Cincinnati
 Art Museum, Cincinnati, Ohio. Anonymous
 Loan. Accession # L11.1993.

riage as a journey as well as the sympathetic exchange that puts them on par with white, middle-class norms pertaining to marriage. As Ellen K. Rothman observes in *Hands and Hearts: A History of Courtship in America*, "The transition to marriage was both a private journey and a public rite of passage."[104] The journey of marriage begins with courtship. When read within the realm of family rather than the touristic experience, Lewis's representation in *The Wooing of Hiawatha* is therefore a domestic scene—replete with gender-appropriate activities—that finds continuity in *Marriage*. Lewis's initial emphasis on the domestic is highly significant. Her visual strategy had much in common with Harriet Beecher Stowe's literary strategy. As Lori Merish argues, "The intimate relation, for Stowe, between having a home and being a person is measured by the fact that she typically frames her introduction of new characters with descriptions of their domestic surroundings; and her chief narrative strategy for representing the humanity of members of different races is showing that they do indeed keep house."[105] Given Lewis's exposure to Chippewa wigwams, she may have weighted the significance of the mats that Minnehaha weaves, referencing both touristic souvenirs and the mats used to cover their lodge (figure 22).[106] Thus, Minnehaha is perhaps also actively creating the domestic space.

I contend that it was a Victorian marriage that Lewis was referencing, just as she did in her slavery works. Her audience was overwhelmingly white and middle class and worshipped Longfellow, whose highly sentimental poems not only reflected their society as they idealized it but also shaped it. "For this generation," claims Rothman, "romantic love was the only means to the end for which both men and women assumed they were destined: marriage. Marriage, they believed, must be based not on transient passions but on sympathy and shared interests. The vision of romantic love that prevailed in the mid-1800s stressed mutuality, commonality, and sympathy between man and woman—precisely those qualities most likely to bridge the widening gap between home and world . . . they must have a mutuality of tastes and interests because they might have little else to share."[107] These qualities also helped to bridge the power gap between men and women. Unlike the Currier and Ives print that inspired Lewis's composition, her version of the marriage is extremely romantic. In Louis Maurer's print, Minnehaha and Hiawatha walk away from the wigwam of her father, hand in hand, but not really acknowledging one another (figure 15). Conversely, in Lewis's sculptures, Minnehaha and Hiawatha are hyper-

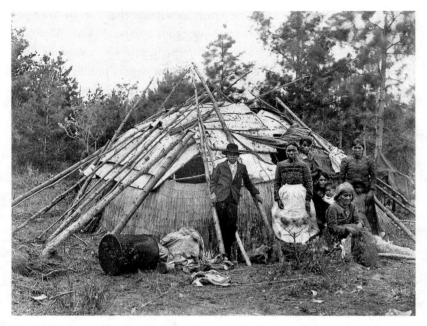

22 Edward Augustus Bromley, Birch bark and lake grass wigwam at Leech Lake Agency, 1896.
Photo courtesy of the Minnesota Historical Society, St. Paul, Minnesota. Loc# E97.31 p.50;
Neg# 10515.

aware of one another: they gaze at one another and their contact expresses both mutuality and partnership and, simultaneously, Hiawatha's possession of Minnehaha. The gender dynamics are in the sentimental mode, a clear reference to feminine consent to male power.

All of Lewis's ideal works were in some way responses to the dominant ideologies of the cults of sentiment and true womanhood. Yet the reaction of Lewis's contemporaries to her sentimental sculptures was not always favorable, while twentieth- and twenty-first-century scholars have found her limited as well. An example of the former is Henry T. Tuckerman's *Book of the Artists*, consisting mostly of data gathered from letters and articles written by third parties.[108] Tuckerman included Lewis in the first edition of his book (1867) in the section devoted to women sculptors working in Rome. (Lewis is the only African American artist included in Tuckerman's work.) The entry on Lewis is notable in commenting on both her African American and Native American subject matter. More revealing, however, of a certain critical mindset of the period is a passage that focuses on her

Native American subject matter and on the quality of her work. Quoting directly from the unnamed sources, Tuckerman wrote,

Miss Lewis is by no means a prodigy; she has great natural genius, originality, earnestness, and a simple genuine taste. Her works are as yet those of a girl. She has read Evangeline, and some others of Longfellow's poems, and has caught from them a girlish sentimentality, but has rather improved upon her author's conceptions in the process of giving them shape and reality. By and by, when her horizon of knowledge becomes more expanded, and her grasp on it firmer, she will leave the *prettiness* of poems, and give us Pocahontas, Logan, Pontiac, Tecumseh, Red Jacket, and, it may be, Black Hawk and Osceola. Or if these may seem too near and real, and admitting less of effective accessories, there lie behind them all the great dramatic characters, Montezuma, Guatimozin, Huascar, and Atahualpa, to say nothing of Malinche, that lost her country that she might save her love.[109]

Unlike Lydia Maria Child, who finds nothing of genius in Lewis, Tuckerman's source allows Lewis "natural genius." The reference to "girlish sentimentality" is telling on a number of levels (recall the inescapable association with childhood that Lewis could not shake). In Victorian America, the words *girlish sentimentality* were practically redundant, for sentimentality was considered to be synonymous with the feminine. Scholars today tend to interpret the range of Lewis's Native American and African American subjects as one chord struck on the theme of oppression. For example, in her biography of Harriet Hosmer, the historian Dolly Sherwood writes of Lewis, "While her first works were done in the prevailing Neoclassical style, she moved toward a more naturalistic expression of the oppression that black people and Indians had suffered."[110] Sherwood ignores the fact that Lewis opted for only the happiest moments in the lives of Hiawatha and Minnehaha, leaving the unhappy ending to Longfellow's other interpreters. Instead, Sherwood operates under an assumptive system that equates the representation of "race" (and only nonwhites possess such a thing) with both "naturalism" — and this connects back to that nineteenth-century characterization of Lewis as having "natural genius" — and "oppression/pain" (of not being white).

Additionally, the passage from Tuckerman is revealing in its confluence of ideologies of race and sex in the estimation of Lewis's talent. Tuckerman begins the section on Lewis with a description of her "mixed negro and Indian blood."[111] Such prefatory descriptions were endemic to discus-

sions of Lewis, but what is most interesting is the recommended subject matter for Lewis's mature career — all Native American themes — a litany of defeated chiefs whose existence is defined by their contact with either the Spanish or the British empire. At issue, then, is Lewis's perceived girlishness and her authenticity *as* a Native American, an authenticity which allows her the authority to "improve" upon Longfellow's conceptions. It is an authenticity that will later allow her to undertake the more dramatic Native American subjects. Nature has informed her talent rather than adherence to any socializing influence, such as school, an apprenticeship, or participation in an academy. By virtue of her heritage as opposed to anything learned, she gives Longfellow's invention "shape" and "reality." Without doubt, Lewis's purported facility for the subject is helped by the fact that the fictional Hiawatha also belongs to the Chippewa nation. Sexism and racism dovetail here, where constructions of gender, racial difference, and authenticity briefly employ similar strategies of exclusion, for by virtue of her race *and* her sex, Lewis can never aspire to genius.

Tuckerman's recommendations for Lewis's future subject matter are divided into two categories: those who are "her people" — contemporary Indians — and those who are Aztec and fell under the Spanish and Cortez. But, according to Tuckerman's source, Lewis was to attempt the Aztecs only if the others "may seem too near and real, and admitting less of effective accessories." If the reality and tragedy of the "real" American Indians interfered with Lewis's own reality — art again crossing the boundary into life — she could avoid them. The only other acceptable reason to avoid the "real" American Indians was if they caused a conflict with the natural feminine propensity for decoration. The recommendations themselves are equally telling. On one hand, the exhortation for more "dramatic" subjects sheds some light on what acceptable representations of American Indians were to a nineteenth-century public. On the other hand, the list of acceptable Native Americans provides a "negative checklist" for works that Lewis either never sculpted or signed her name to.[112]

If Lewis believed, as Emerson did, that everything that a civilization had attained, its progress or evolution, was mirrored in its art, then her sculptures are an instructive voice in the discourse of nationhood. In order to claim for African and Native American women the rights that would at least make them equal to white women, Lewis inserted herself into the cultural dialogue, acknowledging the aesthetic dimension of racial ideol-

ogy and answering it through her sculptures. Therefore, Lewis's art is not self-portraiture; rather it reflects her desire to participate in the dominant ideologies whose existence absolutely depends upon the presence of senti- mental objects. She attempted to sculpt her way "inside." Yet, in line with her strategy of "distancing," she chose not to come too close. Rather than engaging the autobiographic or the "autobiological" in her use of Long- fellow, Lewis played upon the perception of her as Native American to represent what Mary Louise Pratt termed the "autoethnographic." Auto- ethnographic expressions are those in which "colonized subjects undertake to represent themselves in ways that engage with the colonizer's own terms . . . [involving] partial collaboration with and appropriation of the idioms of the conqueror."[113]

As an "unintended reader" of Longfellow, Lewis challenged his "lack" of race, which allowed him to speak for the nation. In her rhetorical perfor- mance of Indianness, Lewis recapitulated and rearticulated the narrative of the nation. Concurrently, the irony of Lewis *not* sculpting a *nonexistent* Indian — that is, leaving out Hiawatha in the scenes of courtship — became an index of her past and placed stress upon the distance she tried to estab- lish between her past and her present. I contend that because Lewis chose not to represent Malinche or Pocahontas, and because she ends her rep- resentation of ideal works inspired by Longfellow with a marriage rather than a death, she ultimately betrays sentimentalism. At first, her art seems to attest to the effectiveness of the cults of true womanhood and senti- ment. The historian Laura Wexler describes the "imperial project of sen- timentalism" and suggests that the "energies it developed were intended as a tool for the control of others, not merely as aid in the conquest of self." The actual, intended audience in its acts of "externalized aggression" was not white, middle-class women. Instead, sentimentalism "aimed at the subjection of different classes and even races who were compelled to play not the leading roles but the human scenery before which the melodrama of middle-class redemption could be enacted, for the enlightenment of an audience that was not even themselves."[114]

But rather than participate as a passive member of a colonized audi- ence, Lewis became an unintended reader with unexpected and unwanted consequences. As Philip Fisher notes, "The entire sentimental procedure is already present in the novels of Richardson in the 1740s: The extended central scenes of dying and deathbeds, mourning and loss, the rhetorical

treatment of the central theme of suffering, the creation of the prisoner as the central character, the themes of imprisonment, the violation of self-hood, power relations in the intimate and familiar territory, freedom, the centrality of the family and the definition of the power of literary representation in terms of tears—the novel as a 'tear jerker' or as a 'three-handkerchief' novel."[115] Contrarily, Lewis leaves the tragedy of death and departure in the representation of *The Song of Hiawatha* to others (and to her representation of Cleopatra), exposing with her decision the tension between past and future, extinction and the promise of renewal through the children that Minnehaha and Hiawatha might bring forth (all those little busts?). Lewis takes the end-structured narrative of Longfellow's poem and her own statements about her Indian past and opens it all up again with her art.[116]

In the nineteenth century, ideal sculpture was an integral part of the cultural dialogue about race and gender. Within the fiction of Hiawatha and through the recycled images of slavery, Lewis acknowledged her heritage only peripherally. However, until Lewis, the Native American woman, whose model was the antique Greek ideal female form, and the ethnographically marked Native American male were never paired. Nevertheless, Lewis's earliest decision to "neutralize" her women while racializing the men was more complicated than making her heroines acceptable, sympathetic figures to the dominant culture. In the representation of a miscegenated pairing, the one-drop rule ensures the inevitable disappearance of whites. Furthermore, her representation of black and Indian patriarchies was truly radical. Alternatively, with her scenes of Hiawatha's marriage, she achieves something within ideal sculpture and the tropes of sentiment and true womanhood that has been heretofore unacknowledged—she has attempted to sculpt perhaps the first representation of the ethnographically correct Native American woman. Even such subtle variation in profile—or any variation from the "norm"—was significant and easily understood by a nineteenth-century audience, as I explore in chapter 4. Therefore, Lewis carries the debate about who could and could not be considered a woman to the very pinnacle of cultural expression—art itself.

➤ Identity, Tautology, and *The Death of Cleopatra*

Since the nineteenth century, scholars have persistently described Edmonia Lewis's ideal works as illustrations of her "identity." This line of exposition is what I have tried to interrogate and disrupt with my analysis. As I have tried to show, Lewis's work formed part of an intricate web of relations, what Michael Baxandall would call the "intention" of the artist that is present in the artwork, in the objective task or problem, and in a range of culturally determined possibilities. I would reiterate here what Baxandall describes as his "low and simple theoretical stance" — "that historical objects may be explained by treating them as solutions to problems in situations, and by reconstructing a rational relationship between these three."[1] By looking at Lewis's sculptures individually (despite the sameness of theme), by providing a cultural context for them, one realizes that her art was not an illustration of a fixed identity, not a by-product of ostensibly "internalized" ideologies.[2] Rather, Lewis's works are acts of agency that, while not literal transcriptions, *facilitated* the continuity of the dominant ideologies — sentimentalism, true womanhood, the vanishing American — which, in turn, were keyed to act in certain definable ways on her sense of herself.

Nonetheless, her acts of agency cannot be comprehended directly. Before the artwork can be explained, it

must be described, that is, translated into words and concepts. Baxandall contends, "Every evolved explanation of a picture includes or implies an elaborate description of that picture. The explanation of the picture then in its turn becomes part of the larger description of the picture, a way of describing things about it that would be difficult to describe in another way. But though 'description' and 'explanation' interpenetrate each other, this should not distract us from the fact that description is the mediating object of explanation."[3] The relation is complex indeed, for description in the case of Lewis's art is hampered because, for most scholars, the description of the artwork *is* the explanation of the artist.

THE FAILURE OF DESCRIPTION

The issue of "description" is an important one. If, as Baxandall posits, "description is the mediating object of explanation," then what does it mean that "description" has proven most illusive as it pertains to Lewis and her work? Not to imply that there is a "correct" interpretation, but the failure to find *any* consensus about meaning is revealed by the failure to describe with any consistency Lewis or her art, by the wildly diverging descriptions of both the body of the artist and her "body" of work. These failures are a legacy of the nineteenth century and the imperative, which still exists, for the black artist to enter as her own subject matter. These failures reflect the central and fundamental confusion between Lewis and her objects. Their very interchangeability makes the artist *the* object of description and explanation, where the artwork is reduced to a "solution" to the "problem" of "race" (that is, the lack of whiteness).

Broadly speaking, Edmonia Lewis is a product of two histories, trapped between two paradigms: that of the exotic on the one hand and, on the other, the wily, subversive feminist who manipulated her white audience through the use of her white marble sculpture. These diverging perceptions of the artist reached their culmination in two radically opposed descriptions of her sculpture *The Death of Cleopatra*. In 1990, the art historian Albert Boime described Lewis's *Cleopatra* as "an angry and conflicted image . . . writhing in agony, her face distorted into a pained grimace" (plate 12).[4] In 1996 the art historian Judith Wilson provides a description of the sculpture very different from Boime's: "The upper torso of Lewis's dying sovereign arches back and her head is thrown up and over to one

side in a particularly graphic description of the expiring monarch's death throes. While this results in a degree of natural fidelity . . . it also rhymes with the body language of haughty defiance."[5] There is a vast difference between writhing in agony and a posture of haughty defiance. It seems as if Boime and Wilson are describing two very different objects even as they use those objects ultimately to explain Lewis. Their analysis bears out Baxandall's contention that description is demonstrative rather than informative and that "what one offers in a description is a representation of thinking about a picture more than a representation of a picture."[6]

I will examine how and why description fails. As the narrator of her own life and the narrated, Lewis both created her art and remained the subject of it well into the twentieth century. Her subjectivity is fused with and confused by her subject matter. To demonstrate art history's continued reliance on nineteenth-century forms of interpretation, I will begin by investigating how Lewis's contemporaries used the intersection of science and aesthetics to register Lewis's appearance and how those descriptions became part of the larger explanation of her "identity" read narrowly as "race." Well into the twentieth century, art history continued to depend on the reification of race—what I will later clarify as "sexual racialism"—in order to fix Lewis as either the exotic or the subversive. Art history relied for its evidence, however, on descriptions of Lewis's artwork rather than descriptions of the artist herself—but the description of the artwork always reflects back onto the artist. Focusing on the writings by Boime and Wilson, I will demonstrate the unreliability of such tautological methods of description and reveal, in the midst of their conflicting imagery, the uniformity of their goals—the reinvention of art history's black subject.

Describing the Artist

From the nineteenth century to the early twenty-first, the perception persists that Lewis's choice of subject matter was appropriate and more "authentic" because of her heritage. As Adolph Reed has argued, "The idea of the authentic is always *hortatory rather than descriptive*. It is an attempt to impose a boundary on the intrinsically fluid, syncretic, pragmatic processes that are the substance of human social existence."[7] Admittedly, fostering the perception of authenticity was in part Lewis's strategy. For the self-proclaimed descendent of African and Native American parents, Lewis encouraged the idea of the authentic through her choice of subject

matter, and consequently the public was happy to view the works as self-portraiture well into the twentieth century.[8] One result of the perception that Lewis's work was an authentic expression of her identity was that her style was deemed "naturalistic" (in the sense of "natural" to her) rather than "ideal."[9] What emerges in the context of such discussions is a complex matrix of connections and associations — between style, subject matter, heritage, and phenotype. The perception that style is a manifestation of heritage and that heritage must be articulated in appearance and mirrored in subject matter is symptomatic of the tautological method, which reduces intention to the most limited sense of reifying and re-representing a fixed racialized and gendered identity.

Because of those associations and connections, Lewis's appearance was an obsession with her reviewers and interviewers. Appearance was an index of "blood" in the nineteenth century, which was thought to carry racial characteristics that were then made manifest on the body. The obsession with blood reflected American society's need to maintain the boundaries of racial difference. And thus, blood and its relative "purity" became a fixation in the United States. The truth of this is illustrated in the terminology of the day, beginning with "miscegenation," or sexual relations between someone who was nonwhite with someone who was white, while the categories for racial classification were based on the relative degrees of "white" and "black" blood flowing through one's veins: "mulatto," or one parent white and the other black; "quadroon," having one-quarter "black blood"; and "octoroon," possessing one-eighth "black blood."

Also, in the nineteenth century there was a direct correlation between appearance and blood-as-identity. Embedded in the concept of identity at this time were the pseudosciences of physiognomy, phrenology, and craniology. Sciences of the surface, they turned the body into an open book. For the literate, character, behavior, blood, and morality were present in the lumps and bumps of the skull, in the formation of the ear and brow, and in any number of visual cues. These sciences were so endemic to culture that they could reference equally the human being or the work of art. Mary Cowling, in *The Artist as Anthropologist*, writes, "The clue to understanding the painted figures lies in those ideas and beliefs which attached to the real one . . . Victorian anthropology . . . helps to explain how the human type was conceived as a physical, psychological and moral entity, and how those same conceptions conditioned the realization and interpretation of

its artistic equivalents."[10] Lewis, like her art, became the subject of Victorian anthropology. She represented "the real" while her sculpture functioned as a reiteration of her identity. Nevertheless, the fallacy of tautology as method is born out in the contradictory accounts of Lewis's appearance, as they relate to the primacy of her Native American or African heritage.

I direct your attention to the carte-de-visite of Lewis by Henry Rocher not as "proof" of anything — neither of the relative rightness nor wrongness of the following descriptions (plate 1). The photograph is authoritative of nothing. I merely reference it so that you can visually mark out — map, if you will — the varying and conflicting coordinates of race-as-identity that Lewis's interviewers found on her face. One could reasonably speculate that Lewis hoped that her cartes-de-visite would represent a moment of stability within the conflicting accounts of her appearance qua identity. But this is not the case. The question is then: why didn't Lewis take more aggressive advantage of photography as a means to stabilize and to commodify the self and generate interest in her product? As far as we know, this image belongs to the only known set of cartes-de-visite commissioned by the artist. Rather than a proliferating visual archive of the artist, this carte-de-visit is but one of a myriad of ways the artist both represents her "self" and was represented by others. Accordingly, Lewis's carte-de-visite is no more "true" or "real" than the myriad of representations of the artist. It, too, is a construction, strategically inserted into the field of representations of Lewis and thus holding no absolute authority over her. Even so, the photograph does constitute a conscious choice on the part of Lewis, perhaps to construct an image that denies the exotic interpretations favored by the biases of the time.[11]

The accounts with which I am concerned appeared at the height of Lewis's fame between 1864 and 1874, in an article by Henry Wreford, an interview with Lydia Maria Child, an interview with Laura Curtis Bullard, and a biographical sketch by William Wells Brown. Wreford, an Englishman, asserts, "[Edmonia Lewis's] eyes and the upper part of her face are fine; the crisp hair and thick lips, on the other hand, bespeak her negro paternity." Bullard, a white American woman, claims, "Edmonia Lewis is below the medium height; her complexion and features betray her African origin; her hair is more of the Indian type, black, straight, and abundant . . . and if she has more of the African in her personal appearance, she has more of the Indian in her character." Child, also a white American woman,

relates, "I told her I judged by her complexion that there might be some of what was called white blood in her veins. She replied, 'No; I have not a single drop of what is called white blood in my veins.'" Brown, an African American male, repeats Bullard's description verbatim, "Edmonia Lewis is below the medium height; her complexion and features betray her African origin; her hair is more of the Indian type, black, straight, and abundant... and if she has more of the African in her personal appearance, she has more of the Indian in her character."[12] The contradictions emerged because each author (with the exception of Child) wanted to stress something different about Lewis that would coincide with his or her construction of her and simultaneously coincide with a common belief in the fixity and coherence, despite interracial sex, of racial characteristics.

Finally, the obsession with her appearance as it conveyed her racial identity culminated in an artwork of Victorian anthropology. In 1870 the (London) *Art-Journal* reported that Lewis's friend, Charlotte Cholmley, had created an unusual bust of the artist (its location is unknown). The aesthetic dimension of racial theory is here revealed, as the so-called portrait traced "the mixed races from which she descends. On one side of the head the hair is woolly, her father having been a negro, on the other, it is of the soft flaccid character which distinguishes the Indian race, from which her mother sprang."[13] One can imagine Lewis's face recreated in white marble with the two grades of her hair functioning as the signifiers of racial identity, racial difference, and racial fixity. The function of Lewis's hair in this sculpture is instructive. Cholmley's use of hair as a signifier of race and femininity, like the curly hair of the woman on the abolitionist emblem, lets us know what *might have been* possible for Lewis to deploy in her own sculptures of African and African American women. Therefore, one must assume that Lewis refused such physiognomic specificity in her own sculptures of the freedwoman, Hagar, and Cleopatra.

Cholmley's sculpture also suggests the idea of the composite, which references an accumulation of identities where one is inadequate and which can only exist relationally to its other(s). This tendency to fragment, or to parse, the body of Edmonia Lewis brings to mind Roland Barthes's definition of the "blazon." With the exception of the Cholmley sculpture, the parsing of Lewis's body occurred primarily in written *descriptions* of the artist. According to Barthes, "Language undoes the body, returns it to

the fetish . . . The blazon consists of predicating a single subject, beauty, upon a certain number of anatomical attributes . . . It expresses the belief that a complete inventory can reproduce the total body, as if the extremity of enumeration could devise a new category, that of totality."[14] For Lewis's interpreters, the subject was not overtly about "beauty" but about "race" that (like beauty) was predicated on a taxonomy of anatomical attributes, the sum of which meant something different for each writer who subjected her to language. The anatomical inventories to which Lewis was subjected were an attempt to fix the boundaries of race and to explain the character of the artist. Allow me to reiterate here that to explain race is to describe the artist and to describe the artist is to explain race, in a never-ending, tautological loop. Like Boime's and Wilson's perceptions of *The Death of Cleopatra*, the instability and infuriating mutability of Lewis was born out in the competing descriptions of her, until finally the attempt to fix and to stabilize her identity fulfilled itself in Cholmley's sculpture.

I would like to return for a moment to two physical descriptions of Lewis employed by her supporters: the first by white abolitionist Laura Curtis Bullard and the second by the former slave and African American abolitionist William Wells Brown. In the conflicting accounts of Lewis's appearance, these two are the same. Why did Brown recycle Bullard's description when we know for a fact that both Brown and Bullard were well acquainted with Lewis? (Recall that Brown attended the dedication ceremony of *Forever Free* in 1869.) If one supposes that his portrayal of Lewis is more "truthful" or "accurate" because he, like Lewis, was African American or because he was an advocate of "the colored race," his appropriation of Bullard's description should disabuse one of that notion. The question that one must ask, then, above all the others is why did he choose to repeat someone else's description at all, given that he knew Lewis and he was a writer? Perhaps Brown used it because Bullard's verbal portrait was the one that most directly dealt with "character," and moreover it was the one that stripped Lewis of character traits held in common with the African.

The context for Brown's recycled description of Lewis is his book *The Rising Son; or, The Antecedents and Advancement of the Colored Race*, published in 1874. Brown ended the volume with a series of biographical sketches in a chapter titled "Representative Men and Women," with "representative" carrying the nineteenth-century signification of "extraor-

dinary" and "exemplary." Prior to the sketches, however, Brown included the following observations in a chapter titled "Causes of the difference in Features" that reiterates the association between physical appearance, brain size, and morality:

There is a decided coincidence between the physical characteristics of the varieties of man, and their moral and social condition; and it also appears that their condition in civilized society produces marked modification in the intellectual qualities of the race. Religious superstition and the worship of idols have done much towards changing the features of the Negro from the original Ethiopian of Meroe, to the present inhabitants of the shores of the Zambesi. The farther the human mind strays from the ever-living God as a spirit, the nearer it approximates to the beasts; and as the mental controls the physical, so ignorance and brutality are depicted upon the countenance. As the African by his fall has lost those qualities that adorn the face of man, so the Anglo-Saxon, by his rise in the scale of humanity, has improved his features, enlarged his brain, and brightened his intellect.[15]

Brown's subsequent biographical sketches correspond with his belief in the pseudosciences by enumerating the visible markers of "character" of his chosen heroes and heroines that clearly distinguish them from "pure" Africans. As a result, instead of revealing anything about Lewis in his description of her, Brown obscures her with his own racial theories about the inferiority of African blood, as caused by purposeful disfigurement, religious superstition and idolatry, and climate. Consequently, the formulaic and often contradictory method of describing Lewis's person according to her Indian and African ancestry merely highlights the unreliability of *all* press surrounding her. Another method must be employed, one that looks directly at the work produced by Lewis but refuses to interpret the body of work as a mirror for the body of the artist.

It is useful, however, to think briefly about what her body meant in nineteenth-century discourse, especially in light of the sculptures she created. In American society, while the intersection of race, gender, and class influenced cultural and artistic constructions of women in general, the ideology of true womanhood deemed the bodies of African American and Native American women of less value than those of middle-class white women. In this context, the proliferating images of white women as captives or as victims predominated. Such images were in part the result of white male fear with regard to the instability of white female identity,

caught as it was, in the midst of change and dislocation. The white captive became a countersymbol of the new Victorian woman, who was increasingly independent, sexually liberated, outspoken, and sometimes androgynous.[16] The white captive and the image of the pioneer mother threatened by the Indian male also functioned as important symbols in the war of aggression against Native American communities — compare, for example, Erastus Dow Palmer's *White Captive* (figure 23) to Horatio Greenough's *Rescue Group* (figure 24) or to John Mix Stanley's *Osage Scalp Dance* (figure 13). With such images, prevalent in captivity narratives, fiction, painting, and sculpture, both the government and whites, whose interest a transfer of property rights would benefit, could assume a position of "self-defense" in the face of Native American "hostility." Writing about James Fenimore Cooper's novel *The Deerslayer* (1840), Philip Fisher notes, "The entire, frail set of early settlements within the American wilderness can be redesignated. No longer 'invaders,' they are 'prisoners' surrounded by hostile Indians. Once visualized as prisoners or captives with their freedom limited by the surrounding hostility . . . they become the victims and seem licensed to whatever violence, now seen as purely reactive, may be needed to end their captive state and recover their freedom."[17]

For an African American or Native American woman, however, the dangers of gender constituted more than a challenge to her self-determination. Not only were they the victims of vile stereotypes but black and Indian women faced real, bodily danger.[18] Remember that Lewis herself was the victim of terrifying violence. While at Oberlin College, she was accused of poisoning two white females who boarded with her at a rooming house on campus. When a certain faction of the white community felt that her case did not come to trial swiftly enough, they beat and robbed her, stripped her naked (perhaps sexually abused her?), and left her for dead in a field. Various authors have described her as below medium height, and Lewis's passport lists her as four feet tall (yet another questionable description of the artist even though it is supposedly an "official" document). Would this slight woman ever have forgotten the violation of her body and the message that her gender counted for nothing in a society that worshipped ideals of a certain class of white womanhood?[19]

Through the dismantling of her body, the stereotyping of her character, and descriptions of her art, Lewis's critics sought to invent a new category that could define and circumscribe her. Lewis and her art functioned as a

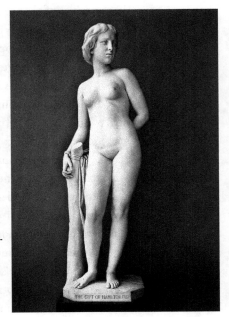

23 Erastus Dow Palmer, *The White Captive*, modeled 1857–58; this version, 1858–59. Marble, 65 × 20¼ × 17 inches. The Metropolitan Museum of Art, New York City. Bequest of Hamilton Fish, 1894 (94.9.3). Image © The Metropolitan Museum of Art.

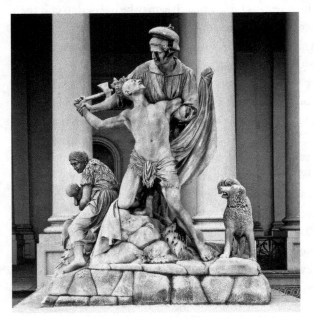

24 Horatio Greenough, *The Rescue Group*, 1837–53. Marble, 141 × 122 inches. U.S. Capitol, Washington, D.C. Photograph taken before 1920, showing the work in situ to the right of the staircase on the east façade of the U.S. Capitol. In storage since 1958. Courtesy of the Architect of the Capitol.

locus of meaning where the perceptions of abolitionists, African Americans, and the expatriate community intersected and scattered according to their own agendas. Through her art and through Lewis herself, the various groups (both white and black) were able to formulate racialist and sexual stereotypes out of myths of ideal womanhood, to which "exotic" figures such as Lewis could never aspire. Such constructions of her as exotic, or as having an unfair racial advantage, were born in the nineteenth century and continue today. Alternately, and more recently, Lewis has been constructed as a feminist whose position was more palatable to a twentieth-century sensibility. Rather than the perception that she was active in the creation of the dominant ideologies, even as her status as an "unintended reader" sometimes bore strange fruit, Lewis is perceived as standing outside of culture, using her work to subvert and overthrow the status quo of racial and gender inequities. In either case, Lewis is other; and like Cholmley's sculpture with its origins in the graphic arts tradition of splitting a figure down the middle to convey "true" identity, the exotic and the subversive, when based almost entirely on ahistoric racialism, are merely two sides of the same coin.

Boime's Sentimental Form and the Withdrawal of the Black Subject

In *The Art of Exclusion: Representing Blacks in the Nineteenth Century*, Albert Boime opens his study with at least three very important observations: first, art helps to shape ideas, define social attitudes, and fix stereotypes; second, no art lies beyond the boundaries of ideological investment — what he terms "political and social inquiry"; and third, there is one set of images that proves the first two contentions, those images of people of color that engage the international debate over slavery during the nineteenth century.[20] Significantly, Boime also notes that, with few exceptions, the images were made by privileged white artists either in support of or against slavery; and where there was ambiguity about the artist's position, we should not make any assumptions about art's autonomy. Rather, "we would have to presuppose the artist's undergoing a process of adaptation to historical transition and/or his or her ambivalence in the face of change and unyielding racist attitudes."[21] Moreover, Boime argues, artists contributed to the racial mythologies of subordinate people by making visible the differences in skin color and physical features. "I will show," he

asserts, "how the power and the privilege enjoyed almost exclusively by whites was rationalized by a wide range of Western artists in their images of blacks."[22]

In his preface, however, Boime reveals a disquieting ambivalence toward his chosen subject. His hesitance is reminiscent of the "pitfalls" that David Lubin identified in his pro forma initial reluctance as a self-identified white art historian to work on the African American landscape painter Robert S. Duncanson. As I discussed in chapter 2, Lubin's avowed disinclination stemmed from the belief that a white art historian who studied a black artist must reduce the black artist to an object of knowledge for the white knowing subject. Like Lubin, however, it is enough for Boime to state his ambivalence and then proceed anyway, with solution in hand, so that the ritual declaration of ambivalence or reluctance is somehow a necessary gesture before proceeding. According to Boime,

The most decisive event in this process of getting at the roots of the paradoxical pervasiveness in Western art of the "invisible man" was my discovery of the book by Freeman Henry Morris Murray, the first black American art historian. Murray approached the imagery of black people not from the point of view of the refined aesthete or connoisseur but with an eye to the survival of black Americans at the time of World War I. Almost totally neglected in the history of art, *Murray's penetrating criticism helped me resolve a lingering ambivalence I had about a white scholar doing a study from the perspective of the black victim.* By bringing to light Murray's work, I was adding a substantial chapter to modern art history and at the same time monitoring my perspective with the insights of a black scholar with whom I engaged in a kind of dialogue. Naturally, I am aware that it is still the same camera—albeit with a different lens—and that the final picture is my personal construction.[23]

Boime's ambivalence, I believe, is at the heart of his study and reveals (even as he rejects) his belief in the dichotomy of noncontingent, uninflected difference, of the white knowing subject and the black known object. Boime finds his particular solution in a little-known study by Murray titled *Emancipation and the Freed in American Sculpture: a Study in Interpretation.*[24] The chapters from Murray's book were initially presented as a series of lectures for the Chautauqua Institution and later published by Murray in 1916. And yet, even though he raises the specter of Murray in the preface, Boime doesn't reintroduce Murray until the final chapter

of his book. Titled "Emancipation and the Freed," repeating the title of Murray's study, it is also the chapter in which Edmonia Lewis appears. Consequently, Murray's absence from Boime's text until the final chapter, coupled with the brief mention of him in the preface, functions as a metaphorical blessing conferred on the "white scholar" by the "black scholar." Concomitantly, Boime's "discovery" of Murray reciprocates the favor as the white scholar gives voice and *visibility* to the black scholar.

As it turns out, the social history of art is not Boime's only method. Underlying a most respected form of "doing" art history is yet another method that emerges clearly in the phrase "doing a study from the perspective of the black victim." Like the writers of sentimental novels, both Boime and Lubin enact, in the words of Philip Fisher in *Hard Facts*, "experimental, even dangerous, extensions of the self" as they assume the consciousness, in this instance, of the black victim or the black artist. Boime's understanding of the impetus behind Murray's project — that "Murray approached the imagery of black people not from the point of view of the refined aesthete or connoisseur but with an eye to the survival of black Americans at the time of World War I" — acts as a further experimental extension of normality to black people (Boime to Murray) and reveals the potential of art history to those who now "dabble" — those refined aesthetes and connoisseurs. As Fisher contends, "This experimental loaning out of normality assumes that normality — full human normality — is itself a prized possession and not yet an object of boredom and contempt, as normality is in the modern Romance of Consciousness. Sentimentality is, therefore, a romance of the object rather than a romance of the subject."[25] Murray's perceived gravitas therefore confers on Boime a corresponding urgency and seriousness for his own project as Boime uses the past as critique of the present. Nevertheless, certain questions remain: Why is it Boime's assumption that to study the image of the black is to identify with the "black victim" (sentimentality's object) and not the privileged (with few exceptions) white artists who invented that "victim"? Why is it that to study the image of the black is to study the state of being embodied as "victim"?

Before engaging those questions, a detour might prove enlightening. Boime continued his romance of the sentimental object in a separate essay on Henry Ossawa Tanner, the African American painter (1859–1937).[26] Published three years after *The Art of Exclusion*, in 1993, the essay presents

compelling similarities in at least four areas to the work done by Lubin on Duncanson: first, Boime's study of Tanner is a discourse on race in which Tanner is posited as the victim of double consciousness; second, like Lubin, who identifies an element of genre painting in Duncanson's landscapes, Boime describes Tanner's biblical subjects not as history painting but as genre; third, Boime, like Lubin, focuses heavily on the family and constructs the black male artist as obsessed by patriarchy; and fourth, Boime interprets Tanner's withdrawal of the black subject as a denial of his racial identity and as a betrayal by Tanner of his duty to "the" black race. Boime establishes Tanner as strictly reactive, answerable to his supporters and patrons to such an extent that, in Boime's analysis, Tanner compromises his art.

As with Lubin's second identified pitfall, transforming the discussion of Duncanson into a discourse on race, Boime has transformed Tanner's entire oeuvre into a discourse on race. At the beginning of the essay, Boime establishes Tanner as a light-skinned black who benefited from his skin tone both within white society, for whom fair skin functioned as a "social signifier," and within the intraracial hierarchies of his African American supporters.[27] Boime claims that he will demonstrate how Tanner's "development as an artist-producer is inseparable from his cross-cultural social relationships. These include his church affiliation and community obligations, and his interaction with African-American, European-American, and European supporters and patrons in the United States and France, all of which simultaneously constrained and liberated his artistic sensibilities."[28]

But Boime has placed himself in a bit of a bind. In order to maintain the integrity of his (simplistic) argument, that Tanner sided with the "accommodationist" Booker T. Washington over the "radical" W. E. B. Du Bois, Boime cannot cite specifically Du Bois's formulation of double consciousness. But Boime does succumb to the allure of double consciousness, as a discussion of Tanner's "light skin" is followed by a generalization about the "agony of this isolation and consequent self-awareness that empowered *certain mulattoes* to clarify and articulate the predicament of African-Americans in postbellum America."[29] The indirect reference to Du Bois as one of those mulattoes, to Du Bois's formulation of "The Talented Tenth," and to double consciousness is clear as is the reductive reading of Tanner as a "tragic mulatto" because of his "agony" of isolation and "consequent

self-awareness." Boime is obviously thinking of Du Bois, who claims, "It is a peculiar sensation, this double-consciousness, this sense of always looking at one's self through the eyes of others, of measuring one's soul by the tape of a world that looks on in amused contempt and pity. One ever feels his twoness, — an American, a Negro; two souls, two thoughts, two unreconciled strivings; two warring ideals in one dark body . . . The history of the American Negro is the history of this strife, — this longing to attain self-conscious manhood, to merge his double self into a better and truer self."[30] Continuing with the unspoken theme of double consciousness, Boime writes, "I will propose in this paper that his shifting uses of genre painting derived from his decision to engage in the dilemmas of *living in a world of split allegiances*. His *willingness to negotiate* his self-perceived and socially perceived *dual cultural and racial heritage* led to work that at times challenged the standard images of American genre painting and at other times acted in complicity with them. The specific shifts in Tanner's visual practice attest in part to the ambivalence developing out of his singular negotiating position."[31] As in Lubin's interpretation of Duncanson, Boime constructs Tanner as living a bifurcated identity, a "two-ness" that constitutes a racial and cultural demarcation between whiteness and blackness. Also, Boime's summation of Tanner's "willingness to negotiate" his "dual cultural and racial heritage," like Timothy Burgard's construction of Lewis, implies racial opportunism.

At the core of Boime's essay about Tanner is a merging of the terms "style" and "subject matter" and an implied accusation of racial misidentification on Tanner's part that reveals the extent to which the African American artist is presumed to enter as his own subject. In examining Tanner's experiences with his various communities, supporters, and patrons, Boime claims, "I believe it is possible to interpret *the stylistic shifts* in his genre painting at the turn of the century as a condition of *his constant negotiation of the social terms of his racial identity* as constructed through these relationships. I will argue here that *the difficulties in trying to determine racial identity* and the contradictions of institutionalized racism are exemplified in the development of his career."[32] As the essay develops, the reader begins to understand that what Boime means by "stylistic shifts" is not only a loosening of Tanner's brushwork but also a shift from genre focusing on African American life and pedagogical narratives to themes focusing exclusively on the Bible. Boime collapses subject matter into style.

The two are not usually considered synonymous, but if the racial component is added — with all its attendant associations of style, subject matter, heritage, and phenotype — then a "shift" in "style" signaled by what Boime refers to as "difficulties in trying to determine racial identity" must ultimately shade toward a "betrayal" of the "authentic," or a betrayal of that which comes "naturally." Yet, as is the case with Lubin, Boime believes that the black artist *must* replicate the black self in the art, and if the "reinscription," as Boime terms it, is not apparent on the canvas then the artist has masked that presence as absence.

In the late nineteenth and early twentieth centuries, Henry Ossawa Tanner was perhaps one of the most sophisticated and evolved thinkers about race and racism to have a public forum. I contend that Tanner had no "difficulties determining racial identity." His enlightenment is proven by his work, the trajectory that his work took, and by the few written statements that we have by him. Between 1892 and 1895, Tanner painted four works that dealt with intergenerational pedagogy, two of which represented African Americans: *The Bagpipe Lesson* (1892–93); *The Banjo Lesson* (1893); *The Thankful Poor* (1894); and *The Young Sabot Maker* (1895). In *The Banjo Lesson* Tanner bravely engages the stereotyped associations of African American men, banjos, and minstrelsy (plate 13). In early October 1893, Tanner exhibited *The Banjo Lesson* at Earle's Gallery in Philadelphia, where he spent the fall and winter of 1893–94. The painting is a sensitive portrayal of an elderly black man and a young black boy in humble surroundings. They are not playing to an audience; instead, they evince total absorption in one another and in the object (the banjo) that ritualizes as it externalizes their bond.

Tanner would have had access to the review of *The Banjo Lesson* (then titled *The First Lesson*) that appeared in the *Daily Evening Telegraph* two days after the gallery opening. The reviewer noted the following:

In a present venture Mr. Tanner has entered upon a field new to his endeavor, so far as this public is aware his first exhibit of a figure subject of importance being now on view . . . This is a large upright entitled, "The First Lesson," a composition of two figures . . . An old Uncle Ned, bald and venerable, has a bare-footed little darkey of seven or eight years between his knees, and is earnestly instructing the youngster how to finger the strings of an ancient banjo. The figures are firmly modelled and well "enveloped," each occupying its own space and place and each

bearing the stamp of individuality. The heads are especially well drawn, that of the child being a study Mr. Tanner may well be proud of, and the faces are informed with intelligence and expression. On its literary side the picture is in every way to be commended, its simple and rather pathetic story being told very cleverly and with interesting effect.[33]

The review is of critical importance because it exposes how an audience contemporary to Tanner would view the painting; for, even though acknowledging that the faces are informed with intelligence and expression and "bearing the stamp of individuality," the reviewer nevertheless identifies Tanner's figures with the stereotyped associations of "Uncle Ned" and the "little darkey." As the cultural anthropologist Mary Douglas observes, "It seems that whatever we perceive is organized into patterns for which we, the perceivers, are largely responsible. Perceiving is not a matter of passively allowing an organ—say of sight or hearing—to receive ready-made impression from without, like a palette receiving a spot of paint . . . As receivers we select from all the stimuli falling on our senses only those which interest us, and our interests are governed by a pattern-making tendency, sometimes called *schema* . . . In a chaos of shifting impressions, each of us constructs a stable world in which objects have recognizable shapes, are located in depth, and have permanence."[34] For a nineteenth-century audience, Tanner's composition would have been highly legible because of its connection to stereotype and minstrelsy. However, when Boime mentions this review, he prefaces it with the claim that "not everyone grasped Tanner's subversion of the convention of the banjo-picking Negro."[35] Boime's characterization of the review as a polite form of Northern racism is too summary, in my opinion, as is Boime's dismissal of those who did not "grasp" Tanner's "subversion."

Tanner's second painting to deal with African American life, *The Thankful Poor*, was created almost one year after *The Banjo Lesson*, and as Dewey Mosby, referencing both paintings, remarks, "Tanner did not break new ground." He notes, "Tanner again selected a familiar convention from European peasant and African-American genre painting, in which piety, humility, and poverty were frequently portrayed."[36] Had Tanner chosen the route of the reactionary (intransigent and backward-looking), he could have spent the rest of his life battling the hydra of negative black stereotypes. Furthermore, had Tanner made such a choice, he would have

fit more comfortably within the framework of the Negro Problem, which actively constructs African Americans as purely reactive and responsive to white American concerns and white initiatives. Given Tanner's astuteness, however, I believe that he understood very early on that engaging stereotypes is a losing proposition. Because most people can only see what they are predisposed to see, any attempt to salvage the stereotype, whether through attempts to humanize the subjects or through irony, must fail because the resuscitation of the image simply breathes new life into racialism. Such enthusiastic racialism was produced by Tanner's contemporaries and by twentieth-century art historians and is demonstrated in the critical response to his African American genre subjects as well as the critical response to the artist himself.[37]

At this point, having established why Tanner's images could not be successful within his own historical context, it is instructive to clarify what Boime believes the nature of Tanner's subversion to be and, following that, to explore the terms upon which Tanner's subversion could be meaningful to Boime. Boime identifies the original intent of genre as "fabricated to please prospective patrons" and its emphasis on mundane domestic, workplace, and leisure surroundings served as "uncanny guides to the dominant values and prejudices of the local and regional elites. Genre's themes are most often visual transcriptions of human interaction and objects that communicate these values and prejudices, painted by members of the community who shared them."[38] Boime constructs Tanner's subversion as a response to the traditional motives of genre, and thus, as having a clearly defined purpose and method. The purpose was to counter the negative stereotypes of blacks. The method that Boime ascribes to Tanner, though, is highly problematic. Boime writes, "Instead of positioning himself from a superior vantage point to win a middle-class white audience, Tanner, on the other hand, identifies himself with his subject matter and thus subverts the original social intention of genre."[39] The disturbing proposition that Tanner must submerge himself in his black subject matter—that he must paint himself—in order to subvert genre is not a real solution at all; it is, instead, a reiteration by the art historian of tautology as method, where the description of the object is the description/explanation of the artist. Also, as a proposition it elides Tanner's own distance from his subjects in terms of class and phenotype, a distance initially pointed out by Boime himself; and it elides Tanner's own reiteration of the causal link between phenotype

and impoverishment. Tanner's choice of "pigment" (the paint he mixes and applies to represent phenotype) must be taken into consideration. A genuine "subversion" of genre, for example, would have been to portray poor African Americans as fair-skinned.

Tanner left the United States, African Americans as subject matter, and genre far behind him. And yet Boime does not describe Tanner's biblical subjects as history painting or as Orientalist but as genre, nor does he distinguish between noticeable stylistic shifts over time in Tanner's biblical works.[40] I do not mean to suggest that the categories of painting possess impermeable boundaries, rather that how the art historian interprets those boundaries is very much open to question. Boime establishes the boundary with an unsubstantiated and unqualified claim that "several scholars" have noted Tanner's "different approach" from other artists of biblical subjects. According to Boime,

On one level, Tanner's biblical works reverted to the traditional definition and aims of genre. It might be argued, as several scholars do, that Tanner's approach differs from conventional or academicized representations of biblical themes: using members of his family and close friends for models and digging relentlessly into the architecture, accessories, and costumes of ancient Palestine, he tried to make his works as archaeologically accurate as possible. He also humanized the protagonists and minimized the tendency to sensationalism or sentimentalism so common in renderings of biblical themes of the period. Some contemporary critics saw in this method a want of nobility, however, a raw depiction of ordinary men and women moving against a neutral background.[41]

The association with genre is crucial because, as I noted in relation to Lubin's discussion of Duncanson's landscapes, genre is the embodied art and relies on schema or patterns understood by the dominant society as being particular to racialized, classed, or gendered "others." In fact, Boime's discussion of Tanner's religious paintings as genre fits comfortably within the two major characteristics established by Lubin's construction of Duncanson as the black artist who willfully absents the black subject: first, Tanner's "humanization" of his protagonists corresponds to Duncanson's supposed ability to infuse the staffage in his landscapes with "more feeling" than is found in the work of his (white) Hudson River School counterparts. Second, by associating Tanner's religious work with genre, Boime can argue that Tanner is present in his paintings. Boime can now establish

Tanner's religious subjects as simply another expression of the artist's racial self with the implication being that by virtue of his "race" Tanner *is* genre's natural object. Boime can now comfortably claim, "Tanner did not stop painting genre when he stopped painting African-American subjects, but his work allowed for a different expression of his racialized identity."[42]

At the core of Lubin's and Boime's respective critiques of Duncanson and Tanner is the issue of patriarchy. Like Lubin's construction of Duncanson, Boime establishes for Tanner the centrality and reiteration of the father/son relationship in the artist's dealings with paternal longings and pressures and patronage. In Boime's estimation, Tanner is answerable to his father and to powerful white male patrons, who determine the course of his career. The strength of Tanner's father in the artist's life and career, according to Boime, is displayed early with Tanner's pedagogical genre paintings. Like Lubin, Boime even suggests that Tanner's pedagogical narratives are autobiographical, that they "may very well contain autobiographical recollections of his own training and education, at the same time that they constitute a means to communicate his personal message as an alternative to that of standard genre imagery and popular illustration." Eerily similar to Lubin's insistence on the presence of Duncanson's (fictional, white) father is the following speculation on Boime's part: "This is the theme also of the newly discovered 'Spinning by Firelight — The Boyhood of George Washington Gray,' painted [by Tanner] in 1894. Although here the protagonists are white, the critical male figure is the Reverend Gray, a minister in the white Methodist Episcopal Church, a sort of grayish doppelgänger of Tanner's father."[43] Again, Boime constitutes Tanner's "subversion" as "submersion."

I have said that had Tanner chosen to spend the entirety of his career battling negative racial stereotypes, he would have been purely reactive and responsive to white American concerns and white initiatives, in whose interests such images were generated. Contrarily, Boime puts forward that Tanner's minister father and the elite white patrons who supported Tanner represent a fundamentally oppositional position relative to the artist — that indeed they represent white American concerns and initiatives that are contrary to Tanner's. Boime contends, "[Tanner] launched a new series of biblical genre more in keeping with his father's aspirations and those of the academic community to which he now belonged. This series was further motivated by the influence of a growing circle of elite white patrons

who made him cognizant of prevailing market demands."[44] I leave it to the reader to decide where the Negro Problem framework actually resides, but it is important to consider the following: Boime proposes that, until Tanner came under the influence of his minister father, whom Boime views as equally compromised, and wealthy, white, male patrons who prefer the artist to paint religious subjects, his best work was heralded by his active engagement with stereotype. Furthermore, if we view *The Art of Exclusion* and Boime's essay about Tanner in tandem, Boime seems to imply that Tanner's engagement with "the academic community" must perforce align the artist with the aesthetes and connoisseurs whose work Boime contrasts negatively with the scholarship of Murray. Interestingly, Boime implies, it is Tanner's own ascension to fatherhood that weakens and compromises his individuality and freedom of expression. As Boime asserts,

I would argue, then, that Tanner was most subversive when he aligned himself with his father's militant radicalism and confronted prejudice head-on, and that he adopted a more conservative mode when he began to take on the responsibilities of the head of a household himself at the end of 1899. As in the case of the father who stifled his outrage outside the confines of the church, respectability within the community counted for more than raising one's voice. In Paris Tanner continued to address racial difference but in a less direct manner, making subtle strategic moves in his negotiation of ethnic representations. In France, where he was accepted as a gifted painter rather than as a Negro who paints, his anger and class consciousness dissipated. At the same time, he was encouraged in this direction by wealthy white American patrons who were uncomfortable with his earlier genre pictures and more at home with imaginary and exotic people of color.[45]

The unnatural influence of Tanner's father and Tanner's white male patrons, who argue successfully for the primacy of "the market," by implication, causes an "unnatural" or "inauthentic" expression of Tanner's talent. Tanner, perforce, has to sneak by his father and patrons "subtle" expressions of his racial self. Thus, an unfortunate coincidence of filial duty and venality subvert Tanner's "subversion." Finally, Boime is insistent that Tanner's subversion could only be expressed by anger and raising his voice and by locating himself in a place overtly hostile to him racially and, concomitantly, by submerging himself and losing that voice in the black subject—the very picture of the stereotypical (incoherent, inchoate, and inarticulate) "angry, black man."

Both Lubin and Boime imply that Duncanson and Tanner are locked into an eternal boyhood—that they are not men because they do not enact the modernist separation from the father. Separation from the "father" (paternal, white male patrons) signifies true subversion for Boime. By implication, Tanner must choose between manhood and the "father" and, according to Boime's analysis, he has chosen wrongly. As a result, Tanner's refusal to submerge himself in the black subject, his withdrawal of that subject, causes Boime to determine that Tanner is not a modern artist. There is a divergence between what Boime considers "the modern" to be and what Tanner judges it to be, and that split is determined by what each considers "subversive." For Boime, the subversive is predicated on Tanner's "race" and thus must be expressed in Tanner's acknowledgment that "race" is "real" and that acknowledgment is only valid by its reiteration in the artist's work. For Tanner, "race" was not "real" but rac*ism* was—he understood and challenged the contradictions and fictions of race and its reification in racism very clearly.[46] Contrary to Boime's ("hindsighted") expectations of Tanner, Tanner situated his subversion in translating biblical subjects via the medium of stylistic modernism and thus exposing the timelessness of biblical truth. As Tanner argued in 1909, "It has very often seemed to me that many painters of religious subjects (in our time) seem to forget that their pictures should be as much works of art (regardless of the subject) as are other paintings with less holy subjects." He still held such beliefs in 1924, when he asserted, "My effort has been to not only put the Biblical incident in the original setting . . . While giving truth of detail not to lose sight of more important matters, by this I mean that of color and design should be as carefully thought out as if the subject had only these qualities."[47]

By 1909 Tanner was becoming increasingly experimental in terms of mixing pigments and applying them to canvas. Although the art historian John Davis treats Tanner in the epilogue of his study *The Landscape of Belief,* he still manages to do a very credible job of contextualizing Tanner's religious subjects beyond the constraints of racialism. Tanner's generation of religious painters, as Davis notes, shared a relaxed sense of geography that allowed them to treat the Holy Land as equally belonging to themselves and, in many instances, as a powerful expression of American identity. They were suspicious of literal transcriptions of the land—"fieldwork" as it was called. Davis's description of Tanner's technique is illumi-

nating: "In such typical works as 'The Good Shepherd,'" he writes, "figure and ground are fused into an undulating, tremulous exhalation of the spirit, richly composed of tractable, yielding paint rather than petrological fact. His glowing surface conveys an almost kinesthetic depth of feeling, eschewing prosaic description in favor of the expressive, loaded stroke" (plate 14).[48]

Conversely, Boime dismisses Tanner's sense of his own subversiveness as a universalizing tendency reached as a compromise with patriarchy — one that "took him far afield from the American experience he knew at first hand."[49] (The notion of "first hand" is interesting and reveals Boime's disregard of Tanner's time in Europe and his travels in the Middle East, as if they were meaningless.) Introducing Tanner's statement of 1909, Boime prefaces it with the claim that Tanner "understood that he ran the risk of exposing himself to the modernist assumption of 'an equality sign between religious art and mediocrity.' His rationale for working in this genre took the form of an apologia rooted in formalist rhetoric."[50] Here is where description fails and fails spectacularly. First, Boime is unwilling or unable to distinguish between Tanner's early and late style of religious painting. Between 1895 and about 1904, the archaeological accuracy of Tanner's early work, Orientalist in its appearance, gradually gives way to a dream-like fusion between figure and ground — visionary rather than viewlike as so eloquently expressed in Davis's description.[51] Second, and most importantly, Boime dismisses Tanner's own assessment of his work and writes off observable formal qualities in that work as "rhetoric." Tellingly, Boime withholds description.

Boime's appraisal of Tanner situates the artist between Lewis and Duncanson relative to the presence or absence of the black subject. Like Lewis's oeuvre, Tanner's earliest works offered up the black subject, and those are the works with which he is most identified by scholars. As a result of the reductive reading of artist as art object, Boime is more generous in his interpretation of Tanner's African American subjects. Clearly, Boime privileges Tanner's engagement with racialism (what Boime describes as "the American experience") as more authentic because Tanner had what Boime characterized as "first hand" experience of it. After painting only two works that featured the black subject, however, Tanner deemphasized and/or eliminated it entirely in subsequent works. Tanner focused instead on biblical subjects, for which Boime charges him with abandonment of

his duty to his people, implying that Tanner favored fiction over reality. According to Boime, Tanner "*abandoned* the depiction of contemporary people and experience for a world of fantasy and biblical mythology. He *deserted* overt representations of the economically repressed conditions of African-Americans, and ultimately he *reinscribed* them in a biblical past to please his father and wealthy [white] patrons."[52] Boime responds to the withdrawal of the black subject in strong terms that are reminiscent of Lubin's analysis of Duncanson, especially in Boime's persistent attempts to read the black subject as "reinscribed" even in the face of its nonpresence.

Describing the Exotic

Like Tanner's earliest works, Lewis's oeuvre offered up the black subject for the art historian; but why do Tanner's pedagogical narratives succeed and why do Lewis's black subjects fail completely in Boime's estimation? The answer may lie with the two questions I posed earlier about Boime's stated purpose for his project, which is to do a study from the perspective of the black victim: Why is it Boime's assumption that to study the image of the black is to identify with the "black victim" and not the privileged (with few exceptions) white artists who invented that "victim"? Why is it that to study the image of the black is to study the state of being embodied as "victim"? Consistent with Boime's work on Tanner, who is the "victim" of his father and of powerful, white male patrons, when Boime examines Murray, and through Murray, Lewis, Boime does so from the perspective that Murray and Lewis also are "victims." Furthermore, Boime's assumption that perception is something that can be appropriated, no matter the purity of motive, truly reenacts the dichotomous relationship of otherness—of white knowing subject to black known object. Even as Boime acknowledges that "the final picture is my personal construction," his empathy—tantamount to the transference of his consciousness into the object of feeling—comes with certain privileges that are apparent in his "dialogue" with Murray, which begins in the final chapter of *The Art of Exclusion*. This "dialogue" is characterized by four themes: he praises Murray for being ahead of his time; he chastises Murray for his misguided enthusiasm; he charges Murray with being Victorian and suffering Victorian "blindspots"; and finally, there is, at times, a merging of authorial voice so that occasionally it is unclear if Murray is being paraphrased or if Boime is expressing his own opinions.[53] The heady cocktail of hindsight and the

right to admonish Murray, all under the guise of empathy, is the privilege of the white knowing subject.[54] Boime confers on Murray a voice, but it is a voice mediated by Boime's editorializing, "scoring," and excoriation of Murray's intention.[55]

As it happens, however, Boime has taken the theme of his own text from what he identifies as Murray's "subtext" — that is, that the inspiration and energy that drove U.S. art in the nineteenth century was the issue of slavery. After paraphrasing Murray's discussion of Hiram Powers's *Greek Slave*, Boime writes, "Murray concludes that Powers's work, which he considers the nation's first internationally acclaimed sculpture, is 'America's first antislavery document in marble.' Related to this observation is Murray's subtext, which runs throughout his study, that America's outstanding sculpture has derived its energy and attention from its relationship to the history and abolition of slavery. Slavery was the one significant national issue that could command the talents and thoughts of its most gifted practitioners."[56] Boime loosely structures his final chapter according to Murray's chronological discussion of emancipation images in American sculpture, spanning from Powers's *Greek Slave* (1842), William Wetmore Story's *Libyan Sibyl* (1861) (figure 25), and John Quincy Adams Ward's *Freedman* (1863) to Edmonia Lewis's *Forever Free* (1867), Augustus Saint-Gaudens's *Shaw Memorial* (1901), and Meta Vaux Warrick Fuller's *Emancipation Group* (sometimes known as *Emancipation Proclamation* (1913) (figure 26).

Following Murray's lead, Boime introduces Edmonia Lewis prefatory to discussing her one extant work that deals directly with the theme of emancipation. Boime begins with a brief biographical account of her education at Oberlin College and references some of the problems Lewis faced there. He talks about her time in Boston, the abolitionist supporters she found, and her transformation of them into patrons via the bust portraits she made of them: men such as William Lloyd Garrison, Charles Sumner, and Wendell Phillips, all of whom became her subjects. Boime then references her bust of Colonel Robert Gould Shaw and her success in selling enough plaster copies to finance her trip to Rome, where she joined the large expatriate community of American artists. Making no mention of her works based on Longfellow's poetry, Boime notes that once in Rome Lewis "immediately took up the theme of the emancipated slave" and describes the two results: *The Freedwoman on First Hearing of Her Liberty* (now lost)

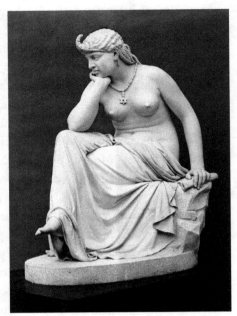

25 William Wetmore Story, *The Libyan Sibyl*, modeled 1860; this version, 1861. Marble, 53 × 27¾ × 45½ inches. The Metropolitan Museum of Art, New York City. Gift of Erving Wolf Foundation, 1979 (1979.266). Image © The Metropolitan Museum of Art.

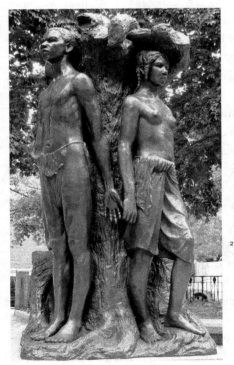

26 Meta Vaux Warrick Fuller, *Emancipation Proclamation*, plaster produced in 1913; 2000, Bronze, 85 × 42 × 41 inches. Location: Harriet Tubman Park, south end, Boston; jointly owned by the Museum of the National Center of Afro-American Artists and the Museum of Afro-American History. Photo courtesy of Erika Adams.

and *The Morning of Liberty* (known as *Forever Free*). As Boime remarks, "The theme of 'forever free' had become a major source of hope and propaganda for black people and their abolitionist supporters in their drive to gain maximum political recognition during the Civil War."[57] Boime traces the theme's manifestation in popular poetry, music, and imagery, all as corollaries to military and governmental edicts of the time. Quoting a poem by William Wells Brown inducing Lincoln to "tell Jeff Davis to let my people go," Boime points out the agency of African Americans in the fight for emancipation.[58] It is within this realm that Boime constructs the first of three contexts for *Forever Free*. The second context is for the dedication ceremony at Tremont Temple that Boime argues was Lewis's acknowledgment of the connection between African American agency and emancipation. The third context for the sculpture is Murray's book, and here is where the authorial voice becomes unclear; in five paragraphs of discussion, Boime uses Murray's interpretation as the foundation for his own argument about how Lewis's art betrays her pathology.

In order to not misrepresent Boime's argument, I will summarize as I analyze each of the paragraphs. He begins by noting Murray's confusion between Lewis's two emancipation images, neither of which Murray had seen though Murray did have access to nineteenth-century descriptions of the works. Boime praises Murray, however, for his grasp of the historical influences on Lewis's career following the Civil War, a period Murray describes as the "re-enslavement" of African Americans. Boime quotes Murray's speculation about Lewis's reaction to the conflicting emotions of the time, namely, that she surely would have embodied these emotions in her sculpture. This quote, coupled with Boime's next sentence that summarizes Murray's analysis, is very important because it sets up Boime's own tautology and gives it a historical precedent. Immediately following the claim that Lewis identified with the freedwoman in her sculpture, Boime writes, "Murray declares that by American custom Lewis was 'identified wholly with the Negro.' Thus she had to experience her *Freedwoman* (his title for *Forever Free*, which he had not yet seen) differently from the way Ward had experienced his *Freedman*. Not only the racial differences, he [Murray] claims, but the different moments—although relatively close in time—in which they worked gave rise to different conceptions."[59] Eventually, Murray was able to locate the sculpture. It was in the possession of George Glover, an African American living in Boston. As Boime notes, see-

ing a photograph of the sculpture did not substantively change Murray's interpretation but he did send a copy of it to the African American sculptor Meta Warrick Fuller (1877–1968), whose *Emancipation Group* was also featured in Murray's book.[60] In a postscript, Murray prints Fuller's response: "The man accepts it (freedom) as a glorious victory, while the woman looks upon it as a precious gift."[61] Boime ends the paragraph with a tentative endorsement of not only the gendered reading of male and female response to emancipation but also to the idea (substantiated at this point by both Murray and Fuller) that Lewis identified with her female subject. Boime argued that Fuller's "distinction between the attitudes of the male and female added considerable insight to Murray's complex reading, hinging on the presumed identification of the sculptor with her female subject."[62]

In the next paragraph, Boime states that despite Murray's refusal to change his reading after seeing a reproduction of *Forever Free*, Murray's understanding of the historical influences on Lewis's work is borne out by her subsequent career. Boime's summary of Lewis's career contains his description of *The Death of Cleopatra* that I quoted earlier in this chapter. Having established, albeit tentatively, that Lewis identified with her female subjects, Boime's analysis takes a familiar and ominous turn toward the tautological. "She returned to her native land only during summers or for business, and her late years are a blank, with the date and the place of her death unknown. Her last notable public appearance came with the exhibition of the bizarre *Death of Cleopatra*, which she sent to the Philadelphia Centennial of 1876. This is an angry and conflicted image of Cleopatra writhing in agony, her face distorted into a pained grimace. That such an embodiment of feminist power should be subjected to this unprecedented treatment suggests Lewis's alienation from the Neoclassical circle in Rome and gives evidence of antifeminist feelings turned against herself."[63] Clearly, for Boime, the description of Cleopatra is the explanation for Lewis. It is incomprehensible that he would be able to reach such a conclusion or make such a claim with so little space given over to her or with such a limited discussion of her art. Entirely consistent with Boime's stated method of doing art history from the perspective of the black victim, he has transformed Lewis into a casualty rather than an agent of ideology. Her pathology is made manifest in her art, which replicates Cleopatra's suicide. Nevertheless, like Boime's construction of Tanner, Lewis's business sense carried her along despite a crippled art. With no mention of

her Longfellow-inspired works (much less *Hagar*), and with emphasis on her heritage, Boime contends, "A shrewd businesswoman, however, Lewis often took her show on the road, participating in western fairs to avoid the competition in New York and setting up booths in the form of wigwams, emphasizing the links between the West and her Native American heritage. It is clear that she devoted much of her time to her financial affairs to subsidize her permanent exile."[64] His reading of her career as driven by opportunism is reminiscent of Burgard's treatment of Lewis's career. Equally worth noting is the literalness with which Boime takes the wigwam reference. In the nineteenth-century account, the reporter said that Lewis "preferred" to call her booth a wigwam, but by the time Boime retells the story he makes it sound as if it was fact and a regular occurrence. Finally, as I have demonstrated, even though Lewis actively distinguished her brand of "Indianism" from that practiced and performed in the West by the Plains tribes, Boime conflates "the West" and Lewis's "Native American heritage" as if they were the same.

In the third paragraph or "act" (and it is climactic in the Shakespearean sense and the pun will become obvious soon), Boime completely abandons Murray's lead and tenders an interpretation of the artist that dovetails with his reading of *Cleopatra*. It is in this paragraph that Lewis is deemed "exotic." Boime reports that Lewis "tried to find her way into the cosmopolitan society of the American colony in Rome," but she met with obstacles and prejudices similar to those found at Oberlin. Boime reasons that it was Lewis's attitude that was responsible for some of the hostility. "As at Oberlin," he argues, "she refused *to act out* the assigned role of the passive black and disregarded the proprieties of upper-class society that still marked the lifestyles of her more advantaged white counterparts."[65]

Boime is fond of the phrase "to act out" and uses it in an earlier chapter about Henry Ossawa Tanner's *The Banjo Lesson*, which he covers only briefly in this book. The figures in Tanner's painting, according to Boime, also refused a stereotypical role because, as he explains, "The intimacy of this scene is far removed from the 'acting out' so typical of the scenes of blacks with banjos; here the object of the lesson counts for less than the depth of the pedagogical exchange."[66] In one sense, "to act out" could signify performance, a put-on behavior, or even deception. As the anthropologist Richard Schechner demonstrates, performance is behavior heightened and publicly displayed, and its subject is transformation. "Even in con

games, spies, and stings where performances are cunningly masked and folded into the expected, these are enjoyed by a secret audience, the producers of the deceptions."[67]

Having decreed her refusal of the role of the passive black, Boime assigns Lewis another role — that of the exotic in desperate search for attention and acceptance. He continues, "She wore mannish costumes and *acted out* the role of the eccentric, transforming herself into an exotic attraction for her visiting American compatriots. Her early conversion to Catholicism around 1868, however, evinces her need to overcome her sense of isolation and also raises interesting questions about the pressures of race and class in her new surroundings."[68] There is another sense of "acting out" that can be inferred here, that of a child having a tantrum, behaving in a socially unacceptable way, so desperate to be noticed that her spirituality has no strong grounding but is yet another performance to get herself recognized. Such interpretations of misbehavior are part of a long history of stereotyped infantilized blacks and cannot be discounted given the ascriptions against Duncanson and Tanner as unable to separate from their "fathers" as well as the constant association of Lewis with childishness. Most disturbing is Boime's summation of Lewis as a person embodied in and circumscribed by her own sculptures. He concludes, "It is possible that her masochistic female images, more consistent with male fears of emasculating women, provided a psychological compensation for her unconventional lifestyle and masculine identity. In this context, the sculptures could be seen as embodiments of her frustration at the very real powerlessness that she tried to overcome and which she despised in her sex."[69] In this sense, "acting out" not only constitutes her art but also her art becomes a sign or an externalization of self-loathing (the pathological), as well as a sign of Lewis's absolute difference, all made concrete by and reaffirmed in her creations.[70]

If the third paragraph was climactic, the fourth and fifth are anticlimactic. In these remaining two paragraphs about the artist, Boime refocuses on *Forever Free* and his "diagnosis" (now that we, as readers, have been prepared to view the female figure *as* Lewis) fulfills itself in the explanation of the sculpture. The sculpture's medium is examined in this paragraph and Boime's ruminations on white marble and whiteness recall Lubin's investigation of Duncanson. Boime begins, "Lewis's *Forever Free* is carved, ironically, from white marble. Like Manet and Melville, she went out of her way to break the stereotype, in this case using the beloved medium of the Neo-

classical idealists to render the physiognomies and the costumes of an op-
pressed ethnic group." Despite the fact that Lewis had never been a slave,
Boime, rather than lodging a valid critique of Murray's use of tautology as
method, follows him in his unwillingness to understand that any identifi-
cation on Lewis's part beyond sympathy with those who suffered enslave-
ment was indeed a "performance." In order to move Lewis closer to her
freedwoman, Boime compares Powers's use of the stone in his *Greek Slave*
to Lewis's use of the stone in *Forever Free*. The assessment is notable for
the comparative trajectory of manipulation between the white male artist
(outward) and the black female artist (inward) and is reminiscent of Bur-
gard's contention that Longfellow's representations of Indians were "con-
structed" whereas Lewis's were "incorporations": "Whereas Hiram Powers
exploited white marble for his discreet Caucasian slave, Lewis *appropriated*
the medium for her metaphorical black *sister and brother*."[71] Her appro-
priation of white marble has, according to Boime, two possible significa-
tions. One is related to an emancipation of the medium, as Boime specu-
lates: "Either she 'liberated' the white marble from its exclusive function
in perpetuating the hegemony of white mythology and history—thereby
liberating blacks from their stereotyped role in art." However, Boime's es-
timation of Lewis's art as a reflection of her masochism and self-hatred
would hardly account for such a usage of white marble by Lewis. Instead,
it is Boime's second signification in which he is clearly invested. The second
meaning has to do with a correlation that we have encountered before with
Lubin where "white(ness)" is the equivalent of "freedom." Boime counter-
poises, "Or she used the color 'white' in this instance as the desired goal of
emancipation and the 'ideal' state of all peoples." He finds the basis for this
second signification in Murray, as he summarizes: "Murray was disturbed
to find that the physiognomy of Lewis's kneeling female more closely re-
sembled a white person than that of the standing male. This phenomenon
he compares with what he called 'toning,' the attempt on the part of some
blacks to lighten their complexion in identification with their oppressors,
or the predominant social group."[72] Boime's acceptance and perpetuation
of the tautology, where the body of the artist is fused and confused with
her body of work, is apparent. Like Lubin's Duncanson, Boime's Lewis
wants to be white, and her sculptures, like Duncanson's painting, function
as both a register of that desire and as a form of passing. Such correlations
between art and artist function as Victorian reiterations of the represented

as the real, exposing Boime's and Lubin's investment in sentimental art history.

In the final paragraph to deal substantively with Lewis, Boime takes up the formal aspects of *Forever Free* and claims that both Murray and Fuller "rightfully see the kneeling figure as more problematic than the male." He uses their words about the relative subordination and dependence of the female figure in terms of race and sex as an endorsement of his position that Lewis was a self-hating masochist, masculine identified, and beholden to her white male patrons. The key to such interpretations, whether exoticizing or celebratory, relies on an oppositional reading of the male and female figures with the attendant uncritical absorption of Lewis into the female. Boime notes the tradition in which "the formula for sculpture in the nineteenth century generally positioned the subordinate, accessory, or complementary figures in kneeling positions." "Given the tradition," he contends, "Lewis's female figure has to be seen as subordinate and dependent in the double sense of gender and race . . . As the victim of both racism and sexism, 'freedom' is more ironic for the woman than for the man. The male places his hand condescendingly on her shoulder as he lifts the manacles up to heaven." Male agency does not stop with the represented black male, according to Boime, who concludes the paragraph with the following claim about Lewis's own subordination in the face of male power as recorded in her art: "Lewis's group manifests her personal indebtedness to the predominantly (white) male social reformers and abolitionists who guided her early career and who show up most frequently in her portrait busts."[73] Lewis and Tanner, in the hands of Boime, like Duncanson in the hands of Lubin, are "mastered" by the ultimate authority—by white male art historians who enact through their scholarship "American Africanisms." These scholarly acts—"actings out"—are indeed the rhetorical indexes of the condition of racial subordination within which white subjectivity performs itself. But, let me reiterate, such acts are not limited to white males, as I have tried to show and will explore further in the next subsection of this chapter.

Edmonia Lewis's reputation as picturesque or exotic began as soon as she stepped onto the national and international stage, and one finds that perceptions of her as exotic continue to emerge at odd times and in odd ways. She defied the Victorian definition of the ideal woman with her odd clothes, her lack of marriage, her expatriation to Rome, and her decision to

sculpt. These facts, however, in no way distinguished Lewis from the other women sculptors who had preceded her, women such as Harriet Hosmer, Anne Whitney, and Louisa Lander. Yet in some art historical texts, Lewis continues to be singled out as exotic.[74] Boime's charge against Lewis as exotic, however, differs from previous and later designations of her as such. His use is more self-conscious and considered (though still problematic), not as a state of being but as action/performance/persona. Nevertheless, in all these writings, one can trace continuing, unconscious assumptions about the nature of difference as noncontingent and racialist in origin. But it is hollow reasoning that would have difference signify the exotic, and whether used to mean "foreign" (imported, alien, extrinsic, and out-landish, outside, other, or external) or "fascinating" (romantic, strange, un-usual, mysterious, wondrous, or different), the term has resonance enough to decontextualize her. In the complex process of differentiation, Lewis was an integral part of how the American artistic and abolitionist com-munities of the nineteenth century viewed themselves. In fact, current art history practices continue to rely upon nineteenth-century strategies for (not) dealing with difference. Those who label Lewis's difference as abso-lute, by comparison, inhabit an imagined position of "normalcy." Until the issues of exclusion are confronted, Lewis will continue to be dismissed as "picturesque" or "exotic," reinscribed as the absolute outsider.

Describing the Subversive

Unlike descriptions of her as "picturesque" or "exotic," Edmonia Lewis's reputation as the facile manipulator of marble and white patrons is a product of more recent histories. From the nineteenth to the mid-twentieth century, when Lewis was celebrated it was usually for her con-tribution as an African American woman to the arts of the United States. The subtle shift in narratives about Lewis, from celebratory to subversive, coincides with two movements that were reflected in art history: the civil rights movement of the 1960s and the second wave of U.S. feminism of the 1970s. In order to transform Lewis into a heroine more palatable to a late-twentieth-century sensibility, Lewis's art had to pull double duty: she had to "stick it to the man" (that is, stand up for her blackness with a display of "black power") and she had to "stick up for her sisters" (she was "woman hear her roar"). The art historian Judith Wilson, in her essay "Hagar's Daughters: Social History, Cultural Heritage, and Afro-U.S.

Women's Art," assigns Lewis's work a third responsibility that I will examine below. First I want to preface my discussion of her essay by providing a brief context for it. The essay was written for an exhibition and catalogue of the same title, *Bearing Witness: Contemporary Works by African American Women Artists*. The exhibition was curated in 1996 by Jontyle Theresa Robinson for Spelman College, the historically black woman's institution in Atlanta, Georgia. Both the exhibition and the catalogue paid tribute to women who are prominent in their fields: artists such as Lois Mailou Jones, Howardena Pindell, Amalia Amaki, Barbara Chase Riboud, Alison Saar, Betye Saar, Freida High, Emma Amos, Carrie Mae Weems, and Lorna Simpson; the catalogue includes essays by scholars such as Tritobia Hayes Benjamin, Beverly Guy-Sheftall, Lowery Stokes Sims, M. Akua McDaniel, Judith Wilson, with a foreword by Maya Angelou and an afterword by the playwright Pearl Cleage. I was fortunate to attend the opening at Spelman, and most of the programming took place in the newly renovated museum building, a renovation project paid for by Bill and Camille Cosby. In what turned out to be an enlightening and uplifting event, many of the artists were present, as were many scholars not featured in the catalogue but well known in the field of African American art history.[75] Perfectly attuned to the nature of the wider project, Judith Wilson's essay has one major goal, as a close reading will reveal: an origination narrative that makes the case for Edmonia Lewis and Meta Warrick Fuller as the "foremothers" of contemporary African American women artists.

In order to establish a genealogy for contemporary African American women artists, Wilson begins her essay by claiming that the celebration of "African identity" is a key trope of what she calls U.S. black modernism. Using as a springboard an essay by the cultural critic Michele Wallace, "Modernism, Postmodernism and the Problem of the Visual in Afro-American Culture" (1990), Wilson promises to rectify the two major absences that Wallace notes in the history of modernism: the absence of African Americans from prevailing accounts of modernism; and the absence of women from counterhistories of African American modernism.[76] To Wallace's lament, Wilson adds her own: "Widespread reluctance to abandon conventional definitions of 'modernism' in which 'style' outweighs 'content' has also impeded efforts to name women pioneers or precursors of an African American modernism."[77] Her claim is reminiscent of Emerson's — that the key to the unsung poem that is America is to be found in its

regions, Negroes, and Indians, that is, a content-based modernism that will free America from a stylistic subservience to Europe, and in Wilson's case, liberate African Americans from charges of stylistic derivation because of their racial/experiential difference (their "content" or "root culture") from European Americans. To that end, Wilson lays out the purpose of her essay: to detect noncanonical brands of modernism; to retrieve marginalized modernist histories through a close scrutiny of the various sociocultural contexts that determine both an art form and its content; and to locate the earliest, significant appearances of said content — the celebration of African identity in the works of Lewis and Fuller.

In the second section of the essay, Wilson attempts to circumscribe the context for and definition of African American modernism by acknowledging the role of colonialism in the construction of modernism, and specifically, an African American modernism. According to Wilson, "Increasingly, art historians are probing links between colonial politics and early modern art. Yet, all too often, theorists of an African American modernism forget that the so-called 'New Negro' came of age in the heyday of Western imperialism." She argues further that early-twentieth-century black cultural self-assertion was the product of black involvement with abolitionism and the post-Emancipation struggle for civil rights "that took place in an international context of colonial commerce, evangelism, exploration, and imperialist expansion." Finally, she poses a consciousness of Africa as inherently oppositional in the minds of nineteenth- and early-twentieth-century African Americans.

Black abolitionists, ranging from Frederick Douglass to African American photographer James P. Ball, also recognized that European myths of African "barbarism" or "savagery" provided excuses for slavery. After Emancipation and the brief period of federal protection under Reconstruction, African Americans faced a "red tide" of unprecedented anti-black violence and a program of systematic disenfranchisement not unlike today's reversal of Civil Rights and Affirmative Action legislation. Then as now, the defense of African civilization not only staved off black despair, but also aimed to counter an ascendant "scientific" racism that licensed both Jim Crow in the United States and the European "scramble for Africa."[78]

Problematically, Wilson argues for a highly self-conscious and deliberate essentialism figured as "African identity" that somehow makes the African

American experience "modern" and that does not accommodate excep-
tions, such as William Wells Brown or those African Americans who op-
posed colonization. Her purpose can be likened to Adolph Reed's pointed
critique of Houston Baker's attempt "to posit racial or cultural traditions
in order to formulate notions of black authenticity."[79] Reed notes two
consequences of such attempts: "First, it justifies an approach that is ahis-
torical, acontextual, and idealist in that it characterizes tradition as the
elemental persistence of definitive forms — the constitutive idea of black-
ness — through all concrete environments." And second, "in abstracting
away from historically specific discursive contexts," such attempts overlook
"real tensions and differences and trivializes the substance of real debates
among black Americans; to that extent it grounds Afro-American intel-
lectual history on a false unity."[80] As Reed holds, "The presumption of a
unitary black experience imposes a false homogeneity on Afro-American
intellectual history. It also supports reduction of politics to the expression
of group identity."[81]

In the third part of her essay, Wilson, through a series of structurally
opposed binaries, makes the case for an unfettered African American
female agency and for black women's involvement in this constitutive idea
of Afro-U.S. modernism. Looking to the cult of true womanhood, the
first binary opposes the political activism of black men to an ideological
and economic marginalization of white women. Wilson notes that the fig-
ures generally associated with various "Africa" movements are black males
and that this seems to reflect the dominant culture's practice of gendering
the public sphere as male and the domestic sphere as female. Wilson con-
cludes, "A by-product of industrialization and the accompanying triumph
of modern capitalism, the emergence of sex segregation as a social ideal co-
incided with an increased economic marginalization of middle-class white
women."[82] The second binary constructs white women as passive and black
women as active. Completely overlooking poor white women, Wilson ob-
serves that the economic disparities forged by race and class throughout
American history meant disparities in the respective wealth of white and
black households. As a result, Wilson reasons, middle-class white women
could be exempt from materially productive roles while black women had
to work and thus were permitted a place in public life. "This racial differ-
ence," she writes, "in the articulation of nineteenth-century codes of gen-

der difference forms a crucial backdrop to the careers of black women pio-
neers in the visual arts."[83] Wilson oversimplifies black women's so-called
permission to participate in public life as wholehearted and uncomplicated
by ideology, especially as she fails to mention African American women's
ideological participation in the cult of true womanhood. The third bi-
nary contrasts the political agency of black men, who acted on an inter-
national stage according to Wilson, to black women, who were limited to
action on a domestic political stage. And here, she does not acknowledge
that this reflected the experience of white women activists as well, that
these middle-class black and white women, because of economics, had the
leisure time to act. Instead, she explains, "Such conspicuous female activity
in the public sphere clearly deviates from nineteenth-century bourgeois
white gender ideals." Such qualifications exemplify the overarching binary
of all her comparisons — white ideology as the domain of white women
versus black material reality as the domain of black women. She continues
to employ a false opposition between raced gender ideals and the actual
activity of black women but with no corresponding discussion of white
women's activism until her discussion of Lewis, but then she names those
women only to lend Lewis agency in her artwork.[84] Her structured binaries
end with a comparison between black women activists who were limited
to the domestic sphere and black women artists: "For there the first signs
of an *international* black consciousness apparently issued from the hands
of Afro-U.S. *women.*"[85] In the fourth part of her essay, Wilson introduces
Edmonia Lewis, briefly mentioning her birth and childhood before mov-
ing to Lewis's education at Oberlin College. At Oberlin, Wilson specu-
lates, Lewis's first encounters with feminism probably took place. Wilson
mentions Mary Wollstonecraft's belief in the rights to female education
and the Reverend John Keep's advocacy of female education and abolition,
but Wilson does not qualify what Oberlin educated women *for* nor does
she put nineteenth-century feminism or abolitionism in any historical con-
text, as if "feminism" and "abolitionism" mean one thing throughout their
histories. Wilson does note, however, "The conjunction of abolitionism
and feminism that she [Lewis] experienced in the Keep household would
play a crucial role in Edmonia Lewis's subsequent career, determining the
specific character of her art's references to African heritage."[86] By taking
for granted an ahistorical perception of "feminism" and an unsophisti-

cated idea of "abolitionism," by not exploring Oberlin's gender-segregated curriculum, Wilson is able to assign to Lewis's work a subversiveness that simply does not exist.

Wilson's false sense of Lewis's subversiveness is reinforced by the physical layout of the essay. What appears next is an extended description by Maria W. Stewart, in a pamphlet published in 1831, of a daguerreotype of Sojourner Truth. And while the actual daguerreotype of Truth is not reproduced, the description is positioned to the right of a carte-de-visite of Edmonia Lewis (as if it describes that object).[87] Visual and verbal portraits are almost equal in size, while the juxtaposition sets up a comparison between Lewis and Truth that Wilson will make between the "feminist" beliefs supposedly shared by the two women. Wilson segues from Stewart's claim that "Truth willfully engaged the symbolic reference to ancient oracles and/or Egyptian sphinxes, in service to her own ends" with the suggestion that "two extant works by Edmonia Lewis hint that, through her sculpture, this artist sought to locate African American history and culture on a *world* stage. Both sculptures [of Hagar and Cleopatra] refer to Africa in ways that are consistent with a contemporaneous black folk theology in which Biblical references to Egypt and Ethiopia were meant to instill group pride and deflect white claims that the curse of Ham doomed blacks to servile status" (plates 8, 12). Wilson further contends, "But both works can also be linked to the rhetoric and history of early black feminism, as we can see by the noted black abolitionist-feminist Sojourner Truth's exploitation of a related visual and literary symbolism during the same period."[88] Wilson then notes the inadequate attention paid to Lewis's connections to black feminists of her day. This observation *must* occur *after* Wilson's introduction of Sojourner Truth because, as far as scholars know, there wasn't *any* connection between Truth and Lewis. Thus, the placement of the statement can *suggest* a connection (if only ideological) without substantiating one even as Wilson subsequently mentions several African American women who did have some connection to Lewis.

I agree with Wilson's contention — that feminism and abolition were linked discourses in Lewis's art — but where we part ways is Wilson's belief that such discourses were by their very nature "subversive." Wilson holds, "The subversive character of Lewis's Emancipation group is especially apparent when it is compared with works on this theme by her American contemporaries."[89] She then compares the self-assertion present in Lewis's

male figure in *Forever Free* to the subservient position of Thomas Ball's figure in his *Freedmen's Memorial* (plate 2; figure 4). But, Wilson argues, it is Lewis's female supplicant that "lends Lewis's Emancipation group an especially subversive meaning." Noting that antebellum images of slavery by black artists before Lewis are rare, Wilson mentions Patrick Reason's *Kneeling Slave* (1835) and Robert S. Duncanson's *Uncle Tom and Little Eva* (1853). By the time that Lewis sculpted *Forever Free*, Wilson points out, the Fourteenth Amendment had been ratified, conferring citizenship on newly emancipated blacks, but the Fifteenth Amendment limited the vote to male citizens. It is in this sociohistorical context that Lewis made her sculpture, according to Wilson. And rather than associate Lewis with those African American women who were willing to wait on the issue of enfranchisement, trusting black men to vote their interests, Wilson aligns Lewis and Lewis's work with Sojourner Truth's outspoken stance against partial enfranchisement.[90] Wilson does not even entertain the possibility that Lewis and Lewis's work were in support of the Fifteenth Amendment, following the opinion of African American women like Frances Ellen Watkins Harper. As the historian Paula Giddings observes, Harper "had much more faith in the abilities — and intelligence — of Black women, and Black men, than Sojourner Truth did. As Harper saw it, *the greatest obstacle to the progress of Black women was not Black men but White racism*, including the racism of her White 'sisters.' At a convention in 1869, Harper expressed her support for the Fifteenth Amendment. By that year she had reason to believe that if the bill was defeated, Black women would be less, not more, secure."[91] Nevertheless, Wilson views Lewis's sculpture as "the visual analogue of Sojourner Truth's characterization of emancipation without universal suffrage as 'slavery partly destroyed, not entirely.'"[92] That reading is based, like Boime's, on an oppositional reading of the male and female figures in Lewis's sculpture; on the submersion of the artist into the female figure; and finally, on a totalizing, noncontingent idea of blackness, which, in this instance, chastises black men for destroying what should have been a unitary experience rather than one divided by gender.

At this point, I want to distinguish how I, Boime, and Wilson divide Lewis's works thematically: I place Lewis's Hagar sculptures under the category of "slavery works," separate and apart from her Cleopatra; Boime, who does not mention Hagar but does discuss *Forever Free* and *The Death of Cleopatra*, seems to categorize them as "black"; while Wilson, in the final

section of her essay to deal with Lewis alone, categorizes Hagar and Cleo-patra as "African." I will examine what this means to the writing of Lewis's art history in the final part of this section, but for now an awareness of our disparate agendas should be clarified as I begin to analyze Wilson's assertion that Lewis shared a consciousness of Africa (an "African iden-tity") that functioned subversively. According to Wilson, the ideological significance of Lewis's Hagar and Cleopatra is the "line of interpretation . . . that links the Nile Valley to the Mississippi by way of countless black preachers, teachers, and ideologues, who in the bleakness of the Post-Reconstruction era invoked the splendors of ancient African civilizations as a beacon of hope to African Americans. This line seems to run directly from Lewis's dying Cleopatra to *Ethiopia Awakening* by Meta Warrick Fuller" (figure 27).[93] In light of Wilson's hypothesis about the link between African American modernism and identification with Africa, one can see how William Wetmore Story's *Cleopatra* would suffer in her comparison to Lewis's statue (plate 12; figure 28).

The difference between the two artists' treatment of the fabled queen's suicide is striking. Story's dying monarch slouches glamorously in resignation, her head propped listlessly on her palm and her brow furrowed in gloom . . . the overall mood is one of defeat and despair. In contrast, the upper torso of Lewis's dying sovereign arches back and her head is thrown up and over to one side in a particu-larly graphic description of the expiring monarch's death throes. While this results in a degree of natural fidelity . . . it also rhymes with the body language of haughty defiance. Thus, even in death, Lewis seems to say the Queen of the Nile radiates the indomitable pride and wily independence that precluded her surrender to the Romans.[94]

Tellingly, the images are placed on the page out of "chronological" order so that they sit back to back, strengthening Wilson's construction of them as competing. In Wilson's defense, they could be situated in the order that they are discussed, but the side-by-side pairing is a striking and evocative image. Lewis's *Cleopatra* is on the left, even though it was made in 1875, while Story's *Cleopatra* (the version that Wilson illustrates was made in 1869 but the first copy dates even earlier, to 1861) is placed on the right. Also, as I will discuss in the next section, Story's Cleopatra predates Lewis's based on the narrative of the queen's suicide: Story's Cleopatra contem-plates death while Lewis's is already deceased.[95]

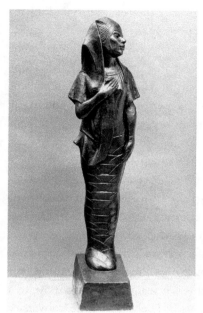

27 Meta Vaux Warrick Fuller, *Ethiopia Awakening*, ca. 1921. Bronze, 67 × 16 × 20 inches. Art and Artifacts Division, Schomburg Center for Research in Black Culture, The New York Public Library, Astor, Lenox and Tilden Foundations, New York City.

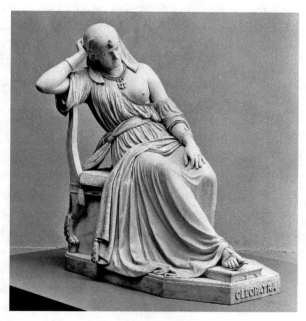

28 William Wetmore Story, *Cleopatra*, modeled 1858; this carving, 1869. Marble, 55½ × 33¼ × 51½ inches. The Metropolitan Museum of Art, New York City. Gift of John Taylor Johnston, 1888 (88.5a-d). Image © The Metropolitan Museum of Art.

In the fifth section, Wilson continues to trace this celebratory and affirming consciousness of Africa (more appropriately so) in the work of Fuller. As Wilson maintains, "This African American recovery and valorization of African heritage figured centrally in a broad program of psycho-social 'uplift' that was widely advocated by members of the black clergy, intelligentsia, and the Civil Rights movement at the turn of the century and in the years prior to World War I."[96] I have already suggested that the purpose of Wilson's narrative is the creation of a genealogy for contemporary African American women artists. But what are the consequences of the "subversive discourse" as it applies to Lewis? What is sacrificed by placing on Lewis's shoulders the burden of "anticipat[ing] the entire subsequent history of black artists' conscious struggle with questions of cultural heritage and racial identity in the United States"?[97] As Michael Baxandall asserts, "A first task in the historical perception of a picture is therefore often that of working through to a realization of quite how alien it and the mind that made it are; only when one has done this is it really possible to move to a genuine sense of its human affinity with us."[98] I believe that the "subversive discourse" as deployed by Wilson places Lewis closer to us ideologically while making her "strange" to her own time. She is made "strange" to her own time in order that she become relevant to ours, thus dehistoricizing her work and her life. This leads to the sixth part of Wilson's essay, the formation or origination story for African American modernism.

Wilson begins with a deliberate oversimplification of stylistic modernism's significance by asking us to "look beyond questions of mere formal invention to the more complex problem of merging specific ideological goals with an appropriate visual language."[99] Ironically, she could not justify the visual language of Lewis and Fuller as appropriate on any level, for she immediately attempts to reconcile the stylistic and visual disjunctures—the conservative and stylistically derivative vocabularies—between Lewis and Fuller's "African" subjects and the work of contemporary African American women's art. Her inability to reconcile the styles of Lewis and Fuller's art would explain Wilson's distortion of stylistic modernism as unwedded to ideology. However, she cannot leave style unregarded, as she concedes, "Thus, despite the obvious stylistic conservatism of both Lewis and Fuller's work, in their art we can trace the origins of African American modernism in the visual arts to an upsurge of politically-motivated identification with Africa's ancient Nile Valley civilizations and a conflation of this romantic

attachment to ancient Egypt and Nubia with concern for modern Ethiopia's fate. In Lewis's case, this orientation seems to converge with certain strains of nineteenth-century black feminism."[100] Therefore, reconciliation of the stylistic and visual disjunctures between past and present must ultimately render description irrelevant because outside of race, there is no formal explanation for Lewis and Fuller as "foremothers."

Wilson explains the visual and stylistic disjunctures as the artists working "within the confines of an elite art form" and operating "according to hegemonic (that is to say, 'Eurocentric') canons." As a result, Wilson admits, "Lewis and Fuller may seem profoundly alien to contemporary black women." But Wilson rejects what Michael Baxandall has described as the necessary "first task in the historical perception of a picture" — that of "making strange" in order to explore and contextualize the image; instead, she raises an additional set of disjunctures that will all be reconciled by the end of her essay. She continues, "And finally, efforts to identify with these artistic pioneers may be further hampered by the degree to which they appear to be 'exceptional' in both race and gender terms — of biracial (African and Native American) ancestry in the case of Lewis and of 'mixed' ancestry in the case of Fuller (judging by her light skin), both escaped the patterns of early marriage and frequent childbearing typical of women of their day."[101] In essence, by declaring Lewis and Fuller racially other in comparison to contemporary African American women artists, Wilson has constructed those women of her art historical present as monolithic and "racially pure," occupying a space similar to those who proclaim Lewis "exotic." She implies that, unlike Lewis (and Fuller), contemporary African American women artists work outside "elite art form(s)" and operate outside "hegemonic (that is to say, 'Eurocentric') canons." Wilson is on a self-proclaimed mission: to return "full knowledge" of Lewis and Fuller to "contemporary Afro-U.S. women artists [who] . . . have been denied their rightful inheritance. Deprived of full knowledge of the female art historical continuum of which they are a part, they remain 'Hagar's daughters' crying in the wilderness of cultural anomie."[102] Nevertheless, as Wilson has constructed her particular canon of African American modernism, Lewis now truly is a victim: she is the victim of two displacements because through the "subversive discourse" the meaning contained in her work is "made strange" to her own time, but she is also "made strange" to the present because of her appearance and the appearance of her work.

Reinventing Art History's Black Subject

How did we arrive at such an impasse so that to work in the idiom of the mainstream is to be self-hating? Or alternately, to consider anything other than insurgent strategizing is insupportable? As I have tried to demonstrate in the sections of my chapters that engaged art historical discourse, the collapse between art and self is fulfilled by art history's inscription and reinscription of the black subject. What we are left with is an amalgam: "the self-hating subversive." This new creature, the progeny of exoticizing and subversion narratives, is discernible in at least four areas that are profoundly interdependent: the manner in which the art historian assigns "intention"; the marginalization of the black or Indian subject; the use of sexual racialism to determine appropriate meaning in the work that as a result must disregard "inconvenient" evidence; and the search for the authentic. "The self-hating subversive" is indeed perceptible in the way in which Boime and Wilson assign "intention." Tellingly, both argue for a "content-based" signification of "the modern," but with diametrically opposed results. Their descriptions of *Forever Free* are essentially the same: male and female figures read in opposition, the female subservient to the male, Lewis present as that female figure. But Boime and Wilson base their explanations of the sculpture on an intentionality determined by an a priori designation of Lewis as either exotic or subversive; and thus they arrive at radically opposed descriptions/explanations for Lewis's Cleopatra. Because *The Death of Cleopatra* is the last major work by Lewis, scholars interpret it as the culmination of her "psychological self-portraits," hence the qualities that are ascribed to it via description are the ones that adhere to Lewis as a person, thereby closing the circle and completing the tautology. Rather than employ Baxandall's method — his triangle of reenactment — where intention can be perceived in the artwork, in the objective task or problem, and in a range of culturally determined possibilities, Boime and Wilson locate "intention" solely within the artist, as if it were something that could be identified, recovered, and fixed with any degree of certainty by the art historian.

As I have argued, exoticizing and subversion narratives are merely two sides of the same coin that both reinvent even as they marginalize, in this case, the black subject. Both narratives are strictly reactive to "white" issues and concerns, for example, the overly simple idea that, with her sculptures of Hagar and Cleopatra, Lewis answered negative stereotypes of Africa

with positive ones. The existence of the black subject is contingent upon both narratives' affirmation of "whiteness" as a separate and pure category of "difference," and whether that difference is constructed as "cultural" or "racial," both narratives function extraordinarily well within the framework of the "Negro Problem." They function so well because the perception that they share is that "race" means a "lack of whiteness," and as a result, both exoticizing and subversion narratives must strategize how one deals with that lack. For David Lubin and Albert Boime, if everyone was "white," there would be no "problem." Thus they theorize into existence black artists such as Duncanson and Tanner who supposedly want to erase this problem by becoming white men and whose work traces and reflects the "whitening" of their consciousness. In Lewis's case, Boime writes into existence an artist who, unhappy with both her race (lack of whiteness) and gender (lack of masculinity), wants to erase herself completely and resorts to "toning" her works in order to pass. Whereas Boime argues for a freedom located only within whiteness, Wilson constructs freedom as inherent in an oppositional (to whiteness) Africanness — but only for the female in Lewis's work. For Wilson, Lewis must react to the lack of whiteness and masculinity — that is, her distance from power/freedom — by pitting the female in her sculpture against the black male who seems, in Wilson's eyes, positioned closer to power (qua whiteness and maleness).

Moreover, both exoticizing and subversion narratives operate under a specific kind of "sexual racialism." It is a term that I have culled from the original constructions, "sexual racism" and "romantic racialism," because it is appropriate to the writing of art history's black subjects. "Sexual racism" is a term that has historically signified the perception of black women as sexually depraved (not ladies), dominant over black men (a perversion of the appropriate gender hierarchy), and pathological (that is, "other" than white), and is explored by the historian Patricia Morton in *Disfigured Images: The Historical Assault on Afro-American Women*.[103] According to Morton, "From the promiscuous mix of history and sociology, the black woman emerged, in past and present alike, as the linchpin of Negro pathology and cultural inferiority."[104]

"Romantic racialism" appealed, according to the historian George Fredrickson, to those who "ascribed to the priority of feeling over intellect sanctioned both by romanticism and evangelical religion" and was "widely espoused by Northern humanitarians who were more or less antislavery" —

humanitarians like Lydia Maria Child and Harriet Beecher Stowe. During the antebellum era, these romantic racialists found redeeming virtues among blacks even as they recognized that blacks were fundamentally different from whites. "At its most tentative," Fredrickson explains, "the romantic racialist view simply endorsed the 'child' stereotype of the most sentimental school of proslavery paternalists and plantation romancers and then rejected slavery itself because it took unfair advantage of the Negro's innocence and good nature."[105]

I have modified the term for the following reason: racism implies the systemic access to power and the direct ability to inflict or sustain harm because of a person's assigned or perceived race; simply put, racism implies action. Racialism, on the other hand, implies belief, the belief that an inventory of traits will signify absolute difference from that to which it is being compared. I have used "racism" and "racialism" with this in mind throughout my text and have hoped that the distinction has been clear.

In the context of art history, then, "sexual racialism" signifies the search for race-appropriate art that is contingent upon the gender and/or sexual orientation of the artist. Concomitantly, Boime and Wilson share a disregard for Lewis's inconvenient Native American works and marginalize her claims to a Native American identity. And thus, they do not provide any analysis of either the work or Lewis's claims on that identity; description is absented. For Boime, Lewis's Indianness is inconvenient to his reductive reading of Lewis *as* her black subjects. For Wilson, a sustained analysis of Lewis's self-proclaimed Indianness might further emphasize her otherness in relation to contemporary African American women artists and contradict Wilson's reductive reading of Lewis's "Africanness" as a sign of the early stages of African American modernism. "Sexual racialism" augurs a different but contingent interpretation for black male artists. Given Lubin's and Boime's belief in the compromised state of black masculinity, Duncanson and Tanner are subject to the "slave paradigm" because, in the estimation of the two art historians, being black is synonymous with being a slave. For Lubin and Boime, both artists are subservient to and mastered by patriarchy even as they futilely seek to imitate it in their lifestyles and in their art. Lubin and Boime adopt and adapt the idea of black cultural inferiority, underpinned by "Negro pathology." As Morton writes, "From this inferiority rooted in history seemingly sprang what was called 'Negro

pathology'; that is, as blacks strove and failed to imitate white culture, this process was said to promote their self-contempt."[106]

For Lewis, sexual racialism is determined by the "matriarchal paradigm" in which Lewis is judged by Boime and Wilson relative to her suitability to "mother." Morton, commenting on the research by black and white scholars, notes, "Her [the black woman's] sexual behavior was of primary interest, and of interest primarily as evidence of black pathology and familial demoralization. And during the interwar decades a vast body of social science literature came to identify the mother-led family—which was variously called the 'maternally organized' or, sometimes, the 'matriarchal' black family—as central to the 'Negro Problem.' This analysis pervaded racially liberal sociological research, both white- and black-authored."[107] For Boime, Lewis fails twice: she fails in her suitability to mother and fails to fulfill the stereotype of black pathology—the matriarchal black family. In the second instance, she "fails to fail." In his construction of her as "male identified" and hating the weakness of her own gender, he presents us with a failed human being (even if that failure means not living down to the proscribed pathology) who must make failed art.[108] In a sense, for Boime, Lewis is doubly pathological because she is unwilling or unable to fulfill her duty to her gender and therefore incapable of reifying the ideology of black pathology borrowed by art history from the disciplines of history and the social sciences. Alternately for Wilson, Lewis succeeds in her *suitability* to mother contemporary African American women artists, but she is a mother who also fails. Lewis fails because she is unknown to her children. Lewis fails stylistically as well because her art cannot nurture her children since there is no discernible continuity between past and present. Finally, Lewis fails racially. Ultimately, Lewis is a mother who has birthed orphans.

The search for the "authentic" is at the core of both Boime's and Wilson's work on the black subject; it is their particular brand of "American Africanism" deployed to police and reify the boundaries of race. Boime does not find the authentic in Lewis but does, to a limited degree, in Tanner. In Boime's discussion of Tanner, like Wilson's of Lewis, the "authentic" is contingent on the subversive, while the subversive is structured as a reaction to absolute, noncontingent difference. The subversive can only occur for these art historians in the artist's reification through the art work

of his or her blackness or Africanness. Adolph Reed contends, "The presumption that group identities are monadic entities — essences — persists broadly as an organizing feature in American discourse. The boundaries may be construed as more or less permeable, but the crucial point is that Americans generally continue to apprehend salient group affiliations such as race/ethnicity, class, gender, and, more recently, sexual orientation as unitary properties that are in effect primordial and that confer corresponding states of feeling and perceiving."[109] In the search for an authenticity defined strictly on the subversive, description must fail. Description (which is demonstrative rather than informative) feeds the idea of the authentic (which is hortatory rather than descriptive), as if the authentic could be recreated by description. The circularity of the preceding sentence reinforces how tautology works, because even as description pretends to be informative — relating facts rather than attempting to convince one of its realness — authenticity also pretends to relate facts rather than persuade. Yet the authentic closes off or circumvents description because description must cede its authority to those qualities already determined to be authentic. When not in the service of the authentic, description is fluid and filled with possibilities. But in the service of the authentic, description becomes a reflection of it — static, inflexible, and unchanging.

The self-hating subversive predominates in the narratives of African American art history. Interlarded with and influenced by the stories of sociologists, politicians, and academics of all kinds, art history tells and retells the tale of the timid, weakened black father and the domineering black mother manifested in the painting and sculpture of black artists. Perhaps this is because the positive aspects of art history are circumvented when shortcuts to intention are lodged within reified racialist beliefs rather than in an expanding and expansive attempt to contextualize the work of the artist.

There are so many confluences in the way that exoticizing and subversion narratives are constructed that one must ask constantly in whose interests are the black and Indian subjects reinvented? Perhaps because of our obsession with "getting it right" and our discomfort with the fact that art history is not a science, we search all the more vigorously for the "authentic" and its synonyms ("genuine," "real," "valid," "bona fide," "true") which soothe our uncertainty about what we do. If we begin our journey

intent on finding the real, the genuine, the valid, and the true, we arrive at such different destinations that we find no common ground. We cannot even *see* the same image, as Boime and Wilson's converging description of *Forever Free* and subsequent opposing descriptions of the same sculpture of Cleopatra attest. With such distorting precepts that weigh so mightily on perception and the discipline of art history, how far are we from the description that explains Lewis's *Forever Free* as the kneeling black man and the black woman who stands with fist raised?

KILLING CLEOPATRA: THE DISAVOWAL
OF THE BLACK SUBJECT

For nineteenth-century audiences, Cleopatra represented the corruption of womanly influence, particularly the Cleopatra as dramatized by Shakespeare, who used tears, sighs, and vapors to manipulate Mark Antony. By Edmonia Lewis's time, the life of Cleopatra had been distilled into very specific events in her biography whether true or fabricated: Cleopatra's unorthodox presentation to Julius Caesar; Cleopatra floating down the Nile on her barge; her banquet; Cleopatra testing poisons on condemned prisoners; and her suicide. The tale of Cleopatra's suicide defines, if not forecloses, her life. And in the nineteenth century, the almost synonymous relationship of beauty, femininity, death, and representation made the figure of Cleopatra wildly appealing.[110] Mary Hamer contends that, in the nineteenth century, "issues of politics and desire are at stake in representing Cleopatra. In this figure they are fascinatingly entwined and collapsed into each other. That is one reason the figure of Cleopatra has survived so strongly as a term in cultural exchange and been reworked so often. Its power to generate and sustain fantasy is exceptional. More than eroticism is involved: it is a question of the status of Cleopatra as a founding myth in Western culture."[111]

Passion was Cleopatra's downfall, and nineteenth-century women scrambled to differentiate themselves from Cleopatra by highlighting her foreignness and her racial heritage as a black African despite her Greek associations as a member of the Ptolemaic dynasty. Ultimately, Cleopatra was the yardstick by which proper and improper womanhood was measured.[112] Alternately, abolitionists argued that Cleopatra was racially "black" in

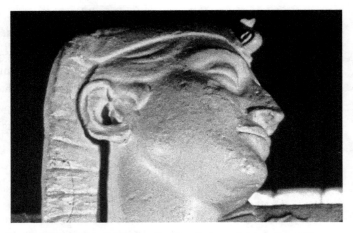

29 Edmonia Lewis, *The Death of Cleopatra*, detail of profile, 1875. Photograph taken after 1988
and before the restoration of 1994. Smithsonian American Art Museum, Washington, D.C.
Gift of the Historical Society of Forest Park, Illinois. Photo George Gurney.

order to prove that people of African descent could be self-governing and
could sustain a great civilization. Such debates depended on an ahistorical,
fixed perception of the various significations of "blackness" and shared a
belief in the aberrant sexuality of those descended from Africa.

As this section will show, Lewis would have been aware of the debates
and her rendering of Cleopatra reflects that awareness. A number of
viewers noted the artist's close attention to archaeological detail, but it
was Cleopatra's nose that made Lewis's work unique (plate 12; figure 29).
Rather than creating an obviously African physiognomy, most distinctive
in Lewis's depiction of the queen was the sculptor's decision to model the
profile from coins struck during Cleopatra's reign. Modeling from coins
provided Lewis's Cleopatra with a sharply aquiline nose that was immedi-
ately commented on by critics of Lewis's day. Her decision raises a number
of interesting questions. Why, having eschewed ethnological models for
the African American and most of the Native American women in her
sculpture, did Lewis definitively attempt a "true" physiognomic likeness?
And why did she choose to depict the death of Cleopatra? How did her
indoctrination in the cults of sentiment and true womanhood influence
Lewis's representation of Cleopatra? I will offer a narrative that counters
the tautological reduction of the object to a reiteration of Lewis's identity.

As I will show, simply by choosing Cleopatra's death as a subject, one positioned oneself within a complex, ongoing discussion about race, sexuality, and power.

Cleopatra in Nineteenth-Century Racialist Discourse

The investment in Cleopatra's blackness appears to date from the time of modern slavery in the West and the struggle to abolish it. In the nineteenth century, science was the equal of history in giving authoritative voice to the figure of Cleopatra, and nineteenth-century "armchair anthropologists" of all kinds were taking part in a wider cultural dialogue about the underlying connections between ancient Egypt and modern race relations. Numerous biographies existed in many languages and as long as the modern concept of "races of man" has existed — as biological and physical categories that reflect behavior and culture — Cleopatra's heritage has been an issue. In 1864, Adolf Stahr's biography of Cleopatra was reviewed by the *Saturday Review* and reprinted in the *Living Age*. The reviewer took Stahr to task for his attempt to "redeem" the character of Cleopatra. According to the reviewer, "Cleopatra was a Greek no doubt, with many of the charms of Greek culture, but these were obscured in her by the darker traits belonging to all Oriental despots. Murder and violence were weapons which she employed as familiarly as her smiles."[113] The ability to distinguish within one body Greek versus Oriental traits is entirely consistent with racialism and happens more than once when Cleopatra and her perceived contradictions are at issue. (This is similar to nineteenth-century discussions of Lewis's dual racial content and the ability to perceive it clearly on the surface of her body.) Where science and history intersect in the body of the nineteenth-century Cleopatra is in the debate over her "complexion." The question of Cleopatra's parentage was at the heart of the issue. It was accepted that on her father's side she was a descendent of the Ptolemies, but her mother was unknown.[114] Had her father married a woman who was his sister or had he impregnated a "Nubian" slave? Was she the "Queen of Egypt" or the "Egyptian Queen"? These were burning questions.[115]

Physical anthropology had a significant role to play in the debate over Cleopatra's race. Dr. Samuel George Morton published *Crania Aegyptiaca* in 1844 in which he "proved" through cranial and archaeological evidence that Egyptians of the ruling class were not Negroes. Contrary to what abolitionists supposed, Morton argued that blacks had occupied the same

servile positions in ancient Egypt as in modern America. Also, the evidence of Egypt was crucial in proving separate creation, or the theory of polygenesis. Morton's work was aided by Louis Agassiz at Harvard University, who made the American school of anthropology famous by way of his pioneering work on polygenesis.[116] Morton's theories were carried one step farther by Josiah Nott, who wrote that unless the fact could be established that "the Egyptians were Caucasians," the theory of polygenesis must be abandoned. According to Nott, "History, the Egyptian Monuments, her paintings and sculptures, the examination of skulls . . . and everything else connected with this country, combine to prove beyond possible doubt, that the Ancient Egyptian race were Caucasians." Even more ominously, Nott wrote that the "adulteration of blood is the reason why Egypt and the Barbary States never can rise again, until the present races are exterminated, and the Caucasian substituted."[117] As the historian Robert Young states, "Here, then, was an ancient historical precedent for a white society with black slaves: Nott and [George R.] Gliddon deployed Morton's account of Egypt to justify the place of 'negroes' as servants or slaves in American society through a theory of a permanent natural apartheid. They stressed the everlasting nature of racial social relations, and claimed that the Caucasian and Negro races were as different in ancient Egypt as in the United States of the 1840s."[118]

Four main (though false) premises emerged from the Egyptology of the nineteenth century. First, the rulers of Egypt were white while the servants were black. Second, there is a stability of racial inequality stretching back at least three thousand years. Third, blacks never possessed a glorious civilization because of that stability of racial inequality; and fourth, the stability of racial inequality can be accounted for because blacks and whites are separate species.[119] Such reasoning also helped to justify the modern era's enslavement of Africans, providing a historical basis for black slavery in addition to the biblical.[120] Abolitionists, as well as anyone who would represent the queen as black, African (those who believed in the wild sexual nature of black women, for example), challenged such theories every time they claimed Cleopatra for their purpose. While Egypt was the linchpin that held the doctrine of the stability of racial inequality together, the infuriating mutability of the figure of Cleopatra challenged those assumptions over and over again. "Cleopatra" could never satisfy, being as she was, fundamentally unstable and indeterminate.

As late as 1886, the critic John Lord was taking William Wetmore Story to task for Story's portrayal of the queen. According to Lord, Cleopatra was "by birth . . . more Greek than she was African or Oriental." He complained that "there was nothing African about her, as we understand the term African, except that her complexion may have been darkened by the intermarriage of the Ptolemies; and I have often wondered why so learned and classical a man as Story should have given to this queen, in his famous statue, such thick lips and African features . . . On the ancient coins and medals her features are severely classical." Much of his reasoning sprang from what he felt to be character differences between Cleopatra and present-day Africans, observed by Lord firsthand via slavery. According to Lord's biographer, Lord had visited the South in 1857 and noticed that not only did the slaves seem comfortable and happy; they had also been converted from barbarism to Christianity. The northern abolitionists, he felt, had misrepresented the southerners, and although he still advocated the abolition of slavery, he continued to view slavery as a providential occurrence. "Christianity had worked on material ready for its reception, — on a race naturally religious, affectionate, and faithful."[121] These were virtues, of course, to which Cleopatra could never aspire that in Lord's estimation made her more Greek than African.

John Lord's position may have been intensified by the fact that abolitionists had already enthusiastically co-opted the figure of Cleopatra for their cause. Harriet Beecher Stowe, in the context of an article on Sojourner Truth as Story's *Libyan Sibyl*, praised the artist's Cleopatra: "Already had his mind begun to turn to Egypt in search of a type of art which should represent a larger more vigorous development of nature than the cold elegance of Greek lines. His glorious Cleopatra was then in process of evolution, and his mind was working out the problem of her broadly developed nature, of all that slumbering weight and fullness of passion with which this statue seems charged, as a heavy thundercloud is charged with electricity."[122]

Even the actress Sarah Bernhardt came under fire for her stage performance of Cleopatra when visiting the United States. In 1890 she toured throughout Europe and the United States in "Cleopatra," a role that was created specifically for her by the playwright Victorien Sardou.[123] One American theatergoer responded to the performance with a vituperative letter to the editor of *The Nation*:

Sir: I see that Mme. Bernhardt is playing Cleopatra in a mahogany-red wig, with her skin stained copper color (*your* correspondent says "auburn" as to hair and "brown" as to skin). I suppose this is in accordance with the rule that *Othello*, a *Moor*, must wear wool, instead of hair, and smutch to the blackness of the negro. Cleopatra was, as you know, a Greek by blood, descended in the eighth degree from Ptolemy I . . . the reputed son of Philip of Macedon, the honored and trusted half-brother of Alexander the Great; hence, although an Egyptian queen, she was not of the Egyptian race. While she may have worn royal Egyptian robes, she herself, physically, must have possessed the characteristics of the Aryan — at least a *white* skin, and, possibly, blue eyes and golden hair. Now, under these circumstances, will not one of the several "Cleopatras" at present about give us the Queen in all the splendor of *Aryan* beauty! C.[124]

The letter reveals the seriousness with which questions of Cleopatra's racial heritage were taken, allowing no room for artistic license. The author clearly is a proponent of the idea of the fixity of racial categories across time and irrespective of historical context and change, making it clear that although Cleopatra may have been costumed as an Egyptian, racially, she was Aryan, or "white." How Cleopatra was portrayed had to fit nineteenth-century historiographies of Egypt. Thus, this late-nineteenth-century letter shows the effectiveness and pervasiveness of the tenets of Egyptology and gives one a sense of Cleopatra's role within that set of beliefs.

Killing Cleopatra

Edmonia Lewis worked for over four years to complete her major work, *The Death of Cleopatra*. By 1875 she had completed the life-size marble sculpture, and in an interview with Lewis at the Centennial Exhibition in Philadelphia, Lail Gay reports, "When she began she lacked means to finish it. She went to California, exhibited and sold [some] pieces, which enabled her to proceed with her labor. When her funds were exhausted she exhibited in Minnesota, thus raising means to [execute] her great work which has cost her so much time and money."[125] *The Death of Cleopatra* was clearly a labor of love for Lewis. In one of the rare personal anecdotes about Lewis, the *New York Times* recounted her reaction when the judges for the Centennial's art exhibition unveiled the sculpture. In an interview titled "Seeking Equality Abroad," the newspaper wrote, "She tells the story of the reception of her work at Philadelphia with curious frankness. She

was lingering about within earshot of the committee-room when it was brought out and opened. She had seen, with trembling for the fate of hers, work after work rejected by the committee. At length the box containing the 'Dying Cleopatra' was brought in and opened. 'I scarcely breathed,' she said, 'I felt as though I was nothing. They opened the box, looked at the work, talked together a moment, and then I heard the order given to place it in such and such position.' The Indian stoicism gave way. Miss Lewis swallowed her sobs for the moment, and went home and had a good cry all by herself."[126] *Cleopatra* was placed in Gallery K of Memorial Hall and it was marked in all of the guidebooks with an asterisk, signifying that it was for sale. The gallery appears to have been reserved for American artists: female sculptors Margaret Foley (three medallion portraits) and Vinnie Ream (the bust of a child) as well as work by W. G. Turner, A. E. Harnisch, F. Meynen, and Joseph Graef. Lewis also had works on display in the Annex, Gallery No. 22: *Asleep* (also marked with an asterisk), *Hiawatha's Marriage, Old Indian Arrowmaker and His Daughter*, terracotta busts of Longfellow, Sumner, and John Brown. Also displayed were twenty-nine groups in plaster "for house and lawn" by John Rogers.[127]

There were many reasons why this subject was important to Lewis. One reason is that in the nineteenth century, sculptors generally felt that they had to do at least one monumental ideal work, and that work was usually a female subject. Furthermore, Cleopatra was one of the most popular subjects for artists of the period because her story was well known and quite titillating. She was the mistress of two eminent Romans, the emperor Julius Caesar and the soldier and politician Mark Antony. She was the wife and self-made widow of her two younger brothers; political and military ruler of the rich kingdom of Egypt; and after her defeat by Octavius at the Battle of Actium in 31 BCE, she committed a historic suicide. Her final act was to deny Octavius the ultimate victory of having her paraded through the streets of Rome in chains.[128] The tie to Egypt may have been another reason Lewis felt drawn to Cleopatra. This would not have been the first time an Egyptian subject had attracted Lewis. In 1870 Lewis created the first of two known works based on the Old Testament story of Hagar, the Egyptian handmaid to Abraham's wife Sarah. Finally, Lewis may have chosen Cleopatra because two well-respected American sculptors had already attempted the theme — William Wetmore Story and Thomas Ridgeway Gould.

Though the figure is seated, the frontal view of Lewis's *Cleopatra* is emphatically vertical, with dynamism arising from a set of tensions put into play within the statue. Lewis composed the figure so that Cleopatra's head turns to the left, away from the asp and her self-inflicted wound, while her face itself is absent of any expression. The proper right arm rests on the top of the figure's thigh, with the arm curving down and forward. Cupped loosely in the slack palm is the asp. The corresponding right leg has been retracted toward the throne. Lewis designed an opposite tension in Cleopatra's left side (still considering the frontal view). The figure's left foot projects forward while the left arm drapes listlessly over the side of the throne. The hips are pushed forward, reinforcing the sense of the vertical in this seated figure. Her stomach swells softly beneath the simple cord that cinches her gown. She appears as if she were about to slip from her seat onto the floor.

On the throne at knee level, two sphinxes flank the figure; they serve as columns and a lion's claw forms the base of each. The base is inscribed with the title of the work "The Death of Cleopatra" in gothic script. According to Stephen Crawford, Lewis may have seen such a throne in an engraving at the Cairo museum of Chephren's throne from Fourth Dynasty.[129] Marilyn Richardson, who has done extensive work on the iconography of Lewis's *Cleopatra*, suggests that Lewis modeled the throne after two sculptures by Canova: his *Grand Duchess Marie Louise as Concordia* (1809–14), and his mourning female figure seated beside the effigy of the Countess de Haro in the relief composition of her tomb (1806–8).[130] The sunbursts at the foot of the throne relate it to Amun-Re, the male consort of the goddess Mut.[131] Lewis used a vulture, symbol of the goddess Mut, on the headdress.[132] Mut is the Egyptian word for "mother," and she was indeed the mother of all gods. The Egyptologist Lewis Spence explained that "[Mut] was styled the 'lady of heaven' and 'queen of the gods,' and her hieroglyphic symbol, a vulture, was worn on the crowns of Egypt's queens as typical of their motherhood."[133]

Lewis carefully designed the statue so that both the left and right sides would be of equal interest. From the proper left side we are able to see Cleopatra's face. Her lips are slightly parted as if her final breath has escaped, while the impression that she has died is reinforced by the slack right palm and the prolapsed arm. This arm is a kind of sign or shorthand for death. In Christian art, the same configuration of the arm is employed

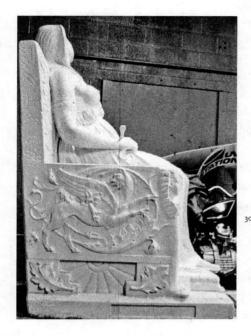

30 Edmonia Lewis, *The Death of Cleo-patra*, detail of right side of throne, 1875. Photograph taken after 1988 and before the restoration of 1994. Smithsonian American Art Museum, Washington, D.C. Gift of the Historical Society of Forest Park, Illinois. Photo George Gurney.

for images of the Deposition, the Entombment, or the Pietà.[134] The angularity of her profile — both jaw and nose — is contradicted by the soft oval of the frontal view. Also visible from the left are symbols meant to represent hieroglyphic script marching down the side of the throne. Partially obscuring the throne is the figure's voluminous robe, which is lined with roses and acanthus leaves. The device of the throne-obscuring robe helps to focus attention on the face of Cleopatra. Eventually, we notice that a pillow is placed at the figure's back, which compositionally explains the slight arch of the torso. From the proper right view, in the absence of Cleopatra's face, Lewis animates the sculpture by revealing the motifs on the throne (figure 30). A large griffin covers the side of the throne, as do more of the forms and shapes made to appear like writing. Finally, in lieu of Cleopatra's face, there are the bared breast and the asp to hold the audience's interest.

In addition to representations in literature, the death of Cleopatra became a favorite theme of visual artists in the nineteenth century. However, the requirements for portraying a racialized Cleopatra in paint were different from those for sculpture. Before the eighteenth century, and prior to any concerted investment in Cleopatra's racial identity, painters tended

to portray Cleopatra with blond hair and dressed in the garb contempo-
rary to the artist. When in 1799, however, Napoleon invaded Egypt and
returned with treasure, he ushered in a new era of interest, spawning a taste
for Egyptian-inspired clothing, architecture, furnishing, and art. Cleo-
patra, who had long been a subject of fascination, became the receptacle
of Orientalist fantasy now with black hair and decadent rituals that served
to distinguish Orient from Occident.[135] In theatricals and in painting (and
later, film) an artist could exhibit the doctrine of racial stability/inequality
by depicting a white-skinned Cleopatra surrounded by black-skinned ser-
vants. Mosè Bianchi's voluptuous *Cleopatra* (1865) is an excellent example
(plate 15). The queen is naked to the waist, her lower limbs draped in leop-
ard fur, making her seem as if she is in the midst of transformation. Her
arms are raised behind her head and viewers are privy to something rarely
seen in painting prior to the twentieth century—underarm hair. Above
and beyond her is a servant who mimics her pose but who is actually carry-
ing a basket on his or her head. Unlike the pale queen, the servant is very
dark as s/he is seen entering into or exiting from the sunlit doorway.

In contrast to painting, nineteenth-century sculptural practice required
that the racialized depiction of Cleopatra rest solely on the physiognomy
of one figure. Kirk Savage has written compellingly on the relationship
between the sculpture of antiquity and racial theory as it developed during
the Enlightenment and which was further refined during the nineteenth
century. The relationship was illustrated by Nott's and Gliddon's well-
known table of 1854 that compared the "skull" of the Apollo Belvedere
statue to that of an African and an ape. Savage notes, "The sculpture of
antiquity thus became an authenticating document of a normative white
body, a "race" of white men" (figure 31). He writes: "Racism, like sculpture,
centered on the analysis and representation of the human body . . . Sculp-
tors could even create exact molds of the human face and body in plaster,
which gave their art a unique scientific and documentary power that lasted
even after the advent of photography."[136] However, because racial ideology
necessitates comparison, the sculptural representations of what seem to be
iconic figures of Cleopatra actually exist in dialogue with other sculptural
representations of the queen (much like Nott's and Gliddon's "instruc-
tional" chart).

Prior to Lewis, William Wetmore Story and Thomas Ridgeway Gould
each created sculptures of Cleopatra while working in Italy: Story in Rome

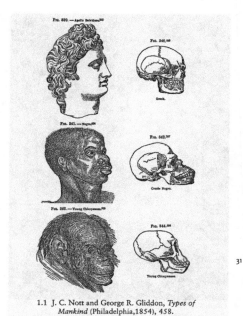

1.1 J. C. Nott and George R. Gliddon, *Types of Mankind* (Philadelphia,1854), 458.

31 J. C. Nott and George R. Gliddon, comparative table, *Types of Mankind* (Philadelphia, 1854), p. 458. Courtesy of the Swem Library, College of William and Mary, Williamsburg, Virginia.

(1861) and Gould in Florence (1873) (figures 28, 32).[137] Both sculptures were widely known and famous in their own right. As the art historian Jan Seidler Ramirez noted, "An audience already existed who were primed to appreciate the plot intricacies of [Cleopatra's] ancestry, multiple marriages, political triumphs and defeats."[138] In Story's *Cleopatra*, the queen has already committed herself to death, but Story chose the moment before the asp actually stings her. It is shown wrapped around her left arm like a bracelet. She is seated; her right arm rests against the back of the chair while her hand supports her head. This Cleopatra is passive and pensive, still alive. As Nathaniel Hawthorne in *The Marble Faun* (1859) describes her, "She was draped from head to foot in a costume minutely and scrupulously studied from that of ancient Egypt. A marvelous repose . . . was diffused throughout the figure. The spectator felt that Cleopatra had sunk down out of the fever and turmoil of her life. It was the repose of despair, indeed; for Octavius had seen her, and remained insensible to her enchantments."[139] Her frustrated sexuality is manifested in verbal descriptions such as Hawthorne's and in a poem written by Story to accompany his *Cleopatra*. In the poem, Cleopatra dreams that she and Mark Antony transform into

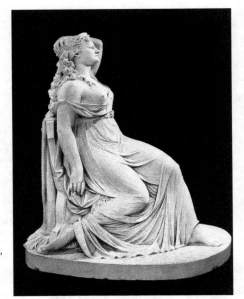

32 Thomas Ridgeway Gould, *The Death of
Cleopatra*, modeled 1873. Marble, 57 ×
24¾ × 49½ inches. Museum of Fine Arts,
Boston, Massachusetts. Gift from the
Isaac Fenno Collection, 18.404. Photo-
graph © Museum of Fine Arts, Boston.

tigers, slaughter an antelope, and drink the blood. The poem ends in the
following lament:

> Come, as you came in the desert,
> Ere we were women and men,
> When the tiger passions were in us,
> And love as you loved me then![140]

The poem serves as a verbal pendant to the sculpture; it gives us Cleopatra's
"thoughts" while she waits for the asp to do its work. Supposedly, Cleo-
patra chose the bite of an asp because it induced a heavy torpor resembling
sleep that led to coma and then to death. In spite of the passivity of Story's
Cleopatra, her "thoughts" are primarily animal and sexual. A living Cleo-
patra is sexualized, defeated, and polluted. A living Cleopatra is no lady.

Inevitably, Story's sculpture was embroiled in the debates about Cleo-
patra's "race." James Jackson Jarves, the art writer and collector, accused
Story of "forget (ting)" that Cleopatra was "wholly Greek in race and
culture."[141] His critique is reminiscent of John Lord's reaction to Story's
sculpture noted earlier. What Kirk Savage called the "aesthetic dimension
of racial theory" was clearly engaged when viewers looked at the marble

Cleopatras of Story, Gould, and Lewis.[142] Intertwined in viewers' aesthetic summations were racialized descriptions of the respective works; and to nineteenth century audiences who looked at Story's Cleopatra, her features were clearly "African." Story encouraged such perceptions when he conceptualized his *Cleopatra* as the "bookend" to his sculpture *Libyan Sibyl*, which represented the grim African prophet looking to the future of African enslavement and degradation (figure 25).[143]

Alternately, Gould's Cleopatra, as described by Jarves, was more "American" in type compared to Story's Africanized rendering; one should also note the overtly sexual language that Jarves employs to describe Gould's statue. It is a language completely intertwined with Cleopatra's identity as a racial other in that her physiognomy (as "American") conflicts with her behavior (as "Oriental"). According to Jarves:

[Gould's] latest work, 'Cleopatra,' makes as substantial an effigy of the seductive queen of Egypt in a physical sense as one can desire. Story's Cleopatra is the beautiful, accomplished, intellectual mistress of pleasure in a meditative pose, the paragon of feminine fascination. But Gould has ventured on the more dubious role of presenting her at a moment when the strong tide of Oriental voluptuousness courses warmest through her veins. She becomes indeed the most passionate woman of history, whose name is a byword for the force of sensual attraction and dominion over men. Reclining with her head thrown back on an antique chair, in wanton relaxation of posture, decorously draped, but with the contours of her lovely limbs well accentuated, Cleopatra is rapt in a waking dream of ecstatic passion. Her features are sufficiently comely, but more American than Eastern in type.[144]

Oddly truncated from the frontal view, Gould's Cleopatra is meant to be seen in profile (figure 32). Unlike Story's sculpture, which is passive and contemplative, Gould's Cleopatra is active, or actively dying. As Elisabeth Bronfen and Sarah Goodwin put it in their introduction to *Death and Representation*, "Although death poses a metaphysical problem, it is a physical event."[145] Death's physicality is conspicuous, but because death is unknown to us, it is circumscribed by what we *can* know: life and a seemingly transcendent sensuality. Gould has divided Cleopatra's body in half; the contrast between the living and dead halves of her body is intentional yet wholly artificial. But with this contrast he attempts to represent death by constructing it visually as the opposite of life.

Death moves in the body of Gould's Cleopatra from her right to left side. The right side of her body is limp. Her right knee is lower than her left, almost at a forty-five-degree angle from the floor. The top of her right foot is curved unnaturally under to touch the base of the statue. As seen in profile view, her right eye is open but heavy-lidded and seeming to be already fixed in death. Her right arm is prolapsed and hangs impotently, causing the sleeve of her gown to fall and expose her breast. In contrast, the left side of her body is still living. Her left arm is raised and her fingers lightly grasp the back of her head. Her profile is set in sharp relief against the elevated limb. Her left knee bends naturally, as it should to accommodate her seated pose. The asp has a much more discrete role in this work; it appears as an ornament on her belt flanked by portraits in relief of Julius Caesar and Mark Antony.

Unlike Jarves, who reads this Cleopatra as more "American" than "Greek," William J. Clark, in his book *Great American Sculptures* (1878), interprets Gould's Cleopatra as a woman of "Grecian" lineage. "The suggestions of this statue," he writes, "are as opposite as may be from those of Story's celebrated work. Gould has not found it necessary to depart from the Grecian type which Hawthorne thought to tame, but which certainly is not tame, and his Cleopatra is unmistakably a woman of Grecian lineage." [146] The interchangeability of "Greek" and "American" (with no great exception taken to the confusion) is instructive especially when contrasted to the tone of those who disagree with a perceived "African" physiognomy in the face of Cleopatra. Even though European Americans would claim a religious and cultural superiority over the "pagans" of antiquity, they had a very real investment in notions of Greek superiority (over Africans) and as themselves being descended from the Aryan stock of ancient Greece (thus the seriousness with which they appraised the "profile" of the Apollo Belvedere) (figure 31).

Cleopatra's imagined stability is predicated to some extent on her death; we know the end of her story and we understand why it ended as it did. After grasping the nettle of power, Cleopatra was made to pay for her desire. As Lori Merish contends, "Sentimental narratives present a deeply conservative, paranoid view of power: power is figured as dangerous and intrusive, its effects uncertain and perhaps uncontrollable (power can hurt). [147] Cleopatra was a sentimental fiction who existed racially and sexually outside the norm. Perhaps her alterity accounted for her popu-

larity in the nineteenth century. Also, her narrative served as a warning to nineteenth-century women, a narrative reinforced by a proliferation of images that insisted on an almost synonymous relationship between death and the female body. Often quoted and discussed is Edgar Allan Poe's assertion that "the death of a beautiful woman is, unquestionably, the most poetical topic in the world."[148] Elisabeth Bronfen and Sarah Goodwin attempt to comprehend why death, beauty, and femininity are linked, proposing that "perhaps the most obvious thing about death is that it is always only represented. There is no knowing death, no experiencing it and then returning to write about it, no intrinsic grounds for authority in the discourse surrounding it."[149]

It is tempting and not entirely inaccurate to link the anxiety surrounding death to high female mortality rates and to the invalidism of the nineteenth century, and then to read the profusion of images treating dead and dying women as a result of that anxiety. But as Bronfen and Goodwin point out,

Death and femininity appear in cultural discourses as the point of impossibility, the blind spot the representational system seeks to refuse even as it constantly addresses it. In Jacqueline Rose's words, "The system is constituted as a system or whole only as a function of what it is attempting to evade and it is within this process that the woman finds herself symbolically placed. Set up as the guarantee of the system she comes to represent two things—what the man is not, that is difference, and what he has to give up, that is excess." Both difference and excess apply equally, as attributes, to our cultural understanding of death. The kinds of power attributed to death are also associated with the woman, because they are the confounding power of the body. Just as woman *is* the body, she is also the body's caretaker, the nurse, the layer-out of the corpse. If death is a kind of return to her care, then she is also contaminated by it, so the rituals must be found first to enable her care and then to dissociate her from the corpse. Like the decaying body, the feminine is unstable, liminal, disturbing. Both mourning rituals and representations of death may seek strategies to stabilize the body, which entails removing it from the feminine and transforming it into a monument, an enduring stone. Stable object, stable meanings: the surviving subject appropriates death's power in his monuments to the dead.[150]

According to ideals current in the nineteenth century, men and women were not unequal, merely "different" with distinct but equally important

functions to fill in society. Difference, however, was displaced onto the female body as was sexuality, leaving the male body to inhabit the site of intellect, culture, and above all, normalcy. The figure of Cleopatra allowed male artists and viewers to fix sexuality, difference, and death onto the feminine. Thus it is no coincidence that representations of Cleopatra were made for the most part by men who appropriated her power of femininity and her power over her own death in order to stabilize the ideal body that is both unsexed (masculine and therefore the norm) and undying. It is also no coincidence that there are few (if any) images of Mark Antony's suicide in the nineteenth century.

Since the time of Octavius, Antony's weakness for Cleopatra was interpreted as a compromise of his masculinity. Within the relationship they enacted a reciprocation of gender in which Antony is feminized and Cleopatra is not masculine but an unnatural woman. In an added expression of her unnaturalness, Cleopatra filled two roles simultaneously—that of royal whore and of seducer (a role typically reserved for males). In the interpretive framework of the nineteenth century, audiences would have understood Antony's transformation into and exchange with Cleopatra as the natural effect of the prostitute on her victim.[151] Furthermore, Cleopatra's suicide was the only closure possible. As Sander Gilman has convincingly argued, in the nineteenth century the appropriate end of the prostitute *is* suicide. "This is her penalty for permitting herself to be seduced by immoral men, to be infected, and thus to spread infection to—innocent men? . . . The seducer and the prostitute are the defining borders of diseased sexuality . . . for in the act of seduction he transforms the innocent female into a copy of himself."[152] Through her seduction of Mark Antony, Cleopatra transformed the innocent male into a copy of herself, but the power of suicide transformed Antony back into a Roman and therefore into a man.[153] As both prostitute and seducer, the figure of Cleopatra alone was enough to define the borders of aberrant sexuality.

Bronfen and Goodwin raise four important points about the representation of death: first, "every representation of death is a misrepresentation," meaning that the attempts to portray death reveal other anxieties and aggressions against individuals or groups in an attempt to appropriate the power of death; second, "death is the constructed Other . . . that which aligns with death in any given representation is Other, dangerous, enigmatic, magnetic: culturally, globally, sexually, racially, histori-

cally, economically"; third, "death is gendered," so that representations of death "bring into play the binary tensions of gender constructs"; fourth, "death is physical," so that even though "death poses a metaphysical problem, it is a physical event." It is, according to Bronfen and Goodwin, "uncanny, the return of the repressed, the excess that is beyond the text and to which the text aspires even as it aims to surpass it in potency. This is where death aligns most clearly with sexuality: with the body that is too common — commonplace — the absence of spirit and intellect and grace. Thus it is frightening and elicits a visceral response that is part repression, part bodily knowledge."[154] Employing these ideas helps us to understand the relationship between the artist and Cleopatra, and thus we can now inquire: If any representation of death is a misrepresentation, what is represented in the two Cleopatras by Story and Gould, distinguishable from Lewis's Cleopatra by virtue of the positions granted them by culture as white male artists? In the representation by Story and Gould, Cleopatra's alterity is obvious, but less so in Lewis's case: Lewis and Cleopatra share the same gender, and they share a cultural connection, however distant, to Africa. How does Lewis handle the binary tensions of gender constructs (life/death as masculine/feminine) and race in the figure of Cleopatra? More precisely, how closely does Lewis's Cleopatra follow the preexisting formula for representing feminine death?

In the nineteenth century, the repression of the horror of dying is evidenced by death's visual similarity to the procreative or generative act. Although Bram Dijkstra's *Idols of Perversity* is primarily about painting, he has written compellingly on the eroticization of feminine death by male artists. "It shows how literal an equation late nineteenth century males made between virtuous passivity, sacrificial ecstasy, and erotic death as indicative of 'feminine fulfillment.' Even those women whose 'animal energies' made them threatening, active forces while alive could be brought back into the realm of passive erotic appeal by painters who chose to depict them safely dead."[155] Indeed, Gould's Cleopatra is being pulled through her death back into the mold of proper femininity. In an expression of "feminine fulfillment" the statue appears postcoital. The "animal energies" suggested by Story's sculpture/poem pendant are here being reigned in with Gould's dead/alive figure. Of the three Cleopatras, Gould's is the least descriptive in terms of Egyptian costuming and attributes. It is interesting to note that in Gould's rendering Cleopatra's feet are bare. Cleopatra is

usually shown wearing the upturned Egyptian sandals of antiquity, affording artists the opportunity to exhibit their knowledge of ancient Egyptian civilization. Yet in Gould's work, Cleopatra's lack of cultural specificity is proper as she makes the ecstatic transition; she is everywoman. Unlike the living Cleopatra who was subject to worldly ambition and passions, Gould's Cleopatra is fulfilled by death — transcendent.

Lewis's Cleopatra closely follows the preexisting formula for representing feminine death, even to the limp arm that we have determined is a kind of shorthand or hieroglyph for death. In fact, a contemporary African American newspaper noted that "the first idea suggested is that the queen is in a profound sleep — closer scrutiny discovers that avoiding the hideousness of wide-open glaring eyes and rigid muscles, Miss Lewis has succeeded in making the eye and left arm tell you that the voluptuous queen is dead, and that she has this moment died."[156] As Bronfen and Goodwin attest, death is impossible to represent, and thus Gould portrayed the physical act of dying as sexual, while Lewis portrayed actual death as a kind of sleep.[157]

During the Victorian era, as Bram Dijkstra has pointed out, there was a "cult of invalidism," where "for many a Victorian husband his wife's physical weakness came to be evidence to the world and to God of her physical and mental purity." Woman was viewed as a "natural invalid." As a result, normal health or any sign of robustness in a woman was suspect and, according to Dijkstra, was associated with "dangerous, masculinizing attitudes." Since Cleopatra was not sickly (therefore making it impossible to show her physical battle with illness as a metaphor for moral struggle), she must exhibit through her suicide the defining "weakness" which redeems her and makes her a "lady." In the same way that Mark Antony's suicide returns him to the realm of the masculine that is synonymous with being Roman, Cleopatra's suicide enables her return to the feminine by way of what Dijkstra terms the "cleansing power of dying."[158]

Cleopatra's death purges her of unhealthy passions and ambition, and it puts the men back in charge of worldly affairs. In the nineteenth century, passion and ambition were for men only. Aside from the limp arm, there exists yet another sign of death that is nevertheless uniquely feminine. Of the three Cleopatras discussed here, in Lewis's statue alone the cut rose appears at the foot of the figure. Again, we must look to Dijkstra, who has explained the meaning of the cut flower. Dead and dying heroines of

IDENTITY, TAUTOLOGY, AND THE DEATH OF CLEOPATRA ～ 199

Victorian literature and art surrounded themselves with cut blossoms "to show (their) equivalence to them."[159] Only after she has died does a cut flower accompany Cleopatra; it is a sign that she is, in her death, a lady. This theory, and Lewis's adherence to it, is reinforced in the painting by Valentine Prinsep whose *Cleopatra* predated Lewis's by about five years (plate 16). In Prinsep's painting, cut roses are strewn about the room, one quite suggestively located in Cleopatra's lap. The *People's Advocate* actually made the comparison between the two works. "Something is borrowed from Prinsep's celebrated oil painting, 'The Death of Cleopatra,' but upon this the touch of Miss Lewis's chisel is certainly very obvious. There is no Iras dead at the queen's feet, [as] in Prinsep's painting for such things would be too elaborate for sculpture."[160]

Lail Gay hailed Lewis's *Cleopatra* as a "masterpiece" during its debut at the Centennial Exhibition of 1876, noting that it was considered "one of the grandest statues in the Exposition."[161] J. S. Ingram, who wrote *The Centennial Exposition Described and Illustrated*, termed it "the most remarkable piece of sculpture in the American section." He mentioned favorably the "canopy of Oriental brightness in color" that had been placed over the work, although he did not care for the human heads that ornamented the arms of the chair. But it was the face that impressed him most. He stated that "the face of the figure was really fine in its naturalness and the gracefulness of the lines. The face was full of pain, and for some reason — perhaps to intensify the expression — the classic standard had been departed from, and the features were not even Egyptian in their outline, but of a decidedly Jewish cast."[162] Ingram's description of Lewis's Cleopatra as having "Jewish" features is illuminating, raising the question of how the nose "animates" the sculpture for him in terms of sexuality and ethnicity. One fact that his description reveals is that Ingram was without access to Lewis's archaeological sources and was unaware that Lewis had modeled Cleopatra's profile on the basis of images on coins from the time of the Egyptian queen. Another revelation in Ingram's description is that any deviation from the classical is fraught with racialism in this nineteenth-century context. The dichotomy between "the classic standard" and a deviation from that standard, which in this instance is signified by "Jewishness," constructs the classical as calm, ideal, remote, without expression, while by default "Jewishness" inhabits the realm of intensity, excess, naturalism, and pain.[163]

The label "masterpiece" is clearly a relative term, and any claims to the

status of masterpiece must be forfeit when Lewis's *Cleopatra* is compared to those of Story and Gould. In 1878, two years after Lewis exhibited her statue at the Centennial, William J. Clark Jr. compared the Cleopatras of Gould, Story, and Lewis. He felt that Lewis's work deserved this special attention precisely "as its ideal was so radically different from those adopted by Story and Gould in their statues of the Egyptian Queen." Clark began his discussion with a statement about Lewis's Cleopatra in particular:

This was not a beautiful work, but it was a very original and striking one, and it deserves particular comment . . . Story gave his Cleopatra Nubian features, and achieved an artistic if not a historical success by so doing. The Cleopatra of Gould suggests Greek lineage. Miss Lewis, on the other hand, has followed the coins, medals, and other authentic records in giving her Cleopatra an aquiline nose and a prominent chin of the Roman type, for the Egyptian Queen appears to have had such features rather than such as would more positively suggest her Grecian descent. This Cleopatra, therefore, *more nearly resembled the real heroine of history* than either of *the others, which, however, it should be remembered, laid no claims to being other than purely ideal works.*[164]

Of the three, Lewis's *Cleopatra* is definitely the most descriptive in terms of Egyptian motifs. And again, we are reminded of the "authority of authenticity" with regard to Lewis's style, when Lewis was said to have "improved" on the literary efforts of Longfellow.[165] Clark's invocation of Lewis's "realism" is separate from the incipient stylistic realism that would change the direction of American sculpture, as artists like Augustus Saint-Gaudens (1848–1907), Daniel Chester French (1850–1931), and Frederick MacMonnies (1863–1937) would begin expatriating to Paris rather than Rome and working in bronze rather than marble. The strains of that realism began earlier with William Rimmer (1816–79), and one finds hints of it beforehand, in the portraits by the neoclassical artists working in Rome.

Instead, Clark has created an ideological dichotomy between realism and idealism. Lewis's work "was not beautiful," but it was historic, original, striking, a portrait, authentic, real. Story's and Gould's representations of Cleopatra, on the other hand, were by implication "beautiful," artistic, and ideal. Lewis's work occupies the realm of the descriptive and literal, while that of Story and Gould inhabit the stratum of high art—the literary, if you will. Because their works are ideal, Clark implies that it was appropriate that Story and Gould take liberties with the racial heritage of Cleo-

patra. It was expected, a measure of their creativity. Clark's dichotomy, therefore, divides along the fault lines of the racial and gender identities of the artists. Clark was not alone, nor was he the first, in his opinion about who could and could not create truly ideal works. I return to the letter from which Tuckerman excerpted for his *Book of the Artists*.

In her coarse but appropriate attire, with her black hair loose, and grasping in her tiny hand the chisel with which she does not disdain — perhaps with which she is obliged — to work . . . Miss Lewis is unquestionably the most interesting representative of our country in Europe. Interesting not alone because she belongs to a contemned and hitherto oppressed race, which labors under the imputation of artistic incapacity, but because she has already distinguished herself in sculpture — not perhaps in its highest grade, according to accepted canons of art, but in its naturalistic, not to say the most pleasing form . . . It may be reserved for the youthful Indian girl . . . to indicate to her countrymen, working in the same field, a distinctive, if not entirely original style in sculpture, which may ultimately take high rank as the "American School."[166]

Written almost twelve years before Clark's commentary on Lewis's *Cleopatra*, the letter is consistent with Clark's critique and illuminates four ideas that are critical to any understanding of Lewis in a nineteenth-century artistic and cultural context. Two of the ideas followed her throughout her early career: that she had to work her own marble so that she would not be accused of allowing someone else to create her sculpture, and that she labored to prove that African Americans could participate in art culture.

The final two ideas, instead of following Lewis, fixed her, as in freezing her at a certain level of ability in the estimation of critics: that her talent was for the "naturalistic," and that her style would point the way to an "American School." As I discussed previously, Emerson perceived of the modern as a move away from the ideal and toward the real. In the case of Emerson, the evolutionary model of progress in American art, the modern, meant a turn to indigenous themes, including Native Americans and African Americans. For a time, the cost of developing an American School would be at the expense of great art, and who better to point the way than Lewis, who, according to Victorian anthropology, sprang from primitive, aboriginal peoples. By following her lead, white American artists, those truly capable of grasping the aesthetic sense of the ideal, would go on to create an American School worthy to follow in the evolutionary footsteps

of classical antiquity and the Renaissance. By virtue of her birth, Lewis was the embodiment of indigenous themes, "distinctive, if not entirely original," her art and her self were collapsed into a neat tautology.[167]

Lewis's depiction of the theme of the death of Cleopatra was as distinctive as the physiognomic feature she provided for Cleopatra's face. Like the Cleopatras of William Wetmore Story and Thomas Ridgeway Gould, Lewis's Cleopatra is seated. Knowing that her statue would be closely compared to the earlier works, she also distinguished her statue by portraying her queen as actually "dead," for Story's Cleopatra contemplates death, while Gould's Cleopatra is in the process of dying. Because Cleopatra's death defines her life, any image of her can be said to "represent" death. Nevertheless, Lewis fulfills the sequence begun by Story and continued by Gould. In a sense, the last word is hers.

The Disavowal of the Black Subject

When Lewis premiered *The Death of Cleopatra* at the Centennial Exhibition in Philadelphia in 1876, the ideological stakes for representing the queen had already been set. I contend that Lewis understood very well what it would have meant to portray Cleopatra as "black" in the racial sense. With such a long, highly charged debate about what Cleopatra represented, to claim Cleopatra's sexuality for black women in the nineteenth century would have reaffirmed racialist beliefs in black female pathology (weirdly anticipating interpretations such as Boime's over a century later). Mary Hamer, writing about the verbal and visual representation of Cleopatra in the nineteenth century, claims that the debate over Cleopatra's "race" was also a debate over the nature of her sexuality. "This journey into the body takes the sexuality of black women as its destination. The fantasy of black women's sexuality had many attractions for contemporary white viewers. The figure suggested first the white authority, which called it up and put it on show, locked under a marble constraint . . . Soothing the anxieties of white women it flattered the continence of white men, by posing them as the indifferent witness of black seductiveness."[168]

Lewis's understanding of what a "black" Cleopatra would have meant in the nineteenth century is registered, I believe, by her decision to employ an archaeologically correct likeness of the queen. And as she would have known, a key signifier of physiognomy is the nose; and although difficult for us to see, it was the broad bridge and slightly thickened lips of Story's

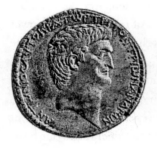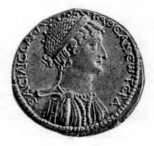

33 Roman, tetradrachm from Antioch with Cleopatra on the obverse and Antony on the reverse, ca. 37–32 BCE. Silver, .82 inches. London, Weill Goudchaux Collection. Photo Peter Clayton.

Cleopatra that alerted nineteenth-century audiences to her racial identity as black African. Given the weight of noses and profiles in the sciences of racialism, then, most distinctive in Lewis's depiction of Cleopatra was the sculptor's decision to model the profile from Roman coins minted during Cleopatra's reign (figure 33). Adherence to such models provided the face with a sharply aquiline nose, commented on immediately by critics of Lewis's day: "Miss Lewis . . . has followed the coins, medals, and other authentic records in giving her Cleopatra an aquiline nose and a prominent chin of the Roman type."[169] Only one photograph survives of Lewis's *The Death of Cleopatra* in its original condition (plate 12); it is archived in the Chicago Historical Society and was probably taken in 1878, when Lewis exhibited the sculpture in Chicago. The problem, of course, is that the photograph gives us only one view of the proper left side of the sculpture and no profile. All other known photographs of Lewis's work date after 1988, when *The Death of Cleopatra* was rediscovered (figure 29). By then, the work had suffered severe losses, including the nose, and many botched restorations. The nose can be reconstructed, however, because the original photograph does provide information about Lewis's initial design. A good-quality photograph or reproduction reveals the shadow of Cleopatra's original nose with its high, curving bridge. Lewis, who had manipulated and made indeterminate the physiognomies of the African American and most of the Native American women in her sculpture, for the first time attempted a "true" physiognomic likeness that depended for its authority on the coins of the Roman realm contemporary to Cleopatra.

The goal of such coins was not portraiture. Nor were coins native to

Egypt. They were Hellenistic, and by the time of Cleopatra they had become part of a long tradition in Egypt and Rome of reinforcing the power and divinity of the Pharaoh and of Caesar.[170] As the fictions of empire, the coins of Cleopatra change according to which empire, Egypt or Rome, issued them. The cultural historian Mary Hamer has done extensive research on them and notes that "there are fifteen or so separate coin issues bearing Cleopatra's head. Between them they repeat only four different images, however, and these belong to distinct phases of her reign: one bears only her own head, one is said to represent her with the infant Caesarion, and the others [the third and fourth] are issued by Cleopatra in conjunction with Mark Antony."[171] On the coins issued in Egypt, Cleopatra's profile is without the high-bridged, aquiline nose. Those coins issued after 37 BCE in conjunction with Mark Antony are strikingly different. As Hamer observes, "It is a revision that relates itself specifically to the Roman rather than the Ptolemaic tradition. The graceful profile of the Alexandrian coins is replaced by an unflattering waist-deep portrait of an older woman wearing a big necklace. The nose is big, the lower jaw sticks out. The image appeals not to past images of Hellenistic queens but to the Roman present. In fact, to the portrait tradition displayed in the image of Mark Antony on the reverse of the coin: Cleopatra looks like Mark Antony in a wig."[172] The Romans portrayed Cleopatra consistently in an unflattering manner, sometimes as an older woman, usually very masculine in appearance with an assertive lower jaw, and typically, with a large nose. Lewis probably had access to the Roman coins, Richardson suggests, through the Vatican's collection of Egyptian antiquities. Richardson also discovered that Lewis was in Paris during the 1867 Exposition Universelle, at which there was an exhibition of Old Kingdom art and artifacts.[173]

In a sense, Lewis's *Cleopatra* is a "true portrait." It is "true" in the sense of its attempt to approximate what was assumed to be an accurate physiognomic likeness of Cleopatra. I use scare quotes as well to acknowledge the constructed and problematic nature of portraits and because, as noted, the coins themselves were fictions or constructs of the Egyptian and Roman governments. Elisabeth Bronfen, in *Over Her Dead Body*, has written cogently about "these representations of dead feminine bodies treated like portraits" that speak strongly to Lewis's Cleopatra. According to Bronfen, such images "articulate the desire for a return to a stable image after a moment of disturbance."[174] One could argue, therefore, that any artist's ren-

dering of Cleopatra always represents a moment of stability in the image of the queen. Of course the stability is an illusion, but because it is a concrete manifestation, ideologies adhere all the more strongly to these images. Problems arise when opposing ideologies attempt to affix themselves to, or measure themselves against, such manifestations.

The work of art and the work of culture dovetail here, for it is indeed the "work" of art to assume what Bronfen described as "a direct compatibility between lived reality and aesthetic depiction."[175] It is the work of culture, as Timothy Mitchell has explained in *Colonising Egypt*, to assume a similar, unproblematic distinction between reality and representation. The modern era, he argues, takes as its paradigm "all the world's an exhibition," and we are to understand "the modern experience of meaning as a process of representation." "By its realism," Mitchell writes, "the artificial proclaims itself to be not the real. The very scale and accuracy of the model assure the visitor that there must exist some original of which this is a mere copy. Such techniques persuade one not that the representation is necessarily exact, but that there is a pure reality out there, untouched by the forms of displacement, intermediation, and repetition that render the image merely an image."[176] Perhaps, in choosing to base the features of her Cleopatra on likenesses found on Roman coins, Lewis hoped to suggest, in Mitchell's words, that there is indeed "a pure reality out there, untouched by the forms of displacement, intermediation, and repetition."

In spite of all that well-intentioned abolitionists hoped to accomplish by capturing the figure of Cleopatra for the African American, Lewis felt compelled to separate Egypt from Cleopatra and Cleopatra from the African American woman. Cleopatra's persona as an authoritarian femme fatale made her association with any black women problematic for Lewis. In order to separate one from the other, Lewis attempted to create a stable image, one that rested on the authority of its historical accuracy. The descriptive detail of the profile, the costume, as well as the script invented by Lewis to resemble hieroglyphs that march down the sides of the throne point to a common feature that artists who worked in the Orientalist tradition share—what Linda Nochlin called, translating and adapting from Roland Barthes's original (*l'effet de réel*), "the reality effect." Lewis inserted authenticating details to imply that Cleopatra's reality was external to Lewis and to black women. This was, according to Nochlin, "a stylistic strategy that sought to avoid "any hint of conceptual identifica-

tion or shared viewpoint with their subjects."[177] At this point, one should compare Lewis's "correct" Cleopatra to the physiognomic manipulation of her black and Indian women. The irony, of course, lies in the fact that the women in her other ideal works, such as Hagar, Minnehaha (in the courtship scenes and in bust format), or the kneeling black woman in *Forever Free*, elude racial identification through an appearance more closely aligned with white women. Conversely, Lewis liberates African American women from all that Cleopatra stood for through the "transparency" of portraiture. She occupied, though not for the same reasons, similar ideological territory as those who claimed that blacks and whites were separate species.

Although writing specifically about painting, Carol Christ clarifies for us the possible complexities of Lewis's involvement with Cleopatra as revealed in Lewis's use of portraiture. In "Painting the Dead: Portraiture and Necrophilia in Victorian Art and Poetry," Christ proposes, "The apparent transparency of representation that the portrait offers provides a kind of cover story for a more complex transposition of artistic identity. The portrait functions almost like a screen memory, replacing a prior concern with some transformation that simultaneously blocks and expresses it."[178] I would argue that Lewis used her portrait of Cleopatra both to express and subsequently block the queen's identification with black women. As an artist perceived by some as both racially (and sexually) aligned with Cleopatra, Lewis would have been credited with having a "natural" affinity for the subject. Furthermore, given Lewis's ambition, a subject such as Cleopatra would have appealed to the artist's competitive spirit, having been attempted before by prominent white male artists in both Europe and America, and in both painting and sculpture. By employing the "reality effect" of portraiture, Lewis was able to assert her artistic authority even as the authenticating gesture of likeness distanced her from the moral implications of a connection to that subject. The power of death and the power of femininity belong to the artist who kills with a look. Edmonia Lewis took that power for her own purposes. As Bronfen and Goodwin aptly state, "death is gendered"; it "brings into play the binary tensions of gender constructs." For Lewis and other black women, there was no psychological space within their own gender for all that Cleopatra implied. Like the men who sculpted Cleopatra before her, Lewis appropriated Cleopatra's power of femininity and Cleopatra's power over her own death in order to stabi-

lize the ideal body that was separate and apart from the queen's body—in this instance, the ideal body of the African American woman.

Given Lewis's sustained interest in freedom, I don't think it would be too much of a stretch to interpret *The Death of Cleopatra* as an emancipation image. In death, Cleopatra escaped Octavius and all that he had planned for her as a "spoil of war." As Plutarch writes, supposedly in Cleopatra's words, "Dear Antony, I buried thee but lately with hands still free; now, however, I pour libations for thee as a captive, and so carefully guarded that I cannot either with blows or tears disfigure this body of mine, which is a slave's body, and closely watched that it may grace the triumph over thee."[179] For the nineteenth century, Cleopatra's death represented a solution to those women—white and black—who violated the tenets of ideal womanhood even as it allowed for an escape from those same tenets. Cleopatra was a sentimental fiction who existed racially and sexually outside of the norm. Through the archaeologically correct likeness, Lewis stabilized the meaning of Cleopatra as distinct from African American women, freeing them "in essence" from the problematic queen. In a sense, Lewis kept Cleopatra close *and* far.

Finally, one can divide Lewis's career into two segments, "Before Cleopatra" and "After Cleopatra." *The Death of Cleopatra* marks the final break (on the level of representation, at least) between Lewis and the cults of true womanhood and sentiment. While Lewis continued to produce busts of great men after her exhibition of *The Death of Cleopatra* in 1876, she turned more and more away from ideal, sentimental themes to religious subjects. Unlike the drama and sentiment of Hagar, which corresponded to the general interest neoclassical artists had for religious subject matter, Lewis's Madonnas were created for specific, religious contexts. Her new religious subjects would appeal to an audience that had expanded beyond the bounds of abolitionism to encompass her fellow Catholics and the ties that she had formed beyond America.

❧ Separate and Unequal

Toward a More Responsive and Responsible Art History

E dmonia Lewis remains an enigma. She represents a fissure or interstice in the representational landscape. I use "interstice" because Lewis's very unknowableness is at issue here.[1] Her appearance, heritage, and words have always been subject to debate. Even the passport from which we derive her birth date may be inaccurate as it lists her as only four feet tall. In art historical discourse, Lewis's function has been that of a cipher that ever points to something else; she is that small space between things or parts. As a result, we must look for Lewis in the disjuncture of representation, those subjects and people she refused to sculpt as much as those she chose. Lewis's disjunctures — the separations, distances, or disconnections — are reflected in her public performances of identity/identification, in the either/or proclamations of Africanness or Indianness as discrete essences. Such disjunctures allowed her to subtly and strategically wield controlling images alternately *against* Africanness or Indianness and allowed her to become (in the eyes of her contemporaries and up until today) the object of her own subject matter.

Lewis's disjunctures also allowed her to reenact the narrative of the nation, and for this reason one can rightly employ the term *appropriation* in the sense that she took for her own use and without sanction the very processes of

Americanization. Lewis's ideal works helped to reinforce her claims, and they allowed her to participate in (create, buttress, and reflect) the dominant ideologies of her era. Simultaneously, the manner in which Lewis chose to depict Cleopatra, Hagar, Minnehaha, and the Freedwoman expose her attempt to extricate African/American and Native American women from the representational burden of race as it was construed in American sculpture and in American society. Lewis's ideal works emphasize family, love, courtship, marriage, and feminine consent to "racially appropriate" patriarchy as solutions to the dangers faced by nonwhite women in the United States.

Out of these *disjunctures*, Lewis was able to create *disjunction*, defined as the correlation of two distinct alternatives. Her greatest illusion is the perception that she is embodied by her work, that her assertions of either Africanness or Indianness are real rather than signifiers. Lewis's disjunction has been ably assisted by art history; specifically the lack of dialogue among art historians about Lewis *is* the discourse. It is a discourse of noncommunication, a flattening or flat-lining of potentially rich exchanges. The result is an unresponsive and rigid discipline that expands beyond Lewis to encompass artists such as Robert S. Duncanson and Henry Ossawa Tanner. In accord with the lack of dialogue-as-discourse is the reversion to controlling images of otherness when writing about these artists, testing and measuring their adherence to these representations in order to confirm their authenticity — a mutually defining authenticity that implicates and affirms the controlling image as a true rendering of the artist and vice versa.

Why do we still converse with stereotype?

Contributing to the unresponsiveness of art history as a discipline is the attitude that a "separate but equal" procedure is sufficient for the task of telling a complete story. One example will suffice. In 1998, the Oxford History of Art series published two much-needed surveys: Janet C. Berlo's and Ruth B. Phillips's *Native North American Art* and Sharon F. Patton's *African-American Art*. These studies represent themselves as exactly what they are, surveys that focus on the creativity of Native Americans and African Americans. Two years later Barbara Groseclose published *Nineteenth-Century American Art*, which on the surface does not represent itself as what it is — a survey of European American art, primarily by artists of the northeastern region of the United States. Groseclose summarizes the purpose and sensitivities of her study in the following manner: "*Nineteenth-*

Century American Art offers an account of painting and sculpture in terms that consider their aesthetics amid political, social and economic contexts. From this angle, whatever might be understood by the term 'American art' constantly shifts and re-forms, a temporal fluidity which, when added to regional variations, defies — or at least inflects — any over-arching definition of 'American.'"[2]

Groseclose then adds the following qualifications to her study: that the European-American cultural interchange has been the predominant one; that this should not imply the absence of other cultures in the shaping of American art, other cultures such as Asian, Mexican, African, and Native American; and finally, that the presence of the earlier two publications in the series makes up for the lack of discussion of Native American and African American artists in her study. Groseclose explains, "As African-American and Native American arts in the United States have already been published as volumes in this series, they are not (with few exceptions) addressed herein. The relevance of the art discussed in this book vis-à-vis African- and Native Americans as subjects, on the other hand, is integral to what it has meant for something to be 'American' art."[3] Why, then, could she not simply title her book "Nineteenth-Century Euroamerican Art"? Groseclose's all-encompassing title coupled with the usual suspects contained therein simply denotes business as usual. Representing African Americans and Native Americans as subjects (with few exceptions) in her study reinforces the fact that art history has both a Negro Problem and an Indian Question. It is my belief that a mark of an evolved discipline is one that has moved beyond "images of" studies and that allows dialogue-as-discourse rather than rehearsing art history's sentimental objects.

Compounding the "separate but equal" method is the self-inflicted decision to be limited in what we can say by the canonical image. As a result, we replicate the narratives of the nineteenth century so that art history is replete with vanishing Indians, the rhetoric of sentimentalism as method, weakened black fathers, failed black mothers, and a host of other signs of pathology that reinscribe the lines between the healthy and the sick, the normal*ized* and the deviant. As Toni Morrison writes in *Playing in the Dark: Whiteness and the Literary Imagination,*

Deep within the word "American" is its association with race. To identify someone as South African is to say very little; we need the adjective "white" or "black" or

"colored" to make our meaning clear. In this country it is quite the reverse. American means white, and Africanist people struggle to make the term applicable to themselves with ethnicity and hyphen after hyphen after hyphen ... For the settlers and for American writers generally, this Africanist other became the means of thinking about body, mind, chaos, kindness, and love; provided the occasion for exercises in the absence of restraint, the presence of restraint, the contemplation of freedom and of aggression; permitted opportunities for the exploration of ethics and morality, for meeting the obligations of the social contract, for bearing the cross of religion and following out the ramifications of power.[4]

One can only conclude that Groseclose in particular (despite her stated sensitivities) and art history in general share the assumption of what it means to be "American." Her redeployment of images of African Americans and Native Americans once again retools them as "the means for thinking about body, mind, chaos, kindness, etc." Consequently, art history continues to play in the dark.

These acts of sympathy, what I have called sentimental art history throughout this study, are acts of substitution in which the other is appropriated and absorbed as the imperfect, distorted self. Linda Bolton, a scholar of American literature, has studied the implications of such acts through the lens of the philosophy of Emmanuel Levinas. In her book *Facing the Other: Ethical Disruption and the American Mind*, she notes, "Levinas names this process of integration, through which the otherness of the world is mediated and converted into the experience of the subject, the 'way of the same.' In a world in which the I can exert its power of possession, the foreignness or otherness of the world is neutralized, and the integrity of the I reemerges in the knowledge of its mastery."[5] I would argue that these "sentimental art historians" are indeed inscribing their own subjectivity through the appropriation, absorption, and redeployment of Lewis, Duncanson, and Tanner as sentimental objects. Sympathy is the guise under which, the space within which, these acts of substitution are made possible. As Bolton argues, "It becomes possible to consider sympathy as a response prior to the ethical, in that the spectator-self has not yet discovered the already existent obligation owed to the Other confronting him."[6] Sympathy cannot allow the integrity of the other and therefore cannot accommodate the possibility that *we* are other to Lewis and Duncanson and Tanner as well as to those artists excluded from Groseclose's

study. As Emmanuel Levinas explains, "Ethics is when I not only do not thematize another; it is when another *obsesses* me or puts me in question. This putting in question does not expect that I respond; it is not a question of giving a response, but of finding oneself responsible."[7]

The question that we must ask ourselves is this: How do we begin the transformation from an unresponsive art history to a discipline that is both responsive to a multiplicity of voices and responsible? I have begun the process for myself at least by interrogating those narratives based upon the premise of the artist as exotic/victim. However, finding an alternative to the model of oppression by creating the artist-as-subversive who can stand totally outside of their cultural context to become the master manipulator is flawed. As scholars, we must leave ourselves open to a "heroism" that is historically and culturally specific, even if we find it problematic.

In conclusion, I submit the following: Edmonia Lewis did not attempt to overthrow, destroy completely, or ruin patriarchy as she found it. Nor did she hate herself because of it. Between 1866 and 1876, her heroism lay not in subversion. Rather it lay analogously in the musical sense of inversion, which comprises a rearrangement or result of the rearrangement of tones in which upper and lower voices are transposed, as in counterpoint, or in which each interval in a single melody is applied in the opposite direction.[8] Although Lewis never overcame her status as an outsider within the American expatriate community, her subject position and her insistence that all women be included in the cult of true womanhood caused a shift in expectation and perspective. She also rejected wholesale the image of her as "victim." To that end, Lewis glossed over unpleasantness in order to recast her biography, so that her experiences were more consistent with those of other internationally renowned artists. To that end, her sojourn in Rome represented an escape from the constraints of race and sex, an escape from American prejudice, and an opportunity that few women (especially women of color) could enjoy. As she slowly disappeared from the correspondence of her Boston acquaintances and from the circle of her fellow expatriates in Rome, one can only suppose that Mary Edmonia Lewis had been busy creating her own community, elsewhere.

PREFACE

1 The film, of course, is Francis Ford Coppola's *The Godfather*.
2 I place "American" in quotes because I employ the term self-consciously to mean British colonial America and the United States and to represent how people of the United States thought of themselves in the nineteenth century. I also place it in quotes because of the artificial separation between "African American" and "American" art, with African American art treated by colleges and universities as if it is not of the United States; rather it is more popularly conceptualized as part of the "African diaspora."
3 Emerson, *The Selected Writings of Ralph Waldo Emerson*, 288.
4 Ibid., 304; emphasis mine.
5 Fields, "Slavery, Race and Ideology in the United States of America," 110.
6 Ibid., 112–13.
7 Baxandall, *Patterns of Intention*, 42.
8 McFeely, *Frederick Douglass*, 371.
9 Merish, *Sentimental Materialism*, 37. Merish is addressing the relational nature of difference in the formation of capitalism's subjects and objects. She writes, "Capitalism's justification in this discourse [of the Scottish Enlightenment] pivots on the status of women, which the Scots conventionally termed the 'treatment of women' [which I employ interchangeably as the 'Woman Question' or the 'Negro Problem']—a rhetorical index of the condition of patriarchal subordination within which sentimental subjectivity takes shape. That status is measured in racial terms

that were acutely resonant in America: implicit in Scottish discourse is the notion that while women in premodern or non-market societies are objectified, treated as drudges and slaves, white women are viewed as 'subjects,' as fully human persons with specific identities, desires, and emotions."

10 Whittier, "The Indian Question [Read at the meeting in Boston, May, 1883, for the consideration of the condition of the Indians in the United States]," *Reform and Politics*, 148–50.

11 Morrison, *Playing in the Dark*, 52.

12 Ibid., 7.

13 Baxandall, *Patterns of Intention*, 42.

14 Ibid., 107.

15 Ibid., 30–36.

16 Hatt, "'The Body in Question,'" 610.

17 Baxandall, *Patterns of Intention*, 47.

1 INVENTING THE ARTIST

1 Bearden and Henderson, *A History of African-American Artists*, 60. Lewis, in not being allowed to register for her final term, was essentially expelled from Oberlin for reasons that will be explained in this chapter. Bearden and Henderson speculate on Lewis's reaction: "Humiliated, Lewis was determined to show that Oberlin had misjudged and mistreated her. In the Chippewa tradition, revenge for humiliation is required, according to Henry R. Schoolcraft. Lewis set out to expose the falsity of the accusations and the hypocrisy of [Marianne] Dascomb by demonstrating her skills and determination."

2 The model for my own work on Lewis's career is indebted to Elizabeth Johns's *Thomas Eakins* and a seminar by Thomas Crow on the career of Gericault held at the University of Michigan during the winter semester of 1993.

3 In 1866, Lewis revealed in an interview with Henry Wreford of the *Athenaeum* that her father was "a negro" and "a gentleman's servant." Henry Wreford, "A Negro Sculptress," 302.

4 The first, most complete biography was contained in Bearden and Henderson, *A History of African-American Artists*, 54–63. Unless indicated otherwise, all early biographical details derive from this source. See also Wolfe, *Edmonia Lewis*.

5 The passport application is reproduced in Wolfe, *Edmonia Lewis*, 13. This rough chronology of Lewis's life, and the inconsistency of Lewis herself in relating that chronology, is also supported by the artist's biographer, Marilyn Richardson, in "Edmonia Lewis' *The Death of Cleopatra*," 44.

6 Bearden and Henderson, *A History of African-American Artists*, 54–55. See also Richardson, "Edmonia Lewis at McGrawville," 242.

7 Wreford, "A Negro Sculptress, 302. If the date of her birth, 1844, is accurate

and she enrolled in Oberlin in 1859, then she was probably at Central College for two and a half years instead of three.

8 For Keep's status on the board, see *Annual Catalogue of the Officers and Students of Oberlin College, for the College Year 1862–3*. For Keep's views on abolition and coeducation, see Fletcher, *A History of Oberlin College*, 1: 167–77; 237–65; 376; and 463–68.

9 Lawson and Merrill, "Antebellum Black Coeds at Oberlin College," 18–20.

10 Fletcher reproduces the actual petition and provides an account of the debate in his *A History of Oberlin College*, 2: 604.

11 Child, "Letter from L. Maria Child," 1.

12 Yee, *Black Women Abolitionists*, 15–16. See also Harley, "Northern Black Female Workers."

13 Yee, *Black Women Abolitionists*, 66.

14 The lecture is quoted in Fletcher, *A History of Oberlin College*, 1: 382; Fairchild, *Woman's Rights and Duties*, 33.

15 Fletcher, *A History of Oberlin College*, 2: 709; 717.

16 Lawson and Merrill, "Antebellum Black Coeds at Oberlin College," 18.

17 Fletcher, *A History of Oberlin College*, 2: 710–11; 719.

18 Ibid., 2: 713.

19 *Annual Catalogue of the Officers and Students of Oberlin College, for the College Year 1862–3*.

20 Fletcher, *A History of Oberlin College*, 2: 715.

21 *General Catalogue of Oberlin College, 1833–1908*, 591.

22 Bearden and Henderson, *A History of African-American Artists*, 486.

23 *Annual Catalogue of the Officers and Students of Oberlin College, for the College Year 1862–3*, 39.

24 Brodhead quoted in Wexler, "Tender Violence," 16.

25 Wexler, "Tender Violence," 16–17.

26 Fletcher, *A History of Oberlin College*, 1: 379.

27 Ibid., 2: 711–12. Fletcher cites several cases in which students were not allowed admission: none were admitted who traveled on the Sabbath, and in 1853, a young girl was refused admission because her parents were unmarried. Another fellow, it was rumored, was refused admission because he was seen drinking a glass of root beer.

28 For information on race relations at Oberlin, see "Prejudice at Oberlin College!"; see also Lawson and Merrill, "Antebellum Black Coeds at Oberlin College," 19.

29 In 1968, a historian at Oberlin brought the poisoning incident to light again. Reading John Mercer Langston's autobiography, he made the connection between Langston's story of his famous, though unnamed, client and Edmonia Lewis. See Blodgett, "John Mercer Langston and the Case of Edmonia Lewis."

30 We know that the suspected poison was cantharides because of a letter by a

fellow student who makes a mocking reference to the incident. Fred Allen to A. A. Wright, February 18, 1863, 4, Oberlin College Archives, 30/17, box 1. Several tracts on the effects of cantharides were published in the nineteenth century alone: Gough, *An Inaugural Essay on Cantharides*; Cowan, *Curious Facts in the History of Insects*, 62–64; Davenport, *Aphrodisiacs and Antiaphrodisiacs*), 96–100; and Hughes and Dake, *A Cyclopedia of Drug Pathogenesy*. I wish to thank Kim Clark, formerly of the Smithsonian American Art Museum, for aiding me in this research.

31 The newspapers that covered the trial were the *Lorain County News*, February 19 and March 12, 1862; the *Cleveland Plain Dealer*, February 11, and 25 and March 3, 1862; the *Cleveland Morning Leader*, March 3, 1862; and the *Elyria Independent Democrat*, March 5, 1862. See also Blodgett, "John Mercer Langston and the Case of Edmonia Lewis."

32 At this time, the Democratic Party was proslavery and anti-abolition. Abolitionism, on the other hand, was made part of the Republican Party platform. I examined several issues of the *Cleveland Plain Dealer* and easily found many stories that cater to the anti-abolitionist, racist sentiments of its readers. One such article reads "A black beast, named Alexander G. Sweet, a colored barber in Providence, R. I., has been arrested at the instance of the school authorities for selling obscene books, prints, and cards to young school girls whom he could decoy into his den." *Cleveland Plain Dealer*, February 1, 1862, 1.

33 "Mysterious Affair at Oberlin," 3.

34 For the history of Oberlin College and the temperance movement, see Fletcher, *A History of Oberlin College*, 1: 336–40.

35 Foner, *Freedom's Lawmakers*, 127–28.

36 Langston, *From the Virginia Plantation to the National Capitol*, 172–73.

37 "The Oberlin Poisoning Case," 3.

38 Langston, *From the Virginia Plantation to the National Capitol*, 176–77.

39 Ibid., 178–79.

40 For the date in which she enrolled for the fall term of her final year, see *Annual Catalogue of the Officers and Students of Oberlin College, for the College Year 1862–3*, 36.

41 *Lorain County News*, February 25, 1863.

42 In 1875, Lewis initiated the contact with William Henry Johnson, an African American physician from Albany, New York. While visiting New York City, Lewis wrote to ask if he would be interested in having a copy of her life-size bust of Senator Charles Sumner, who had died the previous year. If Johnson were interested, Lewis proposed, the price of the sculpture could be raised through efforts by friends of Johnson and by the sculptor herself. Johnson, *Autobiography of Dr. William Henry Johnson*, 2: 18–19.

43 See entry for "Brackett, Edward Augustus," *The National Cyclopedia of American Biography*, vol. 13 (New York: James T. White and Co., 1906), 583.

44 Taft, *The History of American Sculpture*, 1: 200–201.

45 Child, "Edmonia Lewis," 25.

46 Anne Whitney to Addy, August 9, 1864, Anne Whitney Papers, Wellesley College Archives, Margaret Clapp Library.

47 Child, "Edmonia Lewis," and Wreford, "Lady-Artists in Rome," 177.

48 In addition to these four female writers, Lewis was helped greatly by another woman, Maria Weston Chapman of Boston. Perhaps the most comprehensive biography of Child is by Carolyn L. Karcher, *The First Woman in the Republic*; see also Clifford, *Crusader for Freedom*.

49 Quarles, *Black Abolitionists*, 36.

50 Interview with Lydia Maria Child, *Liberator*, February 19, 1864, n.p.

51 "Mr. Brackett, the Sculptor."

52 Lewis gives the number of busts and the price for each in an interview. See "Edmonia Lewis, The Famous Colored Sculptress in San Francisco," sec. 3, 5.

53 Lydia Maria Child to Sarah Blake Sturgis Shaw, April 8, 1866, New York Public Library, Manuscript Division, Shaw Family Papers.

54 Lydia Maria Child to Harriet (Winslow) Sewall, June 24, 1868, Massachusetts Historical Society, Robie-Sewall Papers. For information on Samuel and Harriet Sewall, see Karcher, *The First Woman in the Republic*, 181–82; 582.

55 Lydia Maria Child to Sarah Blake Sturgis Shaw, November 3, 1864, Harvard University, Houghton Library, MS Am 1417 (93). Lewis's first ideal work, *The Freedwoman on First Hearing of her Liberty*, she "dedicated" to two teachers who worked with the Freedmen's Bureau in Boston, Miss H. E. Stevenson and Mrs. Ednah Dow Cheney, "for their dedication to teaching her father's people." "Photographs [The Freedwoman and her Child]."

56 Ronda, "Print and Pedagogy." Peabody was also sister-in-law to Nathaniel Hawthorne, much to his shame.

57 Lydia Maria Child to Sarah Blake Sturgis Shaw, August 1870, Harvard University, Houghton Library, MS Am 1417 (105). The actual date on which the letter was written has been obscured.

58 In her *The Freedman's Book*, for example, Child takes care to underscore the innate intelligence of the subjects who make up the biographical sketches of representative men and women of the African diaspora: from Benjamin Banneker to Phillis Wheatley to Toussaint L'Ouverture. See also Karcher, *The First Woman in the Republic*, 497.

59 Edmonia Lewis to Mrs. Maria W. Chapman, May 3, 1868, Boston Public Library, MS A46 A2, 37.

60 Lydia Maria Child to Harriet (Winslow) Sewall, July 10, 1868. Massachusetts Historical Society, Robie-Sewall papers.

61 Child, "Letter from L. Maria Child to the Editor of the Independent."

62 "Seeking Equality Abroad."

63 Pinkus, "Selling the Black Body," 27.

64 Bossaglia, "Gli orientalisti italiani (1830–1940)," 4.

65 In June 1995, the *Archivio Fotografico Toscano* (AFT) devoted an entire issue to images of Africa taken by Europeans with particular attention paid to Italian colonial interests in Africa during the nineteenth century. See Palma, "La società africana d'Italia."

66 Vance, *America's Rome*, 2: 109–10. See also Angeli's chapter 6 in *Le cronache del Caffè Greco*, his chronicles of the Caffè Greco devoted to the English and Americans; it is titled "Gli Anglosassoni," or "The Anglo-Saxons," 61–72.

67 Chambers-Schiller, "'A Good Work among the People,'" 252–53.

68 Henry Wadsworth Longfellow, *Poesie sulla schiavitù e frammenti di E. W. Longfellow*, translated by Louisa Grace-Bartolini (Florence, 1869).

69 When Gennaro Mondaini published his study on American slavery in 1898, *La questione dei negri nella storia e nella società nord-americana* (The Negro Question in History and in North-American Society), his bibliography included the French translation in 1857 of Harriet Beecher Stowe's *Key to Uncle Tom's Cabin*. Mondaini also cited four earlier works written in Italian treating the subject of race: Villari, *La schiavitù e la guerra civile in America* (Slavery and the Civil War in America) (1864); Manetta, *La razza negra* (The Black Race) (1864); Lomborzo, *L'uomo bianca e l'uomo di colore* (The White Man and the Man of Color) (1871); Ghisleri, *Le razze umane e il diritto nella questione coloniale* (The Colonial Question: Rights and the Races of Man) (1896). Mondaini, *La Questione dei Negri*, 487–91. I wish to thank Domenico Iacono for locating this source.

70 Vance, *America's Rome*, 2: 200 (his emphasis). Vance also lists other American authors who addressed the issue of Italian unification, among them Henry Wadsworth Longfellow, John Greenleaf Whittier, Henry Tuckerman, Margaret Fuller, and James Russell Lowell.

71 While scrolling through issues of the *National Anti-Slavery Standard* I came upon a review of the London performance of one of Rota's ballets, *I Bianchi ed i Negri*. Once I arrived in Italy, I was able to find both libretti at the Biblioteca Nazionale in Rome.

72 The opening of Giuseppe Rota's ballet begins with an allegory that reads as follows: "ALLEGORICO: La Natura deposita sulla terra due bambini una *Bianco* e l'altro *Negro*, ricordando loro che sono fratelli. Per invidioso spirito di dominio, il *Bianco* atterra il *Negro*, e lo rende suo schiavo. Sorge l'*Umanità*, raccapriccia, e fa voto di ritornarli al fratellevole amore." [Allegory: Nature deposits on earth two children, one white and the other black, reminding them that they are brothers. By the invidious need to dominate, the white child attacks the black child, and makes him a slave. Humanity, in a horrific uprising, returns them to a state of loving brotherhood.] Rota, *Bianchi e Negri*, 7.

73 See also Rota, *Giorgio il Negro*; and "'Uncle Tom's Cabin' At Her Majesty's Theatre." For a general treatment of nineteenth-century musical theater, see Liechtenhan, *Danza classica*.

74 Lydia Maria Child to Mr. [James (Thomas)] Fields, October 13, 1865, Huntington Library, James Thomas Fields Collection, FI643; and Lydia Maria Child to Mrs. [Annie (Adams)] Fields, November 25, 1865, Huntington Library, James Thomas Fields Collection, FI650.

75 "Edmonia Lewis, the Famous Colored Sculptress in San Francisco."

76 Hillard, *Six Months in Italy*, 2: 267–69. For England's relationship to ancient Rome, see Liversidge and Edwards, *Imagining Rome*.

77 Chard, "Nakedness and Tourism," 24.

78 Montanelli, *L'Italia del Risorgimento*, 11.

79 Pers, "Political and Social Conditions in Rome during the Reign of Pius IX," 15.

80 Slightly earlier in 1848, Hiram Powers created his statue *America*, which was to symbolize both America's triumph over despotism and Italy's own struggle for unification. Powers, William Wetmore Story, and Thomas Ball were only some of the Americans who were actively involved in Risorgimento politics. See Boime, *The Art of the Macchia*, 172–76; and Green, "Hiram Powers's *Greek Slave*."

81 Hosmer, *Harriet Hosmer*, 292.

82 Arab physiology, French anthropologists argued, proved their predisposition to cupidity, filth, cruelty, and fanaticism, whereas the Kabyles revealed traits that showed their courage and perseverance though they were still judged vastly inferior to French racial characteristics. Lorcin, "Imperialism, Colonial Identity, and Race in Algeria," 662. See also Rice, "African Conscripts/European Conflicts."

83 The now all French Zouave battalions' first action outside of Algeria was during the Crimean War in 1854, and subsequently they served during World War I and World War II and, ironically, fought against the Algerians during the Algerian war for independence in 1962. The traditions of the Zouave regiments are maintained at the present time by the French Army's Commando Training School. See "Zouave" on the Web encyclopedia Wikipedia, available at http://en.wikipedia.org/wiki/Zouave (visited January 1, 2006).

84 Boime, *The Art of the Macchia and the Risorgimento*, 24–32. The *National Anti-Slavery Standard*, for example, reprinted an address published in the *London Morning Post* titled "Garibaldi to the English Nation." In the address, Garibaldi exhorts England to "call the great American Republic. She is, after all, your daughter, risen from your bosom; and, however she may go to work, she is struggling today for the abolition of slavery so generously proclaimed by you. Aid her to come out from the terrible struggle in which she is involved by the traffickers in human flesh. Help her, and then make

her sit by your side in the great assembly of nations, the final work of human reason." After the assassination of Lincoln, William Lloyd Garrison's newspaper, *Liberator*, published a lengthy piece titled "Public Feeling in Italy on the Assassination of Mr. Lincoln."

85 John T. Marck, "Colonel Ephraim Elmer Ellsworth," http://www.about famouspeople.com/article1011.html (visited January 23, 2006).

86 In 1881, the Central Park Museum burned to the ground and among those pieces rescued was Lewis's sculpture of Lincoln with its four caryatids. See "Destruction in the Park," *New York Times*, January 3, 1881, 8.

87 Anne Whitney to Family, October 28, 1867, Anne Whitney Papers, Wellesley College Archives, Margaret Clapp Library.

88 Vance, *America's Rome*, 2: 4.

89 Lewis counted as a dear friend in Rome a Mrs. Cholmley. Mrs. Cholmley was an English lady who would have been well aware of the very active abolitionist movement in her home country. As a fellow Catholic, she would have been even more inclined to offer Lewis aid. Cholmley also was an artist who made a bust of Lewis (now lost), with one side reflecting her Indian mother and the other reflecting her African American father. See "The Studios of Rome," 77.

90 Anne Whitney to Family, February 9, 1868, Wellesley College Archives, Margaret Clapp Library, Anne Whitney Papers. See also "Edmonia Lewis, the Sculptor, has her Latest Work the 'Bride of Spring' at the Grand Bazaar." Lewis was also written up in *Rosary Magazine*, which reported that Lewis was "still with us" and living in Rome. See O'Neill, "The Catholic Who's Who." In a letter to me (December 8, 1997) Jack Rachlin of the Smithsonian American Art Museum suggested that perhaps she was named "Mary" because her father was Catholic. James Hopkins, in his travelogue, also reported that Lewis was Catholic: *European Letters to the Pittsburgh Post*; "Concerning Women" (March 1883).

91 "Noted Woman Sculptor."

92 Bullard, "Edmonia Lewis."

93 Unfortunately, the name of the Italian sculptor who provided the deposition is illegible in the copies made available to me, but it is to be hoped that one day his papers will be found and a new window will open into Lewis's life abroad. "The Courts," January 23–25, 1879; "Legal Lore"; "A Suit by Edmonia Lewis"; and "Art and Artists," November 1, 1878.

94 According to Emily Faithful, in *Three Visits to America*, the Marquis of Bute purchased a Madonna and Child by Lewis for £500; "Concerning Women" (March 1883).

95 "Edmonia Lewis, the Sculptor." See also O'Neill, "The Catholic Who's Who."

96 "The Diary of Frederick Douglass," Wednesday January 26, 1887 — Rome and

Friday January 28, 1887 — Naples. Library of Congress, Manuscript Division, Reading Room.

97 Rome Consulate, Visitor's Register, container 14, vol. 1, December 3, 1889–July 9, 1896.

98 "Biography of a Bozeman Barber."

99 Rome Consulate, Visitor's Register, no. 276, container 14, vol. 2, August 3, 1898.

100 O'Neill, "The Catholic Who's Who."

2 THE "PROBLEM" OF ART HISTORY'S BLACK SUBJECT

1 Reed, *W. E. B. Du Bois and American Political Thought*, 7, 8. The "Negro Problem" has also been posed at various times in history as the "Negro Question" and has not been limited to scholarship in English. While visiting Italy in 1994, I discovered a book published in Turin in 1898 by Gennaro Mondaini, *La questione dei Negri nella storia e nella società nord-americana* (The Negro Question in North-American History and Society). The book is divided into two sections, "The enslavement of Negroes and Anglo-American Civilization (1619–1865)" (La schiavitù dei Negri e la civiltà anglo-americana [1619–1865]), and "The Social Evolution of Afro-Americans and the Present-Day 'Negro Problem' (1865–1897)" (L'evoluzione sociale degli Afro-Americani e l'odierno 'Negro-Problem' [1865–1897]).

2 As a modern discipline, art history owes a great deal to the philosophers Immanuel Kant, David Hume, and Edmund Burke. Even as they developed theories about beauty and aesthetics, they also developed ideas about who could and could not appreciate beauty. Kant, for example, also lectured on anthropology and ethics, dividing mankind into four races together with the ideal or "stem genus" categorized as the "white brunette." The "first race" is described as "very blond (northern Europe), of damp cold." The "second race" is "Copper-red (America), of dry cold"; the "third race, Black (Senegambia), of dry heat"; and the "fourth race, Olive-yellow (Indians), of dry heat." Of the four races, only one (whites) possessed both moral agency and the ability to appreciate beauty. Matthew R. Hachee, "Kant, Race, and Reason," Hachee's website, https://www.msu.edu/~hacheema/kant2.htm (visited March 30, 2009). See also Eze, "The Color of Reason"; Eze, "Hume, Race, and Human Nature"; and Armstrong, "'The Effects of Blackness.'"

3 Honour, *The Image of the Black in Western Art*, 250–51. Further proof of the trend to read Lewis's sculptures as self-portraits is to be found in Naurice Frank Woods's dissertation, "Insuperable Obstacles." Woods speculated that "perhaps Lewis used Cleopatra as an allegory of her own life and career. Could this life-sized statue be, in essence, Edmonia, the 'African queen of Neoclassical sculpture,' reacting against all the unpleasant and negative forces that confronted her throughout much of her life?" (245).

4 Driskell, *Two Centuries of Black American Art*, 48.
5 Gerdts, *American Neo-Classical Sculpture*, 132. I have explored the issue of Lewis as an exotic in an essay published for an exhibition of African American women sculptors. See "Edmonia Lewis in Art History."
6 Geertz, "Art as a Cultural System," 102.
7 Geertz, "Thick Description," 14.
8 In the 1990s, Albert Boime mentions Duncanson's View of Cincinnati, Ohio, from *Covington, Kentucky* (1858) in *The Magisterial Gaze*, 120–23. Duncanson's *View of Cincinnati*, now in the Cincinnati Historical Society, is rare in his oeuvre because of its inclusion of blacks. Duncanson depicts the poignant narrative of an enslaved family living in Kentucky, forced to labor although freedom is literally in sight across the border in Cincinnati. Duncanson is excluded, however, from Angela Miller's *The Empire of the Eye*. For a more recent and cogent analysis of Duncanson, landscape, and identity, see Vendryes, "Race Identity/Identifying Race."
9 Fuss, *Essentially Speaking*, 3. See also Irigaray, *This Sex Which Is Not One*; Schor and Weed, *The Essential Difference*. For a fascinating reappraisal of the essentialist debate, see Ehrenreich, and McIntosh, "The New Creationism."
10 The idea of "white" as an essential type started undergoing scrutiny by scholars beginning in the late 1980s: Dyer, "White," and *White*; Saxton, *The Rise and Fall of the White Republic*; Roediger, *The Wages of Whiteness*; and Allen, *The Invention of the White Race*, vols. 1 and 2.
11 Fields, "Ideology and Race in American History."
12 By 1662, the colony of Virginia had passed nine laws, essentially changing English common law, which stated that children inherited their status from the father. The concern, of course, was over the number of children born by the union of black women and white men. Had Virginia continued to follow the English system, the children of such unions would be born free. To circumvent such potentially disastrous consequences, the Virginia Colony legislated that children would thenceforth inherit their status from the mother. From such practicalities, myths about "black blood" arose to justify the continued enslavement of Africans and to reinforce the differentiation between black and white. Stetson, "Studying Slavery," 72.
13 Ketner, *The Emergence of the African American Artist*, 1.
14 Ibid., 1, 105. See also Lubin, "Reconstructing Duncanson," 124. Lubin claims, "The fact that Duncanson's paintings were seen and bought almost exclusively by members of the white middle class surely does not preclude the possibility that at some level the artist envisioned his most understanding viewers as black and used his art as a way of communicating or, more accurately, *communing* with them in their literal or figurative absence" (his emphasis).
15 Ketner, *The Emergence of the African American Artist*, 75.
16 Ibid., 11–13.

17 Lubin, *Picturing a Nation*, 333–34, note 8. Between Ketner and Lubin, Lubin provides a more nuanced reading of Duncanson, race, and the American landscape, as he asks the reader "to consider . . . the possibility that an artist, in this instance Duncanson, could attempt through his art both to erase his past and inscribe it."

18 Ibid., xiv, 110.

19 As Lubin rightly notes, the shift in style, from storytelling and identity politics that he assumes for Duncanson and Spencer, to one of distance and objectivity that he adopts for his discussion of William Harnett, is no less illusionistic than the other rhetorical mode of presentation. Ibid., 273–74.

20 Ibid., 109.

21 Ibid.

22 Pinder, "Black Representation and Western Survey Textbooks," 533.

23 Lubin, *Picturing a Nation*, 123 (his emphasis).

24 Ibid., 124 (my emphasis).

25 Ibid., 116.

26 Pinder, "Black Representation and Western Survey Textbooks," 533.

27 Reed, *W. E. B. Du Bois and American Political Thought*, 132.

28 Lubin, *Picturing a Nation*, 142–43 (his emphasis).

29 Ibid., 112.

30 Ibid.

31 In her study of antebellum genre painting, published in 1991, Elizabeth Johns isolated three important characteristics of genre: first, the subject of genre paintings were not individuals but types or representatives of social orderings, in characterizations that apparently first achieved permanency in jokes, anecdotes, and stories; second, genre paintings seemed to have been produced for members of the society doing the joking or typing rather than for those being the brunt of it; and third, genre painting was most prominent in enterprising northern Atlantic societies, especially during periods of economic and social change. Johns, *American Genre Painting*, 2.

32 Lubin, *Picturing a Nation*, 122, 141.

33 Pinder, "Black Representation and Western Survey Textbooks," 536.

34 Lubin, *Picturing a Nation*, 122.

35 Ketner, *The Emergence of the African American Artist*, 1; Lubin, *Picturing a Nation*, 123.

36 Reed, *W. E. B. Du Bois and American Political Thought*, 140.

37 Perhaps the most important essay I have ever read on the nature of difference is Brown, "Polyrhythms and Improvisation."

38 Lubin, *Picturing a Nation*, 333–34, note 8.

39 Ibid., 152; on the effects of lead poisoning on Duncanson, see Ketner, *The Emergence of the African American Artist*, 183–84.

40 Lubin, *Picturing a Nation*, 152–53; see also Du Bois, *The Souls of Black Folk*.

41 Reed provides a critical recontextualization for Du Bois's double conscious-
ness. As Reed notes, Du Bois's *The Souls of Black Folk* was written as a direct
challenge to Booker T. Washington's exclusive access to white patronage, but
the scholars who resurrected it beginning in the 1980s suppress the original
conflict in favor of a depoliticizing adaptation to canon building and the
legitimating of a black literary tradition. After tracing the rhetorical origins
of "double consciousness," both historical and its use among Du Bois's white
contemporaries, Reed also notes that Du Bois abandoned the trope soon
after the publication of *The Souls of Black Folk*. Reed, *W. E. B. Du Bois and
American Political Thought*, 59–64, 125, 127–76 passim.

42 Ibid., 97.

43 Ibid., 97–98.

44 An example of the tenacity of double consciousness on the writing of art his-
tory is Michal Harris's *Colored Pictures*, a unique and laudable endeavor, in
which Harris investigates images of race by African American artists. How-
ever, he unproblematically accepts the premise of double consciousness as
the racial worldview of African Americans and even goes so far as to discuss
his own "double consciousness in the Du Boisian sense" relative to Yoruba
culture. See *Colored Pictures*, ix, 9, 11, 40, 113, 150, 171, 183, 223, 232, 233, 245,
247, 258.

45 Lubin, *Picturing a Nation*, xiv.

46 Fisher, *Hard Facts*, 93.

47 Lubin prefaces his chapter on Harnett with the following caveat: "Before
telling these stories, I wish to point out that this chapter will be less marked
than the others by the deliberately intrusive presence of the story-teller. This
is intentional; whether or not it pleases you is another matter. Because I am
writing about art that, as we shall see, was predicated upon the suppression of
authorial presence — art that seemed to appear on the wall full-blown with-
out any human touch — I have chosen to experiment with suppressing not
so much my own touch as the conspicuous signs of that touch: the direct
address, the jokes, the puns, the perorations, all the self-reflexive and idiosyn-
cratic stuff that heretofore has been strewn throughout the book. In other
words, I have tried (rather inconsistently, I must admit) to write imperson-
ally about impersonal art, coolly about art that is cool, dispassionately about
passionlessness. I have tried, that is to say, to write in the bland and neutral
style preferred in the academy today." Lubin, *Picturing a Nation*, 273.

48 Fisher, *Hard Facts*, 98–99 (his emphasis).

49 Ibid., 102.

50 Regarding Duncanson's mythic and mythical white fathers, Lubin posits the
following questions (and answers): "The question, again, is who or what was
Duncanson's master? The father he left behind? Some Scottish clan leader
from whom in truth or imagination he was directly descended? Thomas

Cole, the originator of the Hudson River School style that he slavishly followed? Sir Walter Scott, whose poetry and fiction inspired painters such as Cole and novelists such as Cooper to romanticize the American landscape as he had romanticized the Scottish? Or maybe Wordsworth, whose nature poetry, whose *view* of nature, underlies the work of all the figures named above and certainly that of Duncanson himself? All of these white men, to reverse the Wordsworthian trope, were fathers to the child that was Robert S. Duncanson. To what extent might Nicholas Longworth and other white abolitionists, attentive, dedicated supporters of his career, also have been the great masters who haunted him at the end — if not from the start?" Lubin, *Picturing a Nation*, 154.

51 Fisher's quote concludes, "Such training lies at the heart of sentimental politics. That feeling and empathy are deepest where the capacity to act has been suspended — as it is in the reader's relation to art — defines the limit of sentimental representation." There is a problem with Fisher's notion of sentimentalism, "that feeling and empathy are deepest where the capacity to act has been suspended." Perhaps there is an old gender paradigm at work in Fisher's analysis that equates sentimentalism with femininity and femininity with passivity and the inability to act. Sentimentalism as an ideology is indeed about action, about seeing its agenda systematized and acted upon in various institutions such as boarding schools, prisons, and, in the case of abolitionists, on plantations (meaning of course the disruption of slavery as a competing and therefore incompatible system). Fisher, *Hard Facts*, 121–22.

52 A recent and notable exception is Patton, *African-American Art*. Unlike previous surveys that string together artists' biographies as if they could sufficiently tell the history, Patton's survey of African American art is a critical reevaluation of the historical and cultural contexts that helped to forge almost three hundred years of creativity.

53 Garb, "Berthe Morisot and the Feminizing of Impressionism," 61.

54 Ibid.

55 Kinney, "Morisot," 236.

56 Ibid., 238.

57 Cherry, *Painting Women*, 116.

58 Kinney, "Morisot," 239.

59 Baxandall, *Patterns of Intention*, 35 (his emphasis).

60 Halttunen, *Confidence Men and Painted Women*, 60.

61 Gillman, "The Mulatto, Tragic or Triumphant?" 222–24. Gillman locates sentiment in the race melodramas of the late nineteenth and early twentieth centuries, in novels like Frances Harper's *Iola Leroy; or Shadows Uplifted* (1892) and Pauline E. Hopkins's *Of One Blood; or, The Hidden Self* (1903). In the 1890s, a time that could be approximated as the end of the cults of sentiment and true womanhood, the power allowed women under the cult

of true womanhood was transmogrified by them to encompass all of society, as women took up the causes of temperance, dress reform, and social change in addition to suffrage. Finnegan, *Selling Suffrage*, 4–5.

62 Tompkins, "Sentimental Power," 269, 271.

63 Ibid., 283.

64 "From Foreign Files."

65 The Emancipation Proclamation states that "on the first day of January, in the year of our Lord one thousand eight hundred and sixty-three, all persons held as slaves within any State or designated part of a State . . . shall be then, thenceforward, and forever free." See Boime's discussion of the theme of "forever free" in the popular poetry and song of the day. Boime, *The Art of Exclusion*, 163–66.

66 Lewis also intended to sell by subscription and then personally dedicate *The Freedwoman on First Hearing of Her Liberty* to Ednah Dow Cheney and a Miss H. E. Stevenson, who had labored to teach "her father's people." "Photographs [The Freedwoman and Her Child]."

67 Peterson, *Lincoln in American Memory*, 171. African Americans from Texas, however, celebrated June 19 or "Juneteenth" as their Emancipation Day. According to legend, it took from January to June for a slow-stepping mule to reach Texas with the news of liberty.

68 One notable, recent exception to scholarship that makes no attempt to understand the physical differences in Lewis's figures is Savage, *Standing Soldiers, Kneeling Slaves*, 63–64. Savage proposes that the freedman and freedwoman, "though no longer slaves, their identities are still defined by slavery and its characteristic signifiers; new identities await them as they lift their thanks to God. Even their racial characteristics are mutable, as the Africanized physiognomy of the man is counterbalanced by the flowing hair of the woman, who might 'pass' for white."

69 See Fonvielle-Bontemps, *Forever Free*, 16.

70 Yellin, *Women and Sisters*, 173–75.

71 Boime, *The Art of Exclusion*, 170–71.

72 Pohl, "Black and White in America," 182.

73 Richardson, "Edmonia Lewis's *The Death of Cleopatra*," 50.

74 Tate, "Allegories of Black Female Desire," 99–100.

75 Ibid., 103.

76 Yee, *Black Women Abolitionists*, 4.

77 Welter, "The Cult of True Womanhood, 1820–1860." For the effect of gender conventions on the African American population, see Perkins, "The Impact of the 'Cult of True Womanhood' on the Education of Black Women"; Sealander, "Antebellum Black Press Images of Women"; Horton, "Freedom's Yoke"; Cullen, "'I's a Man Now'"; and Yee, "Black Women and the Cult of True Womanhood," chap. 2 of *Black Women Abolitionists*.

78 Sealander, "Antebellum Black Press Images of Women," 2. For a discussion of the experiences of newly freed African American women, see Clinton, "Reconstructing Freedwomen."

79 Horton, *Free People of Color*, 70.

80 At the University of Michigan Museum of Art there is a plaster sketch by John Rogers of Lincoln freeing a female slave, ca. 1866. It is an anomaly in the history of emancipation imagery, because normally Lincoln is paired with a black male. Rogers's work is consistent with such representations in that the slave is kneeling. However, it is different because Lincoln, as a white male, actually touches a black female slave as he pulls her from a kneeling position. I would like to thank Professor Margaret Cool Root and her class for sharing their thoughts on the work. See also Savage, *Standing Soldiers, Kneeling Slaves*, 76–77. Savage notes that Lincoln pulls her up by her wrist rather than her hand, arguing that had Lincoln touched her hand it would have violated a gesture of courtesy reserved for white women and courtship.

81 Yellin, *Women and Sisters*, 10.

82 Chandler, quoted in ibid., 13.

83 Wreford, "A Negro Sculptress."

84 Douglas, *The Feminization of American Culture*, 74.

85 Horton, *Free People of Color*, 55.

86 Brown, "Negotiating and Transforming the Public Sphere," 125, note 34.

87 I would like to thank George Gurney, chief curator for the Smithsonian American Art Museum, for bringing to my attention the fact that it is with the freedman's unchained, right hand that he touches his wife.

88 Brown, *The Black Man, His Antecedents, His Genius, and His Achievements*, 217–20. Reuniting African American families after emancipation was no easy accomplishment. As the preeminent historian Dorothy Sterling writes, finding family was complicated by the prior selling of family members and by recalcitrant slave owners who attempted to circumvent laws newly enacted. According to Sterling, many wives and husbands found themselves with two families after emancipation, while hundreds of couples were married in mass ceremonies and thousands registered their names with justices of the peace or Freedmen's Bureau officers. See Sterling, "To Build a Free Society."

89 "Presentation to the Rev. L. A. Grimes."

90 "The Marble Group."

91 See the entry for "Hanaford, Phebe Ann Coffin" in Mainiero, *American Women Writers*, 2: 234–36.

92 I was unable to locate the issue of the *Christian Register* that Hanaford quotes, but the article, which is by Elizabeth Palmer Peabody, is datable to around 1869 because the article covers Lewis's career only to the bust that she did of Henry Wadsworth Longfellow in that year and because its wording makes it clear that the event at Tremont Temple had just occurred. See Hanaford,

Daughters of America, 316–18. In 1859, Elizabeth Palmer Peabody (1804–94) became a pioneer in the United States for the kindergarten system of education that had been developed in Germany by Friedrich Froebel. She was also a staunch abolitionist and a member of the Transcendentalist movement. See Mainiero, *American Women Writers*, 3: 355–57. Hanaford also includes an entry for Peabody in her book *Daughters of America*, 240–42.

93 For the complete quotation, see Hanaford, *Daughters of America*, 316–18. For an article on Peabody's career, see Ronda, "Print and Pedagogy."

94 See Hoganson, "Garrisonian Abolitionists and the Rhetoric of Gender, 1850–1860." Hoganson convincingly asserts that Garrisonian abolitionists argued for traditional roles within the slave community, while they inverted for themselves gender expectations for white women and men within the movement. White men were expected to support white women in their endeavors such as public speaking, which was strongly opposed in the nineteenth century. In fact, white men were to exhibit those characteristics usually reserved for the true woman — compassion, kindness, and accommodation — while white women aggressively pursued their independence (563).

95 Ibid., 560, 563–64; see also Riss, "Racial Essentialism and Family Values in *Uncle Tom's Cabin*."

96 Stowe, *Uncle Tom's Cabin*, and *The Key to Uncle Tom's Cabin*. See also Riss, "Racial Essentialism and Family Values in *Uncle Tom's Cabin*"; Hill, "Writing Out the War"; Mullen, "Runaway Tongue."

97 Riss, "Racial Essentialism and Family Values," 529–30.

98 The earliest, and perhaps the most thorough, treatment of emancipation as a theme in nineteenth-century American sculpture is Murray, *Emancipation and the Freed in American Sculpture*.

99 It is important to remember that *Forever Free* was presented to a northern audience of abolitionists and that northern racism was as virulent as that practiced in the South. Leonard L. Richards explores the North's hostility toward free African Americans in his *"Gentlemen of Property and Standing."* Regarding Peabody's description of the sculpture, it might be remarked that I am doing something similar to Lubin in his analysis of Duncanson — that if Peabody doesn't sense danger in the black male figure, she must be afraid of it and repressing it; thus I retrieve dangerous black male physicality as Peabody's subtext. But I can think of three examples in visual culture that registered the dangers of black male embodiment: (1) Edward Clay's lithograph *The Fruits of Amalgamation* (1839) that depicts the horrors of miscegenation (which one could argue is in some ways reinforced by the deracination of Lewis's female); (2) Currier and Ives's attempt to represent the black soldier as nonthreatening in the print *The Colored Volunteer*; (3) the critical reception of John Quincy Adams Ward's statue *The Freedman*. See Savage, "Molding Emancipation." What else could have prompted such a response

by Peabody to Lewis's sculpture? Of course there is nothing in the sculpture to suggest revenge or danger; rather it is in the *culture*, which to this day views the black male body with suspicion. Even as abolitionists worldwide deployed the image of the beaten and brutalized slave, they also envisioned in poem and in art a horrific picture of black vengeance. See Honour, *The Image of the Black in Western Art*, 85–104, 146–55.

100 See Riss, "Racial Essentialism and Family Values," 518–25.

101 This juxtaposition of clothed female and bare-chested male was first noted by Judith Wilson in "Getting Down to Get Over," 119, note 1; 121, note 13.

102 In one instance, both Hosmer's and Lewis's statues were mentioned in the same newspaper. Hosmer's is described as illustrating the "four stages of the negro" from slavery to freedom and self-defense. On the next page is news about Lewis's *The Morning of Liberty*. See "[Harriet Hosmer's] Freedmen's Monument to Abraham Lincoln."

103 Pohl, "Black and White in America," 181.

104 Child, "Letter from L. Maria Child to the Editor [Theodore Tilton] of the Independent."

105 In Harriet Hosmer's collected letters there is no mention at all of Edmonia Lewis. This may be a result of editing on the part of Hosmer's friend, Cornelia Carr, or simply that Lewis was not important enough in Hosmer's life to have figured in her correspondence.

106 Edmonia Lewis to Mrs. Maria W. Chapman, Boston, Mass., February 5, 1867, Boston Public Library, MS A.9.2, vol. 32, no. 64.

107 The extent of what we know of a friendship between Lewis and Hosmer is found in brief notices in articles about Lewis. The *Broken Fetter* reported in 1865 that Hosmer stopped in to see Lewis's bust of Shaw while in Boston for a brief stay. In an interview from 1873 and again in 1879, Lewis spoke of Hosmer as an intimate friend. Lydia Maria Child, "Edmonia Lewis," 26; "Edmonia Lewis, the Famous Colored Sculptress in San Francisco," and "Seeking Equality Abroad."

108 Carby, *Reconstructing Womanhood*, 25.

109 Sánchez-Eppler, "Bodily Bonds," 39.

110 Karcher, "Rape, Murder, and Revenge in 'Slavery's Pleasant Homes.'" See also Wilson, "Optical Illusions," and Morton, *Disfigured Images*.

111 Gerdts, *American Neo-Classic Sculpture*, 70–71. William Gerdts has done a phenomenal job of cataloguing the various types of American neoclassical sculpture. Among other artists who created sculptures based on biblical heroines are Henry Kirk Brown, *Ruth* (1845), in the New-York Historical Society; William Wetmore Story, *Salome* (1871), in the Metropolitan Museum of Art; and a very beautiful *Eve Repentant* (1858), by Edward Sheffield Bartholomew, in the Wadsworth Atheneum, Hartford, Connecticut.

112 The contested nature of ancient Egypt would make for a study in itself. An

article from the *National Magazine* in 1856, "Hagar and Ishmael," considers the heirs of Hagar and Ishmael to be Arabs and Jews. Harriet Beecher Stowe, on the other hand, in "Sojourner Truth, the Libyan Sibyl," described Sojourner Truth interchangeably as African, Libyan, Ethiopian, and Egyptian. Cleopatra's race, as will be discussed below, was also an ongoing debate in the nineteenth century. See Robert J. C. Young, *Colonial Desire*, 118–41; Fredrickson, *The Black Image in the White Mind*, 74–75; and Gossett, *Race*.

113 Keyword search of "Religion — Old Testament — Hagar." See the subject index of the Inventory of American Paintings, Smithsonian American Art Museum, Smithsonian Institution.

114 Born in 1778, Cogdell was a lawyer from South Carolina who took up sculpting at the age of forty-seven. Poor health sent him on a cruise to the Mediterranean, where he met Canova and visited his studio. The visit changed his life and thereafter he took up painting and sculpture. "More admired than patronized," Cogdell eventually returned to banking and became president of the Bank of South Carolina in 1832, a position he held for the rest of his life. Bartholomew was born in 1822 in Hartford, Connecticut, and moved to New York City in the 1840s to study art at the National Academy of Design. Craven, *Sculpture in America*, 94–95; 319–21. For the iconography of the abolitionist emblem, see Yellin, *Women and Sisters*, 3–26.

115 "Gleanings."

116 Bullard, "Edmonia Lewis."

117 Tate, "Allegories of Black Female Desire," 103.

118 Wexler, "Tender Violence," 12. See also Douglas, *The Feminization of American Culture*, and Tompkins, "Sentimental Power." Lori Merish enters the debate with a challenge to all three scholars in *Sentimental Materialism*. About Ann Douglas, Merish writes, "Douglas fails to provide a convincing theoretical account of feminine consumption and women's construction as (sentimental) consumers. Douglas deterministically construes the emergence of female consuming as an inevitable response to female boredom, an insignificant activity women engaged in to fill the domestic vacuum created by industrialism" (17). Merish's critique of Tompkins centers on Tompkins's seeming participation in sentimentalism's rationalization of female agency, as Merish pairs the work of Harriet Beecher Stowe with that of Tompkins: "Stowe's sentimental 'romance of the object,' then, is a materially bounded romance, one localized in the practices of a sentimental domestic economy. It is within the realm of the home that 'objects' are endowed with personal affectional significance and reconstituted as containers of 'sensibility.' Significantly, it is in this feminized domestic ethic that recent critics such as Jane Tompkins have seen sentimentalism's public power and political import. However, although Tompkins (like Stowe) invests in the redemptive social value of 'sentimental power,' I would argue that such power is consti-

tutively ambivalent, with ambivalent political effects: enacting the gendered dynamic of sentimental subjection, texts such as Stowe's produce forms of feminine political 'agency' that are inextricable from submission and dependency" (162). Finally, according to Merish, Wexler neglects to "theorize the production of (white, middle-class, feminine) sentiment on which this [race and class] colonization depends." The problem is that Wexler and others who posit sensibility as a positive expression of feminine counterculture fail to recognize that feminine subjectivity is constituted in scenes of subordination. By failing to theorize when and how this subordination is constituted, such scholars recreate subjection and identification as emotional norms that exist "anterior to the disciplinary, identificatory structure enacted by sentimental texts" (23).

119 Wexler, "Tender Violence," 18.

120 Ibid., 21. According to Wexler, Hampton Institute "benefited the black community in a number of ways and was very successful in equipping and certifying large numbers of Southern blacks to educate their own race . . . The outcome was dramatically different for the Indian graduates, because the Bureau of Indian Affairs and the reservations to which they eventually returned made much more erratic provision for schools even than the rural South, and jobs on the reservation for trained teachers were brief and few."

121 On the issue of black female autobiography, see Adeleke, "Black Biography in the Service of a Revolution"; Alexander, "Let It Lie upon the Table"; Braxton, *Black Women Writing Autobiography*; Painter, "Sojourner Truth in Life and Memory." Also of great help on writing the autobiography of the "eccentric" woman who is also a public figure are Heilbrun, *Writing a Woman's Life*, and Israel, "Writing Inside the Kaleidoscope."

122 Doriani, "Black Womanhood in Nineteenth-Century America," 203.

123 Olney, "'I Was Born,'" 158.

124 Doriani, "Black Womanhood in Nineteenth-Century America," 207.

125 Artistic interpretations of Longfellow were quite common in nineteenth-century American art. See Nickerson, "Artistic Interpretations of Henry Wadsworth Longfellow's *The Song of Hiawatha*, 1855–1900." I believe that Lewis inquired about Pocahontas not to sculpt her but to ingratiate herself with Child, on whom Lewis partially depended for monetary support. See Lydia Maria Child to Harriet (Winslow) Sewall, July 10, 1868, Massachusetts Historical Society, Robie-Sewall Papers.

126 Doriani, "Black Womanhood in Nineteenth-Century America," 208.

127 Ibid., 200.

128 Davis and Gates, introduction to *The Slave's Narrative*, xxvi.

129 Kleeblatt, "Master Narratives/Minority Artists."

3 LONGFELLOW, LEWIS, AND *HIAWATHA*

1 Fisher, *Hard Facts*, 3.
2 Samuels, introduction, *The Culture of Sentiment*, 4.
3 Fisher, *Hard Facts*, 4.
4 Gartner, "Becoming Longfellow," 59.
5 See Gartner, "Becoming Longfellow," and Jackson, "Longfellow's Tradition."
6 Gartner, "Becoming Longfellow," 68.
7 Ibid., 70.
8 Ibid., 80; 65. For perceptions of white male American manhood during the age of Jackson, see Rogin, *Fathers and Children*; Smith-Rosenberg, *Disorderly Conduct*, 77–164; Saxton, *The Rise and Fall of the White Republic*, 23–161; and Burstein, *The Passions of Andrew Jackson*.
9 Haralson, "Mars in Petticoats," 335–36, quoting Longfellow, "Defence of Poetry," *North American Review* 34 (1832): 69; 62.
10 Wexler, "Tender Violence," 16. For additional reading on sentimental manhood, see the essays in Chapman and Hendler, *Sentimental Men*.
11 Gartner, "Becoming Longfellow," 62.
12 Liz Melching [Colclazier], "The Story behind Evangeline," 1994, available at http://www.louisiana101.com/hotlinks_wayback_evangeline.html (visited June 25, 2009); see also Faragher, *A Great and Noble Scheme*, esp. 443–80.
13 Fisher, *Hard Facts*, 26–27; 30.
14 Haralson, "Mars in Petticoats," 351 (his emphasis).
15 Lockard, "The Universal Hiawatha."
16 Derbyshire, "Longfellow and the Fate of Modern Poetry."
17 Maxwell, *Colonial Photography and Exhibitions*, 105.
18 Calhoun, "The Multicultural Longfellow," See also Derbyshire, "Longfellow and the Fate of Modern Poetry."
19 Nickerson, "Artistic Interpretations of Henry Wadsworth Longfellow's *The Song of Hiawatha*," 49.
20 Lockard, "The Universal Hiawatha."
21 Derbyshire, "Longfellow and the Fate of Modern Poetry"; see also Calhoun, "The Multicultural Longfellow," who writes, "To the extent that nineteenth-century poetry survives only in the classroom, Longfellow has dropped off the charts. He has never recovered from the battering he received at the hands of the Modernists, and he rarely caught the attention of the new, politically engaged scholarly communities of the 1980s and '90s (when he did, it was usually as a reminder of the complacencies, moral and aesthetic, of the successful white male Eurocentric poet-craftsman). Not that he ever really disappeared. He still had the respect of some practicing poets . . . and his words were ineradicably lodged in the minds of every American of a certain

age who had to memorize 'The Wreck of the Hesperus' or 'The Village Black-
smith' in school."

22 Jackson, "Longfellow's Tradition; or, Picture-Writing a Nation," 471–72.

23 Ibid., 472–73.

24 Fisher, *Hard Facts*, 21.

25 Jackson, "Longfellow's Tradition," 478 (her emphasis); Romero, "Vanishing
Americans," 115.

26 Nickerson, "Artistic Interpretations of Henry Wadsworth Longfellow's *The
Song of Hiawatha*," 49.

27 Nickerson, "Artistic Interpretations of Henry Wadsworth Longfellow's *The
Song of Hiawatha*," 75.

28 As Charles Calhoun bemoans, the Longfellow Institute was not established
to honor Longfellow's poetry; rather it is "devoted to the study and repub-
lication of historically, aesthetically, and culturally significant works written
in what is now the United States and published in languages other than Eng-
lish." Calhoun, "The Multicultural Longfellow."

29 See the checklist of the exhibition in Burgard, *Edmonia Lewis and Henry
Wadsworth Longfellow*, 10–12. The essay was also published in a slightly
altered and shortened form as part of a Henry Luce Foundation–sponsored
special edition of the *American Art Review*; see Burgard, "Edmonia Lewis
and Henry Wadsworth Longfellow, Images and Identities."

30 Burgard, *Edmonia Lewis and Henry Wadsworth Longfellow*, 8.

31 Ibid., 2. Burgard's wording is slightly but interestingly different in the ver-
sion of this essay published as part of the Luce Foundation's special issue of
the *American Art Review*. In his discussion of Lewis as on the periphery of
American culture relative to Longfellow's position at the center, he replaces
the phrase that deals with her culpability in her own marginalization — "her
biography and her work obscured by critical neglect, historical circumstance,
and her own selective recall" — with "her obfuscations" (114).

32 Burgard, *Edmonia Lewis and Henry Wadsworth Longfellow*, 2.

33 Ibid.

34 Ibid., 3, 4, 5, 6. His chronology is probably taken from Marilyn Richardson,
whom he thanks in his acknowledgments for sharing her expertise on Lewis
(8). Richardson, in her article that appeared in the same year as Burgard's,
states, "Lewis' early work, including that of her first years in Italy, was based
primarily, although not exclusively, on African American themes. Most
of the scenes from Longfellow's *Song of Hiawatha* came somewhat later."
Richardson, "Edmonia Lewis' *The Death of Cleopatra*," 48.

35 Burgard, *Edmonia Lewis and Henry Wadsworth Longfellow*, 6.

36 Ibid., 7.

37 Ibid. (my emphasis).

38 Merish, *Sentimental Materialism*, 103.

39 Gerdts, "The Marble Savage," 70. The notion of the marriage of Hiawatha and Minnehaha representing the metaphoric reunion of the North and South after the Civil War is repeated in Nickerson, "Artistic Interpretations," 62, and Kleeblatt, "Master Narratives/Minority Artists," 31–32.

40 Burgard, *Edmonia Lewis and Henry Wadsworth Longfellow*, 7 (my emphasis).

41 Holland, "Mary Edmonia Lewis's *Minnehaha*," 30. The essay is adapted from chapter 3, "Mary Edmonia Lewis and the Hierarchy of Gender and Race," of Holland's dissertation, "Co-Workers in the Kingdom of Culture."

42 Holland, "Mary Edmonia Lewis's *Minnehaha*," 27.

43 Ibid., 28.

44 Ibid., 29–30.

45 Ibid., 27 (my emphasis).

46 Ibid., 29; 28.

47 Ibid., 31; 34.

48 Ibid., 32.

49 Ibid.

50 Ibid., 33.

51 Collins, *Black Feminist Thought*, 70–71, quoting Carby, *Reconstructing Womanhood*, 25.

52 Holland, "Mary Edmonia Lewis's *Minnehaha*," 27.

53 Ibid., 33.

54 Ibid., 35, note 31. The one exception I have been able to find that does not engage this discussion of Hiawatha and Minnehaha as a metaphor for national unity after the Civil War is Hartigan, *Sharing Traditions*, 85–98.

55 I take the parameters of the Jacksonian era from Rogin, *Fathers and Children*, xvi.

56 Ibid., xxvi.

57 Saxton, *The Rise and Fall of the White Republic*, 24, 131–36.

58 Dippie, *The Vanishing American*, 121.

59 Reed, *W. E. B. Du Bois and American Political Thought*, 7, 8.

60 An invaluable resource for Native American imagery produced by white artists in the nineteenth century is Truettner, *The West as America*.

61 Kerber, "The Abolitionist Perception of the Indian," 275.

62 Mardock, *The Reformers and the American Indian*, 38. See also Prucha, *American Indian Policy in Crisis*, and Fritz, *The Movement for Indian Assimilation*.

63 Ibid., 25.

64 Ibid., 54.

65 Ibid., 55, 168.

66 Ibid., 72.

67 Ibid., 86.

68 Ibid., quoting *Kearney* (Nebraska) *Herald* in the *Marysville* (Kansas) *Enterprise*, July 14, 1866.

69 Ibid., 87.

70 Dippie, *The Vanishing American*, 134–35.

71 Nickerson, "Artistic Interpretations," 54 (my emphasis).

72 Lockard, "The Universal Hiawatha" (my emphasis).

73 Anne Whitney to Addy, August 9, 1864, Wellesley College Archives, Margaret Clapp Library, Anne Whitney Papers.

74 Jahoda, *Images of Savages*, 137.

75 Lydia Maria Child to Sarah Blake Sturgis Shaw, April 8, 1866, New York Public Library, Manuscript Division, Shaw Family Papers (her emphasis).

76 Jahoda, *Images of Savages*, 132 (his emphasis); 140.

77 Wreford, "A Negro Sculptress."

78 *How Edmonia Lewis Became an Artist*; "Art and Artists," September 29, 1876; Gay, "Edmonia Lewis, the Colored Sculptress."

79 Mardock, *The Reformers and the American Indian*, 115–28; Brown, *Bury My Heart at Wounded Knee*, 213–34.

80 Mardock, *The Reformers and the American Indian*, 117.

81 Child, "Edmonia Lewis," 25.

82 "Edmonia Lewis, the Famous Colored Sculptress in San Francisco."

83 As Deloria notes, female societies that "played Indian," such as the Camp Fire Girls, "sought to channel girls away from the labor market and into a symbolic domestic economy based on the work of the home." Essentially, they used these "back to nature" formations to reinforce a woman's place in the domestic sphere. Men, on the other hand, "played Indian" with a different intent — to dispossess the original inhabitants and define themselves as embodiments of the nation. Deloria, *Playing Indian*, 112, 38–70.

84 Twain, *Roughing It*, 98. See also Pritzker, *A Native American Encyclopedia*, 239–42.

85 Douglas, *Purity and Danger*, 35.

86 "San Jose Invaded."

87 Deloria, *Playing Indian*, 101.

88 Ibid., 3.

89 Ibid., 186.

90 Whittier, "The Indian Question," *Reform and Politics*, part 2, vol. 7, 149–50.

91 There are at least four extant versions of *Hiawatha's Wooing*: the earliest, engraved 1866, belongs to Walter O. Evans; two are in the collection of the Smithsonian American Art Museum; and one belongs to the Tuskegee Institute. See Hartigan, *Sharing Traditions*, 93, 119; and Buick, "A Way Out of No Way," 36–39.

92 I have been able to trace at least four versions of *Hiawatha's Marriage*: one is in Bill Cosby's collection; one is in the collection of Walter O. Evans; an-

other belongs to an anonymous benefactor of the Cincinnati Museum of Art where the sculpture is on long-term loan; and a final version was destroyed by fire in 1945 and was part of the collection of the Blake Memorial Library in East Corinth, Vermont. Mrs. Beverly Longo, Blake Memorial Library, East Corinth, Vermont, to William H. Gerdts, Newark Museum, Newark, New Jersey, February 17, 1966; donated by William H. Gerdts to the Smithsonian Institution and now contained in their vertical file on Edmonia Lewis.

93 "Hiawatha's Wooing!—A Fine Engraving." The ad lists the size of the plate as fourteen by eighteen inches and the price as $1.50. Tilton was also listed as living in Salem, Mass.

94 In 1835 Nathaniel Currier started the firm in New York City, and he was joined by James Merritt Ives, who started as a bookkeeper and later as an artist and art director for the firm. After 1857, all prints published by the firm carried their last names jointly. "Currier and Ives," *World Book Multimedia Encyclopedia* (Chicago: World Book Inc., 1999).

95 Nickerson, "Artistic Interpretations," 50.

96 The inscription on the base of *The Wooing of Hiawatha* in the Evans Collection raises several noteworthy issues. Lewis inscribed the base "Edmonia Lewis Roma.1866" on the rear, and on the front of the gray marble base "The Wooing of Hiawatha." When Sotheby's in New York auctioned the piece on March 17, 1994 (Lot #28), they specified that the subject matter did not match the original description of it as published in an article written by Laura Curtis Bullard in 1871 in *Revolution*, which describes *The Wooing of Hiawatha* as representing "Minnehaha seated, making a pair of Moccasins, and Hiawatha by her side with a world of love and longing in his eyes." People in the nineteenth century changed titles of works all the time and were quite free in their descriptions, regardless of accuracy. The sculpture in the Evans Collection is the sculpture that Charlotte Cushman persuaded the president of the Boston YMCA to buy, and it is Lewis's earliest known rendering of the subject. See also Parrott, "Networking in Italy," 330–31.

97 Merish, *Sentimental Materialism*, 19.

98 See Phillips, *Trading Identities*, 257.

99 Ibid., 14.

100 Ibid., 32.

101 Ibid., 7, referencing the research of Dean MacCannell, *The Tourist: A New Theory of the Leisure Class* (New York: Schocken Books, 1976), 41.

102 Phillips, *Trading Identities*, 43.

103 Longfellow, *The Song of Hiawatha*, 98, 100, 103.

104 Rothman, *Hands and Hearts*, 5.

105 Merish, *Sentimental Materialism*, 157.

106 Nabokov and Easton, *Native American Architecture*, 56–67.

107 Rothman, *Hands and Hearts*, 107.

108 Tuckerman, "Edmonia Lewis," *Book of the Artists*, 603–4.

109 Ibid., 604.

110 Sherwood, *Harriet Hosmer*, 258.

111 Tuckerman, "Edmonia Lewis," *Book of the Artists*, 603.

112 In the collection of the High Museum in Atlanta is a sculpture attributed to Lewis and initially identified as *Columbus*. It is a two-figure group comprising a standing male figure whose left hand holds a scroll and whose right hand holds cloth. Kneeling at his feet is a woman, nude from the waist up and left hand modestly covering her breasts, wearing feathers in her hair. In correspondence to the museum, Marilyn Richardson suggests that although the sculpture is unsigned and not mentioned in any of the literature on Lewis, it may indeed be her work but may represent Pocahontas, not Columbus. Marilyn Richardson, Watertown, Massachusetts, to Cynthia Paine, Curatorial Assistant, American Art, High Museum of Art, May 17, 1994, curatorial file, High Museum of Art, Atlanta, Georgia. I would like to thank the High for so generously making the file available to me. Stylistically, the sculpture is very reminiscent of Lewis's rendering of proportion and the early awkwardness with which she treated the limbs of her figures. If and until, however, we learn more about Lewis's career, I am not comfortable discussing where or how the piece belongs in Lewis's iconography.

113 Phillips, *Trading Identities*, 17, quoting from Pratt, *Imperial Eyes: Travel Writing and Transculturation* (New York: Routledge, 1992), 7.

114 Wexler, "Tender Violence," 15.

115 Fisher, *Hard Facts*, 93.

116 On the significance of marriage and children in Cooper's *Deerslayer* novels as "the drive to marry and prevent other marriages, to reproduce society, and to give names that continue through time that are the central drives," see Fisher, *Hard Facts*, 46, 44–51.

4 IDENTITY, TAUTOLOGY, AND *THE DEATH OF CLEOPATRA*

1 Baxandall, *Patterns of Intention*, 35.

2 Fields, "Slavery, Race, and Ideology in the United States of America," 12–13.

3 Baxandall, *Patterns of Intention*, 1.

4 Boime, *The Art of Exclusion*, 169.

5 Wilson, "Hagar's Daughters," 103.

6 Baxandall, *Patterns of Intention*, 5.

7 Reed, *W. E. B. Du Bois and American Political Thought*, 132 (my emphasis).

8 When analyzing Edmonia Lewis's *Forever Free*, Hugh Honour actually proposed that the female figure was a self-portrait or a "reminiscence of Lewis's mother." See Honour, *The Image of the Black in Western Art*, 250–51.

9 In 1878, William Clark made the distinction between Lewis's "naturalism" and William Wetmore Story's and Thomas Ridgeway Gould's "idealism" in

their representations of Cleopatra. See Clark, *Great American Sculptures*, 141.

10 Cowling, *The Artist as Anthropologist*, 4.

11 What can we say about Lewis's carte-de-visite? By comparing it to the cartes-de-visite of other people, we can identify options not taken by Lewis; for example, she easily could have posed as the "Indian Princess" replete with costume and studio props. Instead, she dresses modestly and not at all "boyishly" (as many written descriptions would have her). Ultimately, she does not use the photographer's studio as a space in which to "play" with identity in any obvious manner. As Shawn Michelle Smith writes, "Identity is not fixed in the body but in representation itself" and therefore "One might begin to think of the body as a product, not a producer of identity." Smith, *American Archives*, 104. See also Buick, "Edmonia Lewis, Photographed by Henry Rocher, c.1870," 34.

12 Wreford, "A Negro Sculptress," 302; Child, "Letter from L. Maria Child," and "Edmonia Lewis"; and Bullard, "Edmonia Lewis." William Wells Brown recycled his description of Lewis from Laura Curtis Bullard, although he and Lewis knew one another and had traveled in the same circles in Boston during Lewis's time there. William Wells Brown, *The Rising Son*, 465–68.

13 For the reference to the bust of Lewis by Charlotte Cholmley, see *Art-Journal* (London) 9 (1870): 77.

14 Barthes, "The Blazon," 113–14.

15 Brown, *The Rising Son*, 85–86. The continuity of such beliefs, that phenotype is related to behavior and character and that the darker the skin tone, the closer one is to the "savage African," can be viewed in the portraits from the 1920s and genre subjects from the 1930s and 1940s of Archibald J. Motley Jr., an African American painter. Generally, African American servants were represented as darker-skinned than their African American employers. See Mooney and Motley, *Archibald J. Motley Jr.*

16 For discussions of the instability of the feminine in the nineteenth century, see Kasson, *Marble Queens and Captives*; Hatt, "'The Body in Question'"; and Hoganson, "Garrisonian Abolitionists and the Rhetoric of Gender, 1850–1860."

17 Fisher, *Hard Facts*, 43.

18 For controlling images of Native American women, see Green, "The Pocahontas Perplex"; White, *Ar'n't I a Woman?* 31. See also Collins, "Mammies, Matriarchs, and Other Controlling Images."

19 Something that we will never know, given that crimes against African Americans were rarely prosecuted and the perpetrators of Lewis's savage beating were never apprehended, is whether Lewis was sexually assaulted as well. "The Oberlin Poisoning Case," February 25, 1862. For Lewis's attorney's account, see Langston, *From the Virginia Plantation to the National Capitol*, 171–80.

20 Boime, *Art of Exclusion*, xiii.

21 Ibid., xiv.

22 Ibid., 13.

23 Ibid., xv (my emphasis).

24 Murray, *Emancipation and the Freed in American Sculpture*.

25 Fisher, *Hard Facts*, 98–99.

26 Boime, "Henry Ossawa Tanner's Subversion of Genre." Boime does mention Tanner in *The Art of Exclusion* in comparison to the artist William Sidney Mount. Specifically, Boime contrasts Mount's musicians, whom he locates as firmly in the minstrel tradition, as opposed to Tanner's *Banjo Lesson*, which he describes as being "closer to actuality" because of its "unsentimental affection and tenderness between an African-American grandfather and his grandson." Boime, *Art of Exclusion*, 10–12.

27 Boime, "Henry Ossawa Tanner's Subversion of Genre," 415.

28 Ibid.

29 Ibid., 416 (my emphasis). Although Boime does not mention Du Bois's articulation of double consciousness specifically, he represents Du Bois and Booker T. Washington as a kind of Manichean choice that Tanner must make between the black radicalism of Du Bois and the accommodationist rhetoric of Washington in which the drive for social equality and political agitation was renounced by African Americans. Boime sets up this dichotomy of Du Bois and Washington to emphasize his belief that Tanner "sold out," and even though Washington (and Boime) argues for Tanner to continue his African American subjects, Boime ends the section titled "The Influence of Booker T. Washington" by discussing the importance of religion to Washington in order to maintain the fiction and strength of this "allegiance" (432–33). Therefore, the perceived allegiance to Washington over Du Bois would have made the explicit reference to double consciousness confusing to the reader as it would contradict Boime's argument—unless Boime was willing to declare that "double consciousness" was an overarching "fact" of African American existence rather than simply imply such a thing. For a nuanced analysis of how Booker T. Washington allowed Americans to reconcile the contradictions of Jim Crow with ideological democracy, see West, *The Education of Booker T. Washington*.

30 Du Bois, *The Souls of Black Folk*, 3.

31 Boime, "Henry Ossawa Tanner's Subversion of Genre," 416 (my emphasis).

32 Ibid., 415 (my emphasis).

33 Ibid., 423.

34 Douglas, *Purity and Danger*, 36.

35 Boime, "Henry Ossawa Tanner's Subversion of Genre," 423.

36 Mosby, *Henry Ossawa Tanner*, 120; 123.

37 E. Tietjens, quoted in Boime, "Henry Ossawa Tanner's Subversion of Genre,"

417–18. For Tanner's racialist treatment by authors of survey textbooks, see Pinder, "Black Representation and Western Survey Textbooks," 533–34.

38 Boime, "Henry Ossawa Tanner's Subversion of Genre," 418.

39 Ibid., 419. Boime also attributes Tanner's submersion into his own genre subjects — the crude interiors, the hearth, the household utensils — as "nostalgia for his own far-off childhood, misty recollections of the family hearth that included a great Dutch oven, an image perhaps sparked by the cozy log cabin he had recently rented in Highlands, North Carolina" (423).

40 An argument for Tanner's early religious subjects as Orientalist in style is a compelling one: works like *Annunciation* (1898) and *The Raising of Lazarus* pay particular attention to archaeological accuracy, employing the "stylistic transparency" that seeks to convince the viewer of the scenes' truthfulness. See Nochlin, "The Imaginary Orient." Regarding Tanner's late religious paintings, see John Davis's analysis of the merging of figure and ground in *The Landscape of Belief*, 208–10, 213. One could also reasonably argue for an Orientalist sensibility in Tanner's late works, a sensibility described by John MacKenzie in his book *Orientalism*: "Most art operates through opposites, laughter and tears, triumph and tragedy, the profane and the spiritual, violence and peace, the neurotic and the calm. It secures its elevating power through the exploration of such dualities, the fundamental realities of human existence. This is equally true of the Orientalist arts. No true art can ever be founded upon a perpetual parade of cultural superiority, an outpouring of imperialist (sexist/racist) bile, an earnest expectation of decline and destruction, though the work of late-twentieth-century scholars with particularly contemporary axes to grind attempts to project such single-minded negatives. Nor are the majority of consumers likely to purchase, look at or listen to that which they wholly denigrate, or seek to dominate and destroy. That notions of superiority and inferiority, racial feeling and pride can enter into the complex of sensations of those who imbibe such art cannot be denied, given the intellectual climate of the period, but the power of art comes from its capacity to disturb. Cultural cross-referencing, a sense of lost ideals, an appreciation of the beauty of a pre-industrial craftsmanship, a perception of a pure and vibrant landscape, an awareness of more unbuttoned approaches to life and colour, unfettered responses to the human personality, emotional, sexual, languorous, violent or ecstatic, can all coexist with value-laden and ethno-centric cultural and racial ideals"(213–14).

41 Boime, "Henry Ossawa Tanner's Subversion of Genre," 436.

42 Ibid., 433.

43 Ibid., 426, 427.

44 Ibid., 427.

45 Ibid., 438.

46 Boime does reprint the exchange that Tanner had with one critic about his

work and his race. In 1914 Eunice Tietjens sent Tanner the text of a review article she had written about him, prior to submitting it to either *International Studio* or the *Little Review*, an art journal that she helped to found. In the article she compares Tanner's work to that of other artists in the Paris colony, among them Richard Miller, Frederick Frieseke, Elizabeth Nourse, and Mary Cassatt. Despite their differences in style, Tanner's colleagues were all Anglo-Saxons while Tanner possessed, according to Tietjens, strong psychological differences from them because of his race. "Their work," she wrote, "has the clean, athletic objectivity of their race. But H.O. Tanner is not an Anglo-Saxon. His work is in its essence oriental, it is subjective, almost mystical. If he painted in words instead of colors he would be counted akin to the recent return to mysticism, to the Celtic revival, or more nearly still to the later work of Rabindra Nath Tagore. It is this quality which distinguishes him so sharply from his fellow workers in Paris." Although Boime characterized it as "explosive and conflicted," I believe that Tanner's response was both subtle and incisive as he questioned the simplistic racialism of the United States: "You say 'in his personal life, Mr. T. has had many things to contend with. Ill-health, poverty, race prejudice, always strong against a Negro.' Now am I a Negro? Does not the ¾ of English blood in my veins, which when it flowed in 'pure' Anglo-Saxon veins and which has done in the past effective and distinguished work in the U.S.—does this not count for anything? Does the ¼ or ⅛ of 'pure' Negro blood, in my veins count for all? I believe it, the Negro blood, counts and counts to my advantage—though it has caused me at times a life of great humiliation and sorrow—unlimited 'kicks' and 'cuffs'—but that it is the source of all my talents (if I have any) I do not believe, any more than I believe it all comes from my English ancestors. I suppose according to the distorted way things are seen in the states my blond curly-headed little boy would also be 'Negro.'—True, this condition has driven me out of this country, but still the best friends I have are 'white' Americans and while I cannot sing our National Hymne, 'Land of Liberty,' etc., etc., still deep down in my heart I love it and am sometimes sad that I cannot live where my heart is." Tietjens, "H. O. Tanner," and Tanner to Tietjens; quoted in Boime, "Henry Ossawa Tanner's Subversion of Genre," 417–18.

47 Henry Ossawa Tanner, "The Story of an Artist's Life, II: Recognition," *World's Work* 8 (July 1909): 117–74; and "Tanner Exhibits Paintings," *New York Times*, January 29, 1924; both quoted in Boime, "Henry Ossawa Tanner's Subversion of Genre," 439.

48 Davis, *The Landscape of Belief*, 209.

49 Boime, "Henry Ossawa Tanner's Subversion of Genre," 434.

50 Ibid., 439.

51 On Tanner's early religious paintings, see Harper, "The Early Religious Paint-

ings of Henry Ossawa Tanner." Boime does mention this article in a footnote but still does not distinguish between Tanner's early religious works as opposed to late; see "Henry Ossawa Tanner's Subversion of Genre," 433, note 64.

52 Boime, "Henry Ossawa Tanner's Subversion of Genre," 434 (my emphasis).

53 Boime, *The Art of Exclusion*: "praises": 154, 156; "chastises": 176, 183, 184, 197; "Victorian": 155, 198.

54 Boime's privilege as the white knowing subject (like Lubin's) is the inverse of black privilege when speaking about Lewis. White privilege is based on a faux deference while black privilege seems to stem from a sense of ownership of the subject based on racial (and gendered) alignments. See my discussion of Judith Wilson further along in this chapter.

55 About Murray's book Boime writes, "The text is indispensable to an understanding of how black people (keeping in mind that Murray belonged to the educated class) personally experienced the pictorial matter described in the previous chapters. I have quoted him extensively, not only because his authorial voice deserves a 'hearing,' but because he probingly dissects the central theoretical issues involved in the politics of visual experience—the relationship of part to whole, the opposition between appearance and reality, the dialectic of content and form, and the interaction between subject and object" (*The Art of Exclusion*, 153).

56 Ibid., 156–57, quoting Murray, *Emancipation and the Freed in American Sculpture*, 3.

57 Ibid., 163.

58 Ibid., 166, quoting Brown, *The Negro in the American Rebellion*, 118.

59 Ibid., 167, quoting Murray, *Emancipation and the Freed in American Sculpture*, 21–22.

60 For information on Meta Warrick Fuller, see Farrington, *Creating Their Own Image*, 65–71; Benjamin, "May Howard Jackson and Meta Warrick Fuller," 18–21; and Murray, *Emancipation and the Freed in American Sculpture*, 55–66.

61 Murray, *Emancipation and the Freed in American Sculpture*, 225.

62 Boime, *The Art of Exclusion*, 168.

63 Ibid., 168–69.

64 Ibid., 169.

65 Ibid. (my emphasis).

66 Ibid., 101.

67 Schechner, *The Future of Ritual*, 1.

68 Boime, *Art of Exclusion*, 169 (my emphasis).

69 Ibid.

70 I have used "pathology" and "pathological" very deliberately in summarizing Boime's perception of Edmonia Lewis as embodied in her art. Because he

structures her absolute difference as sickness, I am borrowing the significa-
tion of "pathology" from Sander Gilman, who notes, "The old 'platonic'
idea of disease as a corporeal invasion of the self, a 'thing' lying outside the
self that enters to corrupt it, has not been shaken off by modern medicine.
Models of illness are commonly treated as realities. While this manner of
'seeing' pathology has not gone unchallenged by empirical views of disease,
its persistence into the latter twentieth century is evidence of how deep is
the human disposition to structure perception in terms of binary difference.
We have the 'healthy' and the 'pathological' self... The concept of difference
is needed to distinguish the healer from the patient as well as the 'healthy'
and the 'sick.' Order and control are the antithesis of 'pathology.' 'Pathology'
is disorder and the loss of control, the giving over of the self to the forces
that lie beyond the self. It is because these forces actually lie within and are
projected outside the self that the different is so readily defined as the patho-
logical. Such definitions are an efficient way of displacing the consciousness
that the self, as a biological entity subject to the inexorable rules of aging and
decay, ultimately cannot be controlled." Gilman, *Difference and Pathology*,
24.

71 Boime, *The Art of Exclusion*, 169 (my emphasis).
72 Ibid., 169–70.
73 Ibid., 170–71.
74 I have addressed the issue of scholarship that treats Lewis as exotic in "Ed-
monia Lewis in Art History."
75 The opening of "Bearing Witness: Contemporary Works by African Ameri-
can Women Artists" took place at Spelman College's Museum of Fine Art
on October 25, 1996, in Atlanta, Georgia.
76 Wilson, "Hagar's Daughters," 95; citing Michele Wallace, "Modernism, Post-
modernism and the Problem of the Visual in Afro-American Culture," in
Out There: Marginalization and Contemporary Cultures, ed. Russell Fergu-
son, Martha Gever, Trinh T. Minh-ha, and Cornel West (New York: New
Museum of Contemporary Art; Cambridge, Mass.: MIT Press, 1990), 46.
77 Wilson, "Hagar's Daughters," 95.
78 Ibid., 95–96.
79 Reed, *W. E. B. Du Bois and American Political Thought*, 131.
80 Ibid.
81 Ibid., 133.
82 Wilson, "Hagar's Daughters," 96. Wilson's assumption about the nature of
white women's economic marginalization fails to take into account white
women's contestation of that marginalization. The historian George Robb
contributes an important chapter in this area. As he notes, it is unlikely that
the "she-merchants" of Georgian England and colonial America would have
disappeared totally with the shift to a market economy by the nineteenth cen-

tury. The new economy was dominated by joint-stock companies financed by the investments of thousands of men as well as women. Facilitating women's participation in the market, in 1848 New York became the first state to give married women rights to their own property. Women also founded banks and investment houses for other women. I am deeply grateful to Robb for allowing me access to his research. George Robb, "The Economics of Victimization: Women, Fraud, and the Stock Market in England and America, 1850–1930" (unpublished article cited with permission of the author, 2005).

83 In the note to Wilson's construction of white women as passive (exempt from materially reproductive roles) and black women as active (in economic matters) and how crucial this binary is to the careers of black women in the visual arts, Wilson discusses my work on Lewis. Wilson observes that the racial difference in the articulation of nineteenth-century codes of gender difference is something that I had failed to grasp in my "oddly ahistoric" study of Edmonia Lewis's figures of women of color. She also assigns to me a claim that I did not make, that "the Victorian cult of 'true womanhood' extended undifferentially to black women and therefore determined Lewis's representations of gender." Wilson, "Hagar's Daughters," 96, 108 n. 14; for her references to Boime, see 106, 111 n. 65–66. The point that I made and that I still believe was that *ideologically* the cult of true womanhood did affect African Americans and that Lewis registers that effect in her work on slavery. Wilson's dichotomization of culture—separating out what affected whites versus blacks—is highly problematic given the colonizing nature of sentimentalism and its deliberate deployment against people of color. Wilson further notes that as a result of my extension of the cult of true womanhood, I had failed "to take into account both the contested nature of dominant nineteenth-century gender ideals and the pivotal role of black women as symbols of the intersection of ethnic and sexual exploitation, as well as role models for white female political activists." Ironically, she recommends two works that I had included in the notes to my essay that would supposedly offer the reader a more complex and nuanced reading of black women's awareness and responses to their exclusion from the ideology of true womanhood (Hazel Carby's *Reconstructing Womanhood*) and a more complex and nuanced reading of the black woman's symbolic function in the discourses of feminist abolitionism (Karen Sanchez-Eppler's "Bodily Bonds"). I believe that her underlying issue with my essay was my unwillingness to assign to Lewis a subversive (in the twentieth-century sense of "subversive") engagement with true womanhood, which led to a distorted and distorting reading of my work. Furthermore, Wilson's characterization of black women as role models for white women is highly simplistic and lacking in the very complexity revealed in Sanchez-Eppler's work. See Buick, "The Ideal Works of Edmonia Lewis: Invoking and Inverting Autobiography," *American Art* (Summer 1995): 4–19. See also Sánchez-Eppler, "Bodily Bonds."

84 Wilson, "Hagar's Daughters," 96; 101.

85 Ibid., 96 (her emphasis).

86 Ibid., 97.

87 Ibid., discussing Maria W. Stewart, *Religion and Pure Principles of Morality, the Sure Foundation on Which We Must Build,* excerpted in Bert James Loewenberg and Ruth Bogin, eds., *Black Women in Nineteenth Century American Life* (University Park: Pennsylvania State University Press, 1976), p. 187.

88 Ibid., 97 (her emphasis).

89 Ibid., 98.

90 The African American feminist and abolitionist Frances Ellen Watkins Harper supported Douglass on the issue of partial enfranchisement. According to the *History of Woman Suffrage,* "If the nation could handle only one question she would not have the black woman put a single straw in the way." Harper quoted in Giddings, *When and Where I Enter,* 68. See also Caraway, *Segregated Sisterhood,* especially chap. 5, "'Now I Am Here': Black Women and the First Wave of Feminism," 117–67.

91 Giddings, *When and Where I Enter,* 66 (my emphasis); as Giddings notes, "The support of the Fifteenth Amendment by Black women did not mean that they had less interest in their suffrage, economic independence, education, or any other issue that pertained to them. And their support certainly didn't mean a collective willingness to be oppressed by men, Black or White. But Harper and others understood that the rights of Black men had to be secured before Black women could assert theirs. If the race had no rights, the women's struggle was meaningless. But after the Fifteenth Amendment was assured, Black women continued their own struggle throughout the 1870s with renewed vigor" (68).

92 Wilson, "Hagar's Daughters," 101.

93 Ibid., 103–4.

94 Ibid., 103.

95 Certainly, one could argue that, as the author, Wilson had little or no say in how her essay was laid out on the page, but between the juxtaposition of Lewis's photograph and the description of Sojourner Truth's photograph, and the pairing of Lewis's and Story's sculptures of Cleopatra, one could also speculate on a certain deliberation, if not collusion, between the author's polemic and the designer's comprehension of that polemic.

96 Wilson, "Hagar's Daughters," 105.

97 Ibid., 106.

98 Baxandall continues, "By alluding to the notion of 'making strange,' of course, I do not mean to claim a poetic function for this activity, but it is, in a sense, a romantic thing to do: as Novalis put it, the business of romanticism is to make the familiar strange and the strange familiar, and this seems a fair

critical programme. Also, a failure to do this is a main cause of plain histori-
cal error." Baxandall, *Patterns of Intention*, 115.

99 Wilson, "Hagar's Daughters," 106.

100 Ibid., 106–7.

101 Ibid., 107.

102 Ibid.

103 Morton, *Disfigured Images*, 72–83.

104 Ibid., 71.

105 Fredrickson, *The Black Image in the White Mind*, 101–2.

106 Morton, *Disfigured Images*, 70.

107 Ibid., 74.

108 I feel able to make such claims about Boime's scholarship and his use of sexual
 racialism after reading closely and comparing his work on Rosa Bonheur to
 his work on Edmonia Lewis. Boime concludes that Bonheur's purpose in
 cross-dressing and identification with "the masculine point of view" was to
 achieve perfect androgyny, an asexual angel rather than bisexuality, and was
 expressive of her desire to be a mother. See Boime, "The Case of Rosa Bon-
 heur."

109 Reed, *W. E. B. Du Bois and American Political Thought*, 165.

110 I would like to thank Professor Carol J. Ockman of Williams College for
 bringing the following sources to my attention: Bronfen and Goodwin,
 Death and Representation; Dijkstra, *Idols of Perversity*; and Scarry, *The Body
 in Pain*.

111 Hamer, *Signs of Cleopatra*, xvi.

112 Nineteenth-century women also "looked" at Cleopatra through the text of
 the novel. In at least two instances, the figure of Cleopatra was made to per-
 form as a work of art whose primary role was to be looked at by women: in
 Charlotte Brontë's *Villette* (1853) and Nathaniel Hawthorne's *The Marble
 Faun* (1859). Cleopatra as a work of art appears in the middle of each book;
 Cleopatra's complexion is featured in both, and in both Cleopatra is "black."
 Brontë's Cleopatra is a fictional painting, while Hawthorne's is what the au-
 thor termed in his preface a "robbery" of William Wetmore Story's *Cleo-
 patra*.

113 See "Cleopatra [review of Von Adolf Stahr, *Cleopatra* (Berlin: 1864)]." Other
 nineteenth-century biographies are included in the extensive bibliography in
 Hughes-Hallett, *Cleopatra*. On the origin and the evolution of the concept
 of "race," see Williams, *Keywords*, 248–50.

114 Foss, *The Search for Cleopatra*, 47–48.

115 Nineteenth-century historians also questioned whether Cleopatra was black
 African. A popular form that written and oral history took in the nineteenth
 century was that of the biographical sketch. Typically, the lives of represen-
 tative, outstanding, or infamous individuals were narrated in an abbreviated

format and compiled to illustrate some larger theme. William Wells Brown had included Edmonia Lewis in one such collection on African Americans. Both Anna Jameson, an English historian, and John Lord, an American historian and professional lecturer mainly on the college and university circuit, included sketches of Cleopatra in their works: Jameson's *Memoirs of Celebrated Female Sovereigns* (1831) in two volumes; and Lord's *Great Women* (1886) for his series Beacon Lights of History, described by the publisher as "a series of lectures setting forth the great epochs and master minds of civilization, — a biographical history of the world's life."

116 Wallis, "Black Bodies, White Science."

117 Nott quoted in Young, *Colonial Desire*, 127; 129.

118 Ibid., 129.

119 For the state of Egyptology in Europe and the United States during the nineteenth century, see Bernal, *Black Athena*, 252–69; Fredrickson, *The Black Image in the White Mind*, 13, 74–76; Gossett, *Race*, 54–83; Gould, *The Mismeasure of Man*, 61–64; and Young, *Colonial Desire*, 118–41. It should be noted that Bernal's work is extremely controversial.

120 Books such as Priest, *The Bible Defence of Slavery*, were endemic in the nineteenth century.

121 Lord, "Cleopatra," 23; 25–26. Lucy Hughes-Hallett gave an incorrect citation for John Lord in her bibliography (*Cleopatra*, 326); she lists him as "John Lloyd." I was alerted to his writing on Cleopatra quite unexpectedly after browsing through the journal of Charlotte Forten Grimké. Grimké, an African American woman who was a reformer, teacher, and writer, recorded the following in her journal: "*Friday, July 6, 1888.* Dr. Lord's 'Great Women' opens with 'Cleopatra,' a very interesting sketch. He has taken great pains to inform us that she had no *Negro* blood and that Story has made a mistake in giving his statue the African features. If I may venture to criticise, — there seems to me a little too much repetition in these lectures of Dr. Lord's." *The Journals of Charlotte Forten Grimké*, 534.

122 Stowe, "Sojourner Truth." See also Painter, "Sojourner Truth in Life and Memory"; the essay became a chapter in Painter's influential biography of Truth, *Sojourner Truth*.

123 Carol Ockman, "Dying Nightly: Sarah Bernhardt Plays the Orient" (1990). I would like to thank Ockman for allowing me access to this unpublished essay. See also Ockman, "When Is a Jewish Star Just a Star?"; Gilman, "Salome, Syphilis, Sarah Bernhardt, and the Modern Jewess."

124 "Cleopatra's Complexion."

125 Lail Gay, "Edmonia Lewis, the Colored Sculptress [at the Philadelphia Centennial of 1876]," vertical files at Moorland-Spingarn Research Center, Howard University, Washington, D.C.

126 "Seeking Equality Abroad."

127 *International Exhibition: 1876 Official Catalogue* 7th and rev. ed., 52; 58–59.

128 For this abbreviated history of Cleopatra, I used four sources: Hughes-Hallett, *Cleopatra*, 15–23; Plutarch, *Lives IX*; Cassius, *Roman History*, vols. 4, 5, 6; Shakespeare, *Antony and Cleopatra*.

129 I would like to thank George Gurney, chief curator for the Smithsonian American Art Museum, for allowing me access to notes he took regarding Lewis's *The Death of Cleopatra* during a telephone interview with Professor Stephen Crawford at the University of Delaware, March 22, 1995.

130 Richardson, "Edmonia Lewis's *The Death of Cleopatra*," 47. Lewis's connection to Canova is a valid one. After all, she did take over the revered artist's studio when she moved to Rome. See chapter 1 of the present work.

131 Roberts, *Hathor Rising*, 75.

132 At some point in the statue's history, a restorer modified the headdress, replacing a vulture with the cobra-tipped headdress of an Egyptian goddess. According to Lucy Hughes-Hallett, the Egyptian cobra was the emblem of the royal house of Egypt as well as the sacred beast of the goddess Wadjet. "It sat on the monarch's brow, hood inflated, ready to spit flame at his or her enemies." Wadjet was a goddess from the Lower Nile whose cult was assimilated into the cult of Isis. As the queen, she automatically would have been identified with Isis, and to legitimate and strengthen her power, Cleopatra merged her own iconography with that of the goddess. During ceremonies, she draped herself in the robes and headdress associated with the goddess. She even had coins struck upon the birth of her son that depicted Cleopatra as Isis and her son Caesarion as Isis's son, Horus. Hughes-Hallett, *Cleopatra*, 79–107.

133 Spence, *Ancient Egyptian Myths and Legends*, 143. The vulture was also the symbol of a more ancient and powerful mother goddess, Nekhebet. The iconography of Mut and Nekhebet were joined so that they were both invoked, increasing the status of the Egyptian queens who adopted their symbols. Roberts, *Hathor Rising*, 75–78.

134 I would like to thank Jeffrey A. Nigro of the Art Institute of Chicago for bringing this to my attention.

135 Said, *Orientalism*; Lewis, *Gendering Orientalism*, 35–37. Lewis discusses Charlotte Brontë's use of Cleopatra in *Villette* as an Orientalist type and to represent the negative aspects of feminine sexuality, a view (point) granted to the heroine by the "dynamics of imperialism."

136 Savage, *Standing Soldiers, Kneeling Slaves*, 8–9. See also Colbert, *A Measure of Perfection*.

137 For the history of Story's sculpture of Cleopatra, see Ramirez, "A Critical Reappraisal of the Career of William Wetmore Story (1819–1895)."

138 In her dissertation, Ramirez has done a phenomenal job of reconstructing the cultural context of Story's art. See "A Critical Reappraisal of the Career of William Wetmore Story," 450; 454–57.

139 Hawthorne, *The Marble Faun*, 127–28.

140 Story, "Cleopatra–A Poem," 87.

141 Jarves, *Art Thoughts*, 312. An early study of Egyptian motifs in American art is Gerdts, "Egyptian Motifs in Nineteenth-Century American Painting and Sculpture."

142 Savage, *Standing Soldiers, Kneeling Slaves*, 11.

143 Harriet Beecher Stowe quoted a description of Story's two sculptures thus: "A notice of the two statues from the London 'Athenaeum' must supply a description which I cannot give. 'The Cleopatra and the Sibyl are seated, partly draped, with the characteristic Egyptian gown, that gathers about the *torso* and falls freely around the limbs; the first is covered to the bosom, the second bare to the hips. Queenly Cleopatra rests back against her chair in meditative ease, leaning her cheek against one hand, whose elbow the rail of the seat sustains; the other is outstretched upon her knee, nipping its forefinger upon the thumb thoughtfully, as though some firm, wilful purpose filled her brain, as it seems to set those luxurious features to a smile as if the whole woman "would." Upon her head is the coif, bearing in front the mystic *uraeus*, or twining basilisk of sovereignty, while from its sides depend the wide Egyptian lappels, or wings, that fall upon her shoulders. The *Sibilla Libica* has crossed her knees, — an action universally held amongst the ancients as indicative of reticence or secrecy, and of power to bind. A secret-keeping looking dame she is, in the full-bloom proportions of ripe womanhood, wherein choosing to place his figure the sculptor has deftly gone between the disputed point whether these women were blooming and wise in youth, or deeply furrowed with age and burdened with the knowledge of centuries, as Virgil, Livy, and Gellius say. Good artistic example might be quoted on both sides. Her forward elbow is propped upon one knee; and to keep her secrets close, for this Libyan woman is the closest of all the Sibyls, she rests her shut mouth upon one closed palm, as if holding the African mystery deep in the brooding brain that looks out through mournful, warning eyes, seen under the wide shade of the strange horned (ammonite) crest, that bears the mystery of the Tetragrammaton upon its upturned front. Over her full bosom, mother of myriads as she was, hangs the same symbol. Her face has a Nubian cast, her hair wavy and plaited, as is meet.' We hope to see the day when copies both of the Cleopatra and the Libyan Sibyl shall adorn the Capitol at Washington." See Stowe, "Sojourner Truth, the Libyan Sibyl," 481.

144 Jarves concluded his review: "So intense is her feeling, she bends her right foot backwards, forcing a painful strain on the muscles of the instep, to obtain relief. There is a serpent-like elasticity and flexibility in the entire figure; but the outlines of the body and a portion of its anatomical physiognomy are not equal in grace and precision, and indeed voluptuous *abandon*, to the head, which is better modelled in every respect" (his emphasis). Jarves, "Progress of American Sculpture in Europe," 7. This was not the first time

that a disjuncture was noted between Cleopatra's physiognomy and her behavior; see "Cleopatra [review of Von Adolf Stahr, *Cleopatra* (Berlin: 1864)]," 335.

145 Bronfen and Goodwin, introduction, 20.

146 Clark, *Great American Sculptures*, 126.

147 Merish, *Sentimental Materialism*, 3.

148 Poe, in his essay "The Philosophy of Composition," quoted in Bronfen, *Over Her Dead Body*, 59.

149 Bronfen and Goodwin, introduction, 4.

150 Ibid., 14.

151 See Sander Gilman on the death/suicide of the prostitute in the nineteenth century: "'Who Kills Whores?' 'I Do,' Says Jack."

152 Ibid., 264–65.

153 On Antony's redemption, see Plutarch, *Lives*, 343. See also "Extracts from North's *Plutarch*," in *Antony and Cleopatra*, ed. M. R. Ridley, 273.

154 Goodwin and Bronfen, introduction to *Death and Representation*, 20.

155 Dijkstra, *Idols of Perversity*, 55–56.

156 "Centennial — Negro Mechanism — 'The Death of Cleopatra' — Negro Education."

157 On the fetish of sleep and its association to dead ladies, see Dijkstra, *Idols of Perversity*, 51–63.

158 Ibid., 25; 26; 35; 61.

159 Ibid., 42.

160 "Centennial — Negro Mechanism — 'The Death of Cleopatra' — Negro Education."

161 Gay, "Edmonia Lewis, the Colored Sculptress [at the Philadelphia Centennial of 1876]," vertical files at Moorland-Spingarn Research Center, Howard University.

162 Ingram, *The Centennial Exposition, Described and Illustrated*, 372.

163 Ingram's distinction between "the Classical" and "the Jewish" also may be a result of his knowledge of the physiognomic/behavioral stereotypes assigned to Jewish women in the nineteenth century. Scholarship that deals with controlling images of Jewish women in the nineteenth century tends to focus primarily on France. Carol Ockman, writing about Ingres's portrait of the Baronne de Rothschild, notes, "Jewish women were historically assimilated to Biblical heroines. Typically conceived as virtuous, maternal figures, they were considered to have a rare, spiritual beauty. Although representations of Jewish women, and of Old Testament scenes in general, declined due to the anti-Biblical position of Enlightenment philosophers, they had a renaissance of sorts with romanticism. In her new guise, the Biblical heroine symbolized not so much moral virtue as oriental beauty." The work done by scholars like Ockman is applicable, I believe, because of the concerted

interest of nineteenth-century writers like Harriet Beecher Stowe and Anna Jameson in heroines of the Bible. Ockman theorizes a conflated Orientalist model in which the spiritual beauty of the Jewish woman was wed to oriental sensuality. She adds, "The neat ideological separation between virtuous and unvirtuous women initially appears to differ from the conflated orientalist model operative in most nineteenth-century representations of Jewish women. But this separation is difficult to maintain when one category depends on the other for its very definition. The fact of the matter is that sexuality lies at the heart of definitions of women, be the terms dichotomous or fused. In the case of representations of Jewish women, sexual difference is specifically structured by colonialist discourse . . . Withheld or restrained in positive stereotypes, sexuality is unleashed in negative ones, but only so that it can be conquered." Ockman, "'Two Large Eyebrows à L'Orientale,'" 525; 533–34; see also Adler, "John Singer Sargent's Portraits of the Wertheimer Family"; Gilman, "Salome, Syphilis, Sarah Bernhardt, and the Modern Jewess"; Bergman-Carton, "Negotiating the Categories"; and Lathers, "Posing the 'Belle Juive.'"

164 Clark, *Great American Sculptures*, 141 (my emphasis).

165 For Tuckerman's discussion of Lewis's style, for the recommendation for future subject matter, and Lewis's implied authenticity and authority to represent Native Americans, see Tuckerman, *Book of the Artists*, 603–4.

166 Ibid.

167 The evolutionary model of progress in American art was reiterated by Loredo Taft and Wayne Craven, both of whom undertook the mammoth and admirable task of writing the history of American sculpture. Ultimately, they were dissatisfied with nineteenth-century neoclassicism. Taft, writing in 1903, felt that "it was alien and impersonal, expressing in no way the spirit of the people nor even the emotions of its authors. The lyric strain was almost unknown; our sculptors were executants, not composers." Craven, writing almost fifty years later concurred. "In their detachment from their native soil, this group's native roots often withered. Their imaginary subjects failed to reflect the major social and philosophical movements of America; theirs was in many ways an attempt to create a culture apart from these movements, and to keep it unspoiled by them." Taft, *The History of American Sculpture*, 8; Craven, *Sculpture in America*, 269.

168 Hamer, "Black *and* White? Viewing Cleopatra in 1862," 61–62.

169 Ingram, *The Centennial Exposition, Described and Illustrated*, 372; and Clark, *Great American Sculptures*, 126.

170 Hamer, *Signs of Cleopatra*, 10.

171 Ibid., 7.

172 Ibid., 9.

173 Richardson, "Edmonia Lewis's *The Death of Cleopatra*," 47.

174 Bronfen uses Freudian language to discuss the separation from self that occurs through sexuality or death. She also invokes the binary of male and female so that the female corpse is something both preserved and rejected by the male artist. As is the case with so many feminists who use Freud, she does not consider race. *Over Her Dead Body*, 138.

175 Ibid., 59.

176 Mitchell, *Colonising Egypt*, xiii.

177 Linda Nochlin, "The Imaginary Orient," 38–39; 47; 51; quoting Roland Barthes, "L'Effet de réel," in *Littérature et réalité*, 81–90.

178 Carol Christ, "Painting the Dead," 138–39.

179 Plutarch, *Lives*, 325.

CONCLUSION

1 See Spillers, "Interstices." Hortense Spillers's essay was written in direct response to Calvin Hernton's book *Sex and Racism in America* and its characterization of the black woman as a "creature[s] of sex, but *sexuality* touches her nowhere." Spillers writes, "My own interpretation of the historical narrative concerning the lives of black American women is in accord with Hernton's: Their enslavement relegated them to the marketplace of the flesh, an act of commodifying so thoroughgoing that the daughters labor even now under the outcome. Slavery did not transform the black female into an embodiment of carnality at all, as the myth of the black woman would tend to convince us, nor, alone, the primary receptacle of a highly profitable generative act. She became instead the principal point of passage between the human and the non-human world. Her issue became the focus of a cunning difference — visually, psychologically, ontologically — as the route by which the dominant male decided the distinction between humanity and 'other.' At this level of radical discontinuity in the 'great chain of being,' black is vestibular to culture. In other words, the black person mirrored for the society around her and him what a human being was *not*. Through this stage of the bestial, the act of copulating travels eons before culture incorporates it, before the concept of sexuality can reclaim and 'humanize' it. Neither the picture I am drawing here, nor its symbolic interpretation, is unheard of to our understanding of American and New World history. If, however, it is a stunning idea in its ritual repetition, nonetheless, then that is because the black female remains exotic, her history transformed into a pathology turned back on the subject in tenacious blindness" (76).

2 Groseclose, *Nineteenth-Century American Art*, 1. See also Berlo and Phillips, *Native North American Art*, and Patton, *African-American Art*.

3 Groseclose, *Nineteenth-Century American Art*, 2.

4 Morrison, *Playing in the Dark*, 47–48.

5 Bolton, *Facing the Other*, 9.

6 Ibid., 41.

7 Ibid., 45; quoting Emmanuel Levinas, *Of God Who Comes to Mind*, trans. Bettina Bergo (Stanford, Calif.: Stanford University Press, 1998), 99 (Levinas's emphasis).

8 Douglas Moore, *A Guide to Musical Styles: From Madrigal to Modern Music*, rev. ed. (New York: W. W. Norton, 1962), 326; 333.

NINETEENTH-CENTURY NEWSPAPERS, JOURNALS, AND PRINTED MATERIAL

"American Artist-Life: Mr. Tuckerman's Book of the Artists: Personal Sketches." *Evening Post (New York)*, November 26, 1867, 1–3.

Annual Catalogue of the Officers and Students of Oberlin College, for the College Year 1862–3. Oberlin, Ohio: V. A. Shankland and Co., Printers, 1862.

"Art and Artists." *Daily Evening Transcript (Boston)*, September 29, 1876, 1.

"Art and Artists." *Daily Evening Transcript (Boston)*, November 1, 1878, 2.

"An Artistic Presentation." *Newark (NJ) Daily Advertiser*, December 27, 1878, 3.

"The Artists Speak Again." *Daily Evening Transcript (Boston)*, June 5, 1883, 2.

"Biography of a Bozeman Barber." *Avant Courier (Bozeman, Montana)*, April 6, 1896, n.p.

Bullard, Laura Curtis. "Edmonia Lewis." *New National Era* 2, no. 17 (May 4, 1871): 1.

———. "Edmonia Lewis." *Revolution* 7, no. 16 (April 20, 1871): n.p.

"Bust of Col. Shaw." *Liberator*, December 9, 1864, 199.

"Centennial — Negro Mechanism — 'Death of Cleopatra' — Negro Education." *People's Advocate*, July 22, 1876, 3.

Child, Lydia Maria. "A Chat with the Editor of the Standard." *Liberator*, January 20, 1865, 12.

———. "Edmonia Lewis." *Broken Fetter* 4 (March 3, 1865): 25–26.

———. "Emancipation and Amalgamation." *National Anti-Slavery Standard*
23, no. 18 (September 13, 1862): n.p.

———. "Letter from L. Maria Child." *National Anti-Slavery Standard* 24, no.
42, February 27, 1864, n.p.

———. "Letter from L. Maria Child to the Editor [Theodore Tilton] of the
Independent." *Independent*, April 5, 1866, n.p.

"Cleopatra [review of Von Adolf Stahr, *Cleopatra* (Berlin: 1864)]." *Living Age* 84
(January–March 1865): 333–36.

"Cleopatra's Complexion." *Nation*, December 4, 1890, 441.

"A Colored Artist." *Lorain County News*, March 28, 1866, 3.

"A Colored Sculptor." *New York Tribune*, August 8, 1865, 1.

"The Colored Sculptress: Her Suit against the Thomases for the Price of a
Monument." *Missouri Republican*, January 24, 1879, 4.

"Concerning Women." *Woman's Journal* 10, no. 1 (January 4, 1879): n.p.

"Concerning Women." *Woman's Journal* 14 (March 10, 1883): 73.

"The Courts." *St. Louis Daily Globe-Democrat*, January 23, 1879, 1.

"The Courts." *St. Louis Daily Globe-Democrat*, January 24, 1879, 3.

"The Courts." *St. Louis Daily Globe-Democrat*, January 25, 1879, 3.

"Edmonia Lewis." *Freedmen's Record* 3, no. 1 (January 1867): 3.

"Edmonia Lewis." *Revolution*, August 26, 1869, 122.

"Edmonia Lewis, a Young Colored Woman." *Freedmen's Record* 1, no. 1 (January
1865): 16.

"Edmonia Lewis Is Gradually but Surely Attaining Fame." *Lorain County News*,
December 4, 1867, n.p.

"Edmonia Lewis . . . Is in Syracuse." *Daily Evening Transcript (Boston)*, August 8,
1879, 7.

"Edmonia Lewis, the Famous Colored Sculptress in San Francisco." *San
Francisco Chronicle*, August 26, 1873, 5.

"Edmonia Lewis, the Renowned Sculptress." *Oberlin Review*, November 8, 1876,
201.

"Edmonia Lewis, the Sculptor, Has Her Latest Work the 'Bride of Spring,' at the
Grand Bazaar . . ." *New York Times*, September 25, 1879, 6.

"Edmonia Lewis — a Reception for the Artist." *National Anti-Slavery Standard*
30, no. 29 (November 20, 1869).

"Freedmen's Monument to Abraham Lincoln." *Freedmen's Record* 3, no. 1
(January 1867): 2.

"From Foreign Files." *Daily Evening Transcript (Boston)*, February 3, 1873, 1.

Gay, Lail. "Edmonia Lewis, the Colored Sculptress [at the Philadelphia
Centennial of 1876]." Vertical Files at Howard University, Moorland-Spingarn
Research Center.

General Catalogue of Oberlin College, 1833–1908. Oberlin, Ohio: Oberlin College,
1909.

"Gleanings." *Evening Post (New York)*, August 31, 1870, section 1, 2.

"Hagar and Ishmael." *National Magazine* 9 (July 1856): 236–41.

"Hiawatha's Wooing! — A Fine Engraving." *Home Journal (New York)*, May 9, 1857, 7.

"Hon. John W. Forney." *New Era* 1, no. 7 (February 24, 1870): 2.

How Edmonia Lewis Became an Artist. Philadelphia: John Spence, Printer, 1876.

International Exhibition: 1876 Official Catalogue. United States Centennial Commission. 5th rev. ed. Philadelphia: John R. Nagle and Company, 1876.

International Exhibition: 1876 Official Catalogue. United States Centennial Commission. 7th rev. ed. Philadelphia: John R. Nagle and Company, 1876.

"Legal Lore." *St. Louis Post and Dispatch*, January 23, 1879, 7.

"Life at Oberlin." *Evening Post (New York)*, June 17, 1867, 3.

"The Marble Group." *Daily Evening Transcript (Boston)*, October 18, 1869, section 2, 2.

"Mary Lewis Had Another Audience with Esq. Bushnell . . ." *Lorain County News*, February 25, 1863, n.p.

"Medallion of John Brown." *Liberator*, January 29, 1864, 19.

"Miss Edmonia Lewis — Black! And a Woman!" *Revolution* 1, no. 22 (June 4, 1868): 343.

"Modern Rome." *National Magazine* 1 (July–December 1852): 297–307.

"Mr. Brackett, the Sculptor." *New York Mirror*, December 14, 1839.

"Mysterious Affair at Oberlin — Suspicion of Foul Play — Two Young Ladies Poisoned — the Suspect under Arrest." *Cleveland Plain Dealer*, February 11, 1862, 3.

"The Negro Exhibit; The Women's Committees in Washington Hard at Work." *Evening Star*, July 4, 1895, 10.

"The Negro in Art." *National Anti-Slavery Standard* 23, no. 38 (January 31, 1863): n.p.

"Noted Woman Sculptor: Works of Miss Edmonia Lewis Adorn Homes of British Nobility." *Detroit Informer*, April 17, 1909, n.p.

"Notes from Rome." *Art Journal* 2 (1876): 128.

"The Oberlin Poisoning Case." *Cleveland Plain Dealer*, February 25, 1862, 3.

"The Oberlin Poisoning Case Again." *Cleveland Plain Dealer*, March 3, 1862, 3.

"Personal [Edmonia Lewis Is Very Busy]." *New National Era and Citizen* 4, no. 2 (May 22, 1873): 2.

"Photographs [The Freedwoman and Her Child]." *Freedmen's Record* 2, no. 4 (April 1866): 69.

"Prejudice at Oberlin College!" *National Anti-Slavery Standard* 25, no. 5 (June 11, 1864): n.p.

"Presentation to the Rev. L. A. Grimes." *Daily Evening Transcript (Boston)*, October 19, 1869, section 4, 5.

"Private Life and Public Splendor of Old Rome." *National Magazine* 1 (July–December 1852): 199–211.

"Public Feeling in Italy on the Assassination of Mr. Lincoln." *Liberator*, June 16, 1865, 93.

"Reception to Miss Edmonia Lewis." *New York Times*, December 26, 1878, 5.

"Rev. Dr. [Nathan] Lord—Ham on the Brain." *National Anti-Slavery Standard* 23, no. 52 (May 9, 1863): n.p.

"San Jose Invaded: First Day of the Santa Clara Valley Fair and Races." *San Francisco Chronicle*, October 2, 1873, n.p.

"Sardou's 'Cleopatra.'" *Nation* 51 (November 20, 1890): 396–97.

"Seeking Equality Abroad; Why Miss Edmonia Lewis, the Colored Sculptor, Returns to Rome—Her Early Life and Struggles." *New York Times*, December 29, 1878, 5.

"The Studios of Rome." *Art-Journal (London)* 9 (1870): 77–78.

"A Suit by Edmonia Lewis." *New York Times*, January 26, 1879, 6.

"'Uncle Tom's Cabin' at Her Majesty's Theatre." *National Anti-Slavery Standard* 24, no. 7 (June 27, 1863): n.p.

Waterston, Anna Q. "Edmonia Lewis." *National Anti-Slavery Standard* 25, no. 33 (December 24, 1864): n.p.

Wreford, Henry. "Lady-Artists in Rome." *Art-Journal (London)* (1866): 177.

———. "A Negro Sculptress." *Athenæum*, no. 2001 (March 3, 1866): 302.

———. "Studios of Rome." *Art-Journal (London)* (1870): 141.

BOOKS AND ARTICLES

Adeleke, Tunde. "Black Biography in the Service of a Revolution: Martin R. Delaney in Afro-American Historiography." *Biography* 17, no. 3 (Summer 1994): 248–67.

Adler, Kathleen. "John Singer Sargent's Portraits of the Wertheimer Family." *The Jew in the Text: Modernity and the Construction of Identity*, edited by Linda Nochlin and Tamar Garb, 83–96. London: Thames and Hudson, 1995.

Alexander, Ziggi. "Let It Lie upon the Table: The Status of Black Women's Biography in the UK." *Gender and History* 2, no. 1 (Spring 1990): 22–33.

Allen, Theodore W. *The Invention of the White Race*. Vol. 1, *Racial Oppression and Social Control*. London: Verso Press, 1994.

———. *The Invention of the White Race*. Vol. 2, *The Origin of Racial Oppression in Anglo-America*. London: Verso Press, 1997.

Angeli, Diego. *Le cronache del Caffè Greco*. 2nd ed. Roma: Fratelli Palombi Editori, 1987.

Armstrong, Meg. "'The Effects of Blackness': Gender, Race, and the Sublime in Aesthetic Theories of Burke and Kant." *Journal of Aesthetics and Art Criticism* 54, no. 3 (1996): 213–36.

Barthes, Roland. "The Blazon." *S/Z: An Essay*, edited by Richard Miller, 113–14. New York: Hill and Wang, 1974.

Baxandall, Michael. *Patterns of Intention: On the Historical Explanation of Pictures*. New Haven, Conn.: Yale University Press, 1985.

Bearden, Romare, and Harry Henderson. *A History of African-American Artists from 1792 to the Present*. New York: Pantheon Books, 1993.

Benjamin, Tritobia Hayes. "May Howard Jackson and Meta Warrick Fuller: Philadelphia Trailblazers." *Three Generations of African American Women Sculptors: A Study in Paradox*, edited by Leslie King-Hammond and Tritobia Hayes Benjamin, 18–25. Philadelphia: Afro-American Historical and Cultural Museum, 1996.

Bergman-Carton, Janis. "Negotiating the Categories: Sarah Bernhardt and the Possibilities of Jewishness." *Art Journal* 55, no. 2 (Summer 1996): 55–64.

Berkhofer, Robert F. *The White Man's Indian: Images of the American Indian, from Columbus to the Present*. New York: Vintage Books, 1979.

Berlo, Janet Catherine, and Ruth B. Phillips. *Native North American Art*. Oxford History of Art. Oxford: Oxford University Press, 1998.

Bernal, Martin. *Black Athena: The Afroasiatic Roots of Classical Civilization*. Vol. 1, *The Fabrication of Ancient Greece, 1785–1985*. New Brunswick, N.J.: Rutgers University Press, 1987.

Blodgett, Geoffrey. "John Mercer Langston and the Case of Edmonia Lewis: Oberlin, 1862." *Journal of Negro History* 53, no. 3 (July 1968): 201–18.

Bogin, Ruth, and Jean Fagan Yellin. Introduction. *The Abolitionist Sisterhood: Women's Political Culture in Antebellum America*, edited by Jean Fagan Yellin and John C. Van Horne, 1–19. Ithaca, N.Y.: Cornell University Press, 1994.

Boime, Albert. *The Art of Exclusion: Representing Blacks in the Nineteenth Century*. Washington, D.C.: Smithsonian Institution Press, 1990.

———. *The Art of the Macchia and the Risorgimento: Representing Culture and Nationalism in Nineteenth-Century Italy*. Chicago: University of Chicago Press, 1993.

———. "The Case of Rosa Bonheur: Why Should a Woman Want to Be More Like a Man?" *Art History* 4, no. 4 (December 1981): 384–409.

———. "Henry Ossawa Tanner's Subversion of Genre." *Art Bulletin* 75, no. 3 (September 1993): 415–42.

———. *The Magisterial Gaze: Manifest Destiny and American Landscape Painting, c. 1830–1865*. Washington, D.C.: Smithsonian Institution Press, 1991.

Bolton, Linda. *Facing the Other: Ethical Disruption and the American Mind*. Baton Rouge: Louisiana State University Press, 2004.

Bossaglia, Rossana. "Gli oientalisti italiani (1830–1940)." *Gli orientalisti italiani: Cento anni di esotismo, 1830–1940*, edited by Rossana Bossaglia, 3–13. Turin: Marsilio, 1998.

Braxton, Joanne M. *Black Women Writing Autobiography: A Tradition within a Tradition*. Philadelphia: Temple University Press, 1989.

Bronfen, Elisabeth. *Over Her Dead Body: Death, Femininity, and the Aesthetic*. New York: Routledge, 1992.

Bronfen, Elisabeth, and Sarah W. Goodwin. Introduction. *Death and Representation*, edited by Elisabeth Bronfen and Sarah W. Goodwin, 3–25. Baltimore: Johns Hopkins University Press, 1993.

Brontë, Charlotte. *Villette*. 1853. Reprint, New York: Penguin Books, 1985.

Brown, Dee. *Bury My Heart at Wounded Knee: An Indian History of the American West*. 1970. Reprint, New York: Washington Square Press, 1981.

Brown, Elsa Barkley. "Negotiating and Transforming the Public Sphere: African American Political Life in the Transition from Slavery to Freedom." *Public Culture* 7, no. 1 (Fall 1994): 107–46.

———. "Polyrhythms and Improvisation: Lessons for Women's History." *History Workshop Journal* 31 (Spring 1991): 85–90.

———. "'What Has Happened Here': The Politics of Difference in Women's History and Feminist Politics." *Feminist Studies* 18, no. 2 (Summer 1992): 295–312.

Brown, William Wells. *The Black Man, His Antecedents, His Genius, and His Achievements*. New York: Thomas Hamilton, 1863.

———. *"Narrative of William W. Brown, a Fugitive Slave" (1848) and "My Southern Home" (1880)*. Translated by William L. Andrews. *From Fugitive Slave to Free Man: The Autobiographies of William Wells Brown*. New York: Penguin, 1993.

———. *The Negro in the American Rebellion*, new ed. 1867. Reprint, New York: Citadel Press, 1971.

———. *The Rising Son; or, The Antecedents and Advancement of the Colored Race*. Boston: Little, Brown and Co., 1874.

Buick, Kirsten P. "Edmonia Lewis in Art History: The Paradox of the Exotic Subject." *Three Generations of African American Women Sculptors: A Study in Paradox*, edited by Leslie King-Hammond and Tritobia Hayes Benjamin, 12–17. Philadelphia: Afro-American Historical and Cultural Museum, 1996.

———. "Edmonia Lewis, Photographed by Henry Rocher, c.1870." *Let Your Motto Be Resistance: African American Portraits*, edited by Deborah Willis, 34–35. Washington, D.C.: National Museum of African American History and Culture; National Portrait Gallery, 2007.

———. "The Ideal Works of Edmonia Lewis: Invoking and Inverting Autobiography." *Reading American Art*, edited by Marianne Doezema and Elizabeth Milroy, 190–207. New Haven, Conn.: Yale University Press, 1998.

———. "A Question of 'Likeness': Edmonia Lewis's *The Death of Cleopatra*." *Notes in the History of Art* 24, no. 4 (Summer 2005): 3–12.

———. "A Way Out of No Way: Nineteenth Century African American Artists." *The Walter O. Evans Collection of African American Art*, edited by Andrea D. Barnwell, 27–41. Seattle: University of Washington Press, 1999.

Burgard, Timothy Anglin. *Edmonia Lewis and Henry Wadsworth Longfellow: Images and Identities*. Cambridge, Mass.: Harvard University Art Museums Gallery Series, no. 14, 1995.

————. "Edmonia Lewis and Henry Wadsworth Longfellow, Images and Identities." *American Art Review* 7, no. 1 (February–March 1995): 114–17.

Burstein, Andrew. *The Passions of Andrew Jackson*. New York: Alfred A. Knopf, 2003.

Calhoun, Charles C. *Longfellow: A Rediscovered Life*. Boston: Beacon Press, 2004.

————. "The Multicultural Longfellow." *Chronicle of Higher Education* 50, no. 37 (May 21, 2004). Academic Search Elite database, accession no. 00095982.

Caraway, Nancie. *Segregated Sisterhood: Racism and the Politics of American Feminism*. Knoxville: University of Tennessee Press, 1991.

Carby, Hazel V. *Reconstructing Womanhood: The Emergence of the Afro-American Woman Novelist*. New York: Oxford University Press, 1987.

Cassius, Dio. *Roman History*. Translated by Earnest Cary. 1917. Vol. 4. Reprint, Cambridge, Mass.: Harvard University Press, 1987.

————. *Roman History*. Translated by Earnest Cary. 1917. Vol. 5. Reprint, Cambridge, Mass.: Harvard University Press, 1989.

————. *Roman History*. Translated by Earnest Cary. 1917. Vol. 6. Reprint, Cambridge, Mass.: Harvard University Press, 1994.

Chambers-Schiller, Lee. "'A Good Work among the People': The Political Culture of the Boston Antislavery Fair." *The Abolitionist Sisterhood: Women's Political Culture in Antebellum America*, edited by Jean Fagan Yellin and John C. Van Horne, 249–74. Ithaca, N.Y.: Cornell University Press, 1994.

Chapman, Mary, and Glenn Hendler, eds. *Sentimental Men: Masculinity and the Politics of Affect in American Culture*. Berkeley: University of California Press: 1999.

Chard, Chloe. "Nakedness and Tourism: Classical Sculpture and the Imaginative Geography of the Grand Tour." *Oxford Art Journal* 18, no. 1 (1995): 14–28.

Cherry, Deborah. *Painting Women: Victorian Women Artists*. New York: Routledge, 1993.

Child, Lydia Maria. *The Freedmen's Book*. Boston: Ticknor and Fields, 1865.

————. *Lydia Maria Child Selected Letters, 1817–1880*. Edited by Milton Meltzer and Patricia G. Holland. Amherst: University of Massachusetts Press, 1982.

Christ, Carol. "Painting the Dead: Portraiture and Necrophilia in Victorian Art and Poetry." *Death and Representation*, edited by Elisabeth Bronfen and Sarah W. Goodwin, 133–51. Baltimore: Johns Hopkins University Press, 1993.

Clark, William J. *Great American Sculptures*. Philadelphia: Gebbie and Barrie, Publishers, 1878.

Clifford, Deborah Pickman. *Crusader for Freedom: A Life of Lydia Maria Child*. Boston: Beacon Press, 1992.

Clinton, Catherine. "Reconstructing Freedwomen." *Divided Houses: Gender and the Civil War*, edited by Catherine Clinton and Nina Silber, 306–19. New York: Oxford University Press, 1992.

Colbert, Charles. *A Measure of Perfection: Phrenology and the Fine Arts in America*. Chapel Hill: University of North Carolina Press, 1998.

Collins, Patricia Hill. *Black Feminist Thought: Knowledge, Consciousness, and the Politics of Empowerment*. New York: Routledge, 1991.

Cowan, Frank. *Curious Facts in the History of Insects; Including Spiders and Scorpions*. Philadelphia: J. B. Lippincott and Co., 1865.

Cowling, Mary. *The Artist as Anthropologist: The Representation of Type and Character in Victorian Art*. Cambridge: Cambridge University Press, 1989.

Craven, Wayne. *Sculpture in America*. New York: Cornwall Books, 1984.

Crawford, John S. "The Classical Tradition in American Sculpture: Structure and Surface." *American Art Journal* 11, no. 3 (Summer 1979): 38–52.

Cullen, Jim. "'I's a Man Now': Gender and African American Men." *Divided Houses: Gender and the Civil War*, edited by Catherine Clinton and Silber Nina, 76–91. New York: Oxford University Press, 1992.

Davenport, John. *Aphrodisiacs and Anti-Aphrodisiacs: Three Essays on the Powers of Reproduction; with Some Account of the Judicial "Congress" as Practised in France during the Seventeenth-Century*. London: Privately printed, 1869.

Davis, Charles T., and Henry Louis Gates Jr. Introduction. *The Slave's Narrative*. Oxford: Oxford University Press, 1985.

Davis, John. *The Landscape of Belief: Encountering the Holy Land in Nineteenth-Century American Art and Culture*. Princeton, N.J.: Princeton University Press, 1996.

Deloria, Philip Joseph. *Playing Indian*. New Haven, Conn.: Yale University Press, 1998.

Derbyshire, John. "Longfellow and the Fate of Modern Poetry." *New Criterion* 19, no. 4 (December 2000). Academic Search Elite database, accession no. 4202014.

Dijkstra, Bram. *Idols of Perversity: Fantasies of Feminine Evil in Fin-de-Siecle Culture*. New York: Oxford University Press, 1986.

Dippie, Brian W. *The Vanishing American: White Attitudes and U.S. Indian Policy*. Middletown, Conn.: Wesleyan University Press, 1982.

Doriani, Beth Maclay. "Black Womanhood in Nineteenth-Century America: Subversion and Self-Construction in Two Women's Autobiographies." *American Quarterly* 43, no. 2 (June 1991): 199–222.

Douglas, Ann. *The Feminization of American Culture*. New York: Doubleday, 1977.

Douglas, Mary. *Purity and Danger: An Analysis of the Concepts of Pollution and Taboo*. 1966. Reprint, New York: Routledge, 1991.

Driskell, David C. *Hidden Heritage: Afro-American Art at the Bellevue Art Museum, 1800–1950*. Bellevue, Wash.: Art Museum Association of America, 1985.

———. *Two Centuries of Black American Art: The Los Angeles County Museum of Art*. New York: Alfred A. Knopf, 1976.

Du Bois, W. E. B. *The Souls of Black Folk*. New York: Bantam Books, 1989.

Dyer, Richard. "White." *Screen* 29, no. 4 (Autumn 1988): 44–64.

———. *White*. London: Routledge, 1997.

Ehrenreich, Barbara, and Janet McIntosh. "The New Creationism: Biology under Attack." *Nation* 264, no. 22 (June 9, 1997): 11–16.

Emerson, Ralph Waldo. *Domestic Life, Society and Solitude*. Boston: Houghton Mifflin Company, 1870.

———. *Representative Men (1850)*. New York: Marsilio Publishers, 1994.

———. *The Selected Writings of Ralph Waldo Emerson*. Edited by Brooks Atkinson. New York: Modern Library, 1992.

Eze, Emmanuel. "The Color of Reason: The Idea of 'Race' in Kant's Anthropology." *Anthropology and the German Enlightenment*, edited by Katherine Faull, 200–241. Lewisburg, Pa.: Bucknell University Press, 1995.

———. "Hume, Race, and Human Nature," *Journal of the History of Ideas*, Vol. 61, No. 4 (October 2000), pp. 691–98.

Fairchild, J. H. *Woman's Rights and Duties, A Lecture Delivered before the Students of Oberlin Collegiate Institute, June, 1849*. Oberlin, 1849.

Faithful, Emily. *Three Visits to America*. Edinburgh: David Douglas, 1884.

Faragher, John Mack. *A Great and Noble Scheme: The Tragic Story of the Expulsion of the French Acadians from Their American Homeland*. New York: W. W. Norton, 2005.

Farrington, Lisa E. *Creating Their Own Image: The History of African-American Women Artists*. Oxford: Oxford University Press, 2005.

Fields, Barbara J. "Ideology and Race in American History." *Region, Race, and Reconstruction: Essays in Honor of C. Vann Woodward*, edited by J. Morgan Kousser and James M. McPherson, 143–77. New York: Oxford University Press, 1982.

———. "Slavery, Race and Ideology in the United States of America." *New Left Review* 1, no. 181 (May–June 1990): 95–118.

Fine, Elsa H. *The Afro-American Artist: The Search for Identity*. New York: Holt, Rinehart and Winston, 1973.

Finnegan, Margaret. *Selling Suffrage: Consumer Culture and Votes for Women*. New York: Columbia University Press, 1999.

Fisher, Philip. *Hard Facts: Setting and Form in the American Novel*. New York: Oxford University Press, 1985.

Fletcher, Robert Samuel. *A History of Oberlin College: From Its Foundation through the Civil War*. 2 vols. Oberlin, Ohio: Oberlin College, 1943.

Foner, Eric. *Freedom's Lawmakers: A Directory of Black Officeholders during Reconstruction*. Rev. ed. Baton Rouge: Louisiana State University Press, 1996.

Fonvielle-Bontemps, Jacqueline. *Forever Free: Art by African American Women, 1862–1980*. Normal: Illinois State University, 1980.

Foss, Michael. *The Search for Cleopatra*. New York: Arcade Publishing, 1997.

Fredrickson, George M. *The Black Image in the White Mind: The Debate on Afro-*

American Character and Destiny, 1817–1914. Middletown, Conn.: Wesleyan University Press, 1987.

Fritz, Henry Eugene. *The Movement for Indian Assimilation, 1860–1890*. Philadelphia: University of Pennsylvania Press, 1963.

Fuss, Diana. *Essentially Speaking: Feminism, Nature and Difference*. New York: Routledge, 1989.

Garb, Tamar. "Berthe Morisot and the Feminizing of Impressionism." *Perspectives on Morisot*, edited by Teri J. Edelstein, 57–66. New York: Hudson Hills Press, 1990.

Garrison, William Lloyd. *Thoughts on African Colonization*. New York: Arno Press, 1968.

Gartner, Matthew. "Becoming Longfellow: Work, Manhood, and Poetry." *American Literature* 72, no. 1 (March 2000): 59–86.

Gebbia, Alessandro. *Città teatrale: Lo spettacolo a Roma nelle impressioni dei viaggiatori americani, 1760–1870*. Rome: Officina Edizioni, 1985.

Geertz, Clifford. "Art as a Cultural System." *Local Knowledge: Further Essays in Interpretive Anthropology*, 94–120. New York: Basic Books, 1983.

———. "Thick Description: Toward an Interpretive Theory of Culture." *The Interpretation of Culture*, 3–30. New York: Basic Books, 1973.

Gerdts, William H. *American Neo-Classical Sculpture: The Marble Resurrection*. New York: Viking Press, 1973.

———. "Celebrities of the Grand Tour: The American Sculptors in Florence and Rome." *The Lure of Italy: American Artists and the Italian Experience, 1760–1914*, edited by Theodore E. Stebbins, 66–93. Boston: Museum of Fine Arts, 1992.

———. "Egyptian Motifs in Nineteenth-Century American Painting and Sculpture." *Antiques* 90, no. 4 (October 1966): 495–501.

———. "The Marble Savage." *Art in America* 62, no. 4 (July/August 1974): 64–70.

Giddings, Paula. *When and Where I Enter: The Impact of Black Women on Race and Sex in America*. Toronto: Bantam Books, 1985.

Gillman, Susan. "The Mulatto, Tragic or Triumphant? The Nineteenth-Century American Race Melodrama." *The Culture of Sentiment: Race, Gender, and Sentimentality in Nineteenth-Century America*, edited by Shirley Samuels, 221–43. New York: Oxford University Press, 1992.

Gilman, Sander L. *Difference and Pathology: Stereotypes of Sexuality, Race, and Madness*. Ithaca, N.Y.: Cornell University Press, 1985.

———. "Salome, Syphilis, Sarah Bernhardt, and the Modern Jewess." *The Jew in the Text: Modernity and the Construction of Identity*, edited by Linda Nochlin and Tamar Garb, 97–120. London: Thames and Hudson, 1995.

———. "'Who Kills Whores?' 'I Do,' Says Jack: Race and Gender in Victorian London." *Death and Representation*, edited by Elisabeth Bronfen and Sarah W. Goodwin, 263–84. Baltimore: Johns Hopkins University Press, 1993.

Gossett, Thomas F. *Race: The History of an Idea in America*. Dallas: Southern Methodist University Press, 1963.

Gough, John Parker. *An Inaugural Essay on Cantharides*. Philadelphia: Way and Groff, 1800.

Gould, Stephen Jay. *The Mismeasure of Man*. New York: W. W. Norton, 1981.

Green, Rayna. "The Pocahontas Perplex: The Image of Indian Women in American Culture." *Unequal Sisters: A Multicultural Reader in U.S. Women's History*, edited by Ellen C. DuBois and Vicki L. Ruiz, 15–21. New York: Routledge, 1990.

Green, Vivien M. "Hiram Powers's *Greek Slave*: Emblem of Freedom." *American Art Journal* 14, no. 4 (Autumn 1982): 31–39.

Grimké, Charlotte Forten. *The Journals of Charlotte Forten Grimké*. Edited by Brenda Stevenson. New York: Oxford University Press, 1988.

Groseclose, Barbara S. *Nineteenth-Century American Art*. Oxford History of Art. Oxford: Oxford University Press, 2000.

Halttunen, Karen. *Confidence Men and Painted Women: A Study of Middle-Class Culture in America, 1830–1870*. New Haven, Conn.: Yale University Press, 1982.

Hamer, Mary. "Black and White? Viewing Cleopatra in 1862." *The Victorians and Race*, edited by Shearer West, 53–67. Hants, England: Scholar Press, 1996.

———. *Signs of Cleopatra: History, Politics, Representation*. London: Routledge, 1993.

Hanaford, Phebe Ann. *Daughters of America; or, Women of the Century*. Augusta, Me.: True and Company, 1882.

Haralson, Eric L. "Mars in Petticoats: Longfellow and Sentimental Manhood." *Nineteenth-Century Literature* 51, no. 3 (December 1996): 327–55.

Harley, Sharon. "Northern Black Female Workers: Jacksonian Era." *The Afro-American Woman: Struggles and Images*, edited by Sharon Harley and Rosalyn Terborg-Penn, 5–16. Baltimore, Md.: Black Classic Press, 1997.

Harper, Jennifer J. "The Early Religious Paintings of Henry Ossawa Tanner: A Study of the Influences of Church, Family, and Era." *American Art* 6, no. 4 (Fall 1992): 69–85.

Harris, Michael D. *Colored Pictures: Race and Visual Representation*. Chapel Hill: University of North Carolina Press, 2003.

Hartigan, Lynda R. *Sharing Traditions: Five Black Artists in Nineteenth-Century America*. Washington, D.C.: Smithsonian Institution Press, 1985.

Hatt, Michael. "'The Body in Question.' Review of *Marble Queens and Captives: Women in Nineteenth Century American Sculpture*, by Joy S. Kasson." *Art History* 14 (December 1991): 608–13.

Hawthorne, Nathaniel. *The Marble Faun; or, The Romance of Monte Beni*. New York: Dell, 1960.

Heilbrun, Carolyn G. *Writing a Woman's Life*. New York: Ballantine Books, 1988.

Hill, Patricia R. "Writing out the War: Harriet Beecher Stowe's Averted Gaze." *Divided Houses: Gender and the Civil War*, edited by Catherine Clinton and Nina Silber, 260–78. New York: Oxford University Press, 1992.

Hillard, George S. *Six Months in Italy*. 3rd ed. Vol. 2. Boston: Ticknor, Reed, and Fields, 1854.

Hoganson, Kristin. "Garrisonian Abolitionists and the Rhetoric of Gender, 1850–1860." *American Quarterly* 45, no. 4 (December 1993): 556–95.

Holland, Juanita M. "Co-Workers in the Kingdom of Culture: Edward Mitchell Bannister and the Boston Community of African-American Artists, 1848–1901." Ph.D. diss., Columbia University, 1995.

———. "Mary Edmonia Lewis's *Minnehaha*: Gender, Race, and the 'Indian Maid.'" *Bulletin of the Detroit Institute of Art* 69, no. 1–2 (1995): 26–35.

Honour, Hugh. *The Image of the Black in Western Art: Slaves and Liberators*. Vol. 4, part 1. Cambridge, Mass.: Harvard University Press, 1989.

———. *The Image of the Black in Western Art: Black Models and White Myths*. Vol. 4, part 2. Cambridge, Mass.: Harvard University Press, 1989.

Hopkins, James H. *European Letters to the Pittsburgh Post, 1869–70*. Pittsburgh, Pa., 1870.

Horton, James Oliver. *Free People of Color: Inside the African American Community*. Washington, D.C.: Smithsonian Institution Press, 1993.

———. "Freedom's Yoke: Gender Conventions among Antebellum Free Blacks." *Feminist Studies* 12, no. 1 (Spring 1986): 51–76.

Hosmer, Harriet Goodhue. *Harriet Hosmer: Letters and Memories*. Edited by Cornelia Carr. New York: Moffat, Yard and Company, 1912.

Hughes, Richard, and J. P. Dake. *A Cyclopedia of Drug Pathogenesy: Issued under the Auspices of the British Homeopathic Society and the American Institute of Homeopathy*. Vol. 2, *Cantharis-Iodum*. New York: Boericke and Tafel, 1888.

Hughes-Hallett, Lucy. *Cleopatra: Histories, Dreams, and Distortions*. New York: Harper and Row, 1990.

Ingram, J. S. *The Centennial Exposition, Described and Illustrated*. Philadelphia: Hubbard Bros., 1876.

Irigaray, Luce. *This Sex Which Is Not One*. Translated by Catherine Porter. Ithaca, N.Y.: Cornell University Press, 1985.

Israel, Kali A. K. "Writing Inside the Kaleidoscope: Re-Representing Victorian Women Public Figures." *Gender and History* 2, no. 1 (Spring 1990): 40–48.

Jackson, Virginia. "Longfellow's Tradition; or, Picture-Writing a Nation." *Modern Language Quarterly* 59, no. 4 (December 1998): 471–96.

Jahoda, Gustav. *Images of Savages: Ancient Roots of Modern Prejudice in Western Culture*. London: Routledge, 1999.

James, Henry. *William Wetmore Story and His Friends*. New York: Grove Press, 1903.

Jameson, Anna. *Memoirs of Celebrated Female Sovereigns*. 2 vols. London: Henry Colburn and Richard Bentley, 1831.

Jarves, James Jackson. *Art Thoughts: The Experiences and Observations of an American Amateur in Europe*. New York: Hurd and Houghton, 1870.

———. "Progress of American Sculpture in Europe." *Art-Journal* (London) 10 (1871): 6–8.

Johns, Elizabeth. *American Genre Painting: The Politics of Everyday Life*. New Haven, Conn.: Yale University Press, 1991.

———. *Thomas Eakins: The Heroism of Modern Life*. Princeton, N.J.: Princeton University Press, 1983.

Johnson, William Henry. *Autobiography of Dr. William Henry Johnson*. 1900. Reprint, New York: Haskell House Publishers, 1970.

Karcher, Carolyn L. *The First Woman in the Republic: A Cultural Biography of Lydia Maria Child*. Durham, N.C.: Duke University Press, 1994.

———. "Rape, Murder, and Revenge in 'Slavery's Pleasant Homes': Lydia Maria Child's Antislavery Fiction and the Limits of Genre." *The Culture of Sentiment: Race, Gender, and Sentimentality in Nineteenth-Century America*, edited by Shirley Samuels, 58–72. New York: Oxford University Press, 1992.

Kasson, Joy S. *Marble Queens and Captives: Women in Nineteenth Century American Sculpture*. New Haven, Conn.: Yale University Press, 1990.

Kerber, Linda K. "The Abolitionist Perception of the Indian." *Journal of American History* 62, no. 2 (September 1975): 271–95.

Ketner, Joseph D. *The Emergence of the African American Artist: Robert S. Duncanson, 1821–1872*. Columbia: University of Missouri Press, 1993.

Kinney, Leila W. "Morisot." *Art Journal* 47, no. 3 (Fall 1988): 236–41.

Kleeblatt, Norman L. "Master Narratives/Minority Artists." *Art Journal* 57, no. 3 (Fall 1998): 29–35.

Langston, John Mercer. *From the Virginia Plantation to the National Capitol; or, The First and Only Negro Representative in Congress from the Old Dominion*. Hartford, Conn.: American Publishing Co., 1894.

Lathers, Marie. "Posing the 'Belle Juive': Jewish Models in Nineteenth-Century Paris" *Woman's Art Journal* 21, no. 1 (Spring–Summer 2000): 27–32.

Lawson, Ellen N., and Marlene Merrill. "Antebellum Black Coeds at Oberlin College." *Oberlin Alumni Magazine* (January–February 1980): 18–21.

Lewis, Reina. *Gendering Orientalism: Race, Femininity and Representation*. New York: Routledge, 1996.

Liechtenhan, Rudolf. *Danza classica: Il balletto nel secolo romantico*. Translated by Giuliana Fantoni. Milan: Editoriale Jaca Book, 1993.

Liversidge, Michael, and Catharine Edwards. *Imagining Rome: British Artists and Rome in the Nineteenth Century*. London: Merrell Holberton, 1996.

Lockard, Joe. "The Universal Hiawatha." *American Indian Quarterly* 24, no. 1 (Winter 2000). Academic Search Elite database, accession no. 0095182X.

Longfellow, Henry Wadsworth. *The Song of Hiawatha*. New York: Bounty Books, 1968.

Lorcin, Patricia M. E. "Imperialism, Colonial Identity, and Race in Algeria,

1830–1870: The Role of the French Medical Corps." *Isis* 90, no. 4 (December 1999): 653–79.

Lord, John. "Cleopatra: The Woman of Paganism, 69–30 B.C.E." *Great Women.* Beacon Lights of History 5. New York: Fords, Howard, and Hulbert, 1886, 23–60.

Lubin, David M. "Reconstructing Duncanson." *Picturing a Nation: Art and Social Change in Nineteenth-Century America,* 107–57. New Haven, Conn.: Yale University Press, 1994.

MacKenzie, John M. *Orientalism: History, Theory, and the Arts.* Manchester: Manchester University Press, 1995.

Mainiero, Lina, ed. *American Women Writers: A Critical Reference Guide from Colonial Times to the Present.* 4 vols. New York: Frederick Ungar, 1980.

Mardock, Robert Winston. *The Reformers and the American Indian.* Columbia: University of Missouri Press, 1971.

Mathews, Marcia M. *Henry Ossawa Tanner: American Artist.* Negro American Biographies and Autobiographies Chicago: University of Chicago Press, 1969.

Maxwell, Anne. *Colonial Photography and Exhibitions: Representations of the "Native" and the Making of European Identities.* London: Leicester University Press, 1999.

McFeely, William S. *Frederick Douglass.* New York; London: W. W. Norton, 1991.

Merish, Lori. *Sentimental Materialism: Gender, Commodity Culture, and Nineteenth-Century American Literature.* New Americanists. Durham, N.C.: Duke University Press, 2000.

Miller, Angela L. *The Empire of the Eye: Landscape Representation and American Cultural Politics, 1825–1875.* Ithaca, N.Y.: Cornell University Press, 1993.

Mitchell, Timothy. *Colonising Egypt.* Berkeley: University of California Press, 1991.

Mondaini, Gennaro. *La questione dei Negri nella storia e nella società nord-americana.* Turin: Fratelli Bocca, Editori, 1898.

Montanelli, Indro. *L'italia del Risorgimento.* Milan: RCS Libri, 1998.

Mooney, Amy M., and Archibald John Motley. *Archibald J. Motley Jr.* San Francisco: Pomegranate, 2004.

Morrison, Toni. *Playing in the Dark: Whiteness and the Literary Imagination.* New York: Vintage Books, 1992.

Morton, Patricia. *Disfigured Images: The Historical Assault on Afro-American Women.* New York: Praeger, 1991.

Mosby, Dewey F., Darrel Sewell, and Rae Alexander-Minter. *Henry Ossawa Tanner.* Philadelphia: Philadelphia Museum of Art; New York: Rizzoli International Publications, 1991.

Mullen, Harryette. "Runaway Tongue: Resistant Orality in *Uncle Tom's Cabin, Our Nig, Incidents in the Life of a Slave Girl,* and *Beloved." The Culture of*

Sentiment: Race, Gender, and Sentimentality in Nineteenth-Century America, edited by Shirley Samuels, 244–64. New York: Oxford University Press, 1992.

Murray, Freeman H. M. *Emancipation and the Freed in American Sculpture: A Study in Interpretation*. 1916. Reprint, Freeport, N.Y.: Books for Libraries Press, 1972.

Nabokov, Peter, and Robert Eason. *Native American Architecture*. New York: Oxford: Oxford University Press, 1989.

Nickerson, Cynthia D. "Artistic Interpretations of Henry Wadsworth Longfellow's *The Song of Hiawatha*, 1855–1900." *American Art Journal* 16, no. 3 (Summer 1984): 49–77.

Nochlin, Linda. "The Imaginary Orient." *The Politics of Vision: Essays on Nineteenth-Century Art and Society*, 33–59. New York: Harper and Row, 1989.

Ockman, Carol J. "'Two Large Eyebrows à L'Orientale': Ethnic Stereotyping in Ingres's *Baronne De Rothschild*." *Art History* 14, no. 4 (December 1991): 521–39.

―――. "When Is a Jewish Star Just a Star? Interpreting Images of Sarah Bernhardt." *The Jew in the Text: Modernity and the Construction of Identity*, edited by Linda Nochlin and Tamar Garb, 121–39. London: Thames and Hudson, 1995.

Olney, James. "'I Was Born': Slave Narratives, Their Status as Autobiography and as Literature." *The Slave's Narrative*, edited by Charles T. Davis and Henry Louis Gates Jr., 148–74. New York: Oxford University Press, 1985.

O'Neill, Scannell. "The Catholic Who's Who." *Rosary Magazine* 34 (February 1909): 322–23.

Painter, Nell Irvin. "Sojourner Truth in Life and Memory: Writing the Biography of an American Exotic." *Gender and History* 2, no. 1 (Spring 1990): 3–16.

―――. *Sojourner Truth: A Life, a Symbol*. New York: W. W. Norton, 1996.

Palma, Silvana. "La società africana d'Italia: 'Sodalizio di agitazione' napoletano di fine ottocento." *Archivio Fotografico Toscano* 11, no. 21 (June 1995): 12–16.

Parrott, Sara Foose. "Networking in Italy: Charlotte Cushman and 'the White Marmorean Flock.'" *Women's Studies* 14, no. 4 (1988): 305–38.

Patton, Sharon F. *African-American Art*. Oxford History of Art. Oxford: Oxford University Press, 1998.

Perkins, Linda M. "The Impact of the 'Cult of True Womanhood' on the Education of Black Women." *Journal of Social Issues* 39, no. 3 (1983): 17–28.

Pers, Henrik. "Political and Social Conditions in Rome during the Reign of Pius IX." *Rome in Early Photographs: The Age of Pius IX: Photographs 1846–1878 from Roman and Danish Collections*, 11–17. Translated by Ann Thornton. Copenhagen: Thorvaldsen Museum, 1977.

Peterson, Merrill D. *Lincoln in American Memory*. New York: Oxford University Press, 1994.

Phillips, Ruth B. *Trading Identities: The Souvenir in Native North American Art from the Northeast, 1700–1900*. Seattle: University of Washington Press, 1998.

Pinder, Kymberly N. "Black Representation and Western Survey Textbooks." *Art Bulletin* 81, no. 3 (September 1999): 533–38.

Pinkus, Karen. *Selling the Black Body: Advertising and the African Campaign, Bodily Regimes: Italian Advertising under Fascism*. Minneapolis: University of Minnesota Press, 1995.

Plutarch. *Lives IX: Demetrius and Antony; Pyrrhus and Gaius Marius*. Translated by Bernadotte Perrin. 1920. Reprint, Cambridge, Mass.: Harvard University Press, 1996.

Pohl, Frances K. "Black and White in America." *Nineteenth Century Art: A Critical History*, edited by Stephen F. Eisenman, 163–87. London: Thames and Hudson, 1994.

Priest, Josiah. *The Bible Defence of Slavery*. Glasgow, Ky.: W. S. Brown, 1852.

Pritzker, Barry M. *A Native American Encyclopedia: History, Culture, and Peoples*. New York: Oxford University Press, 2000.

Prucha, Francis Paul. *American Indian Policy in Crisis: Christian Reformers and the Indian, 1865–1900*. Norman: University of Oklahoma Press, 1976.

Quarles, Benjamin. *Black Abolitionists*. New York: Oxford University Press, 1969.

Ramirez, Jan Seidler. "A Critical Reappraisal of the Career of William Wetmore Story (1819–1895): American Sculptor and Man of Letters." Ph.D. diss., Boston University, 1985.

Reed, Adolph L. *W. E. B. Du Bois and American Political Thought: Fabianism and the Color Line*. New York: Oxford University Press, 1997.

Rice, Laura. "African Conscripts/European Conflicts: Race, Memory, and the Lessons of War." *Cultural Critique* no. 45 (Spring 2000): 109–49.

Richards, Leonard L. *"Gentlemen of Property and Standing": Anti-Abolition Mobs in Jacksonian America*. Oxford: Oxford University Press, 1970.

Richardson, Marilyn. "Edmonia Lewis at Mcgrawville: The Early Education of a Nineteenth-Century Black Woman Artist." *Nineteenth-Century Contexts* 22 (2000): 239–56.

———. "Edmonia Lewis's *The Death of Cleopatra*: Myth and Identity." *International Review of African American Art* 12, no. 2 (1995): 36–52.

Riss, Arthur. "Racial Essentialism and Family Values in Uncle Tom's Cabin." *American Quarterly* 46, no. 4 (December 1994): 513–44.

Roberts, Alison. *Hathor Rising: The Power of the Goddess in Ancient Egypt*. Rochester, Vt.: Inner Traditions International, 1997.

Robinson, Jontyle Theresa, Wendy Greenhouse, Archibald John Motley. *The Art of Archibald J. Motley, Jr.* Chicago: Chicago Historical Society, 1991.

Rogin, Michael Paul. *Fathers and Children: Andrew Jackson and the Subjugation of the American Indian*. New Brunswick: Transaction Publishers, 1995.

Romero, Lora. "Vanishing Americans: Gender, Empire, and New Historicism,"

The Culture of Sentiment: Race, Gender, and Sentimentality in Nineteenth-Century America, edited by Shirley Samuels, 115–27. New York: Oxford University Press, 1992.

Ronda, Bruce A. "Print and Pedagogy: The Career of Elizabeth Peabody." *A Living of Words: American Women in Print Culture*, edited by Susan Albertine, 35–48. Knoxville: University of Tennessee Press, 1995.

Rota, Giuseppe. *Bianchi e Negri: Azione storica-allegorica in tre quadri e sette scene nel regio Teatro della Scala nell' autunno 1863*. Translated by Ferdinando Pratesi. Milan: Per Luigi di Giacomo Pirola, 1863.

———. *Giorgio il Negro: Ballo allegorico fantastico in tre parte e sei scene da rappresentarsi al Teatro di Apollo nel Carnevale 1858 in 1859*. Rome: Giovanni Olivieri Tipografo, 1859.

Rothman, Ellen K. *Hands and Hearts: A History of Courtship in America*. Cambridge, Mass.: Harvard University Press, 1987.

Said, Edward W. *Orientalism*. New York: Vintage Books, 1979.

Sánchez-Eppler, Karen. "Bodily Bonds: The Intersecting Rhetorics of Feminism and Abolitionism." *Representations* 24 (Fall 1988): 28–59.

Savage, Kirk. "Molding Emancipation: John Quincy Adams Ward's *The Freedman* and the Meaning of the Civil War." *Terrain of Freedom: American Art and the Civil War*, edited by Andrew Walker, 26–39. Chicago: Art Institute of Chicago *Museum Studies*, 2001.

———. *Standing Soldiers, Kneeling Slaves: Race, War, and Monument in Nineteenth-Century America*. Princeton, N.J.: Princeton University Press, 1997.

Saxton, Alexander. *The Rise and Fall of the White Republic: Class Politics and Mass Culture in Nineteenth-Century America*. London: Verso, 1990.

Schechner, Richard. *The Future of Ritual: Writings on Culture and Performance*. London: Routledge, 1993.

Schor, Naomi, and Elizabeth Weed, eds. *The Essential Difference*. Bloomington: Indiana University Press, 1994.

Sealander, Judith. "Antebellum Black Press Images of Women." *Western Journal of Black Studies* 6, no. 3 (Fall 1982): 159–65.

Shakespeare, William. *Antony and Cleopatra*. Edited by M. R. Ridley. Arden Edition of the Works of William Shakespeare. London: Methuen, 1986.

Sherwood, Dolly. *Harriet Hosmer, American Sculptor, 1830–1908*. Columbia: University of Missouri Press, 1991.

Smith, Shawn Michelle. *American Archives: Gender, Race, and Class in Visual Culture*. Princeton, N.J.: Princeton University Press, 1999.

Smith-Rosenberg, Carroll. *Disorderly Conduct: Visions of Gender in Victorian America*. New York: Oxford University Press, 1985.

Spence, Lewis. *Ancient Egyptian Myths and Legends*. 1915. Reprint, New York: Dover, 1990.

Spillers, Hortense J. "Interstices: A Small Drama of Words." *Pleasure and*

Danger: Exploring Female Sexuality, edited by Carol S. Vance, 73–100. Boston: Routledge and Kegan Paul, 1984.

Sterling, Dorothy. "To Build a Free Society: Nineteenth-Century Black Women." *Southern Exposure* 12, no. 2 (March/April 1984): 24–30.

———, ed. *We Are Your Sisters: Black Women in the Nineteenth Century*. New York: W. W. Norton, 1984.

Stetson, Erlene. "Studying Slavery: Some Literary and Pedagogical Considerations on the Black Female Slave." *All the Women Are White, All the Blacks Are Men, but Some of Us Are Brave*, edited by Gloria T. Hull, Patricia Bell Scott, and Barbara Smith, 61–84. New York: Feminist Press, 1982.

Story, William Wetmore. "Cleopatra — a Poem." *Living Age* 87 (October, November, December, 1865): 86–87.

Stowe, Harriet Beecher. *The Key to Uncle Tom's Cabin*. New York: Arno Press, 1969.

———. "Sojourner Truth, the Libyan Sibyl." *Atlantic Monthly* 11 (April 1863): 473–81.

———. *Uncle Tom's Cabin, or, Life among the Lowly*. 1852. Reprint, New York: Harper and Row, 1965.

Taberner, Peter V. *Aphrodisiacs: The Science and the Myth*. London: Croom Helm, 1985.

Taft, Loredo. *The History of American Sculpture*. New York: Macmillan, 1924.

Tate, Claudia. "Allegories of Black Female Desire; or, Rereading Nineteenth-Century Sentimental Narratives of Black Female Authority." *Changing Our Own Words: Essays on Criticism, Theory, and Writing by Black Women*, edited by Cheryl A. Wall, 98–126. New Brunswick, N.J.: Rutgers University Press, 1989.

Tompkins, Jane. "Sentimental Power: 'Uncle Tom's Cabin' and the Politics of Literary History." *Ideology and Classic American Literature*, edited by Sacvan Bercovitch and Jehlen Myra, 267–92. Cambridge: Cambridge University Press, 1991.

Truettner, William H. *The West as America: Reinterpreting Images of the Frontier, 1820–1920*. Washington, D.C.: Smithsonian Institution Press, 1991.

Tuckerman, Henry T. *Book of the Artists*. 6th ed. New York: G. P. Putnam's Sons, 1882.

Twain, Mark. *Roughing It*. 1872. Reprint, Berkeley: University of California Press, 1993.

Vance, William L. *America's Rome*. Vol. 1, *Classical Rome*. Vol. 2, *Catholic and Contemporary Rome*. New Haven, Conn.: Yale University Press, 1989.

Vendryes, Margaret Rose. "Race Identity/Identifying Race: Robert S. Duncanson and Nineteenth-Century American Painting." *Terrain of Freedom: American Art and the Civil War*, edited by Andrew Walker, 82–99. Chicago: Art Institute of Chicago *Museum Studies*, 2001.

Wallis, Brian. "Black Bodies, White Science: Louis Agassiz's Slave Daguerreotypes." *American Art* 9, no. 2 (Summer 1995): 39–59.

Welter, Barbara. "The Cult of True Womanhood, 1820–1860." *American Quarterly* 18, no. 2 (Summer 1966): 151–74.

West, Michael Rudolph. *The Education of Booker T. Washington: American Democracy and the Idea of Race Relations*. New York: Columbia University Press, 2006.

Wexler, Laura. "Tender Violence: Literary Eavesdropping, Domestic Fiction, and Educational Reform." *The Culture of Sentiment: Race, Gender, and Sentimentality in Nineteenth Century America*, edited by Shirley Samuels, 9–38. Oxford: Oxford University Press, 1992.

White, Deborah Gray. *Ar'n't I a Woman? Female Slaves in the Plantation South*. New York: W. W. Norton, 1985.

Whittier, John Greenleaf. *Reform and Politics*. Part 2, Vol. 7, *The Works of Whittier: The Conflict with Slavery, Politics and Reform, The Inner Life, and Criticism*. Project Gutenberg: Ebook # 9596, December 2005.

Williams, Raymond. *Keywords: A Vocabulary of Culture and Society*, rev. ed. London: Flamingo, 1983.

Wilson, Judith. "Getting Down to Get Over: Romare Bearden's Use of Pornography and the Problem of the Black Female Body in Afro-U.S. Art." *Black Popular Culture*, edited by Gina Dent, 112–22. Seattle: Bay Press, 1992.

———. "Hagar's Daughters: Social History, Cultural Heritage, and Afro-U.S. Women's Art." *Bearing Witness: Contemporary Works by African American Women Artists*, edited by Jontyle Theresa Robinson, 95–112. New York: Spelman College and Rizzoli International Publications, 1996.

———. "Optical Illusions: Images of Miscegenation in Nineteenth- and Twentieth-Century Art." *American Art* 5, no. 3 (Summer 1991): 89–107.

Wolfe, Rinna Evelyn. *Edmonia Lewis: Wildfire in Marble*. Parsippany, N.J.: Dillon Press, 1998.

Woods, Naurice Frank Jr. "Insuperable Obstacles: The Impact of Racism on the Creative and Personal Development of Four Nineteenth Century African American Artists." Ph.D. diss., Union Institute, 1993.

Yee, Shirley J. *Black Women Abolitionists: A Study in Activism, 1828–1860*. Knoxville: University of Tennessee Press, 1992.

Yellin, Jean Fagan. "Text and Contexts of Harriet Jacobs' *Incidents in the Life of a Slave Girl: Written by Herself*." *The Slave's Narrative*, edited by Charles T. Davis and Henry Louis Gates Jr., 262–82. Oxford: Oxford University Press, 1985.

———. *Women and Sisters: The Antislavery Feminists in American Culture*. New Haven, Conn.: Yale University Press, 1989.

Young, Robert J. C. *Colonial Desire: Hybridity in Theory, Culture and Race*. New York: Routledge, 1995.

Page numbers in *italics* refer to illustrations.

—women: African identity, black modernism, and, 166–68, 172, 174–75; as children, 109–11, 154, 162; genealogy for, 166–67, 174–75; Lewis and Fuller as racially other to, 175

African Americans: abolitionists' promotion of, 13, 16, 18, 37; accomplishment exemplified by, 3; "black victim" perspective on, 145, 156–57, 159; class and skin color in depictions of, 240 n. 15; double consciousness conceived for, 42–45, 146–47, 226 n. 41, 226 n. 44; education's significance for, 5–6, 233 n. 120; after emancipation, 229 n. 88; Emancipation Day holidays of, 52, 228 n. 67; fate of Native Americans linked to, 100–102; gender roles reinforced and validated by, 55–57; Gosiutes vs., 114; as immature colonial subject, 109–10; interpretive distance from, 75–76; Lewis as historical paradigm of, 89–90; as never there vs. missing in art, 33, 35–45; partial vs. full enfranchisement for, 170, 171, 247 nn. 90–91; "representative," 139–40; as "young" people, 15

—men: danger embodied by, 61, 230–31 n. 99; fears about, 62–64; in gender binaries, 168–69; manhood and freedom of, 58–59; in slave paradigm, 178–79

—women: agency of, 168–70, 246 n. 83; controlling images of, 98–99; dangers for, 141; educational curriculum for, 6–7; exoticism of, 254 n. 1; in gender binaries, 168–70; Lewis's Cleopatra vs., 205–7; occupational alternatives for, 6; "pathology" read onto, 202; personhood of,

74–76; Spillers's reading of, 254 n. 1; true motherhood for, 56, 58–59

Africanism. *See* American Africanism

Agassiz, Louis, 89, 184

agency: art as precursor to understanding, 133–34; cultural work and, 99–100; emancipation linked to, 159; expansionists' evasion of, 101; feminine consent and, 118, 120; gender binaries and, 168–70, 246 n. 83

Algeria: colonization of, 22–23; independence of, 221 n. 83

Allston, Washington, 12, 68

America (Powers), 221 n. 80

American Africanism: artificial separation of, xix, 215 n. 2; as disabling virus, xviii; Lubin's views and, 164; Morrison's use of term, xviii; search for "authentic" and, 179–80; white and black art historians' enactments of, 134–35, 164–81. *See also* blackness

American Anti-Slavery Society, 107

American art: defined, 210–12; model of progress in, 253 n. 167; national discourse on, xx, xxi; sentimentalism's persistence in, 212–13; style associated with, 201–2

American Art Journal, 86–87

American Art Review, 235 n. 29, 235 n. 31

American Civil War: "Indian Problem" after, 102; reinforcing victory of, 77–78; symbol of North-South reunion after, 92–93, 99–100, 236 n. 39; Zouave links to, *pl. 4*, 23–24, 221–22 n. 84

American Indianism: artificial separation of, xix, 215 n. 2; Lewis's performance of, 102, 108–16, 123, 131–32; as "problem," xvii–xviii. *See also* vanishing American

blackness (*continued*)
79; "purging" of, 66–67; slavery as
synonymous with, 178–79. *See also*
American Africanism
black subject: African American artist
as, 40–42, 134–35, 147–48; dilemma
of "absence" and, 33, 39–45, 166–67;
disavowal of, 202–7; everyday life
depicted for, 148–50; as immature
colonial subject, 109–10; margin-
alization of, 176–77; reinvented in
art histories, 176–81; Tanner read
in relation to, 150–52, 155–56, 242
n. 39. *See also* double consciousness;
sexual racialism; white knowing
subject, black (and Indian) known
object
blazon, 138–39
*Blue Hole, Flood Waters, Little Miami
River* (Duncanson), *pl. 6*, 40–41
Boime, Albert: ambivalence of, 143–
45; American Africanism and, 164;
"black victim" perspective of, 145,
156–57, 159–65, 178–79, 244–45
n. 70; on Bonheur, 248 n. 108; on
Cleopatra, 134, 135, 139, 160–61; on
Duncanson, 224 n. 8; on *Forever
Free*, 53–54, 159–61, 162–64; on
"forever free" theme, 228 n. 65;
"intention" assigned by, 176; Lewis's
works categorized by, 171–72; on
Mount, 241 n. 26; on Murray, 244
n. 55; search for "authentic" and,
179–80; sexual racialism of, 178–
79, 248 n. 108; sources of, 242–43
n. 46; on Tanner, 145–56, 177, 241
n. 26, 242 n. 39; as white knowing
subject, 244 n. 54
Bolton, Linda, 212
Bonaparte, Napoleon, 190
Bonheur, Rosa, 248 n. 108
Bossaglia, Rossana, 19

Boston, 2, 3, 11–18
Bowdoin College, 79–80
Brackett, Edward A., 2, 12, 13
Bride of Spring (M. E. Lewis), 25
Brock, Thomas, 89
Brodhead, Richard, 7
Bromley, Edward Augustus, *128*
Bronfen, Elisabeth: on dead
female bodies, 204–5; on
(mis)representations of death, 193,
195–98, 206; terminology of, 254
n. 174
Brontë, Charlotte, 248 n. 112, 250
n. 135
Brown, Elsa Barley, 58–59
Brown, Henry Kirk, 231 n. 111
Brown, John, 12, 13, 91, 187
Brown, William Wells, 168; biographi-
cal sketches by, 248–49 n. 115; at
dedication of sculpture, 60, 139;
on Grimes, 59; on Lewis's appear-
ance, 137–38, 139–40; poem of, 159;
source of, 240 n. 12
Bullard, Laura Curtis, 12, 137–38, 139,
238 n. 96, 240 n. 12
Burgard, Timothy Anglin: Boime vs.,
147; as curator, 88–94, 163; Holland
vs., 94, 96, 98–99; republished essay
of, 235 n. 29, 235 n. 31; sources of,
235 n. 34
Burke, Edmund, 223 n. 2
Burnett, Peter H., 101
busts (Lewis): Brown, 13, 91, 187;
Douglass, 28; Garrison, 157; Hia-
watha, 66, 94, *95*, 117; Longfellow,
88, 90, 187, 229–30 n. 92; Minne-
haha, 94, *95*, 117; Phillips, 157; Shaw,
13–15, *14*, 157, 231 n. 107; Sumner,
157, 187, 218 n. 42; Voltaire, 15

Calhoun, Charles C., 84, 85, 234–35
n. 21, 235 n. 28
Canova, Antonio, 188, 250 n. 130

Egypt: artifacts from, 204; as black
Africa, 67–68; contested nature of,
231–32 n. 112; motifs of, 188, 200,
250 nn. 132–33, 251 n. 141; Napo-
leon's invasion of, 190
Egyptology, 183–85
Ellison, Ralph, 32
Ellsworth, Elmer, 23–24
*Ellsworth's Campaign in Barrack or
Dress Uniforms* (Mendel), *pl. 4,*
23–24
emancipation: assumptions about,
159–60, 163; creating language of,
65; depictions of, 22, 64, 157, *158*;
families reunited after, 229 n. 88;
as male-gendered, 61–64; slavery
emblem as representing, 73–74;
as theme in sculpture, 170–71, 230
n. 98. *See also* freedom
Emancipation Day, 52, 228 n. 67
Emancipation Group (Fuller), 157, *158*,
160
Emancipation Proclamation: depic-
tions of, 22, 64, 157, *158*; Garibaldi
and, 24; legality of, 77–78; text of,
52, 228 n. 65
Emerson, Ralph Waldo: on America as
"unsung poem," xv, 87, 166–67; on
American attributes, 100; children
of the fire phrase of, xiv, xvi; on
the modern, 201; on poet and true
art, xiv–xv, 80, 130; white knowing
subject, black (and Indian) known
object and, xv, 38, 42, 76
emotions: assumptions about emanci-
pation and, 60, 159–60, 163; Child
on, 16; code words for, 72–73; gen-
der constructions and, 6, 118, 120,
215–16 n. 9, 232–33 n. 118; of Lewis's
Hagar, 70, 71; Longfellow's writing
as form of, 85; vanishing American
ideology and, 101, 109–10; white

knowing subject, black (and Indian)
known object and, 45–47
essentialism: African identity and,
167–68; alternative to, 49–50; in
Americanization, 116; authenticity
defined in, 39–40; in gender and
racial constructions, 35–37, 41–45,
48–49, 224 n. 10
Ethiopia Awakening (Fuller), 172, *173*
Euro-American identity: Indian as
symbolic of freedom in, 113, 115–16;
Longfellow's role in constructing,
80–84, 90, 91–94; male authority
privileged in, 99; "playing Indian"
fantasy and, 113–14, 116; Pocahon-
tas's adaptation to, 96–97
Evangeline (Longfellow), 80–81
Evans, Walter O., 124, 125, 237 n. 91,
237–38 n. 92, 238 n. 96
Eve Repentant (Bartholomew), 231
n. 111
exoticism: alternative narrative to, 213;
black female as, 254 n. 1; failure of
describing Lewis as, 143, 156–65;
implications of narrative of, 176–77,
180–81; Lewis as subversive vs., xiv,
xvi, xix, 33, 134–35, 143, 165; Lewis's
use of, 96, 98, 162; Tanner and, 153.
See also subversiveness
expatriate American artists: Italian
unification supported by, 22–23,
24–25; Lewis among, 33–34, 164–
65, 213; motivations of, 20–21; reli-
gious stance of, 25; role of, 1–2
exploitation, 124
Exposition Universelle (1867), 204

Faithful, Emily, 222 n. 94
family: in abolition debate, 60–61;
African American freedom and,
55–56; Hagar and Ishmael as alle-
gory of, 70–71; reunification after
emancipation of, 229 n. 88

works vs., 91, 117; whereabouts of, 237–38 n. 92

Hiawatha's Wooing (Lewis), *pl. 10*; inscription of, 238 n. 96; other works vs., 91, 124–25, 127; patriarchy celebrated in, 118, 120; souvenirs and tourism in, 120, 122–24; whereabouts of, 237 n. 91

Hillard, George S., 21

Hoganson, Kristin, 230 n. 94

Holland, Juanita M., 94, 96–100, 116

Holocaust, 42

Home Journal, 117

Honour, Hugh, 33, 239 n. 8

Hopkins, James, 222 n. 90

Hopkins, Pauline E., 227–28 n. 61

Horton, James Oliver, 57, 58

Hosmer, Harriet, 51, 129; appearance of, 96; Burgard on, 91; characteristics of, 165; circle of, 73; in Lewis and Longfellow exhibit, 89; Lewis's relationship with, 64, 65, 231 n. 105, 231 n. 107; newspaper's mention of, 231 n. 102

Hudson River School, 38–39, 40–41, 42

Hughes-Hallett, Lucy, 249 n. 121, 250 n. 132

Hume, David, 223 n. 2

Hurston, Zora Neale, 55

Hyperion, a Romance (Longfellow), 79–80

I Bianchi ed i Negri (ballet), 20, 220 nn. 71–72

ideal realism, 51

ideal sculpture: as act of agency, 133–34; concept of, xiv, 34–35; cultural context of, xxi, 34, 50–51; distancing in, 74; ethnicity and race of, 51, 65–67, 71, 75, 132, 163–64, 182, 203, 206–7; figural style of, 69; limits of, 73–74; manhood and motherhood

in, 58–59; material of, 50, 134, 162–63; morality legitimated in, 74–75; as self-portrait, 33, 135–36, 223 n. 3; subjects chosen for, 13–14, 50; subversive interplay in, 75–76. *See also* Indian works; slavery works

identity, 131–32, 180; blood as, 136–37. *See also* Euro-American identity; Lewis, Mary Edmonia: identity

ideologies: artist's role in facilitating, 133–34; of English tourism, 21; of sex and race, 129–30; in social rituals, xv–xvi. *See also* sentimentalism; true womanhood; vanishing American; whiteness

impressionism, 48–49

Independent, 17

Indian Bureau, 107–8

Indian Girl (Palmer), 103, *105*, 125

"Indian Problem": eastern response to, 103, 106–7; Lewis's rhetorical and artistic Indianness and, 102, 108–16, 123, 131–32; re-emergence of, 102; western response to, 107–8, 111–12; Whittier's framing of, xvii–xviii, 116

Indian works: contemporary response to, 128–30; disappearances and distances in, 102–16; historical context of, 100–102; ideal of marriage in, 125, 127–28; inspiration for, 92–94; patriarchy celebrated in, 118, 120; readings of, 76, 97–100; sentimentalism in, 131–32; souvenirs and tourism in, 120, 122–24. *See also* Hiawatha; Minnehaha

inferential criticism, xx–xxi

Ingram, J. S., 199, 252–53 n. 163

Ingres, Jean Auguste Dominique, 252–53 n. 163

Inman, Henry, 40

intention: of art histories, 50; assignment of, 176; in Baxandall's triangle

subjects and themes of, 13–14, 97–
99, 131–32, 135–36, 171–72, 235 n. 34
— identity: African, 166–68, 172,
174–75; audience for, 112; "autobio-
logical," 48–50; as black and Indian
subject, 33; Burgard's portrayal of,
91–92, 98–99; as child or savage,
109–11, 162; failed descriptions of,
134–81; as feminist, 166, 169–70;
fluid notion of, 34–35; as historical
paradigm, 89–90; Holland's por-
trayal of, 94, 96–97, 98–99; as ob-
ject and subject, 1–2; rhetorical and
artistic Indianness in, 102, 108–16,
123, 131–32; self-perception as artist
of, 66–67, 74–76, 137; as unknow-
able, 27–28, 209, 254 n. 1
— personal life: arrest and trial of, 8–
10; beating of, 9–10, 141, 240 n. 19;
birth of, 1, 4, 28, 216–17 n. 7; college
education of, 2–3, 5–11, 12–13, 111,
169–70, 216 n. 1, 217 n. 29; early
education of, 4–5, 111, 112; names of,
xvi, 4, 110–11; parents of, 4, 31, 76,
111, 113, 216 n. 3, 222 n. 89; religious
beliefs of, 3, 25, 26–27, 70, 162
Lewis, Samuel, 3, 4, 5–6, 28
liberal racialism, 31–32, 45, 46
Liberator, 221–22 n. 84
Libyan Sibyl, The (Story), 157, *158*, 185,
193, 251 n. 143
Lincoln, Abraham, 159; assassination
of, 64, 221–22 n. 84; emancipation
imagery of, *pl. 7*, *62*, 62–63, *63*,
64–65, 229 n. 80; Lewis's statue of,
pl. 3, 22–23, *24*; Zouave regiment
and, 23–24
Lincoln, Tad, 24
literary discourse: Africanism as dis-
abling virus in, xviii; black women's
narratives in, 74–76; captivity nar-
ratives in, 141; on Cleopatra, 248

nn. 112–13, 248–49 n. 115, 250 n. 135;
marriage vs. freedom in, 55; poetry,
79–87; "purging" of blackness in,
67; sentimental narrative in, 45–48,
50–51, 72–73; "unintended reader"
of, 72–73, 131–32
Lockard, Joe, 82–83, 109
London Morning Post, 221–22 n. 84
Longfellow, Henry Wadsworth, 42;
art history's construction of, 85–88,
92; as Brackett's client, 12; Lewis's
bust of, *88*, 90, 187, 229–30 n. 92;
literary disappearance of, 84–86, 89,
99, 234–35 n. 21; as manly poet of
sentiment, 79–80; museum exhibit
of Lewis and, 88–94, 163; national
mythology created by, 80–84, 90,
91–94; status of, 127; "unintended
reader" of, 131–32
Longfellow Institute, 88, 235 n. 28
Lonrott, Elias, 81, 82
Lord, John, 185, 248–49 n. 115, 249
n. 121
Lubin, David M.: American African-
ism and, 164; black cultural inferi-
ority idea of, 178–79; Boime vs.,
144, 146, 163–64; on double con-
sciousness, 42, 44–45; on Duncan-
son, 35–48, 154, 224 n. 14, 225 n. 17,
225 n. 19; Duncanson's white father
invented by, 46–47, 152, 162, 177,
226–27 n. 50; on Harnett, 37, 225
n. 19, 226 n. 47; on pathology, 43–
44; sentimental model of, 45–48;
sexual racialism of, 178; on Spencer,
37, 46, 225 n. 19

MacKenzie, John, 242 n. 40
MacMonnies, Frederick, 200
Macpherson, James, 82
Madonna and Child (M. E. Lewis), 27,
222 n. 94
Manrique, Coplas de Don Jorge, 82

"pathology" discourse (*continued*)
45, 70, 176–79; African American
female and, 202; lack as, xvi; Lewis's,
159–65, 179; multiple signs of, 211–
12; use of term, 244–45 n. 70

patriarchy: Boime's reading of, 146,
163–65; defined and celebrated, 118,
120; Lewis's works and, 210, 213;
reading black artists through, 152–
54; sexual racialism and, 178–79

patronage: as dialogue, 3; punitive,
17–18; reading black artists through,
152–54, 224 n. 14; uneasy relation-
ships in, 14–16

Patton, Sharon F., xvi, 210, 227 n. 52

Peabody, Elizabeth Palmer: author's
reflections on, 230–31 n. 99; back-
ground and activities of, 15, 219
n. 56, 229–30 n. 92; on *Forever Free*,
16, 60, 61, 63; Lewis interviewed
by, 12

Peabody Museum of Archaeology and
Ethnology, 89

Peace Commission, 106–7, 112

Pettrich, Ferdinand, 103, *104*

Philadelphia Centennial (1876), 160,
186–87, 199

Phillips, Ruth B., 122–23, 210

Phillips, Wendell, 12, 91, 103, 106, 157

Pinder, Kymberly, 38, 39

Pinkus, Karen, 19

Pius IX (pope), 27

Plutarch, 207

Pocahontas, 96–97, 233 n. 125, 239
n. 112

Poe, Edgar Allan, 195

*Poems on Slavery (Poesie sulla schia-
vitù)* (Longfellow), 19

poetry, 79–87

Pohl, Francis K., 54, 64

polygenesis theory, 184

portraiture: interpretation of, 33, 135–

36, 223 n. 3; reality effect of, 205–7;
"true," 204–5. *See also* busts

Powell, Rick, xiii

Powers, Hiram: Italian unification
supported by, 22; Longfellow por-
trait by, 89

Pratt, Mary Louise, 131

Priest, Josiah, 249 n. 120

Prinsep, Valentine, *pl. 16*, 199

"problems": complexities of, xviii–xix;
Duncanson and Lewis as, 31–32,
49–50; use of term, xvi–xviii, 49.
See also "Indian Problem"; "Negro
Problem"

Quakers, 106

Quarles, Benjamin, 13

race: artist's identity read in, 136–41,
143; "categories" of, 22–23, 35–36,
41–42, 190–91, *191*, 221 n. 82, 224
n. 10; hair as signifier of, 138, 222
n. 89; in ideal vs. real dichotomy,
200–201; Italian views of, 18–21, 220
n. 69, 223 n. 1; "naturalism" linked
to, 129–30; philosophy underlying
definitions of, 223 n. 2; as "prob-
lem," xvi–xviii, 31–32; producer vs.
product of, 21; reification in art his-
tories of, 135–36; scientific construc-
tion of, 183–86; social construction
of, 37–45; tautological reading
based in, 33–35. *See also* sexual
racialism; white knowing subject,
black (and Indian) known object

Rachlin, Jack, 222 n. 90

racialism: in discourse on Cleopatra,
183–86; Lewis's response to, 124;
liberal, 31–32, 45, 46; romantic,
177–78; Rome as escape from, 27;
Tanner and, 150, 155; use of term,
178. *See also* sentimentalism; sexual
racialism

165–66; on feminist and abolitionist discourses, 170–71; on freedom in Africanness, 177; "intention" assigned by, 176; Lewis's Indianness disregarded by, 178; Lewis's works categorized by, 171–72; sexual racialism of, 178–79
Wollstonecraft, Mary, 169
"Woman Question," xviii
Woman's Journal, 27
women: active vs. passive, 168–70, 246 n. 83; African American, 109–11, 154, 162, 166–68, 172, 174–75; bridge between black and white, 61, 67; consent and agency of, 118, 120; cult of invalidism of, 198–99; death and fulfillment of, 195–99; economic marginalization of, 245–46 n. 82; fluid tribal identity of, 118; Lewis as historical paradigm of, 89–90; Oberlin curriculum for, 6–7; "playing Indian" fantasy and,

237 n. 83; sentimental narrative dominated by, 50–51; white captive, depictions of, 103, *105*, 141, *142*. *See also* gender; gender roles; true womanhood
Woods, Naurice Frank, Jr., 223 n. 3
Wordsworth, William, 226–27 n. 50
World's Columbian Exhibition (1893), xvi–xviii
Wreford, Henry, 58, 111, 137, 216 n. 3
Wright, Richard, 55

Yee, Shirley, 56
Yellin, Jean Fagan, 53–54, 59
Young, Robert, 184
Young Sabot Maker, The (Tanner), 148

Zealy, J. T., 89
Zenobia (Hosmer), 64, 89
Zouave regiments: in American Civil War, *pl. 4*, 23–24, 221–22 n. 84; in Crimean and world wars, 221 n. 83; Lewis's depiction of, *pl. 3*, 22–23

KIRSTEN PAI BUICK is an associate professor of art history at
the University of New Mexico.

Library of Congress Cataloging-in-Publication Data

Buick, Kirsten Pai.
Child of the fire : Mary Edmonia Lewis and the problem of art
history's Black and Indian subject / Kirsten Pai Buick.
p. cm.
Includes bibliographical references and index.
ISBN 978-0-8223-4247-2 (cloth : alk. paper)
ISBN 978-0-8223-4266-3 (pbk. : alk. paper)
1. Lewis, Edmonia. 2. African American sculptors.
3. Art, American — Social aspects — History.
4. Art and society.
I. Title. II. Title: Mary Edmonia Lewis and
the problem of art history's Black and Indian subject.
NB237.L487B85 2010
730.92 — dc22 [B] 2009042227

CPSIA information can be obtained
at www.ICGtesting.com
Printed in the USA
LVHW082309140122
708486LV00001B/9

9 780822 342663